LEGENDARY DINNERS

From Grace Kelly to Jackson Pollock

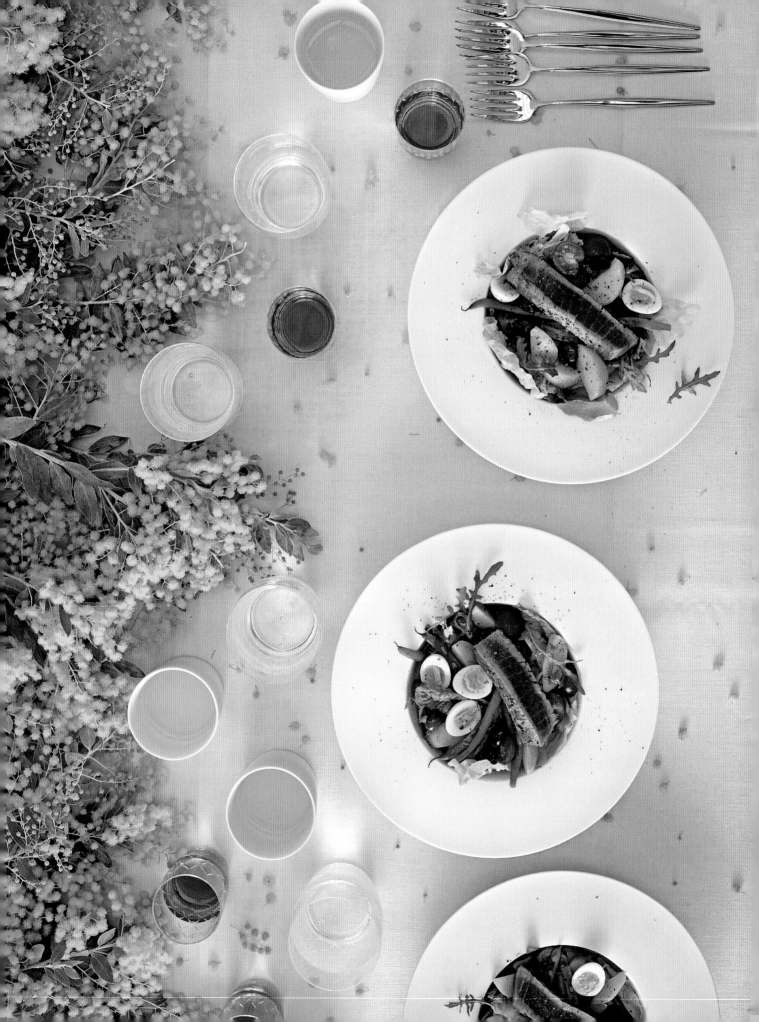

LEGENDARY DINNERS

From Grace Kelly to Jackson Pollock

EDITED BY ANNE PETERSEN

With contributions from Inge Ahrens, Barbara Baumgartner, Tina Bremer,
Annabelle Hirsch, Kristine Kirves, Christina Schneider, Erwin Seitz, Sina Teigelkötter,
Klaus Ungerer, and Marcus Woeller

PRESTEL

MUNICH • LONDON • NEW YORK

CONTENTS

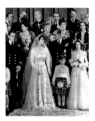
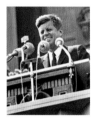
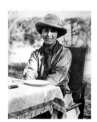

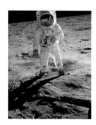

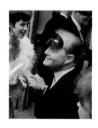
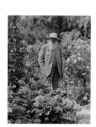

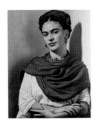
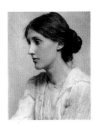

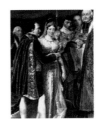
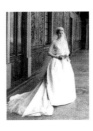

Exactly what makes a successful evening? It fires our imagination, delivering inspiring new encounters, delicious food, a wonderful atmosphere, a magical sense of ease and relaxation, and sometimes even the odd moment of romance.

This book takes a look at the world's most famous hosts, and attends the most legendary and memorable dinners and parties. They are described in such vivid detail that readers will almost feel they were there themselves. We recall amusing anecdotes and spicy details, feature reprints of invitations and menus, and recreate the dishes served so everyone can savor the festivities. It is a collection that will delight you in every respect—with extraordinary recipes, amazing table decorations, masterful combinations of porcelain, glass, and flatware, and flower arrangements suited to the relevant season. Be inspired by the dazzling personalities and their very unique ideas of what a good party should be: French banker's wife and socialite Marie-Hélène de Rothschild, for instance, believed that "those who are small in spirit, who are mean, narrow-minded or timid, should leave entertaining to others." She left nothing to chance, and her parties started with the invitation itself: "Tuxedos, evening gowns, and surrealist heads" was the dress code issued on the invitations to her guests at the unforgettable 1972 Surrealist Ball at Château de Ferrières. She herself appeared with deer antlers on her head, while Audrey Hepburn wore a birdcage around hers. The Spanish surrealist artist Salvador Dalí was the only one not in costume, claiming his old face was his mask.

Just as important as the actual invitation was the question of who was invited. In the summer of 1966, Truman Capote was never seen without his notebook, in which he constantly honed his guest list. He moved his guests around like pawns on a chessboard in a bid to find the most thrilling, elegant, and perhaps even controversial mix. The suspense grew, and America's elite became nervous; after all, not being invited to this party would be akin to social ruin. Capote appeared to have been satisfied with the end result: When the Black and White Ball was finally held at New York's Plaza Hotel in November 1966, the writer forewent any floral decoration, declaring his guests were the flowers.

And what might be served? Perhaps some Bauhaus-style canapés? A casual buffet à la Coco Chanel? Or a garden salad like Michelle Obama? Maybe a bombe glacée Princesse Elizabeth for dessert? That's what was served at the British monarch's Wedding Breakfast, which was actually an elegant meal after the wedding ceremony. In 1947, she married Philip, a Greek-Danish-German prince five years her senior, who had just as many royal ancestors as Elizabeth herself, but not a cent to his name—he was, in fact, still traveling in third-class train carriages until shortly before their marriage. He cut the wedding cake with an épée that, along with a whole slew of aristocratic titles, was a wedding gift from his father-in-law.

Ten years later, Hollywood actress Grace Kelly married Prince Rainier of Monaco, and her dress continues to inspire thousands of brides all over the world to this day. Kelly's father, construction entrepreneur John Kelly, from Philadelphia, could only shake his head at Rainier's fancy uniform, which he had designed himself specially for the occasion. John Kelly would scoff that Rainier was just "any old bankrupt prince" from Europe, but the wedding would be the first in history to be filmed so professionally and in close-up. The pair exchanged their vows in front of a worldwide television audience of thirty million.

A party is, indeed, also a performance—for guests and hosts alike. And sending out an invitation also takes some courage. Will everyone enjoy themselves? Will the conversation flow well at the dinner table? At German writer Johann Wolfgang von Goethe's house, for example, the diners would often sing between courses, with the writer encouraging his guests to read poems and sing songs. He had aristocrats mingling with commoners, flouting the rules of the royal court, and seated people together based on whether he thought they would have something interesting to converse about. Goethe's motto was: "If you always give of your best, your life will be a celebration!"

I hope this book inspires you to do the same. And remember: The best time for a party is now!

Anne Petersen

BUCKINGHAM PALACE
THURSDAY, 20TH NOVEMBER 1947
WEDDING BREAKFAST

Filet de Sole Mountbatten

............

Perdreau en Casserole
Haricots Verts
Pommes Noisette
Salade Royale

............

Bombe Glacée Princesse Elizabeth
Friandises

............

Dessert

............

Café

EP

Queen Elizabeth II

HER MAJESTY THE QUEEN

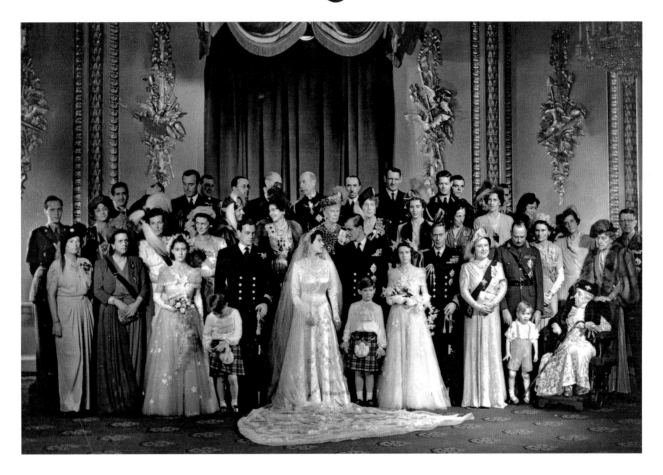

When the wedding of Princess Elizabeth Alexandra Mary Windsor was announced shortly after the end of World War II, some in Great Britain questioned whether such a grand celebration was appropriate. Winston Churchill, however, certainly thought it was, hailing it a "flash of color." We have dug into the archives and found the menu from that day.

- OPPOSITE French is the preferred language of gourmets, even at Buckingham Palace.
- ABOVE Princess Elizabeth's bridal gown took 350 seamstresses seven weeks to make, and her groom bore even more titles than before their marriage. Less plentiful—but all the more delectable—were the menu courses, which were served in the white-and-gold Ball Supper Room.

• SOLE MOUNTBATTEN
WITH LEEK AND PERNOD
The entrée bore the groom's
name. And that was just the
beginning, with "Mountbatten"
now being mentioned in the
same breath as "Windsor."
What an honor for the once-
penniless aristocrat! The
Gloriosa superba, or glory lily,
is a floral symbol of his rapid rise.

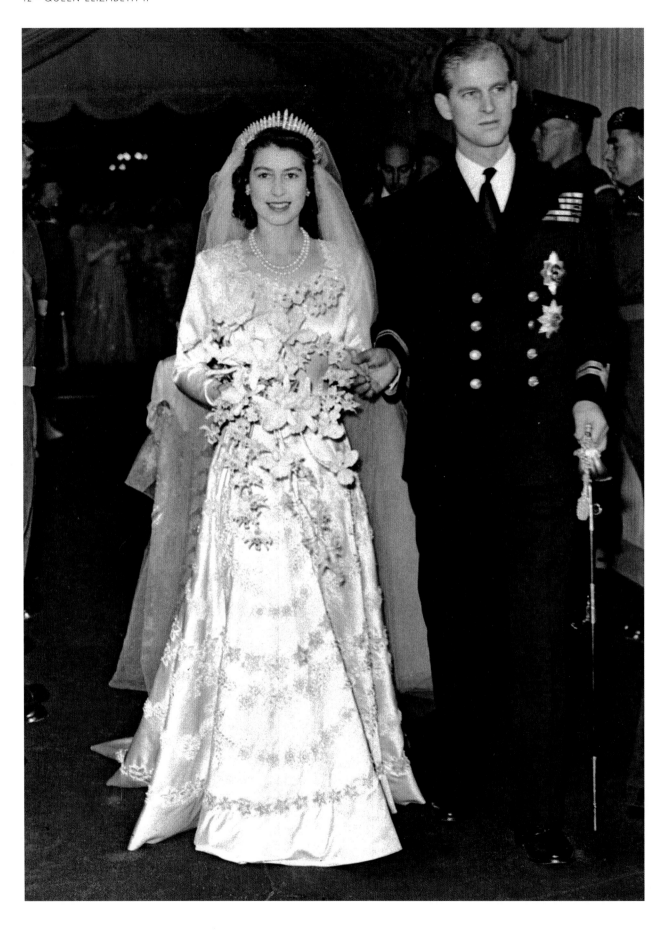

A rainy night had given way to a cold morning—typical of any normal November 20 in London. But as the bride looked out of her bedroom window on the second floor of Buckingham Palace, she saw a vast crowd gathering. Women were washing themselves with water from thermos flasks, and men were rolling up mattresses they had been sleeping out on all night. They were joined by more and more people, who ended up lining the processional route along The Mall all the way to Westminster Abbey—in some places fifty deep. Many had attached pocket mirrors to long sticks in a bid to catch a glimpse of the princess, who, accompanied by her father, King George VI, passed by in a carriage drawn by Windsor Grey horses at 11:30 a.m. The princess was Elizabeth Alexandra Mary Windsor, the heiress to the British throne—a dainty young woman with a wide mouth, brown hair, and a curvy figure attractive enough to prompt *Time Magazine*, in a display of American irreverence, to declare her as having "pin-up charm."

The man she would soon be standing at the altar with was Royal Navy Lieutenant Philip Mountbatten, a Greek-Danish-German prince with just as many royal ancestors as Elizabeth, yet virtually no money—he was, indeed, still riding in third-class train carriages until shortly before his marriage. He grew up in Great Britain, and is a distant cousin of Elizabeth, making him an obvious candidate based on Windsor marriage traditions. But the marriage does not appear to have been arranged: Legend has it Elizabeth fell in love with Philip, five years her elder, at the age of thirteen. He was a cadet at the Royal Naval College in Dartmouth, in the southwest of England, at the time. Elizabeth visited there with her parents, after which she suddenly stopped biting her nails. And however much she enjoyed the company of other men from her social circle at restaurants and parties later on, she clearly never wavered in her conviction that the dashing, amusing Philip was the one for her. He for his part appeared captivated when he saw her play Aladdin at a Christmas pantomime (a seasonal British play), and on his occasional visits to London, he drove his MG sports car (his most prized possession) to the side entrance of the palace and stayed for dinner.

The royal family was not unreservedly thrilled with Elizabeth's choice. Some found the young man rather blunt and unpolished; he had not, after all, attended the most socially acceptable schools, something considered very important in England at the time. His fidelity was also questioned. But there was one thing no one disputed:

• ORIGINAL DRAWING The future queen chose her wedding bouquet based on this sketch by Longmans Florist.

He was incredibly handsome. Without even so much as asking her parents, "Lilibet" accepted Philip's marriage proposal in the summer of 1946, although the engagement was not announced until the following July, once the princess had turned twenty-one.

Her family was initially hesitant to plan a large wedding—a private celebration at Windsor Castle might seem more appropriate in 1947, which was a tough year for Great Britain—the toughest of an already difficult, bleak postwar period. Almost everything was still rationed, with each person allowed only three pounds of potatoes per week. But we won the war, said the people, so why are we in such a bad way? And, it was precisely because of the exhaustion and depletions that the nation was deemed deserving of such a celebration. Even the Labour government of the day was fiercely in favor of this special event, provided it didn't cost a lot. Conservative opposition leader Winston Churchill, meanwhile, labeled it a "flash of color on the hard road we have to travel."

A sumptuous state event was organized. For the first time since the start of World War II, the Household Cavalry

• JUST MARRIED Inspired by a Botticelli painting, Princess Elizabeth's dress reflected spring, hope, and new beginnings.

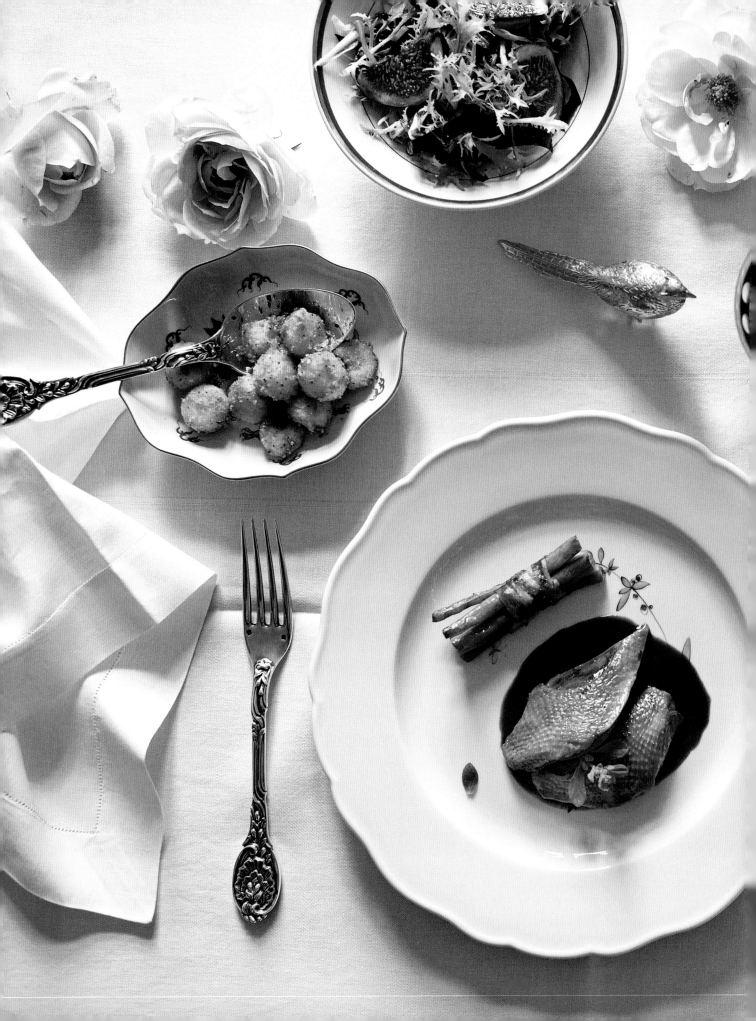

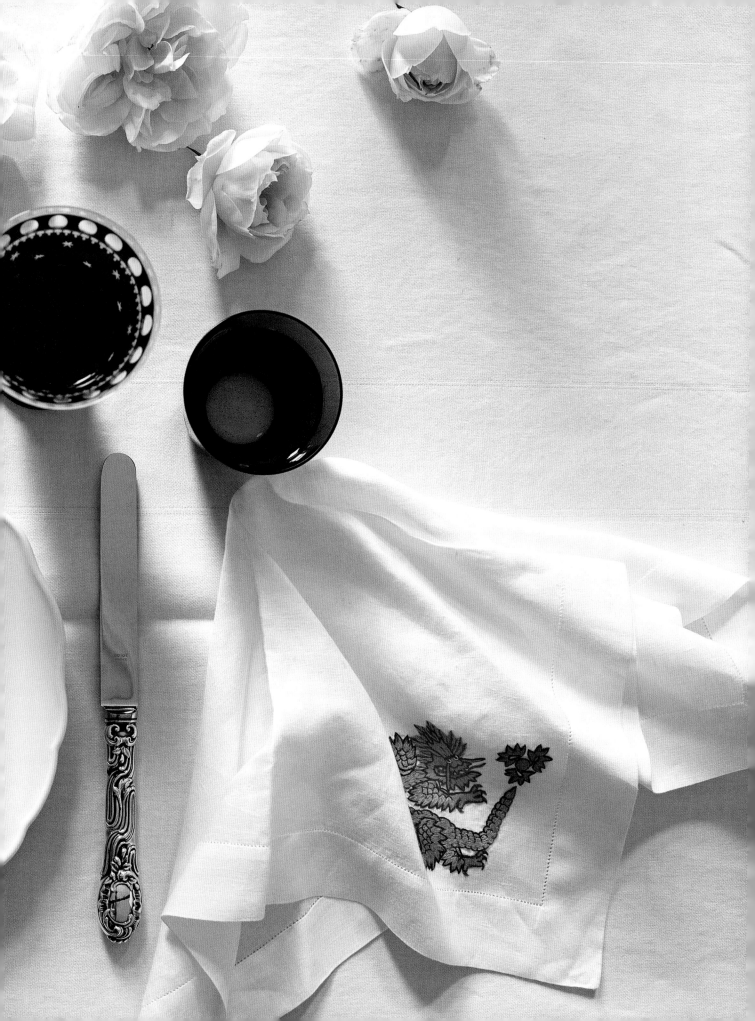

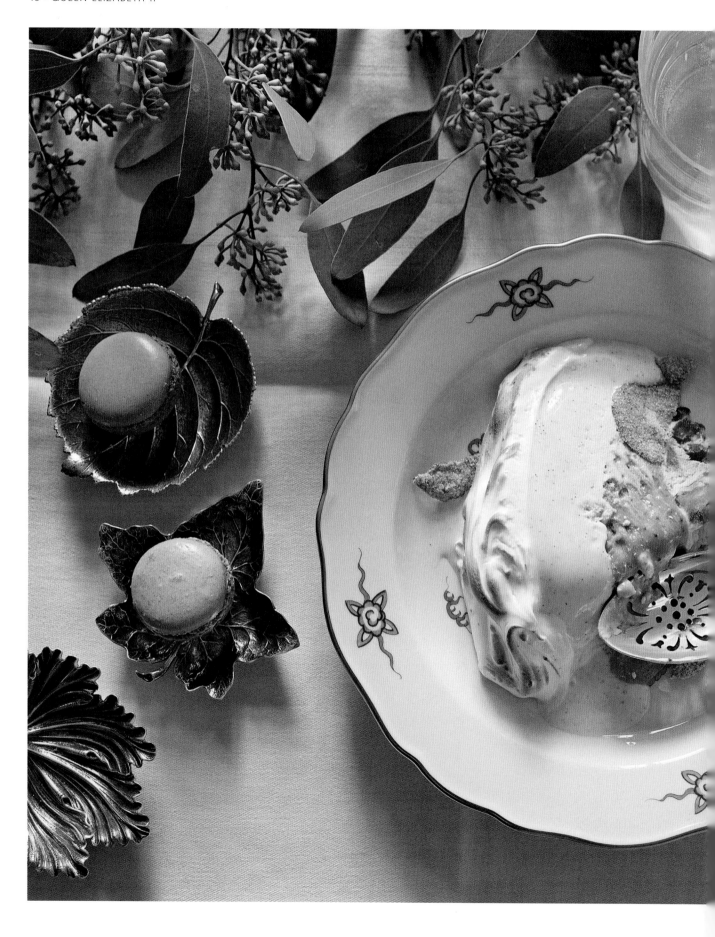

were back in parade uniforms, and royal guests arrived from all over Europe. Jewels long stored away in treasuries saw the light of day once more. (Albeit not always sufficiently cleaned—a fact Princess Juliana of the Netherlands was quick to criticize.)

And then there was the bridal gown! The royal family's favorite designer, Norman Hartnell, found inspiration from the 15th-century Italian masterpiece *Primavera* by Sandro Botticelli. Spring, hope, new beginnings—the ivory-colored, silk creation embroidered with 10,000 pearls was a symbol of all these. And 350 seamstresses spent seven weeks working on it. Despite it being an era when the press still displayed some semblance of decorum, Hartnell, fearing spies, made employees sleep in the workrooms. An electrifying sense of expectation hung over London. No previous royal wedding had so captivated the public, or been presented in such a fairytale-like manner.

But concessions were made. Business suits were permitted in the church, in place of morning dress, and the bridal couple knelt on silk-covered orange crates, so as not to waste timber. Only 150 guests were invited to the "Wedding Breakfast," a lunch, served in the palace's white-and-gold Ball Supper Room. A three-course "austerity" menu was served, described by one newspaper the following day—intended as praise—as being no different to the offerings at any respectable London restaurant. Of Prince Philip's close family, only his mother and an uncle attended the celebrations. His father was dead, and his sisters had married German aristocrats—a fact that, so soon after the war, disqualified them from receiving invitations.

Philip's father-in-law bestowed upon the new prince a whole slew of titles, and also gifted him an épée that the couple used to cut the nearly ten-foot-tall wedding

• PREVIOUS PAGES: PARTRIDGE CASSEROLE WITH HAZELNUT POTATOES AND ROYAL SALAD Wonderfully wild and temptingly tender. A combination that melts in the mouth—and, incidentally, is not a bad recipe for a happy marriage, either. Our suggestion for a table decoration: creamy-white roses, perfect for what was then England's still very young rose.

• BOMBE GLACÉE PRINCESSE ELIZABETH WITH STRAWBERRIES AND MERINGUE Irresistible! And not just the dessert, was very likely to have been Philip's thought as he dined alongside his bride and reflected on the sweet promise they had just given each other. We've added eucalyptus branches as the crowning glory of this moment.

cake. The recipe and ingredients were a wedding present from the Australian Girl Guides Association. Other gifts included 500 boxes of canned pineapples, a Singer sewing machine, silver salt shakers, and hand-knitted bed socks. Mahatma Gandhi sent a piece of fabric made of homespun yarn, which Elizabeth's grandmother, Queen Mary, mistook for a loincloth, calling it an "indelicate gift."

The fairytale pair made an appearance on the balcony of Buckingham Palace before the meal. And when examined more closely, Philip's story does, indeed, sound like the stuff of fairytales: A destitute family, a mother who spent years in a mental asylum, a childhood of being shunted around between relatives—and now here he was waving at the jubilant crowd with his radiant wife, for whom he had given up smoking that very morning. She would become queen just five years later; much earlier than expected, after her father died at the age of fifty-six.

The newlyweds made their way to London's Waterloo Station at dusk; they traveled by train to Hampshire and Scotland. Elizabeth, in a pale-blue velvet hat and coat, took her favorite corgi, Susi, with her. Her parents walked hand-in-hand to the carriage, waving for several minutes. "It has been a wonderful day," said the Queen, upon returning to the palace. "How very lucky we were not to have fog."

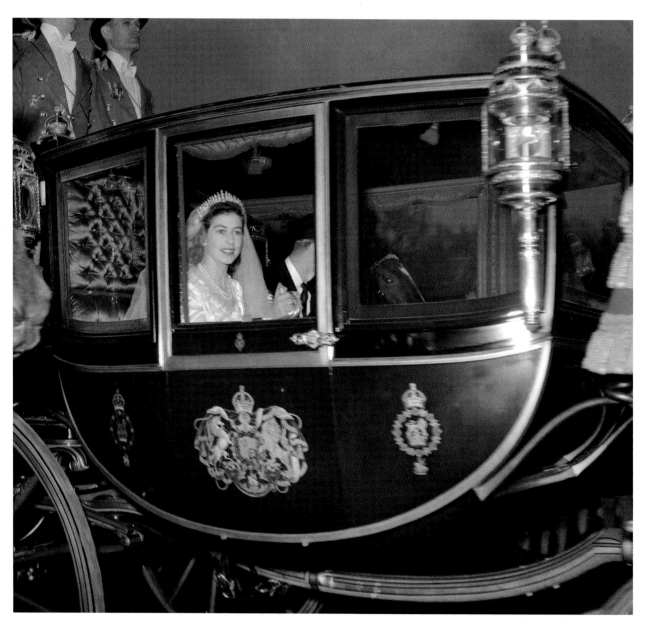

• A MOMENT JUST FOR THE TWO OF THEM After saying their vows, the prince and princess rode in a carriage from Westminster Abbey to Buckingham Palace, where 150 guests had been invited to dine.

Filet de Sole Mountbatten

INGREDIENTS SERVES 4

1 sole, 1¼ lb.–1¾ lb. /
 600–800 g, skinned
4 thin leeks
1 onion
1 carrot
1 tsp. fennel seeds
½ tsp. black peppercorns
2 tsp. kosher salt
1 tbsp. olive oil
1 bay leaf
7 oz. / 200 ml dry white wine
1 tsp. aniseed liqueur, such
 as Pernod
about 7 tbsp. / 100 g butter
 (half softened, half cold)
salt and white pepper
4 small sprigs thyme or dill
 tips, to garnish, optional

TIME NEEDED:
80 mins.

METHOD LEVEL OF DIFFICULTY: MODERATELY DIFFICULT

Using a sharp, flexible fish knife, separate the sole fillets from the bones and place the fillets in the refrigerator. Chop the bones and place them in cold water 30 minutes, then drain and set aside.

Meanwhile, trim the leeks, cut off the dark green parts, discard the roots, and remove the outer layers. Wash the white parts, then cut them into pieces, each about 2¼ in. / 6 cm long. Wash and coarsely chop the green parts of the leeks and set aside.

Peel and finely chop the onion and the carrot. Place them, together with the green leek pieces, fennel seeds, peppercorns, and ½ teaspoon kosher salt in a saucepan over medium heat with the olive oil, and sauté without coloring. Add the bones and the bay leaf and sauté briefly, then pour in the white wine and the liqueur. Increase the heat and bring to a boil.

Add 2 cups / 500 ml cold water and return to a boil. Reduce the heat to low and leave the stock to simmer 25 minutes.

Bring a pan of water with the remaining kosher salt to a boil. Add the white leek pieces to the boiling water and blanch 5 minutes, or until tender. Lift the leeks out of the water and rinse under cold water to stop the cooking. Pat dry with paper towels, then halve them lengthwise. Discard the cooking liquid.

Heat the oven to very low with four dinner plates and a plate large enough to hold the fillets inside.

Cut out 2 circles of parchment paper to fit a wide skillet. Place 1 circle in the skillet and spread with 1 tablespoon / 15 g softened butter. Season the sole fillets with salt and white pepper, place them onto the parchment paper and spread with 1 tablespoon / 15 g softened butter.

Strain the fish stock through a fine strainer into a saucepan and bring to a boil. Pour the stock over the fillets, then cover them with the second parchment paper circle and weigh down with a second, slightly smaller skillet. This stops the fillets from curling. Simmer over low heat 5 minutes. Remove the fillets from the skillet. Cut each fillet in half and trim the edges for neatness.

Transfer the fillets to the warm plate, cover with aluminum foil, and keep hot in the oven. Strain the cooking liquid from the skillet through a fine strainer into a pan, then boil over high heat until reduced to ⅔ cup / 150 ml. Melt the remaining softened butter in another skillet over medium heat. Add the white leek pieces in a single layer, cut sides up. Pour in 3 tablespoons of the fish liquid and simmer until the leeks are warm.

Bring the remaining fish stock to a boil, then pour it into a mixing beaker or mini food processor.

Cut the cold butter into dice and add, then blitz until it has been blended and a slightly foamy emulsion forms. (The emulsion will not last so it's best to make the sauce immediately before serving.) Season the sauce with salt.

Divide the leek pieces among the plates. Place one sole fillet on each plate and drizzle with the foam sauce. Garnish with thyme or dill tips, if liked, and serve immediately.

RECOMMENDED WINE: 2007 Blanc de Blancs, Brut Vintage, Louis Roederer, Champagne, France

Perdreaux en Casserole, Haricots Verts, Pommes Noisettes, Salade Royale (Braised Partridges in Red Wine Sauce with Green Bean Bundles, Hazelnut Potatoes, and Salade Royale)

INGREDIENTS SERVES 4

For the partridges and the red wine sauce:

4 partridges, about 9 oz. / 250 g each, cut up and ready to cook
2 shallots
2 tbsp. clarified butter
1 tbsp. all-purpose flour
1 tbsp. light soy sauce
1 cup / 250 ml red port wine
2 cups / 500 ml dry red wine
2 bay leaves
½ tsp. black peppercorns
salt and pepper
2 garlic cloves
1 sprig rosemary
3 sprigs thyme, plus extra to garnish
2 tsp. / 10 g cold butter

For the green beans and the potatoes:

9 oz. / 250 g green beans
8 bacon slices
2¼ lb. / 1 kg large waxy potatoes
3 tbsp. / 45 g butter
2 tbsp. / 30 g clarified butter
2 tbsp. ground hazelnuts
salt and pepper

For the salade royale:

7 oz. / 200 g mixed salad leaves, such as frisée, escarole, arugula, and radicchio
2 or 3 ripe figs
3 tbsp. walnut halves
3 tbsp. aged balsamic vinegar
½ tsp. maple syrup
salt and pepper
3 tbsp. hazelnut oil
3 tbsp. quality extra virgin olive oil

TIME NEEDED:
2 hours 15 mins.

METHOD LEVEL OF DIFFICULTY: DIFFICULT

Cover the partridge breasts with plastic wrap and set aside.

Chop the carcasses. Peel and thinly slice the shallots.

Heat half the clarified butter in a saucepan over medium-high heat. Add the carcasses, legs, and wings, and fry until brown all over. Add the shallots and stir until they start to brown. Dust with flour and stir 2 minutes.

Add the soy sauce and the port wine and boil, stirring, to reduce by half. Add the red wine and 1 bay leaf and season with pepper. Continue boiling to reduce the liquid by half again. Strain the sauce through a fine strainer into a small pan over high heat. Continue boiling until reduced to about 7 tablespoons / 100 ml. Set aside.

Meanwhile, top and tail the beans, then blanch them in boiling salted water for 3–4 minutes until just tender. Drain them well and rinse under cold water to stop the cooking. Pat the beans dry with paper towels. Halve the bacon slices lengthwise. Divide the beans into 16 bundles, wrap a strip of bacon around each bundle, and set aside. Peel and wash the potatoes. Using a melon baller, cut the potatoes into small balls. Cook the balls in a pan of boiling, salted water until just tender, but still firm to the bite, then drain well. Return them to the pan off the heat, cover and leave to steam in the residual heat.

Trim the salad leaves, tear into bite-size pieces, wash, and spin them dry.

Wash and pat dry the figs, then cut them into eighths. Lightly toast the walnuts in a skillet over medium heat, then coarsely chop. Stir together the vinegar, maple syrup, and salt and pepper to taste, then add the two oils, stirring constantly.

About 20 minutes before serving, heat the oven to 350°F / 180°C (Gas 4; convection ovens not recommended). Melt the remaining clarified butter in a wide, ovenproof skillet or in a cast-iron roasting pan. Season the partridge breasts on both sides with salt, and also season the meaty sides with pepper.

Place the breasts skin-side down into the hot skillet. Fry first one side, then the other. The skin should be nicely browned. Turn the breasts over so they lie on their bony sides and have little contact with the base of the skillet. Lightly crush the garlic cloves, then add them together with the rosemary, thyme, and 1 bay leaf. Place the skillet 10 minutes on the bottom rack of the oven.

Meanwhile, melt 2 tablespoons / 30g of the butter in another wide skillet over medium heat. Add the bean bundles and lightly fry until the bacon is cooked through.

In another skillet, melt the clarified butter. Add the potato balls and fry over medium heat until golden brown. Add the hazelnuts and the remaining 1 tablespoon / 15 g butter and fry until the nuts are lightly browned. Set aside.

Now reheat the sauce. Add the cold butter and constantly stir with a spoon in one direction until the butter melts and lightly binds the sauce.

Remove the pan with the breasts from the oven and take the meat off the bones. Turn off the oven, and keep the meat warm in the oven, ideally with the door ajar.

Combine the salad leaves with the figs and the walnuts and toss with the dressing. Divide among four small bowls. Divide the beans, potatoes, and a little sauce among the plates. Place the breasts on the sauce and serve immediately with the salad.

RECOMMENDED WINE: 2008 Conde de Vimioso Reserva, Falua, Ribatejo, Portugal

Bombe glacée Princesse Elizabeth (Ice Cream Bombe Princess Elizabeth)

INGREDIENTS SERVES 4–6

For the vanilla ice cream:
1 cup / 250 ml whole milk
1 cup / 250 ml whipping cream
1 vanilla bean
⅓ cup /70 g granulated sugar
5 egg yolks

For the strawberry sorbet and the strawberry ice cream:
1¼ lb. / 600 g strawberries
4 tbsp. granulated sugar
2 oz. / 50 g store-bought meringues
4 tbsp. whipping cream

For the meringue:
6 oz. / 180 g egg whites (without any traces of egg yolk)
3⅓ cups / 400 g sifted confectioners' sugar
candied rose leaves, to decorate, optional

TIME NEEDED:
1 hour + freezing

METHOD LEVEL OF DIFFICULTY: DIFFICULT

To make the vanilla ice cream, put the milk and the whipping cream in a saucepan over high heat. Slit the vanilla bean lengthwise, add to the saucepan, and bring the milk to a boil.

Beat the sugar with the egg yolks until foamy. As soon as the milk boils, take the pan off the heat, remove the vanilla bean, and scrape the seeds into the milk. Gradually add the hot milk to the egg yolks, whisking constantly.

Pour the mixture back into the pan and heat over low heat, stirring constantly, until the liquid binds a little. Be careful: The liquid must not come to a boil or it will lose its ability to bind.

Immediately strain the vanilla sauce through a fine strainer into a bowl and leave to cool. Transfer the mixture to an ice-cream maker and freeze. Once frozen, transfer the ice cream to a 1½ quart / 1.5 liter dome-shaped, freezeproof bowl. Push a second 3½ cup / 800 ml freezeproof dome-shaped bowl into the middle. Transfer both bowls to the freezer and leave about 20 minutes. Remove the smaller bowl, cover the top of the larger bowl with plastic wrap, and return to the freezer until firm.

To make the strawberry sorbet, wash, hull, and chop the strawberries. Put 3 cups / 500 g strawberries in a freezer bag, spread out flat, and freeze about 2 hours. Meanwhile, add 4 tablespoons water to the sugar in a pan over high heat and bring to a boil to dissolve the sugar. Take the pan off the heat and leave to cool completely. Finely crumble the meringues. Set both aside.

Put the frozen strawberries into a mixing beaker or food processor. Add the sugar syrup and blend until you have a creamy sorbet. Combine two-thirds of the sorbet with the crumbled meringues and spread into the hollow in the vanilla ice cream. Put a 1¼ cup / 300 ml freezeproof bowl into the middle and return the ice cream bombe to the freezer 20 minutes.

To make the strawberry ice cream, beat the whipping cream until stiff. Fold the whipped cream and remaining strawberries into the remaining strawberry sorbet, then transfer to the freezer 20 minutes. Remove the smaller bowl from the ice cream bombe and fill the hollow with the strawberry ice cream. Cover and return to the freezer at least 2 hours before serving.

To make the meringue topping, beat the egg whites with scant 1 cup / 100 g confectioners' sugar in a food processor or with a hand-held mixer until stiff peaks form.

In a saucepan over high heat, stir the remaining confectioners' sugar into 7 tablespoons / 100 ml water, stirring to dissolve the sugar. Bring to a boil and boil until the sugar mixture reaches exactly 244°F / 118°C on a candy thermometer. Gradually pour the sugar syrup into the beaten egg whites, beating constantly until the meringue cools down. Transfer the meringue to the freezer 20 minutes.

Tip the ice bombe out of the bowl onto a platter. To do so, invert the ice cream bombe onto the platter and cover the bowl with a moist, hot dish towel. (The ice cream will start to melt a little and the bowl can then easily be lifted off.) Beat the meringue until smooth, then, using a metal spatula, spread on top of the ice cream bombe. Return the ice bombe to the freezer until ready to serve.

Immediately before serving, briefly flame the ice bombe with a kitchen torch so the meringue gets a golden-brown patterning.

Using a hot knife, cut the ice cream bombe into portions, garnish with candied rose leaves, if liked, and serve immediately.

RECOMMENDED WINE: 2007 Moscato Rosa Kuenburg Selection, Castel Sallegg, Alto Adige, Italy

Dinner

Saarburger 1959	Saumon de Norvège en Bellevue
Almaden Pinot Noir	Tournedos grillé Henry IV Potatoes Parisienne
	Salade Mimosa Assorted Cheeses
Dom Pérignon 1955	Souffle glacé Grand Marnier Petits-fours sec

Monday, June 24, 1963

John F. Kennedy

A POLITICAL SUPERSTAR INVITES

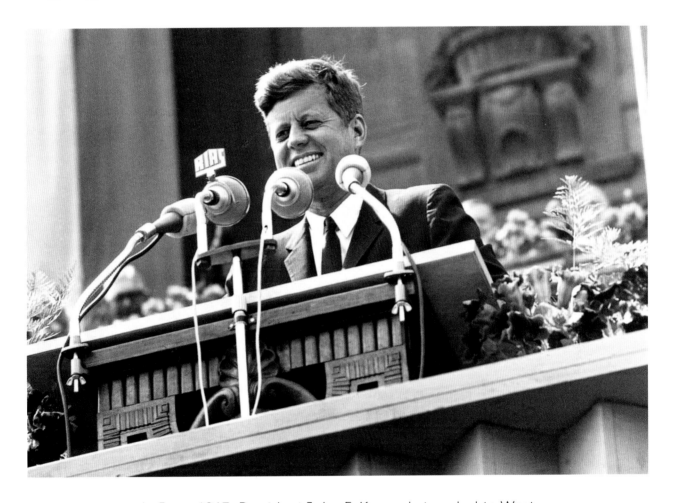

In June 1963, President John F. Kennedy traveled to West Germany. Kennedy is said to have been skeptical, but he was greeted by two million jubilant West Germans. While on this historic trip, Kennedy hosted a lavish dinner in honor of Chancellor Konrad Adenauer. We've recreated the menu.

• OPPOSITE The broiled chicken lunch provided by President Heinrich Lübke of West Germany left several journalists feeling embarrassed. That night, Kennedy held an official dinner for Chancellor Adenauer and more than ninety other guests in Bonn.
• ABOVE In Berlin, Kennedy wowed the crowds with his legendary "Ich bin ein Berliner" speech. Euphoric from the reception he had received from the West German people, he knew, as he sat in his plane afterward, that this had been a unique day.

It's impossible to say when exactly the initial spark was ignited, but it certainly had been by the time John F. Kennedy appeared at Frankfurt's Römerberg square. Much to the horror of his bodyguards, he pushed away the cordons and began mingling with the crowd, shaking outstretched hands and flashing his beaming smile.

It was June 25, 1963, the third day of Kennedy's visit to West Germany. The West Germans—grateful for the care packages and development aid the Americans had provided after World War II, and full of admiration for the young, dynamic politician, who brought hope to the Western world—had been showering him with love and affection from his very first day. Up to that moment, however, Kennedy's response to the enthusiasm had been more disconnected and distanced. He was something of a global superstar; he'd been expecting, even factoring in, the jubilation. He wanted to show both the Bonn government and the voters back home how popular he was. Looking out at the euphoric crowds during his first stop in Cologne, he commented soberly, "It's a shame they're not American voters."

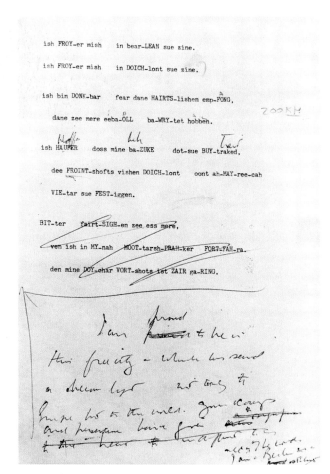

KENNEDY'S CHEAT SHEET FOR HIS TRIP Conversational German phrases were written out phonetically for him.

The West German chancellor and his American guest were strangers, to say the least. Kennedy, forty-six at the time of his visit, made the following observation about Adenauer, forty years his senior: "It felt like I had been talking not only to a different generation, but to a different era, a different world." He found the German inflexible and dyed-in-the-wool—the past personified. Adenauer, on the other hand, was mistrustful of the new guard that had taken over the White House in 1961, and feared it didn't have the backbone required to face up to the Soviets. He felt more aligned with President Charles de Gaulle of France, which was, in turn, taken as an affront by the Americans, to whom the Frenchman was causing nothing but trouble in Europe. To make matters worse, West Germany, having been nursed back to health by the United States, was becoming a booming industrial nation, while the United States was still battling a trade deficit. And that's not all: "John F. Kennedy doesn't love the Germans," claimed *Der Spiegel* prior to the visit. "He's never been particularly interested in Germany or the German people."

Such was the situation at the start of a trip during which, according to subsequent comments by one of Kennedy's bodyguards, the president was the happiest he'd ever seen him. Kennedy himself at the time also mused, "There are things in this world you can only believe if you've experienced them yourself, and with regard to which it is difficult to comprehend afterward what has happened to you." He later confessed to his wife, Jackie, "I love Berlin."

Jackie, heavily pregnant, had stayed at home, and the president was accompanied by his sister, Eunice Shriver. Jackie's sister, Caroline Lee, who was married to a Polish prince, had also been invited to the reception being hosted by Kennedy for Adenauer at the American Club of the United States Embassy in Bonn on June 24. She wanted to get her hair done beforehand—on a Monday of all days! The embassy finally managed to find a hairdresser open in Düsseldorf, and she was flown there by helicopter. The exquisite, European-inspired dinner menu was a reflection of the way the Kennedys held court back in Washington. It included Norwegian salmon à la Bellevue, tournedos à la Henri IV, and chilled Grand Marnier soufflés. At the lunch hosted earlier the same day by President Lübke, Kennedy had been served broiled chicken. "Of all things!" wrote a mortified West German journalist, who had been expecting something a little more sophisticated.

The trip was followed by 700 reporters from all over the world. They recorded Kennedy's every comment, every gesture, analyzing and reading much into whose hand was shaken and for how long. And one question kept being raised: How was Kennedy managing to do all this with his bad back? "All this" on that particular day

• NORWEGIAN SALMON WITH QUAIL EGGS A whole salmon, garnished with wafer-thin cucumber slices and halved quail eggs, made for a light and refreshing change from the traditional Rhineland cuisine usually eaten by Bonn's politicians—Kennedy, who never got quite close with Chancellor Adenauer, also used the menu as a way of signaling a clear focus toward renewal and modernity during his visit.

referred to his discussions with Chancellor Adenauer (after which the chancellor's secretary felt as though "the gentlemen had found common ground"); meeting President Lübke, attending the founding of the Deutscher Entwicklungsdienst (German Development Service); discussions with both with Lübke and Adenauer; lunch with Lübke; another meeting with Adenauer; a press conference; meeting with West Berlin's mayor, Willy Brandt; and, finally, hosting the grand dinner at the American Club with ninety-five predominantly male guests. Kennedy, who suffered a spinal cord injury as a naval officer in World War II, was, indeed, in constant pain. He left the embassy's club at 10:30 p.m. to retreat to the home of the American ambassador, where he spent the night.

Before vacating his house, the ambassador had been instructed to leave a chocolate cake in the bedroom Kennedy would use—evidently something to which the president was quite partial, because another one was brought to his hotel the next day in Wiesbaden. There, too, Kennedy enjoyed and reciprocated the West Germans' affections: In an effort to get him safely into the Kurhaus (the city's culture center) for a reception, his minders had to pull him out of the crowd "inch by inch." Once there, he made his go-to joke about the envelope he would leave for his successor on his desk, which would say "To be opened only in saddest moments," and inside the note would say, "Go visit Germany." Perhaps, Kennedy added, he himself would also open the letter sometime.

At that point, the best was still yet to come: Berlin! The eight magical hours the president spent in the Cold War's frontline city on June 26 would end up being one of the highlights of his political career, and "the most

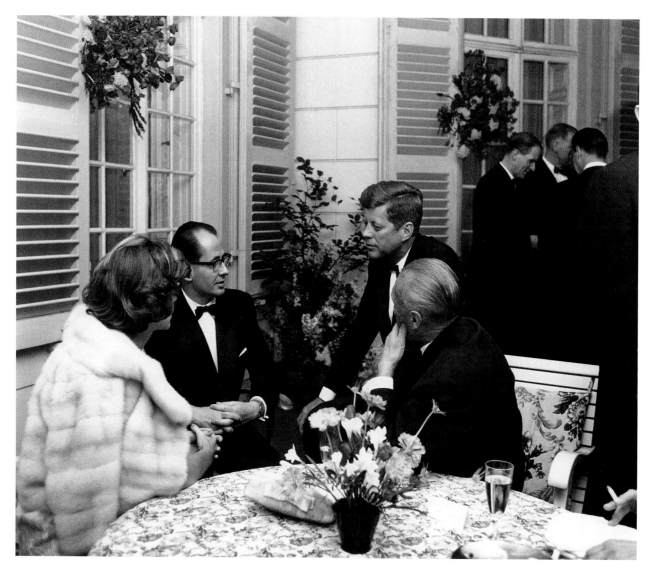

- ABOVE At Palais Schaumburg, in Bonn, with Adenauer and an interpreter.
- BELOW LEFT Kennedy posing outside Villa Hammerschmidt, also in Bonn, with the Lübkes and his sister Eunice Shriver (yellow dress).
- BELOW RIGHT Kennedy's heavily pregnant wife, Jackie, had stayed home in Washington.

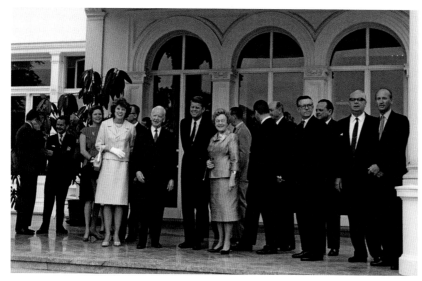

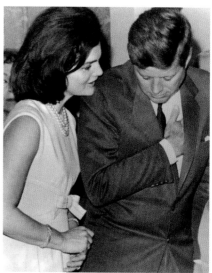

important visit in the city's history," as Brandt later wrote in his memoirs. On the drive through the city in an open-topped Lincoln Continental, Brandt sat between Kennedy and Adenauer—a position he had fought long and hard to secure in a heated telephone conversation with Adenauer. And so it was: Kennedy, young, dashing, and radiant, a political superstar and idol, whose hairstyle was copied even by the Soviet army's recruits; Brandt, also young and dynamic, presented by his party as "the German Kennedy"; and Adenauer, a somewhat frail elderly man, furrowed and hunched, drawing pity from his daughter Libet, who "felt sorry" for him at the time. The convoy drove a quarter of a mile through the city, every inch of it lined with jubilant, waving people. Kennedy was given a redeemer's welcome by two million Berliners.

Some 500,000 people were waiting for Kennedy at the Rathaus Schöneberg (the city hall of one of the Berlin boroughs), following his stops at the Berlin Wall and Checkpoint Charlie. He ended his speech with the iconic message of solidarity he had been practicing earlier in Brandt's office, and which had been transcribed phonet-ically on a cheat sheet: *Ish bin ein Bearleener!* It "soothed the souls of the Berliners," as one observer put it. Kennedy himself was also moved. Sitting in his plane, on his way to Ireland that same afternoon, he said to an advisor, "We'll never have another day like this one as long as we live."

As it turned out, he had less than five months to live. Kennedy was assassinated in Dallas on November 22, in the same type of car that had driven him through a sea of confetti and happy faces in Berlin.

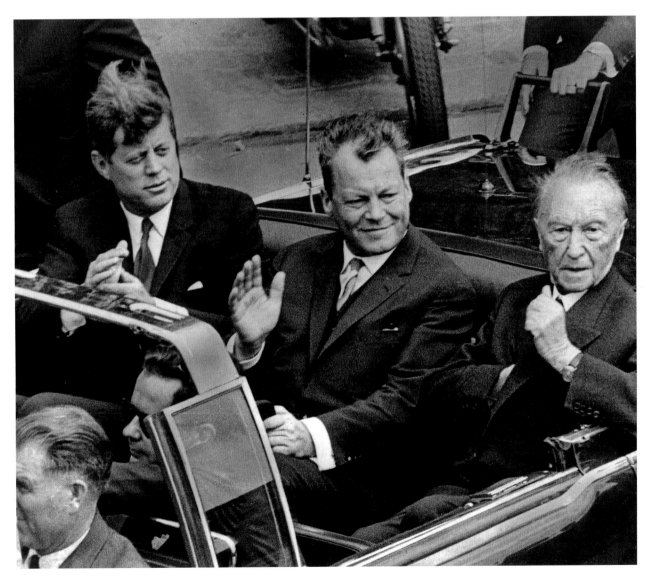

• ABOVE The drive through Berlin: Willy Brandt had fought long and hard to secure the prominent position in the middle. The scene in the car—two young men and an older gentleman—illustrated the generational shift that was starting to take shape in 1960s world politics.

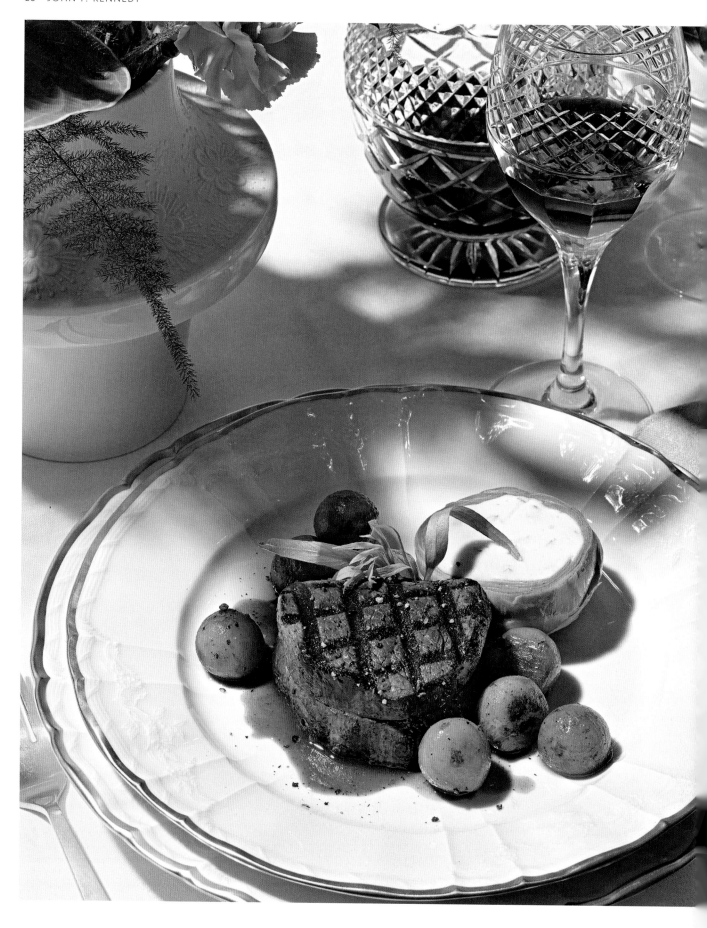

• BEEF FILLET WITH ARTICHOKES AND BÉARNAISE SAUCE The friendship of European nations, translated into a menu: Main course was grilled beef tournedos Henry IV, a classic French dish said to have first been prepared around 1830 at Paris' Pavillon Henri IV restaurant to honor the French king, Henri IV (1553–1610). The irresistible béarnaise sauce, meanwhile, might also have been beneficial to the German-American friendship.

Saumon de Norvège en Bellevue (Norwegian Salmon Bellevue)

INGREDIENTS SERVES 8

1 fresh salmon with skin (gutted, gilled, and scaled; about 2½ lb. / 2 kg)
salt and black pepper
3 sprigs thyme
3 slices organic lemon
3 leaves white gelatin
1 cup / 250 ml fish stock
1 cucumber
1¼ cups / 300 g crème fraîche
7 oz. / 200 ml whipping cream
To garnish:
20 hard-boiled quail eggs
4 tbsp. trout caviar
10 cherry tomatoes
2 handfuls fresh herbs, such as chervil, dill, and chives

TIME NEEDED:
45 mins. + 70 mins. cooking + cooling

METHOD LEVEL OF DIFFICULTY: DIFFICULT

Heat the oven to 300°F / 150°C (Gas 1; convection ovens 250°F / 130°C). Rinse the salmon inside and out under cold water, and pat dry. Season the inside of the belly with salt and pepper, then place the thyme and the lemon slices inside. Place the salmon on a cookie sheet lined with parchment paper. Bend the tail toward the head, tying it in position with kitchen string. Cover the cookie sheet with aluminum foil and roast the salmon for 70–90 minutes.

Remove the cookie sheet from the oven and leave the salmon to cool. Pull off and discard the skin. Soak the gelatin 5 minutes in cold water. Heat the fish stock until it simmers, but do not let it boil. Squeeze out the gelatin, then add to the fish stock and stir until it dissolves. Leave to cool a little.

Wash the cucumber, then slice very thinly on a mandoline, or use a vegetable slicer. Brush the fish with the fish stock (you might have to heat it so it can be brushed; do not boil), then cover with cucumber slices and also brush with the fish stock. Cover loosely and chill until the gelatin sets.

Just before serving, season the crème fraîche and whipping cream with salt and pepper and beat together until stiff. Transfer the whipped cream mixture to a pastry bag with a star tip and use to decorate the fish. Garnish with the quail eggs, trout caviar, cherry tomatoes, and herbs.

RECOMMENDED WINE: Today, Kennedy would probably choose a full-bodied Chardonnay from California, a wine with plenty of fruit and delicate, spicy notes of vanilla.

Tournedos grillés Henri IV

INGREDIENTS SERVES 8

8 artichokes
juice of 1 lemon
2 tbsp. kosher salt
8 large potatoes
4 tbsp. / 60 g butter
½ tsp. meat extract (store bought)
8 filet mignon medallions, each about 4¼ oz. / 120 g
vegetable oil for brushing the pan
salt and black pepper
8 tbsp. veal jus (store bought)
For the béarnaise sauce:
1 small shallot
4 black peppercorns
1 tbsp. white wine vinegar
7 oz. / 200 ml dry white wine
2 sprigs tarragon
1½ sticks / 170 g butter
3 egg yolks
leaves of 3 sprigs tarragon
salt
1 dash lemon juice

TIME NEEDED:
2 hours

METHOD LEVEL OF DIFFICULTY: DIFFICULT

Using a serrated knife, cut off the artichoke stems just under the bottoms and the outer leaves directly above. With a small paring knife, cut any woody parts away from the bottoms. Immediately put the trimmed bottoms into a bowl with cold water and half the lemon juice. Bring a saucepan of water to a boil with the remaining lemon juice and 1 tablespoon salt. Add the artichoke bottoms and simmer 15 minutes over low heat, or until they are tender when pierced with the tip of a knife.

Drain the artichokes and rinse under cold water, then scrape out the hairy choke with a small spoon. Rinse the bottoms and pat them dry. To make the pommes parisiennes, peel and wash the potatoes, then cut out balls using a melon baller. Cook the balls in water with the remaining salt over medium heat until they are just tender. Drain, rinse under cold water, and pat dry. Set aside.

To make the béarnaise sauce, peel, halve, and thinly slice the shallots. Crush the peppercorns. Put the shallots, peppercorns, vinegar, wine, and tarragon into a small saucepan. Bring to a boil and reduce to one-third (5 tablespoons). Pour through a fine strainer into a dish. Set aside. Melt the butter in a second pan over medium heat until the milk residues separate from the butterfat. Pour this through a fine strainer into another bowl, holding back the sediments. Leave to cool without setting.

About 15 minutes before serving, heat the oven to 225°F / 110°C (convection ovens very low / 80°C). Melt 2 tablespoons / 30 g butter in a sauté pan. Add the potato balls and the meat extract, and sauté over medium heat until they are tender. Transfer them to the oven to keep warm.

Meanwhile, heat a cast-iron grill pan over high heat and brush with oil. Season the medallions with salt and pepper and charbroil, turning once, until done to your liking. Keep warm in the oven. Melt the remaining butter in a second pan. Fry the artichoke bottoms over medium heat until lightly browned, then also keep warm in the oven. To make the béarnaise sauce, set a heatproof bowl over a pan of simmering water without it touching the water. Put the egg yolks and the reduced white wine in the bowl and whisk until the mixture is pale yellow and thick. Take off the pan. Beating constantly, add the clarified butter, first in drops, then as a thin stream. Chop the tarragon leaves and add to the sauce. Season the sauce with salt and lemon juice to taste. Heat the veal jus.

To serve, place the tournedos on the plates. Fill the artichoke bottoms with sauce béarnaise and place them next to the tournedos. Add the pommes parisiennes and the veal jus.

-RECOMMENDED WINE: The first choice for these beef filets is a mature Bordeaux or a soft, powerful Bordeaux blend from the Santa Cruz Mountains growing area, south of Francisco Bay.

Soufflé Glacé Grand Marnier

INGREDIENTS SERVES 8

½–1 tbsp. / 15–30 g softened butter for the soufflé dishes
4 organic oranges
1 cup / 200 g granulated sugar
1½ cups + 2 tbsp. / 650 ml whipping cream
5 egg yolks
about 7 tbsp. Grand Marnier
unsweetened cocoa powder for dusting
4–8 kumquats, optional

TIME NEEDED:
35 mins. + 4 hours freezing

METHOD LEVEL OF DIFFICULTY: DIFFICULT

Lightly grease the outer rims of eight soufflé dishes (about 6 tablespoons / 90 ml volume; 2½ in. / 7 cm diameter) with the butter. Tightly wrap a strip of baking paper (2¾ x 14½ in. / 7 x 37 cm) around each dish and fix with a paperclip at the top edge.

Wash 2 oranges under hot water, then rub them dry. Thinly grate off the zest and squeeze out all the juices. Simmer the juice with 3 tablespoons sugar until reduced to 7 tablespoons. Stir in the zest and set aside to cool.

Beat the whipping cream until stiff. Fit a heatproof bowl over a pan of simmering water without it touching the water. Set aside a larger bowl with ice water. Add the egg yolks with the remaining sugar to the bowl over water and use a hand-held mixer to whisk until foamy and thickened—make sure the mixture doesn't get too hot! Transfer the hot bowl to the bowl with cold water and continue beating until the mixture is cool. Stir in the orange syrup and fold in one-third of the whipped cream. Add everything to the remaining cream, then stir in 3 tablespoons of the Grand Marnier.

Equally divide the mixture among the soufflé dishes—the mixture should come above the rim of the mold. Leave to cool completely, then place into the freezer for 4 hours. Take the soufflés out of the freezer 5 minutes before serving and carefully peel off the baking paper. Dust the soufflés with cacao powder. Using a melon baller or a teaspoon, make a small hollow in each soufflé, then divide the remaining Grand Marnier among them.

Slice the kumquats and use to garnish the soufflés. Serve immediately!

RECOMMENDED DRINK: The opulent fruitiness and sweetness of this dessert demands a bitter espresso for balance. A modern suggestion would be a Rooibos espresso or a Matcha tea, or a cognac.

• SOUFFLÉ GLACÉ GRAND MARNIER To finish off the soirée hosted by Kennedy in honor of Adenauer, a soufflé glacé—made with orange juice and underlined with the flavors of Grand Marnier. "There is no substitute for personal inspection through a personal visit," the President said in his dinner speech: "We have received unforgettable impressions during these days."

Karen Blixen

ONE HEART, ONE CROWN

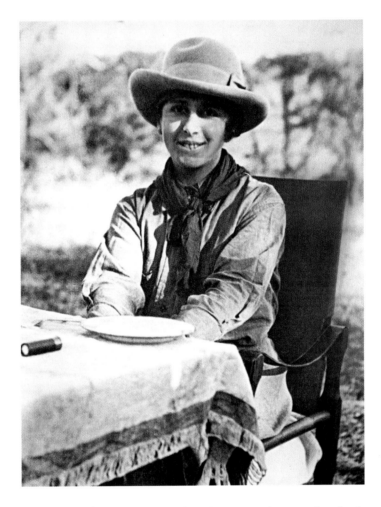

The Danish baroness and writer was known for being
a resourceful host in her adopted home country of Kenya.
In November 1928, the then Prince of Wales was among
her guests and an unforgettable evening ensued.

• CLEAR SOUP WITH SQUASH AND ZUCCHINI A broth made from marrowbone, herbs, and vegetables,
with thinly sliced zucchini and finely diced squash, and served in warmed plates.
• ABOVE "I have a feeling that wherever I may be in the future I will always be wondering whether there
is rain at Ngong."

I t's been more than thirty-five years since filming first started on *Out of Africa* (released in 1985), and millions of people continue to dream about the romantic love portrayed by Meryl Streep and Robert Redford. It was the memoirs of Danish writer Baroness Karen Christenze von Blixen-Finecke, who used the pen name Isak Dinesen, a declaration of love to Kenya and to the man in her life, Denys Finch Hatton, that were subsequently adapted for the big screen. The eccentric baroness was an exceptionally gifted host on her farm, located at the base of the Ngong Hills that stretch southwest of Nairobi. The present-day Karen Blixen Museum there displays the menu for a dinner that Finch Hatton and Blixen hosted for Prince Edward on November 9, 1928, which would end up being one of her happiest evenings.

Blixen-Finecke had driven to nearby Nairobi to buy her ingredients, since Prince Edward was coming for dinner the following night. Fish was a must, and she would shoot the partridge herself. She just needed fruit and vegetables. "Hopefully!" the great-grandson of Queen Victoria wouldn't insist on leaden roly-poly puddings (a steamed or baked sweet dough with jam) or sago pudding. Finch Hatton took care of the cigars and wine, in which he was well versed. He had been deer stalking with the British prince, an avid big-game hunter, for a few days. Spicing up the situation was the fact that the shooting party also included one Bror von Blixen-Finecke, the baroness' ex-husband, although he would not be invited to the dinner.

Love works in mysterious ways. In 1909, Karen Blixen had fallen hopelessly in love with her second cousin, Baron Hans von Blixen-Finecke. Four years later, however, she had become engaged not to Hans, but rather to his twin brother, Bror, and it was with him that she had traveled from Øresund to Africa. Denmark and the Rungstedlund family estate, north of Copenhagen, were too parochial for such an artistically ambitious young woman. She needed to get out—and Kenya was just far enough away. The country was then known as British East Africa, and was a protectorate and Crown Colony. Europeans had been settling on the fertile White Highlands since 1902. Bror and "Tanne," as Karen was affectionately known, married in Mombasa in January 1914. They used the money provided by Karen's mother to buy a coffee

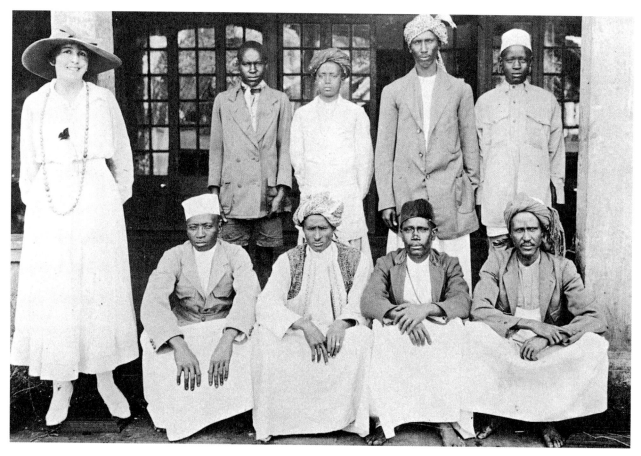

• ABOVE Karen Blixen with her workers outside the farmhouse. Farah Aden, one of her confidants (first row, second from left), was her farm manager of sorts. She dedicated a chapter of her novel *Shadows on the Grass*, which became the basis for the movie *Out of Africa*, to him.
• OPPOSITE: TURBOT WITH HOLLANDAISE SAUCE Seared and roasted fish steaks, served with hollandaise sauce and orange zest.

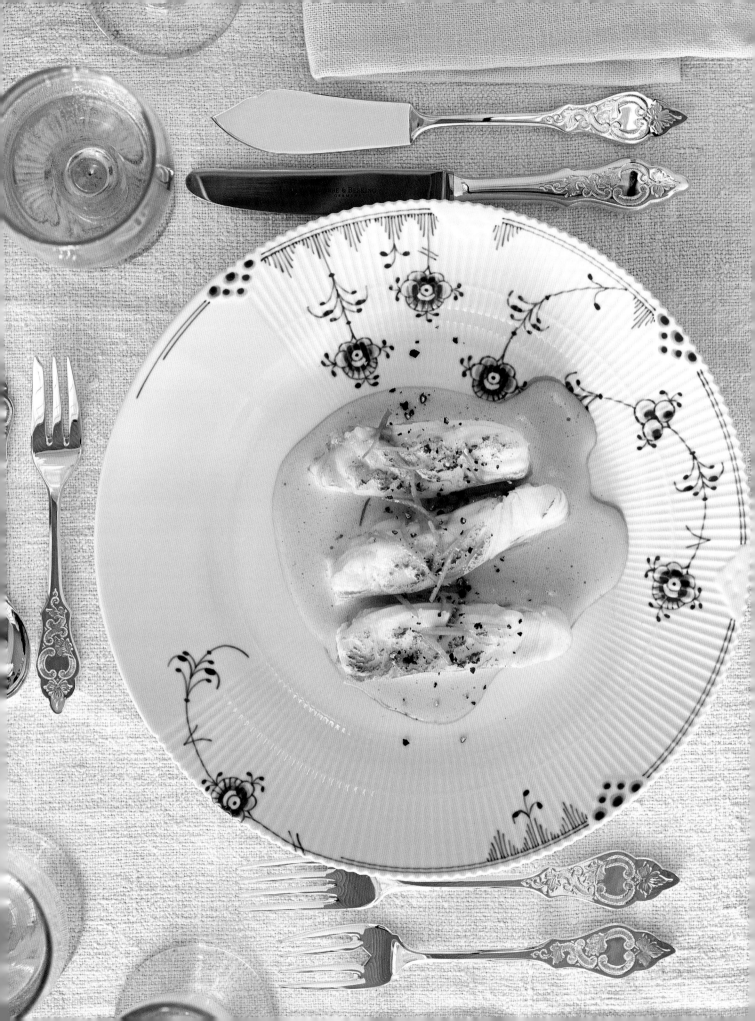

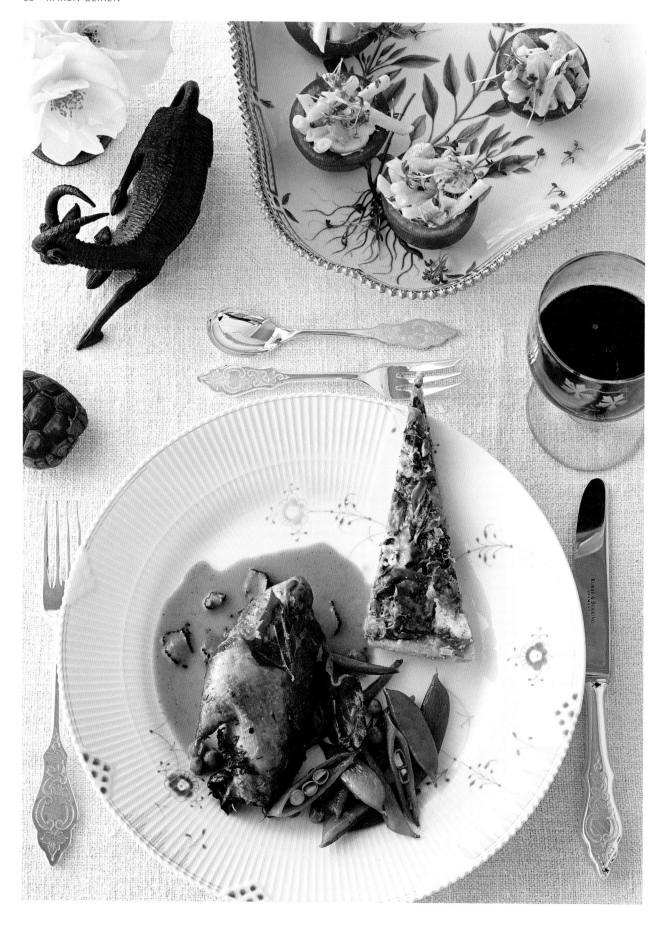

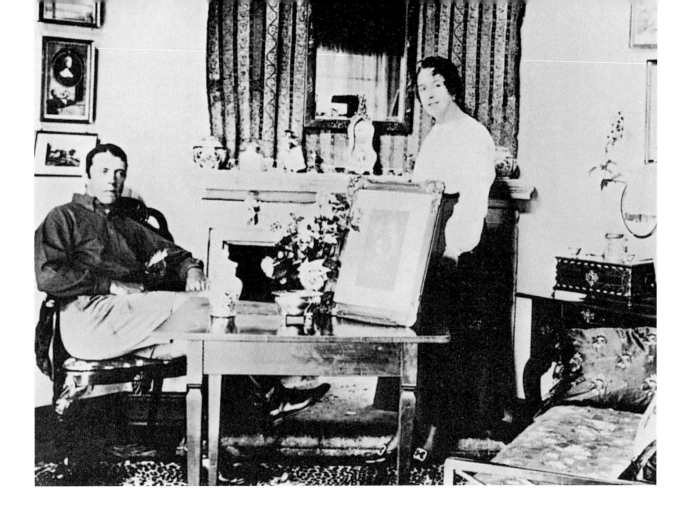

farm at the base of the Ngong Hills, at an altitude of 6,500 feet. It was a challenge for the inexperienced pair, and one that Karen ended up tackling alone after her ongoing marital crisis with Bror resulted in them separating. She found a friend and witty conversation partner in Finch Hatton, the attractive strawberry-blonde son of an English count from Sussex, who organized big-game hunts in Kenya. He ended up becoming the love of her life. For all the worries about the coffee farm, and despite her ailing health and constant lack of money, Blixen enjoyed every minute spent with Finch Hatton. "Denys adds an indescribable sweetness to my life," she wrote to her brother Thomas in August 1926. Outside of Blixen's farm, Finch Hatton had no other abode in Africa—he stayed with her between safaris, coming and going as he pleased. When he went off flying in his Gypsy Moth biplane, she attended to running the farm. Or, she wrote.

Her west-facing dining room, which doubled as her study, offered spectacular views of the plains and its vast hunting grounds. Snaking beyond it was the Mbagathi River, whose banks were lined with leafy acacias. The

Ngong Hills silhouetted sharply against the evening sky. At the start of the mini rainy season in November, the coffee blossoms gave off their slightly bitter aroma. It was heavenly . . . and surely enough to make the overindulged royal visitor swoon!

Blixen had already met the crown prince once before. Upon his arrival, he had invited her and Finch Hatton to lunch in the dining car of the juddering train on which he had traveled to Nairobi. It was uncomfortable, and the food onboard was abysmal. Perhaps this was the reason the prince had simply invited himself to Blixen's farm. After all, she was well renowned for being a fabulous host. While Blixen's friends and acquaintances were largely happy to go along with cucumber sandwiches at champagne parties, a Parisian chef had introduced her to haute cuisine on one of her trips to Europe. This meant the British visitors were in for a surprise. And Blixen was able to rely on her manservant, Kamante. The young Kikuyu boy Blixen had nursed to health had long proved to be an excellent chef, much to Blixen's relief. "I love to cook, and

• OPPOSITE: TRUFFLED PARTRIDGE WITH THREE SIDE DISHES Roasted partridge flavored with truffles and ham, served with snap peas tossed in butter and sugar, tomatoes stuffed with macaroni salad, and a mushroom croustade.
• ABOVE "We have . . . forgone much by not acknowledging and seeking to acquire the African tribes' dignity, wisdom, and poetry," wrote Blixen about her fellow humans in Africa. Blixen with her husband, Bror von Blixen-Finecke, in 1919.

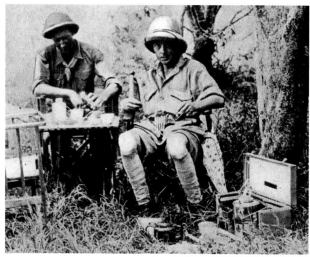

• TOP Denys Finch Hatton went on safari with
the Prince of Wales in 1928 and 1930.
• ABOVE Blixen's house, now a museum, at the
base of the Ngong Hills near Nairobi.

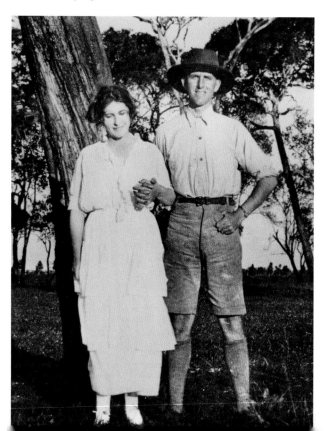

• LEFT Blixen and her brother, Thomas,
on the farm around 1920.

I love giving dinner parties. But I don't at all like having to do both," she once wrote in a letter.

Kamante could not speak nor read English, but Blixen—a magnificent writer who was also a skilled painter—illustrated each menu for him (the plates, glasses, flatware, fish, vegetables). Kamante later remembered every dinner, associating the respective dish with incidents that occurred on the day it was served. As such, he spoke of the "sauce of the lightning that hit the tree," to describe a meal that had been eaten during a fierce storm. The loyal Kikuyu became famous throughout the colony for his delicious meals.

Everything had been purchased and prepared. Finch Hatton had brought with him an English ham that Blixen, as she later wrote to her mother, cooked in five bottles of champagne. An English friend had sent her 144 bottles, whose contents he had deemed to have "too flat" a taste for the isle, but which he believed would suffice for the Kenyan highlands. A total of six people would be dining with the Prince of Wales that evening: Blixen and Finch Hatton were joined by the prince's private secretary, Sir Alan Frederick Lascelles, and his adjutant, Piers Legh, as well as Vivienne de Watteville, a Swiss writer, and her English colleague and aviation pioneer, Beryl Markham.

The evening began with a coffee cocktail on the terrace. The fragrances of thyme and sweet gale that wafted up from the plains mingled in the mild twilight air. The champagne sparkled gloriously, and the whole scene was set to a backdrop of singing cicadas.

The dinner was a great success. Kamante was praised for his culinary skills, with the prince gushing that the meal was the best he had ever been served in the colony. He raved about the Cumberland sauce, and had a second helping of the "pickled" ham. Karen's brown hair curled up at her earlobes, and her drop earrings twinkled in the candlelight. She gleefully waved at Finch Hatton across the table. And wished life could stay this way forever.

Squash and Zucchini Broth

INGREDIENTS

3 carrots
1 leek
2 onions
4 celery sticks
2 turnips
10 oz. / 300 g organic
* marrowbone*
1 bouquet garni (½ bunch
* parsley, 1 bay leaf, plus*
* 2 sprigs thyme)*
2 garlic cloves
vegetable oil for sautéing
4 baby zucchini
3½ oz. / 100 g red kuri or
* other winter squash flesh*
salt and white pepper
1½ tsp. organic orange zest

TIME NEEDED:
30 mins. + 65 mins. cooking

METHOD LEVEL OF DIFFICULTY: EASY

To make the broth, wash and peel or trim the carrots, the white of the leek, the onions, celery, and turnips. Cut all the vegetables into large chunks. Rinse the marrowbone. Tie the herbs together. Peel and crush the garlic. Briefly sauté the vegetable pieces in a large saucepan, then pour in 1½ quarts / 1½ liters cold water. Add the marrowbone, bouquet garni, and garlic. Bring to a boil, cover, and simmer about 1 hour over low heat.

Wash and trim the zucchini, then cut lengthwise into paper-thin slices. Very finely dice the squash flesh. Strain the broth through a strainer lined with cheesecloth, catching the broth. Season with salt and pepper. Add the zucchini slices and the squash dice, and simmer 3–4 minutes in the broth. Divide the soup among warm soup bowls and sprinkle with the orange zest.

TIPS: To serve, let a fresh egg yolk glide into the plate and serve with pumpkin seed oil, chopped pumpkin seeds, and chopped herbs, if liked. Accompany with fried bread triangles with the crusts cut off. You can drizzle with sherry, if you like.

RECOMMENDED WINE: This classic marrowbone dish demands to be enjoyed with a sherry! Who knows which one Finch Hatton would have preferred? We recommend a modern, light fino sherry—chilled, of course.

Turbot with Hollandaise Sauce

INGREDIENTS

2 turbot steaks, unboned
* and skin on, about 1 lb.*
* 2 oz. / 500 g per each,*
* 1¼–1½ in. / 3½–4 cm*
* thick*
salt and crushed pepper
2 tbsp. olive oil
For the hollandaise sauce:
3 egg yolks
2–3 tbsp. orange juice
salt and white pepper
1¾ sticks / 200 g butter, cold
tarragon or dill
½ tbsp. julienned zest of an
* organic orange, to garnish*

TIME NEEDED:
35 mins. + 20 mins. cooking

METHOD LEVEL OF DIFFICULTY: DIFFICULT

Heat the oven to 425°F / 220°C (Gas 7; convection ovens 400°F / 200°C). Rinse the turbot steaks under cold water and carefully pat them dry. Cut off the cartilage ends. Season both sides with salt and pepper.

Heat the oil in a large ovenproof, nonstick skillet over high heat, then reduce the heat to medium. Add the fish and fry about 4½ minutes without moving the steaks, until they start to turn brown. Turn the steaks over. Finish cooking 9–10 minutes on the middle rack in the oven.

To make the hollandaise sauce, heat a water bath to boiling, then reduce the heat. Put the egg yolks, orange juice, and a little salt and white pepper into a small saucepan and stir until smooth. Place the pan over the water bath and beat until you have a foamy mixture.

Chop the butter and add, a few pieces at a time, beating constantly. The sauce should have a creamy consistency. Tear or chop tarragon or dill, then stir it in.

Skin the fish on both sides and lift the fillets off the bones. Serve with sauce hollandaise and garnish with orange zest, and herbs, if desired.

TIP: If the hollandaise turns out too thick, add 1–2 tablespoons warm orange juice.

RECOMMENDED WINE: An extravagant Condrieu from the northern Rhône in France might have been a favorite among the illustrious guests. Today, however, the tendency is more toward an aromatic, spicy, not-too-young Sauvignon Blanc from the Styria area of Austria.

Truffled Partridges

INGREDIENTS

4 oven-ready partridges,
 10 oz. / 300 g each
2 small jars preserved
 truffles (scant ½ oz. /
 10 g drained weight each)
5 tbsp. / 75 g butter, softened
4 fresh grape leaves
vegetable oil for browning
 the partridges
fleur de sel and freshly
 ground pepper
4 thin slices smoked ham
7 oz. / 200 ml game broth
⅔ cup / 150 g crème fraîche
a little Madeira wine

TIME NEEDED:
35 mins. + 50 mins. cooking

METHOD LEVEL OF DIFFICULTY: MEDIUM

Wipe the partridges inside and out with dry paper towels. Use your fingers to loosen the skin on the breasts. Slice half the truffles, reserving the liquid, then combine the sliced truffles with the butter, and gently push the mixture under the skins. Tie the partridges up with kitchen string so the legs are tight against the bodies. Wrap each with a grape leaf.

Heat a thin layer of oil in a flameproof Dutch oven and fry the partridges in it 15–20 minutes on both breast sides until golden-brown. Turn them over and season with salt and pepper. Place the smoked ham on top of the partridges. Meanwhile, heat the oven to 375°F / 190°C (Gas 5; convection ovens 350°F / 170°C). Cover the pot and roast the partridges 30 minutes on the middle rack.

Take out the partridges, cover in aluminum foil, and keep warm. Add the game broth to the roasting juices in the pot and boil, stirring. Add the crème fraîche and the reserved truffle liquid and continue boiling to reduce a little. Very thinly slice the remaining truffles and fold them into the sauce. Flavor with a little Madeira wine.

RECOMMENDED WINE: To stay on the African continent, we'll go for Anthony Hamilton Russell's superb Pinot Noir. The trailblazer from the Cape of Good Hope knows what to serve with an opulent dish.

Glazed Snap Peas

INGREDIENTS

9 oz. / 250 g sugar snap peas
3 sprigs flat-leaf parsley
4 tsp. / 20 g butter
1 tsp. brown sugar
⅔ cup / 100 g frozen peas
salt

TIME NEEDED:
10 mins. + 8 mins. cooking

METHOD LEVEL OF DIFFICULTY: EASY

Clean the sugar snap peas and halve them lengthwise, if liked. Wash and shake dry the parsley, then pull off the leaves and thinly slice.

Melt the butter with the sugar in a skillet. Add the sugar snap peas and toss 2–3 minutes in the butter. Add the green peas and toss another 2 minutes. Fold in the parsley and season with a little salt.

Mushroom Croustade

INGREDIENTS

For the pastry dough:
1½ cups + 2 tbsp. / 200 g all-
 purpose flour
7 tbsp. / 100 g cold butter,
 diced + extra for greasing
1 egg yolk
1 tsp. salt
1 tsp. sugar
legumes for blind baking
For the filling:
1 lb. / 450 g mushrooms
2 shallots
2 garlic cloves
½ bunch parsley
1 sprig summer savory
2 tbsp. olive oil
1 dash lemon juice
3 tbsp. white port wine
7 oz. / 200 g crème fraîche
grated Parmesan

TIME NEEDED:
55 mins. + 30 mins. baking +
30 mins. chilling the croustade

METHOD LEVEL OF DIFFICULTY: MEDIUM

To make the pastry dough, quickly knead all the ingredients and 3 tablespoons cold water until a smooth dough forms. Wrap it in plastic wrap and chill 30 minutes. Wipe the mushrooms with paper towels and cut off the stems, then thinly slice the caps. Peel and finely chop the shallots. Peel and chop the garlic. Wash and shake dry the parsley and the savory, then thinly slice the leaves.

Heat the olive oil in a skillet over high heat. Add the mushrooms and fry. Add the shallots, garlic, lemon juice, and port wine and continue stirring until the liquid cooks away. Leave to cool a little, then fold in the crème fraîche and the herbs.

Meanwhile, heat the oven to 375°F / 190°C (Gas 5; convection ovens 350°F / 170°C). Roll out the dough between 2 sheets of plastic wrap to the thickness of the back of a knife. Grease a tarte pan with a removable bottom (10 in. / 25 cm diameter) with butter. Place the dough in the pan and cut off the overhanging edges.

Prick several times with a fork. Place a sheet of parchment paper on the dough, then cover it with the legumes and bake blind 15 minutes, or until the pastry looks dry and is light golden. Remove the parchment paper and the legumes. Spread the mushroom mixture over the pastry, sprinkle with Parmesan, and bake 10–15 minutes longer. Serve lukewarm or cold.

Stuffed Tomatoes

INGREDIENTS

4 oz. / 125 g dry macaroni
salt
10–12 Cape gooseberries
2–4 tomatoes
garden cress, to garnish
For the mayonnaise:
1 small organic egg
2 tbsp. lemon juice
2 tbsp. honey
2 tbsp. medium-hot mustard
fleur de sel and pepper
½ cup / 125 ml olive oil
a pinch mild curry powder
⅔–¾ cup + 2 tbsp. /
* 150–200 g plain yogurt*

TIME NEEDED:
25 mins. + 10 mins. cooking

METHOD LEVEL OF DIFFICULTY: EASY

Cook the macaroni in boiling salted water until tender, but still firm to the bite, then drain and rinse under cold water. Separate the Cape gooseberries from the leaves and quarter the berries.

To make the mayonnaise, blitz the egg yolk, lemon juice, honey, mustard, salt, and pepper with a handheld mixer, then gradually add the olive oil and beat in. Fold in the curry powder and the yogurt. Combine with the pasta and chopped Cape gooseberries.

Check the pasta salad again for seasoning. Wash and pat dry the tomatoes, then halve them cross-wise and hollow them. Fill the tomato halves with the pasta salad, garnish with cress, and serve one or two halves per person. Or serve the salad on thinly slices tomatoes.

Savarin with Strawberries and Granadilla

INGREDIENTS

For the yeast dough for 2 savarins
(freeze half the dough for later):
6 tbsp. milk, lukewarm
½ envelope active dry yeast
1½–2 tbsp. granulated sugar
1¼ cups / 150 g all-purpose
* flour*
¼ tsp. salt
2 eggs
1–2 tsp. vanilla extract
6 tbsp. / 90 g butter, softened
* and flaked*
For soaking:
½ cup + 1 tbsp. / 115 g
* granulated sugar*
4 tbsp. Grand Marnier
For the filling:
7 oz. / 200 ml whipping
* cream*
14 oz. / 400 g strawberries
1–2 granadilla (or passion
* fruit)*

TIME NEEDED:
55 mins. + 40 mins. baking
+ 1 hour 30 mins. resting

METHOD LEVEL OF DIFFICULTY: MEDIUM

Stir together the milk, yeast, and 1 tablespoon of the sugar and leave about 20 minutes to froth. Mix the flour, remaining sugar, and salt together in a large bowl and make a well in the middle. Lightly beat the eggs. Beatin the yeast and milk mixture, the eggs, and the vanilla extract into the flour until you have a smooth dough. Cover and leave 45 minutes to rise.

Grease a savarin pan (6 in. / 15 cm diameter). Heat the oven to 425°F / 220°C (Gas 7; convection ovens 400°F / 200°C). Gradually beat the butter into the dough. Pipe half the dough into each pan using a pastry bag. Keep warm and leave to rise until the dough reaches the rim. Bake 10 minutes on the middle rack in the oven. Reduce the temperature to 350°F / 180°C (Gas 4; convection ovens 325°F / 160°C) and continue baking 30 minutes. Turn out the savarin onto a deep plate and leave to cool 10–15 minutes.

In a saucepan, bring 1 cup / 250 ml water and the sugar to a boil, stirring until the sugar has dissolved. Leave to cool until still warm, then add the Grand Marnier. Drizzle about one-third of the syrup over the savarin, adding another third after 15 minutes and the final third after 30 minutes.

Beat the cream until stiff. Wash and hull the strawberries, then halve them. Halve the granadilla or passion fruit and spoon out the seeds. Fill the savarin with cream, strawberries, and granadilla.

RECOMMENDED WINE: Finch Hatton would probably have poured a round of port wine to go with this dish. A glass of champagne—not too dry—would be a little less heavy.

• SAVARIN WITH STRAWBERRIES AND GRANADILLA Savarins are ring-shaped yeast cakes, originally French. In this recipe, the savarin is drizzled with sugared Grand Marnier and then served with strawberries, granadillas, and whipped cream.

Lemon Pudding
3 egg yolks juice of
1 lemon 1 scant cup
sugar creamed with
1 tables. butter pinch
of salt 1/3 cup flour
1 cup milk
Beat eggs seperately
mix yolks juice flour
+ milk in creamed
butter + sugar. Fold
in beaten egg whites
1 - mix sugar into butter
+ alternate milk + flour
slowly into creamed mix.
3 Add beaten yolks +
L. juice

Lois

(You can make this in morning and heat
up at night.)
(... a little more liquid)

Jackson Pollock

ACTION COOKING

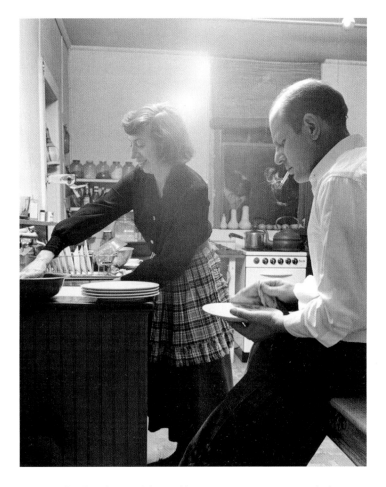

Jackson Pollock and Lee Krasner were one of the most dazzling couples in the history of art. Dinner parties in their small timber home on Long Island became the meeting place for New York's Bohemian scene.

• OPPOSITE Lemon Pudding, Pollock Bread—some of the other handwritten recipes of the couple, attesting to relaxed, intimate evenings with friends.

• ABOVE She cooks, he bakes, and the dishwashing is shared. Krasner and Pollock were as good a team in the kitchen as in the studio. They swapped the liveliness of New York City for a slower-paced life in rural Long Island, bringing the vibrant art scene with them in the form of convivial dinner parties.

One of art history's most legendary love stories began in a Greenwich Village studio in the fall of 1941: He was Jackson Pollock, an aspiring young painter from the New York School, and she was Lee Krasner, a critical, abstract-painting intellectual. The pair had met fleetingly at an exhibition opening, which was how many couples met in that lower-Manhattan, west-side neighborhood in those days. "The Village," as the district was—and still is—affectionately known, had established itself as the hub of the city's artists' colony in the late 1930s, a magnet to aspiring artists attracted by its cheap housing and studios. After the initial meeting, Pollock visited Krasner, three years his elder, and she flirted with him self-confidently. Yet, she didn't offer him a coffee, simply because she didn't know how to make one.

Pollock was also an amateur in the kitchen. Just like Krasner, however, whose parents ran a market stall in Brooklyn, he loved good, simple food made with high-quality ingredients. Born in Wyoming in 1912, he initially grew up on a farm in Arizona and later in California. His father, LeRoy, grew corn, cereals, vegetables, and even apricots, while his mother, Stella May, raised their five sons. She never taught the boys how to cook—but she was a source of culinary memories and some of her recipes were passed on to Pollock and his older brothers.

Pollock's small apartment, which he would soon share with Krasner, did not have a kitchen. City life then wasn't that different to today, however, in that you didn't need to be able to cook to eat well. The pair would get their coffee from one of the numerous coffee shops in the Village, and would dine at the many international restaurants between Houston Street and 14th Street.

Life soon changed for the couple, however. They felt as if New York City was closing in on them. Pollock, in particular, felt a need for freedom, for wide open spaces, for views that swept over fields and dunes and out toward the sea. Krasner sensed that this man, who had battled depression and alcoholism, urgently needed stability and tranquility. The remote east-coast idyll of Long Island would suit him well, she decided.

Soon after their marriage in 1945, Krasner and Pollock moved to the old fisherman's house they had bought for $5,000 in Springs, a village near East Hampton. They quickly adapted to life in the local artists' colony, which had already attracted sculptors like John Ferren and writers such as John Steinbeck. Pollock had started to get into "all-over" painting by then, and was to be recognized as an "action painter," laying giant canvases on the floor, vigorously adding pigments to them, often splattered and dripped rather than applied with brushstrokes. He achieved critical acclaim and financial success, with the support of his wife, who put her own career somewhat on the backburner.

To make sure they weren't forgotten by Manhattan's bohemian society, the couple began hosting dinner parties in their remote abode. They had installed a functional kitchen in the two-story house, where the movers and shakers of New York's art scene frequently gathered for years to come. Krasner learned to cook, Pollock took charge of the baking, and together they were great hosts. So it was, perhaps, not surprising weekend guests from the city willingly made the long trek down Montauk Highway to the eastern end of Long Island.

• CLASSIC BORSCHT WITH SOUR CREAM Krasner, the child of Russian-Jewish immigrants, cooked borscht for her guests with beets from her own garden. It was prepared with what was then considered a state-of-the-art electric blender, which Pollock and Krasner had bought for themselves.
• OPPOSITE Pollock's *Eyes in the Heat*, oil and enamel on canvas.

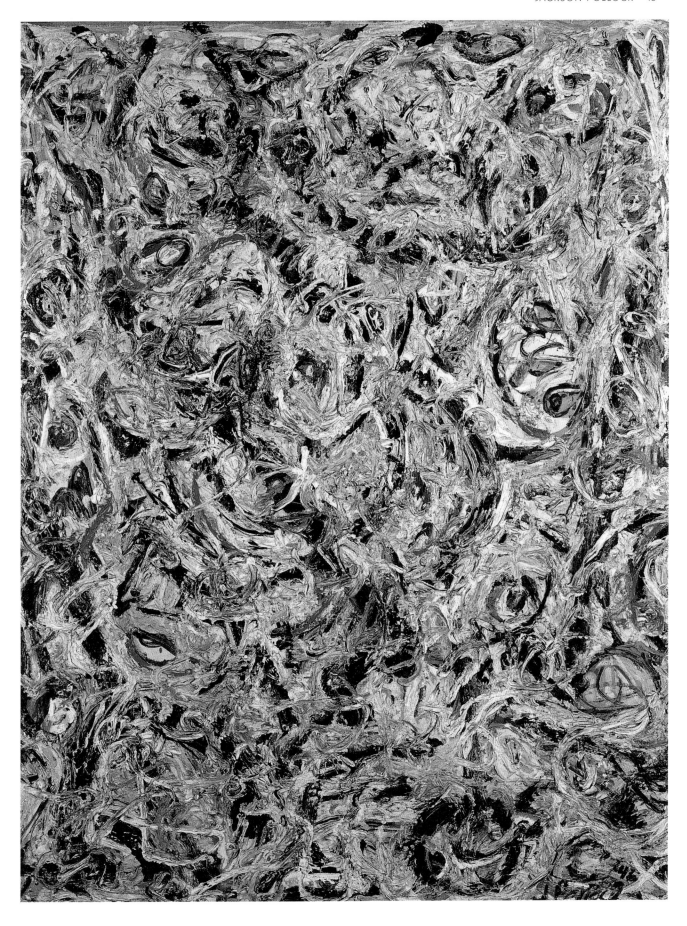

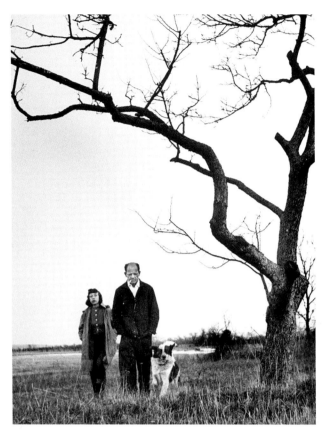

• Krasner and Pollock.

• A windmill in East Hampton.

• The floor of Pollock's studio.

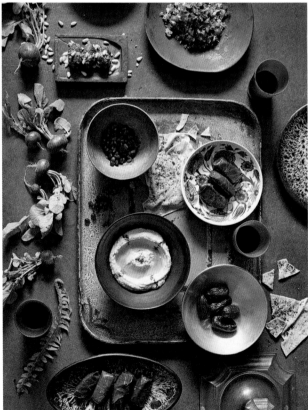

• Lucia Wilcox brought along Syrian specialties.

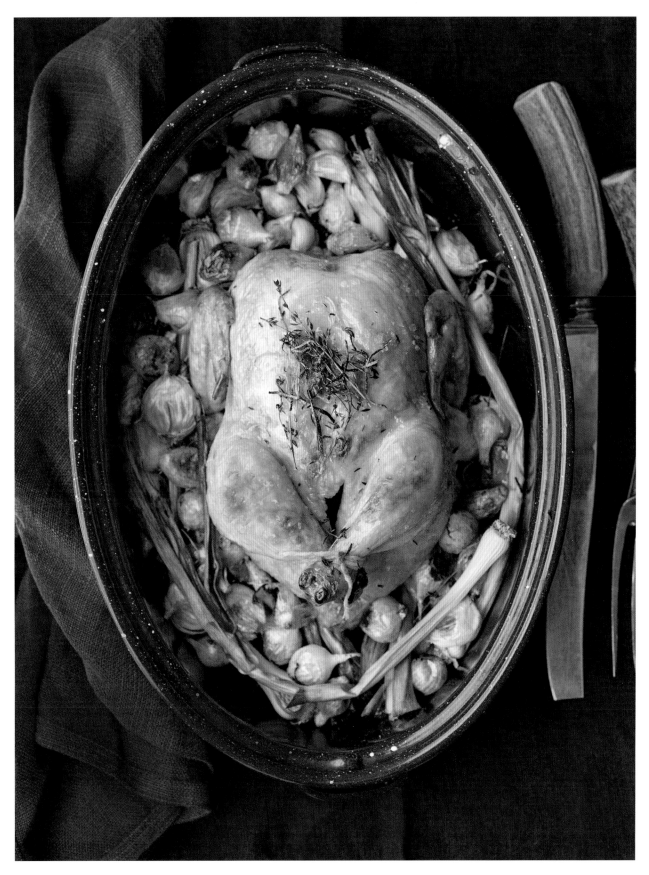

• FRENCH POULARDE STUFFED WITH HERBS Classic, simple dishes were served to guests, just as the "Bonackers," as the inhabitants of Springs were called, liked it. Krasner supported the local poultry farmers, and often served her guests pot-roast chicken.

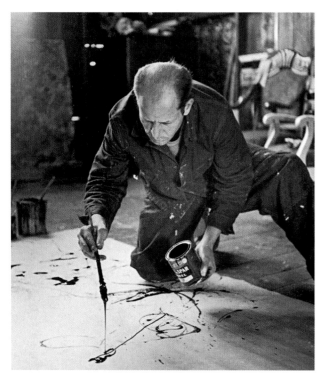

• ACTION PAINTING Pollock in his studio extension to the
house, April 1949.
• A WINTER WONDERLAND IN EAST HAMPTON When it was
cold outside, the aroma of home-baked treats, such as pecan torte,
wafted through the Pollocks' cozy timber house.

Peggy Guggenheim was one of the illustrious guests.
The wealthy gallery owner and art collector had assisted
Krasner and Pollock with a personal loan to buy the house.
Another keen guest was Clement Greenberg, the legend-
ary art critic, whose support for the new, young, abstract
American action-painting style had helped Pollock and
fellow artist Willem de Kooning to their breakthroughs.

Before there was anything for guests to eat, however, they
first had to pitch in; Pollock would, indeed, sometimes be
waiting for his friends to arrive, in shorts, armed with a
bucket and scoop net, ready for collecting shellfish on the
beach. At Accabonac Harbor, for example, Venus clams
were as easy to pluck out of the shallow water as if they
were blueberries in a forest. One of Pollock's good friends,
Lucia Wilcox, another Manhattan artist, would bring
her Syrian-inspired picnic with her: Various mezes with
baba ghanoush (pureed eggplant), hummus, stuffed grape
leaves, and kibbe made from ground beef and pine nuts,
along with juicy dates, and glistening granadilla seeds.

The buckets filled quickly in the lagoon's gentle surf.
Pollock would open the smallest clams straightaway, eat-
ing them raw out of the shell with Lucia's husband, painter
Roger Wilcox. Meanwhile, Krasner would be in the kitchen
preparing the meal. She might have received some help
from Josephine Little, a frequent guest along with her
husband John, an abstract expressionist artist, joining
the likes of German-born artist couple Vita and Gustav
Petersen and photographer Hans Namuth.

Meals usually kicked off with borscht. Not just because
Krasner was familiar with the recipe from her Russian-
Jewish family, but also for practical reasons: She had
bought one of the new electric blenders. The Waring
Blender (only patented in 1938 and just beginning to
feature in American kitchens), was ideal for process-
ing beets—freshly picked from the vegetable garden,
and boiled with beef broth, juice, and lemon zest—into a
hearty soup.

Krasner also liked to serve French-style poularde, or
roast chicken, stuffed with herbs and prepared in a cast-
iron pot made by the French company, Le Creuset. This
was a recommendation from Alfonso Ossorio, a collector,
friend, and future artist who was knowledgeable about
good cookware. In his personal notes, Ossorio regularly
recorded details about the nights spent in the Pollock-
Krasner home.

Author and photographer Robyn Lea later read these
notes for her book *Dinner with Jackson Pollock* (2015),
bringing to the public various original documents, includ-
ing recipes Krasner had originally copied from magazines,
or which Pollock had been given by friends. One of these
was Rita Benton's recipe for pecan torte. Rita was the wife
of Thomas Hart Benton, a prominent American realist
painter and muralist, who had been Pollock's teacher and
sponsor in the 1930s.

When the snowy winters of the Atlantic coast sent
a fresh breeze billowing around the Pollock-Krasner
home as the pecan torte was being baked, aromas of cof-
fee, coconut, vanilla, and pecans would waft through the
house, creating a cozy, homely atmosphere.

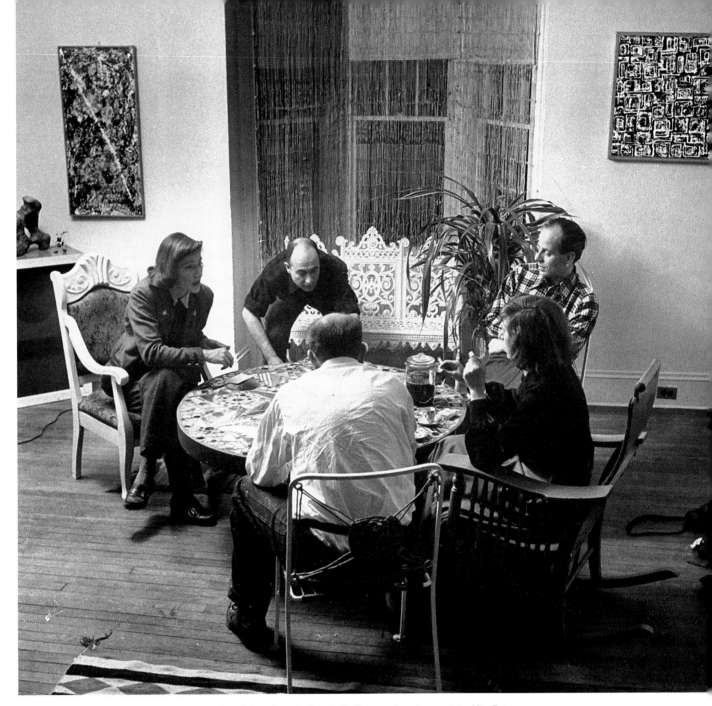

• POLLOCK AND KRASNER (in the foreground) with their friends (from left), German-American painter Vita Petersen, painter and gallery owner John Little, and Gustav Peterson.

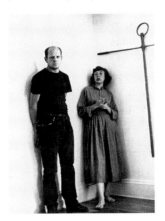

• LEFT Pollock and Krasner in their timber house. On the wall are the remains of an anchor they had found.
• RIGHT A predinner studio tour: Krasner and Pollock with a friend.

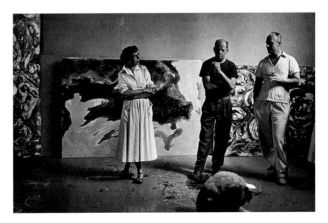

Borscht

INGREDIENTS SERVES 4
1 lb. / 450 g beets
salt and pepper
about 1 cup / 250 ml meat
* stock*
⅔ cup / 150 ml sour cream
juice and zest of ½ organic
* lemon*
¼ bunch dill or chives, to
* garnish*

TIME NEEDED:
30 mins. + 40 mins. cooking

METHOD LEVEL OF DIFFICULTY: EASY

Thoroughly wash and scrub the beets. Put them into a saucepan, cover with cold water, add salt, and bring to a boil. Simmer over low heat about 40 minutes, or until the beets are soft. Take the pan off the heat and leave the beets to cool.

Strain the beets, reserving the cooking liquid. Peel and quarter the beets. Put them into a food processor. Then add about 1 cup / 250 ml of the cooking liquid, the stock, scant ½ cup / 100 ml sour cream, lemon juice and zest, ½ teaspoon salt, and pepper, and blitz to a fine puree.

Wash and shake dry the dill, then pull off and chop the tips. Serve the soup in small bowls. Put a dab of the remaining sour cream on top of each serving and pull a fork through in a spiral motion.

Sprinkle with the dill. Delicious enjoyed hot or cold.

• LEFT This recipe came from a friend, Rita Benton. She was the wife of the artist Thomas Hart Benton, one of Jackson Pollock's teachers and patrons.

Kibbe

INGREDIENTS SERVES 6–8

For the coating:
about 1 cup / 225 g bulgur wheat
1 onion
2 lb. / 900 g ground beef
salt and pepper
For the stuffing:
6 small white onions
3 tbsp. / 45 g butter
about 4 tbsp. / 60 g pine nuts
¼ tsp. ground allspice
2 lb. / 900 g ground beef
about 7 tbsp. / 100 ml canola or sunflower oil

TIME NEEDED:
3 hours soaking + 55 mins. +
40 mins. cooking

METHOD LEVEL OF DIFFICULTY: MEDIUM

Put the bulgur wheat into a bowl, cover with about 2 quarts / 2 liters boiling water, and stir. Cover and leave to soak about 3 hours, then pour into a strainer lined with muslin and leave to drain. Use the cloth to squeeze out the excess liquid.

Peel and finely chop the onion. Combine the ground beef and onion and season with salt and pepper. Add the bulgur wheat and knead until you have a smooth mixture, adding a little cold water, if necessary.

To make the stuffing, peel and finely chop the white onions. Melt the butter in a skillet. Add the onions and fry briefly. Add the pine nuts and fry, stirring, until lightly browned. Sprinkle in the allspice, then add the ground beef and season with salt and pepper. Cook the meat over medium heat until it becomes crumbly and the liquid evaporates, but the meat is not yet browned. Take the skillet off the heat.

Shape the mixture into golf ball-size balls (about 2 in. / 5 cm diameter). With your index finger, make a deep hole in each ball and, turning, hollow it out to form a bulgur-and-ground beef shell that is thin, smooth, and firm. Now divide the spiced ground beef mixture among the hollowed-out shells and press the openings closed.

Heat the oil in a large skillet. Add the stuffed kibbe in batches and fry until brown all over. Remove and drain on paper towels. Delicious with yogurt or tahini (sesame paste).

French Poularde with Herb Stuffing

INGREDIENTS SERVES 4

For the poularde:
1 organic French poularde or roasting chicken, about 3 lb. / 1.3 kg
½ cup / 125 ml olive oil
2½ tsp. kosher salt
¼ tsp. black pepper
2 tbsp. thyme leaves
12 pearl onions
3 scallions
12 garlic cloves, or more
juice and zest of 1 organic lemon
For the stuffing:
2 onions
2 sticks celery
½ bunch parsley
2 tbsp. / 30 g butter
about ⅔ cup /80 g fresh bread crumbs
1 tbsp. sage leaves
1 tbsp. rosemary needles
1 tbsp. thyme leaves
a pinch of ground ginger
salt and pepper

TIME NEEDED:
60 mins. + 1½ hours cooking

METHOD LEVEL OF DIFFICULTY: MEDIUM

Remove the giblets from the body of the poularde. Thoroughly wash and dry the poularde inside and out and pat dry. Brush all over with about 4 tablespoons of the oil and sprinkle with kosher salt, pepper, and thyme leaves. Cover the poularde with a dish towel and leave to rest at room temperature.

Meanwhile, make the stuffing. Peel and finely chop the onions. Wash, trim, and finely chop the celery. Rinse, shake dry, and chop the parsley. Melt the butter in a large heavy saucepan. Add the onions and the celery and sauté until soft. In a bowl, combine the bread crumbs, sage, rosemary, thyme, parsley, and ginger. Season with salt and pepper. Moisten the mixture with a little water. Loosely pack the stuffing into the bird, then tie the legs together with kitchen yarn.

Heat the oven to 350°F/ 180°C (Gas 4; convection oven 325°F / 160°C). Peel the pearl onions. Trim and wash the scallions. Pour the remaining olive oil into a cast-iron Dutch oven. Add the unpeeled garlic cloves and the pearl onions and sauté about 10 minutes. Take off the heat. Place the poularde, breast side up, into the Dutch oven, and add the scallions. Drizzle with a little of the frying fat and lemon juice; sprinkle with the lemon zest. Place the Dutch oven on the second rack from the bottom in the oven and roast about 1 hour. From time to time, baste the bird with some of the frying fat.

Raise the oven temperature to 425°F / 220°C (Gas 7; convection oven 400°F / 200°C) and roast the poularde 15 minutes longer, or until the skin is a nice, crispy golden-brown. Briefly leave to rest in the oven. To serve, divide the poularde into pieces and serve with the stuffing.

Coco Chanel

LUNCH AND LOVE

In 1928, fashion designer Coco Chanel bought a piece of land
on the Côte d'Azur and had the La Pausa villa built on it,
which became a swanky, relaxed retreat for herself, all her
friends, and her lover, the Duke of Westminster. Lazy days were
spent surrounded by fragrant lavender, with lunch served
as a buffet—a modern sensation at the time.

• OPPOSITE: NO SHOW BEFORE MIDDAY Chanel with her dog, Gigot, in the garden of La Pausa in 1930,
as always dressed casual, yet elegant. She was one of the first Parisian women to flout the ban on women
wearing pants, which had been in force since 1800.
• ABOVE At her villa in Roquebrune-Cap-Martin, on the Côte d'Azur, Chanel hosted friends such as Salvador
Dalí, Jean Cocteau, Pablo Picasso, and her lover, the Duke of Westminster.

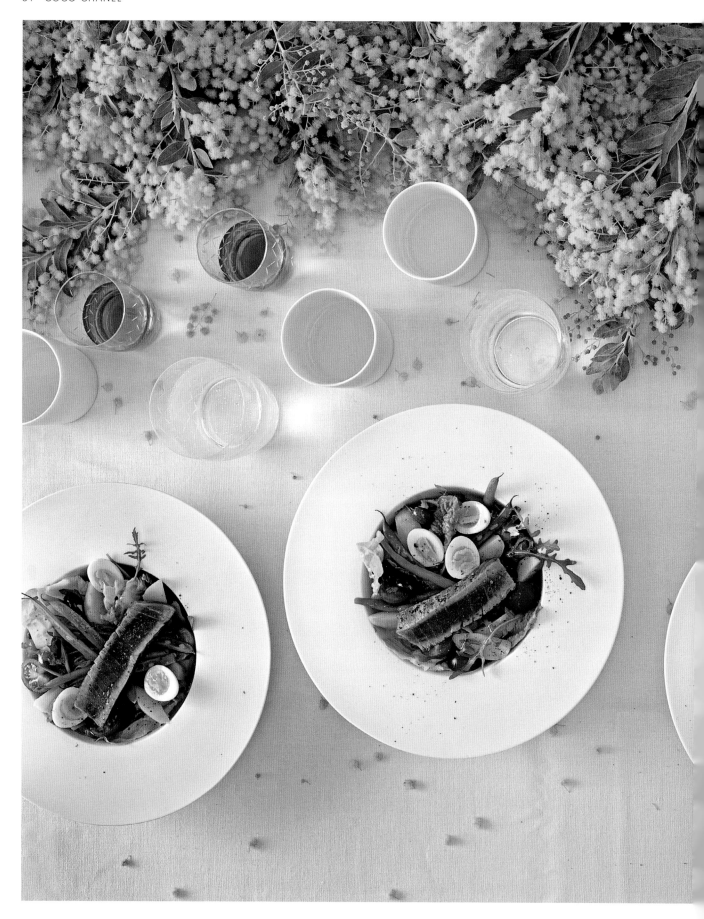

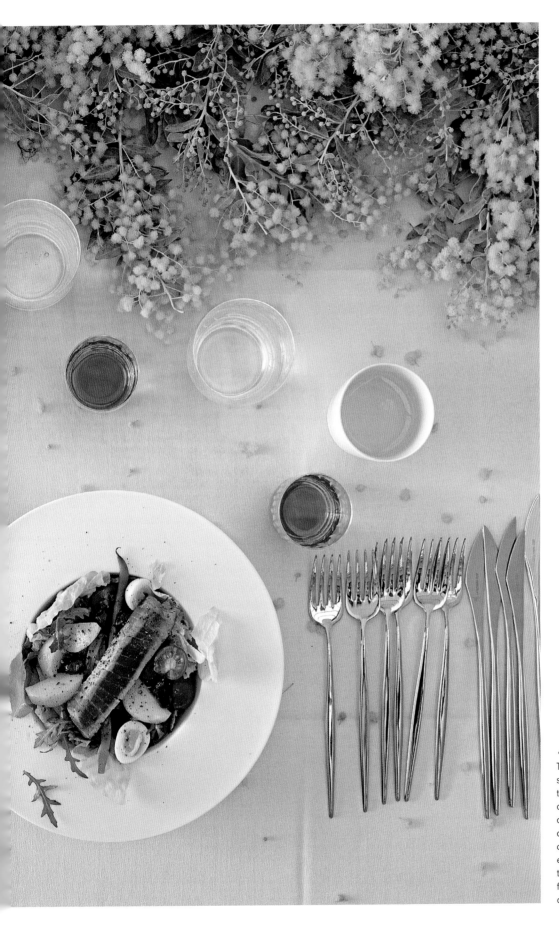

• SALADE NIÇOISE
This classic Mediterranean salad, with lightly seared tuna, is made with a mix of arugula, frisee, butterhead, and cos lettuce leaves, along with green beans, cherry tomatoes, and quail eggs. It is dressed with a traditional vinaigrette made from white wine vinegar and olive oil.

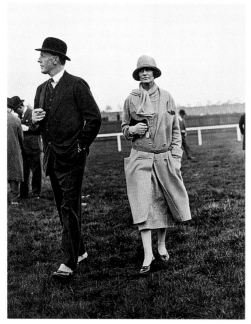

• Madame Chanel and the Duke of Westminster at the races in March 1925.

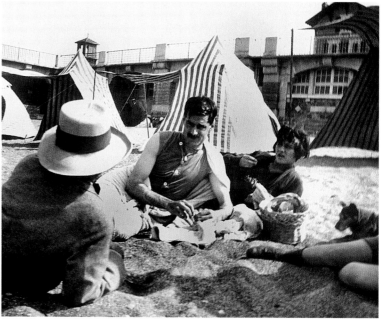

• Coco Chanel and her lover, Arthur "Boy" Capel (middle), with Constant Say (left) on the beach in Saint-Jean-de-Luz in 1917.

H e saw her. And, he was instantly fascinated. When the Duke of Westminster met Coco Chanel in Monte Carlo in 1923, he spontaneously invited her onto his yacht. As was so often the case, the *Flying Cloud*—one of his two boats—was moored in Monaco. Chanel, who had just turned forty, was casual and elegant, somewhat androgynous, yet feminine. She knew what she wanted, caring little about the opinions of others. And it was this self-confidence, unerring sense of style, and unparalleled discipline that saw her go from modest seamstress to successful fashion designer with boutiques in both Paris and Cannes.

When the Duke of Westminster asked her to dinner, she agreed, but also brought a friend along. She knew who she was dealing with; the forty-four-year-old duke was not only the richest man in England—perhaps even Europe— but also a notorious womanizer. He was in his second marriage, and was rumored to have had countless affairs. He was unquestionably handsome: tall, blonde, and athletic. But his lifestyle was vastly different to Chanel's; he had inherited his wealth, constantly flitted between his many properties, and spent his leisure time driving Rolls-Royces, fishing for salmon, or hunting grouse. An old-school British aristocrat and a modern, French, self-made designer—could they be a match?

Chanel initially kept the duke at a distance. She left him hanging—and he hung. He picked orchids from his own garden and took the giant bouquets to her in person at her salon on Paris' Rue Cambon. He sent her baskets of exotic fruit from his greenhouses, once even hiding an emerald in the basket. Eventually, months later, Chanel acquiesced to the advances of her perseverant admirer, and they became a couple.

From then on, Chanel's relationship with her international celebrity lover let her experience a life of luxury like something from a bygone era. Up to sixty guests would regularly be pampered and entertained by a legion of liveried servants at Eaton Hall, the duke's enormous main residence in Cheshire, in the English countryside. With expensive porcelain, polished sterling silver flatware, exotic flowers, and muted orchestral music, the dinner parties at Eaton Hall were carefully choreographed productions. Chanel handled the occasions with confidence and ease from the beginning. After all—perhaps she herself would soon be hosting this illustrious society as the Duchess of Westminster, for the duke had divorced.

But what Chanel and the duke were missing was a place they could both feel at home. Chanel was more like a guest at Eaton Hall, and the duke was not comfortable in Paris.

• OPPOSITE: ROAST CHICKEN WITH ASPARAGUS, ARTICHOKES, AND FAVA BEANS The chicken breasts are seasoned with rosemary before being put in the oven. The artichokes, garlic, and bay leaves are roasted in the same pan, and then served with lemon slices.

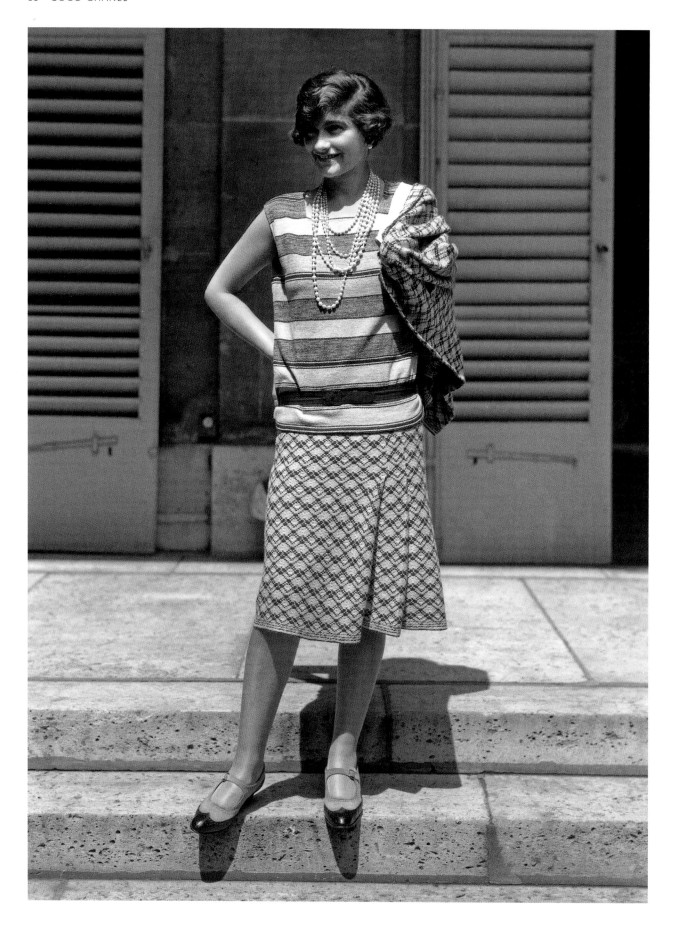

While she became involved in her work and meeting up with her artist friends, he got bored and soon moved on.

They needed a home; more specifically, they needed a refuge. Far away from stuffy England and hectic Paris. The French Mediterranean was the place where the Bohemian scene had been vacationing since the 1920s. Picasso, Dorothy Parker, Ernest Hemingway, F. Scott Fitzgerald, and his wife Zelda, were among regular visitors, all enjoying the sophisticated, but relaxed, atmosphere.

In 1928, Chanel bought a piece of hunting land from the Monegasque royal family, and contracted architect Robert Streitz to create "the ideal Mediterranean villa" in Roquebrune, at Cap Martin, overlooking the sea. Construction of the three-winged building cost six million francs. La Pausa, as Chanel christened the villa, was pointedly simple in its appearance. And it was here that she would entertain the duke and her friends. She held her guests' freedom as sacred, and nobody was disturbed before lunchtime. Only at lunch did they all meet—and it was an event nobody wanted to miss.

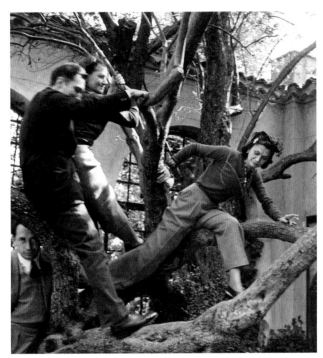

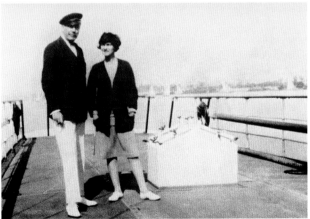

Meals at La Pausa were the antithesis to the dinner parties at Eaton Hall. The motto? It's all about relaxation! There was never a strict menu; instead, guests served themselves from a large buffet, eating as much or as little of whatever they wanted, however they wanted. Plates were filled with chops, steaks, poultry, and roast beef, along with lots of vegetables and salads.

Chanel was always the last to arrive, wearing black velvet pants, her pink satin pajamas just showing underneath. She would couple this with a sweater and pearls. There was no dress code at La Pausa. Some got dressed up for the meal—some didn't. Chanel would grab a plate of salad, sit down, entertain her guests magnificently for as long as she felt like it—then leave once she grew tired.

La Pausa soon became a legendary place for high society to gather, with Chanel inviting the world into her home, including, among others, Jean Cocteau, Salvador Dalí, and friends of the duke, such as Winston Churchill, so her lover could relax, too.

The pair's love gradually faded, with the duke traveling less and less frequently to the French Riviera refuge. And when he did put in an appearance, arguments often ensued. The duke was still not the faithful type, and he desperately wanted a male heir. Chanel was forty-six at the time, and, despite many attempts, had been unable to become pregnant. She looked on as the duke went about pursuing his aim: He met a young Englishwoman in a nightclub, and became engaged to her a month later.

"We stayed friends," Chanel said sometime after. After all, you can't stand in people's way. She never let on how much he had disappointed her, or how much she had bemoaned her fate and the conventions of her time. She went on her way—a strong woman, perhaps too strong for him.

Years after the end of the affair, Chanel sold La Pausa. In 2015, the Chanel fashion house bought the villa to restore it to its original condition. Today it is used to display jewelry to potential wealthy buyers.

• OPPOSITE On the villa's terrace in the late 1920s. From here, Chanel not only had a view of the sea, but also of the coastal strip from which the essences for her No. 5 fragrance were sourced.
• TOP The designer with her friends Valentine and Jean Hugo in the garden of the villa.
• ABOVE He chased—she made him wait. Chanel and the duke on his yacht.

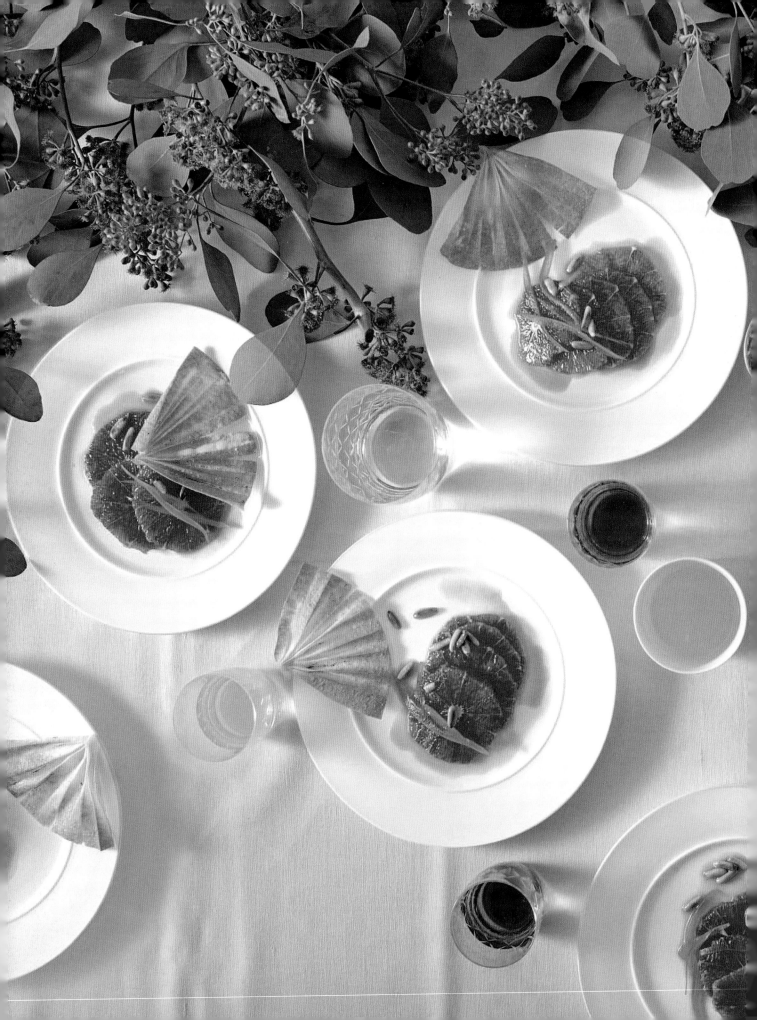

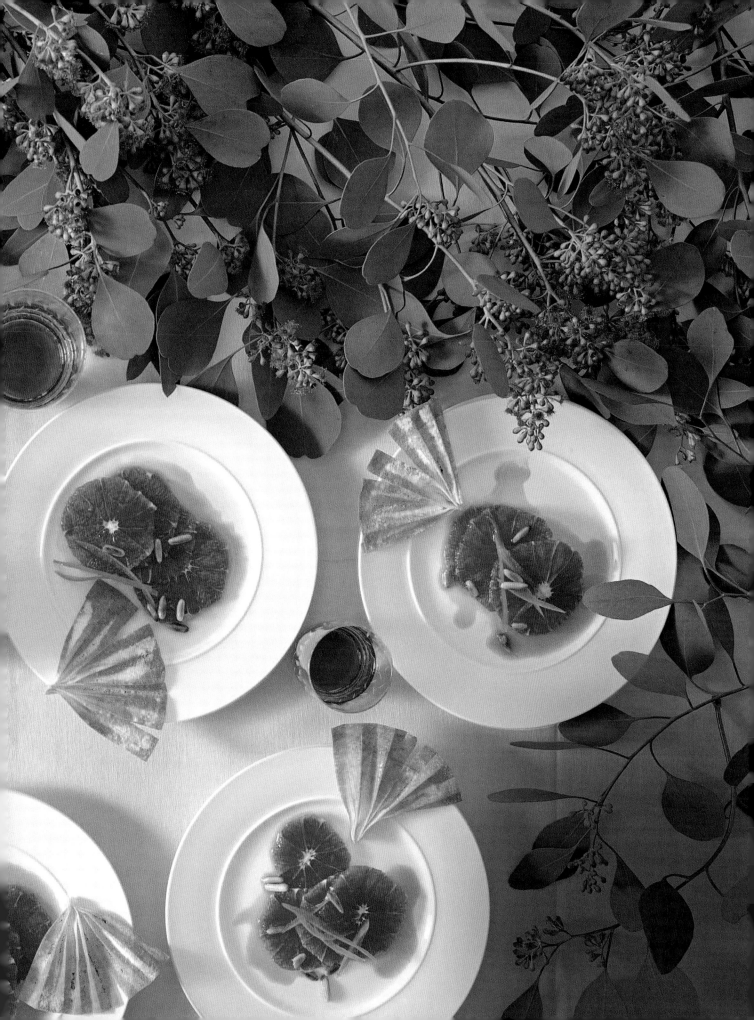

Salade Niçoise with Tuna Steaks

INGREDIENTS SERVES 8
12 small waxy potatoes
salt and pepper
12–16 fresh quail eggs, or
* use quail eggs from a jar*
9 oz. / 250 g green beans
10 oz. / 300 g trimmed leaf
* salads, such as arugula,*
* frisée, butterhead lettuce,*
* or romaine lettuce*
16 cherry tomatoes
1 lb. 2 oz. / 500 g very fresh
* tuna*
2 tbsp. olive oil
6 tbsp. black olives in oil,
* such as Cailletier olives*
8 pinches Espelette pepper
For the vinaigrette:
6 tbsp. white wine vinegar
¾ cup / 175 ml quality olive
* oil*
a pinch granulated sugar,
* optional*
salt and black pepper

TIME NEEDED:
5 mins. + 30 mins. cooking

METHOD LEVEL OF DIFFICULTY: EASY

Wash the potatoes, then cook them in boiling salted water until tender. Drain and leave to cool a little, then pull off the skins.

Meanwhile, cook the quail eggs in boiling water 3 minutes, drain, rinse under cold water, and shell.

Trim the green beans and cook in boiling salted water 3–5 minutes until tender. Drain the beans, rinse under cold water, and leave to drain in a strainer.

Trim, wash, and spin-dry the salad leaves, then tear them into bite-size pieces.

To make the vinaigrette, stir together the vinegar, oil, sugar, if using, and salt and pepper to taste.

Wash and halve the tomatoes. Halve the quail eggs. Cut the potatoes into bite-size wedges. Halve the beans diagonally or lengthwise.

Cut the tuna into 1¼–1½ in. / 3–4 cm thick steaks and season with salt and pepper. Heat the olive oil in a skillet over high heat. Add the tuna steaks and fry briefly, about 30 seconds on each side.

Combine the salad leaves with the tomatoes, potatoes, beans, and olives. Pour the vinaigrette over and toss. Divide the salad among the plates. Thinly slice the tuna and arrange on the salad together with the quail eggs. Sprinkle each serving with a pinch of Espelette pepper and freshly ground black pepper. Serve immediately.

RECOMMENDED WINE Chanel would probably have chosen a fruity Rosé de Provence to serve with her salade niçoise, perhaps even the celebrated Rosé Cœur de Grain of the Domaines Ott.

Fried Chicken with Asparagus, Artichokes, and Fava Beans

INGREDIENTS SERVES 6-8
12 small artichokes
juice of ½ lemon
10 oz. / 300 g podded fava
* beans*
3 double chicken breasts,
* with bones and unskinned*
salt and pepper
6 tbsp. olive oil
3 sprigs rosemary
2 garlic cloves
3 bay leaves
7 oz. / 200 ml chicken broth
2 bundles green asparagus
2 organic lemons
6–8 tbsp. good-quality olive
* oil*

TIME NEEDED:
65 mins. + 40 mins. cooking

METHOD LEVEL OF DIFFICULTY: MEDIUM

With a serrated knife, cut off the artichoke stems 1¼ in. / 3 cm above the bottoms. Remove the outermost leaves and cut off the tips of the remaining leaves to ½ in. / 1 cm above the bottoms. Using a small, sharp paring knife, cut out any woody parts. Halve each trimmed artichoke and remove the hairy chokes with a small knife or melon baller. Immediately plunge the prepared artichoke halves in a bowl of cold water and lemon juice.

Heat the oven to 325°F / 170°C (Gas 3; convection ovens 300°F / 150°C). Blanch the fava beans in a saucepan with plenty of boiling water 1 minute, then drain, rinse under cold water, and drain again. With your fingers, open the skins at one point and gently squeeze out the beans.

Season the chicken breasts with salt and pepper on both sides. In a large nonstick, ovenproof skillet, heat 3 tablespoons olive oil over medium heat. Add the breasts and fry 3 minutes on each breast side. Use two skillets, if necessary. Turn the chicken breasts onto their bone sides and add the rosemary. Transfer the skillet(s) to the oven and roast the chicken breasts 30–35 minutes until tender.

Meanwhile, take the artichokes out of the water and pat dry. Heat the remaining oil in a wide skillet over medium-low heat. Add the artichokes and fry 2 minutes, then season with salt and pepper. Lightly crush the garlic cloves. Add them to the skillet together with the bay leaves and the chicken broth. Continue cooking the artichokes, turning them occasionally, until tender and the liquid has almost cooked away.

Cut off about ¾ in. / 2 cm at the bottom of the asparagus stalks, then peel the bottom third. Bring plenty of salted water to a boil in a large saucepan. Add the asparagus and blanch 3 minutes. Lift the asparagus out of the pan and drain.

Wash and rub dry the lemons, then cut them into wedges.

Take the skillet(s) with the chicken breasts out of the oven, briefly heat on top of the stove, and briefly fry the breasts again on their skin sides, so the skins are nice and crisp. Using a carving knife, separate the chicken meat from the bones.

Add the asparagus and the fava beans to the artichokes and heat together. Divide the vegetables and the chicken among the plates, drizzle with olive oil, and serve with lemon wedges.

RECOMMENDED WINE A wine from Provence also goes well with the chicken—for example, fruity and spicy Château Revelette Rouge, with cherry and violet notes on the palate.

Crispy Fans with Grapefruit and Pine Nuts

INGREDIENTS SERVES 8

*2 sheets phyllo dough
 pastry, 9½ x 13in. /
 24 x 33 cm each, thawed
 if frozen*
5 tbsp. / 75 g salted butter
seeds of ½ vanilla bean
*6 organic grapefruit, ideally
 ruby grapefruit*
*½ cup / 100 g granulated
 sugar*
3 tbsp. / 45 g pine nuts
*about 6 tbsp. confectioners'
 sugar*

TIME NEEDED:
45 mins. + 30 mins. cooking
+ 30 mins. drying

METHOD LEVEL OF DIFFICULTY: MEDIUM

Halve the phyllo sheets lengthwise, then cut them crosswise into thirds, so you have 12 pastry pieces of 4½ x 4¼ in. / 12 x 11 cm. It's best to make a few extra fans because some will break up or might turn too dark while baking.

Fold the pastry pieces as fans. To do so, first fold them in a concertina pattern, then press the pastry together at one end, and ease it open at the other end. On the work surface, spread out the fans next to each other and leave 30 minutes to dry so they keep their shapes.

Meanwhile, melt the butter in a small saucepan, then boil until the whey in the bottom of the pan turns light brown and the butter starts to release a nutty aroma. Immediately strain the butter through a fine strainer lined with paper towels, into a second pan. Add the vanilla seeds and simmer about 5 minutes over low heat.

Wash and rub dry 2 grapefruit, then pare off the zest with a zester. Halve the fruit and squeeze out the juice.

In a saucepan of water, bring the grapefruit zest to a boil, then simmer 5 minutes. Drain off the water, then add 7 oz. / 200 ml fresh water and ¼ cup / 50 g sugar. Bring to a boil and boil until the liquid reduces to a syrup. Remove the zest from the pan, stir in the remaining sugar and the grapefruit juice, and cook to reduce to 7 tablespoons. Leave to cool.

Peel the remaining grapefruit with a paring knife so the bitter white pith is also removed. Thinly slice the peeled grapefruit.

In a skillet without any fat, dry-fry the pine nuts over medium heat until golden-brown.

Heat the oven broiler to 500°F / 250°C. Brush the pastry fans with the vanilla butter, then dust them with confectioners' sugar. Place the fans on a cookie tray lined with parchment paper. Place the tray on the lowest rack in the oven until the confectioners' sugar starts to melt and caramelize. Take the fans out of the oven and leave to cool. As most ovens do not bake entirely evenly, it might be best to take the fans out of the oven a few at a time. They should not get too dark, nor remain too pale. The pastry fans are perfect when the sugar has melted and they are a shiny, light brown color.

To serve, divide the grapefruit slices among plates and drizzle with the grapefruit syrup and candied zest. Sprinkle with the pine nuts, then add one fan to each plate. Serve immediately.

RECOMMENDED DRINK Serve with a fine, fruity pink champagne, a demi-sec, such as the bright and fruity Nectar Impérial by Moët & Chandon; followed by a thé verveine—lemon verbena tea, which, as the French appreciate, revives body and soul after a meal.

• PREVIOUS PAGES: GRAPEFRUIT WITH PINE NUTS, GARNISHED WITH A CRISPY FAN À LA CHANEL The crispy fan is one of the accessories Chanel knew to use perfectly. For dessert we have crispy fans of phyllo dough pastry, folded and baked in the oven until crispy.

Apollo 11

OUT OF THIS WORLD

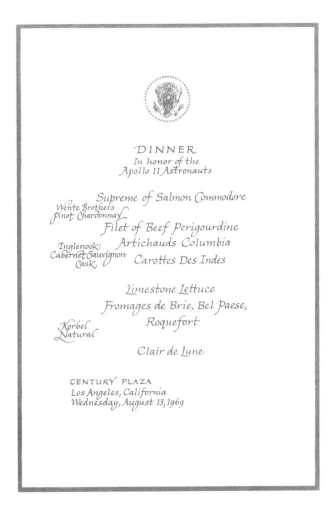

DINNER
In honor of the
Apollo 11 Astronauts

Supreme of Salmon Commodore
Wente Brothers
Pinot Chardonnay
Filet of Beef Perigourdine
Inglenook
Cabernet Sauvignon Artichauds Columbia
Cask Carottes Des Indes

Limestone Lettuce
Fromages de Brie, Bel Paese,
Roquefort
Korbel
Natural

Clair de Lune

CENTURY PLAZA
Los Angeles, California
Wednesday, August 13, 1969

On August 13, 1969, President Richard Nixon hosted a lavish
Los Angeles party with 1,400 guests to honor the astronauts who
had returned from the Apollo 11 mission. It was the largest and
most luxurious state dinner in White House history.

• OPPOSITE Neil Armstrong steps on the moon and utters the famous words:
"That's one small step for a man, one giant leap for mankind."
• ABOVE The menu of an unforgettable evening. The lavish banquet was held in the three-story ballroom
of Los Angeles' Century Plaza Hotel. Four courses were served, paired with California wines.

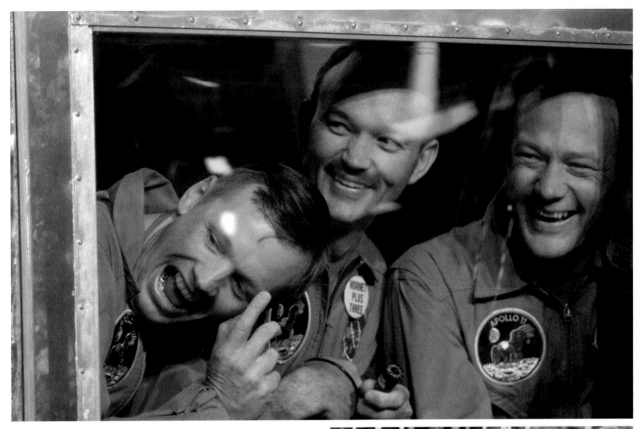

E ntrenched in the ongoing Vietnam War, an opponent of the Soviet Union in the Cold War, and in an uncomfortable relationship with the small, neighboring state of Cuba, America had a lot of enemies in those days. But the world all seemed to be united as one on the morning of July 20, 1969, at 20:17 Coordinated Universal Time (UCT), or at 9:32 EST, when humans first landed on the moon—in the form of astronauts Neil Armstrong and Buzz Aldrin, while pilot Michael Collins circled the pale-white celestial body in the command module. The streets of metropolises from Belgrade to Oslo to Mexico City were empty. In Warsaw, hundreds applauded outside the US embassy. Parisians danced with American tourists on the Champs-Élysées. Pope Paul VI sent greetings to the astronauts, telling them to "carry the voice of the Holy Spirit to the moon." The Soviet Union proved to be a fair loser in the race to be first on the moon, and congratulated the astronauts.

Having only been in office a few months, President Nixon had not been responsible for getting the lunar mission off the ground—his predecessors John F. Kennedy and Lyndon B. Johnson had been working on that. He, however, was in the right place at the right time, and saw the

• OPPOSITE: FILET OF BEEF PÉRIGOURDINE WITH ARTICHOKES, POTATOES, AND TRUFFLES Slices of beef tenderloin served with steamed artichokes, baby carrots, and a rich sauce made from veal jus, truffle jus, and port wine.

• TOP The returning astronauts: Armstrong, Collins, and Aldrin.
• ABOVE Actor and entertainer Bob Hope with his wife, Dolores.

successful mission as an opportunity for a gigantic PR coup. Soon after Armstrong had uttered his legendary words—"That's one small step for a man, one giant leap for mankind"—upon emerging from the landing module, Nixon called the astronauts from the Oval Office. The call was broadcast live and watched on television by half a billion people: "As you talk to us from the Sea of Tranquility, it inspires us to redouble our efforts to bring peace and tranquility to Earth. For one priceless moment, in the whole history of man, all the people on this Earth are truly one." Nixon then personally took charge of organizing the celebrations to honor the astronauts, which would otherwise have been the responsibility of NASA (the National Aeronautics and Space Administration), and declared the festivities a state dinner.

White House staff began preparations immediately after the return of the astronauts, who then had to spend three weeks in quarantine. Instead of the customary 140 guests for state dinners, this dinner would have 1,400. And Nixon's choice of venue was the Century Plaza Hotel in Los Angeles, which had been built just three years prior. When the hotel's astonished manager asked why his property had been chosen, Nixon's staff replied that it was "the most beautiful hotel in the world." With its space-age design, it was, indeed, the perfect choice.

The guests included senators, governors, members of Congress, ambassadors from eighty-three countries, NASA's fifty-odd astronauts and engineers such as German Dr. Wernher von Braun, the chief architect of the team that developed the launch vehicles for the Apollo mission. Hollywood stars, singers, and entertainers, including Bob Hope, James Stewart, Tony Martin, and Pat Boone, were also invited. The finest produce from all over the US was ordered for the hors d'oeuvres and dinner menus, with blackberries from Oregon, limestone lettuce from Kentucky, shrimp from Louisiana, and lobsters from Boston. Fine Californian wines would also be served.

On the morning of August 13, the three astronauts and their wives flew in Air Force Two, the vice president's plane, to ticker tape parades in New York City—where crowds were larger than they had been for the victory parades at the end of World War II—and Chicago. They then continued on to Los Angeles, where the processions left them wading through ankle-deep ticker tape. Everyone wanted to see the daring men who had achieved the greatest feast of pioneering since Columbus' voyage to America. It seemed as though anything was now possible—interstellar travel, colonies on other planets, and even contact with extraterrestrial lifeforms.

The gala at the Century Plaza was scheduled for 8:30 p.m., with the guests of honor landing by helicopter in the hotel parking lot about an hour beforehand.

The astronauts barely had time to relax in their suites on the nineteenth floor before being escorted to the ballroom, which measured more than 20,000 sq ft (1900 sq m). Shimmering gold curtains and tablecloths vied with silver candelabra, silver plates, and the finest porcelain for top billing in the dazzle stakes, while tables were strewn with lavish bouquets of roses and chrysanthemums. Flags of all the American states and the United Nations hung from the ceiling. Sitting atop the hors d'oeuvres buffet were giant ice carvings of eagles—the *Eagle* lunar module having been named after the United States' heraldic animal.

A trumpet fanfare rang out as the astronauts entered the room alongside the president and his wife, Pat, dressed in a green, full-length gown covered in sequins that twinkled like stars. The mood among the guests seated at the tables of ten was one of exuberance, for they could finally catch a glimpse of the national heroes. Meanwhile, about 100 journalists followed the goings on from purpose-built boxes, filming or commentating live for radio broadcasts.

The president and his wife sat on an elevated platform at the front of the room, flanked by Armstrong, Aldrin, Collins, and their wives. No sooner had the first course (salmon) been finished than the euphoric Nixon could no longer contain himself on his chair. He said he felt "like a proud father at his son's bar mitzvah," then he linked arms with Armstrong to do a tour of the room with the first man on the moon.

"You must be so tired!" one woman said to Armstrong. "You can be sure of that!" Nixon replied on his behalf. "But he looks terrific!" the woman responded. Wernher von Braun then interjected: "In the nine pressure-filled years of the Apollo program, I've never seen the astronauts look as rested as they do today!"

Between courses—filet of beef Perigourdine with artichokes and Indian-style carrots, followed by limestone lettuce with a selection of French and Italian cheeses— the Marine Band played patriotic pieces interspersed with songs such as *Fly Me to the Moon*, *Moon River*, and *Up, Up and Away*.

Nixon raised a toast to the astronauts. "We thank you for your courage," he said into the microphone. "We thank you for raising our sights, the sights of men and women throughout the world, to a new dimension—the sky is no longer the limit." Buzz Aldrin then stood up, "There are footprints on the moon. Those footprints belong to each and every one of you, to all mankind." And Neil Armstrong followed up by saying, "I was struck this morning in New York by a proudly waved but uncarefully scribbled sign. It said: 'Through you, we touched the moon.' It was our privilege today to touch America."

Nixon awarded the astronauts the Presidential Medal of Freedom, American's highest distinction. The menu's

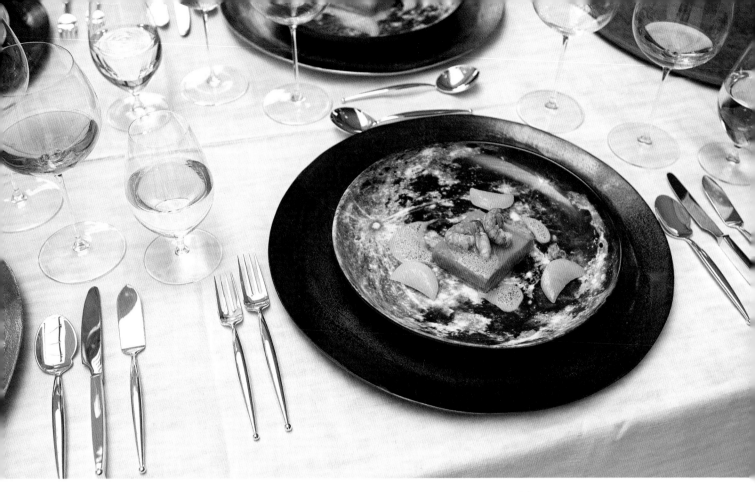

SUPREME OF SALMON COMMODORE, CRAWFISH, AND KOHLRABI Roasted salmon served with crawfish, steamed kohlrabi, and a frothy crawfish sauce.

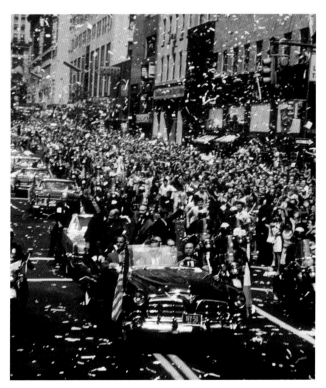

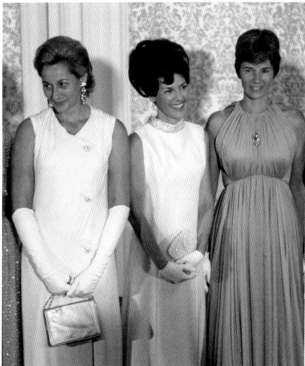

• ABOVE LEFT The triumphal parade in New York City—a bigger celebration than at the end of World War II.
• ABOVE RIGHT The moon-landers' wives (from left): Joan Aldrin, Pat Collins, and Janet Armstrong.

crowning glory was the especially created Clair de Lune dessert made from meringue and ice cream, with a US flag on top. The astronauts didn't leave the room until 2:30 a.m., and Aldrin later joked it was only thanks to the Scotch and adrenalin that they had been able to hold up so long.

The following day, the president's advisors rated the dinner a resounding success, describing it as a "highly emotional and patriotic evening that completely succeeded in meeting all the president's objectives. Well worth all the work." The *Los Angeles Times*, meanwhile, ran the headline of "The Party of the Century." Admittedly, Nixon will likely noy be remembered by his contemporaries for his sense of a great American moment, but rather as the orchestrator of the Watergate scandal, one of the country's darkest chapters in recent history. But that's another story

• CLAIR DE LUNE ICE-CREAM DESSERT WITH MERINGUE AND BLACKBERRY SAUCE "Clair de Lune" translates as "moonlight," and has been used as the title for poems and musical compositions. In 1969, it inspired this dessert consisting of meringues, ice cream, and a blackberry sauce.

Supreme of Salmon Commodore

INGREDIENTS SERVES 4

For the crayfish velouté:

16 crayfish
3 tbsp. / 45 ml white wine vinegar
3 tbsp. coarse kosher salt
3 tbsp. olive oil
1 onion
1 carrot
1 celery
2 garlic cloves
2 tbsp. tomato paste
7 oz. / 200 ml Noilly Prat or other dry white vermouth
1¼ cups / 300 ml dry white wine
1 bay leaf
1 sprig thyme
1 sprig rosemary
5 sprigs tarragon
1 tsp. salt
10 white peppercorns
5 tbsp. / 75 g butter, cold

For the salmon:

3 tbsp. / 45 g butter, softened
4 salmon fillets, about 5½ oz. / 150 g each
salt and pepper
1 kohlrabi
4 chervil tips, to garnish

TIME NEEDED:
1 hour 10 mins.
+ 2 hours cooking

METHOD LEVEL OF DIFFICULTY: DIFFICULT

To prepare the crayfish, fill a large saucepan with water and bring to a boil. Add the white wine vinegar and the kosher salt, then lower the crayfish in batches into the boiling water. Cook the crayfish 3 minutes, then transfer them to a colander and rinse under cold water.

Separate the heads and the pincers from the tails. Using kitchen scissors, cut off the edges of the tails on both sides so the flesh in the tail can be broken out of its shell. Slightly cut open the tail meat in the middle and remove the thin, black intestine. Set the crayfish aside. Use the crayfish carcasses to make the sauce. Heat the olive oil in a large saucepan. Add the shells and slowly fry them.

Meanwhile, peel and chop the onion and peel the carrot. Trim and wash the celery. Cut the carrot and celery into equal-size pieces. Lightly crush the garlic cloves and add to the pan with the onion, carrot, and celery.

Sauté the vegetables about 5 minutes. Add the tomato paste and cook 1 minute longer. Stir in the Noilly Prat and the white wine and bring to a boil.

Pour in enough water to cover the carcasses. Add the herbs and season with salt and pepper. Slowly bring everything to a boil, stirring occasionally. After about 40 minutes, strain the crayfish broth through a cheesecloth-lined strainer, pressing down on the shells with the back of a ladle. Return the strained crayfish broth to the washed pan and boil to reduce to 2 cups / 500 ml.

Heat the oven to 140°F / 60°C (gas and convection ovens not recommended). Line a cookie sheet with parchment paper and spread with 1 tablespoon of the softened butter. Season the salmon fillets with salt and pepper, and place them side by side on the cookie sheet. Spread 1 tablespoon butter on the salmon fillets. Cover the salmon with aluminum foil. Put on the middle shelf in the oven and roast 40 minutes. This cooks the salmon so gently it retains its pale coral color.

Meanwhile, peel the kohlrabi and cut it into 12 wedges, then cut these into half-moon shapes, if liked. Put the kohlrabi wedges or slices and the remaining butter into a sauté pan over medium heat. Add just enough water to cover, season with salt and pepper, and simmer until the kohlrabi is tender, but still firm to the bite, shaking the pan occasionally.

To serve, put half the crayfish broth into another sauté pan or skillet and bring to a boil. Remove the pan from the heat. Add the crayfish, cover the pan, and leave them to heat in the residual heat. Bring the remaining broth to a boil. Dice and add the cold butter, and mix with a handheld mixer until the butter dissolves and the sauce is foamy. Divide the salmon, crayfish, and kohlrabi among plates, drizzle with the foamed crayfish sauce and garnish with chervil, if you like.

RECOMMENDED WINE Then as now, a full-bodied white wine from the California Wente winery is a good match. We suggest an aromatic Morning Fog Chardonnay with its wonderfully exotic fruit aromas.

Filet of Beef Périgourdine

INGREDIENTS SERVES 4

1¼ lb. / 600 g beef tenderloin
salt and pepper
1 tbsp. / 15 g clarified butter
7 tbsp. / 100 ml red port wine
½ cup / 125 ml veal jus
3 tbsp. truffle jus
2 black Périgord truffles
4 artichokes
juice of ½ lemon
1 tbsp. kosher salt
4 baby bunched carrots
3 tbsp. / 45 g butter, cold

TIME NEEDED:
2 hours

METHOD LEVEL OF DIFFICULTY: MEDIUM

Heat the oven to 175°F / 80°C (gas and convection ovens not recommended). Season the beef on all sides with salt and pepper. Melt the clarified butter in a skillet. Add the tenderloin and brown all over, then transfer to a roasting pan. Put the roasting pan on the oven's middle rack and roast about 1½ hours, turning the beef occasionally, until it reaches an internal temperature of 127°F / 53°C.

Meanwhile, add the port wine to the skillet, scrape to loosen the fat sediment, and boil to reduce. Add the veal and truffle jus and simmer 5 minutes over low heat. Clean and halve the truffles, then add them to the sauce. Simmer about 5 minutes, then lift them out of the sauce and set aside.

Using a serrated knife, cut off each artichoke stem just below the bottom and the outer leaves directly above the bottom. Make sure you don't cut too deeply, so you do not accidentally cut off parts of the bottoms. Using a small, sharp paring knife, free the bottoms from all woody parts at the stem end. Place the cleaned artichoke bottoms immediately into a bowl of cold water with half the lemon juice.

Once all the artichokes are trimmed, bring a saucepan of water with the remaining lemon juice and the salt to a boil. Add the artichoke bottoms, reduce the heat, and simmer about 15 minutes, or until they are tender (check with a knife). Rinse the artichoke bottoms under cold water, then, using a small spoon, scrape out the hairy choke from the middle of each. Rinse the artichoke bottoms again and pat them dry, then cut them into slices or wedges. Set aside until ready to serve.

Peel and wash the carrots, then cut them lengthwise into thin strips. Place the carrots in a sauté pan over medium heat with just enough water to cover. Add 1 tablespoon / 15 g butter, season with salt and pepper, and simmer until tender, but still firm to the bite.

Once the beef has reached the correct temperature, wrap it in aluminum foil and leave to rest 5 minutes.

To serve, add the artichokes to the carrots and heat through. Reheat the truffle sauce. Dice the remaining butter, add to the sauce, and stir in with a small whisk—make sure you always stir in the same direction, because this makes it easier for the butter and the sauce to emulsify and bind; if you don't, the butter will separate from the sauce. Return the truffles to the sauce and warm through without boiling. Slice the beef and arrange on plates. Arrange the vegetables around the meat.

RECOMMENDED WINE This culinary highlight demands to be partnered by an appropriate wine. We think the perfect match would be a Cask Cabernet Sauvignon by Inglenook, movie director Francis Ford Coppola's vineyard. Notes of licorice and berry fruits, plus spices—a magnificent combination!

Clair de Lune

INGREDIENTS SERVES 4

1 medium egg white
a dash lemon juice
½ cup / 60 g unsifted
 confectioners' sugar
2 cups / 300 g blackberries
¼ cup / 50 g granulated
 sugar
14 oz. / 400 g vanilla ice
 cream
3 tbsp. / 5 g finely chopped
 candied lemon zest,
 optional

TIME NEEDED:
40 mins. + 35 mins. drying
+ 5 mins. cooking + freezing

METHOD LEVEL OF DIFFICULTY: MEDIUM

Heat the oven to 212°F / 100°C (gas ovens not recommended; convection ovens 176°F / 80°C). Using a handheld mixer, beat the egg white and lemon juice on the highest speed until stiff. Add the confectioners' sugar and continue beating until the sugar dissolves.

Transfer the egg-white mixture to a cookie sheet lined with parchment paper, and spread evenly onto the paper about 2 mm thick, using a wet metal spatula. Small bumps are desirable—they evoke the crater landscape on the moon. Using a round cookie cutter (4 in. / 10 cm diameter), mark circles next to each other on the meringue's surface, then trace the circles along the cutter once with your finger.

Put the cookie sheet on the middle rack in the oven and bake about 35 minutes to dry. The meringues should not take on any coloring; reduce the heat if necessary. As soon as the meringues are dry, remove the cookie sheet from the oven. Using a metal spatula, carefully lift the "moons" off the paper—they will easily break! Finely crumb the meringue remains around the moons.

Wash and drain the blackberries, then halve them. In a saucepan, bring the berries and the sugar to a boil. Remove the pan from the heat and leave the mixture to cool a little, then puree everything. Push the sauce through a strainer. Transfer the puree to the washed pan, cook to reduce a little, then leave to cool. Chill until ready to use.

Line a cookie sheet with parchment paper. Using a round cookie cutter, about 2½ in. / 6 cm wide, shape four "pedestals" from the vanilla ice cream. Transfer them to the cookie sheet and place into the freezer. Put the serving plates into the refrigerator to chill. It is important that the ice cream is thoroughly frozen when you are ready to serve. To serve, brush the fruit sauce onto the cold plates. Transfer one vanilla ice cream pedestal on each plate and place a meringue "moon" on top of it. Sprinkle the meringue crumbs and the candied lemon zest like stars on the sauce, if you like. Serve immediately.

RECOMMENDED WINE Of course you can drink a champagne with this dish—not too dry! We, however, suggest something rather special: the spicy raspberry red Sparkling Rouge de Noirs by the Schug Carneros Estate Winery, in Sonoma, California.

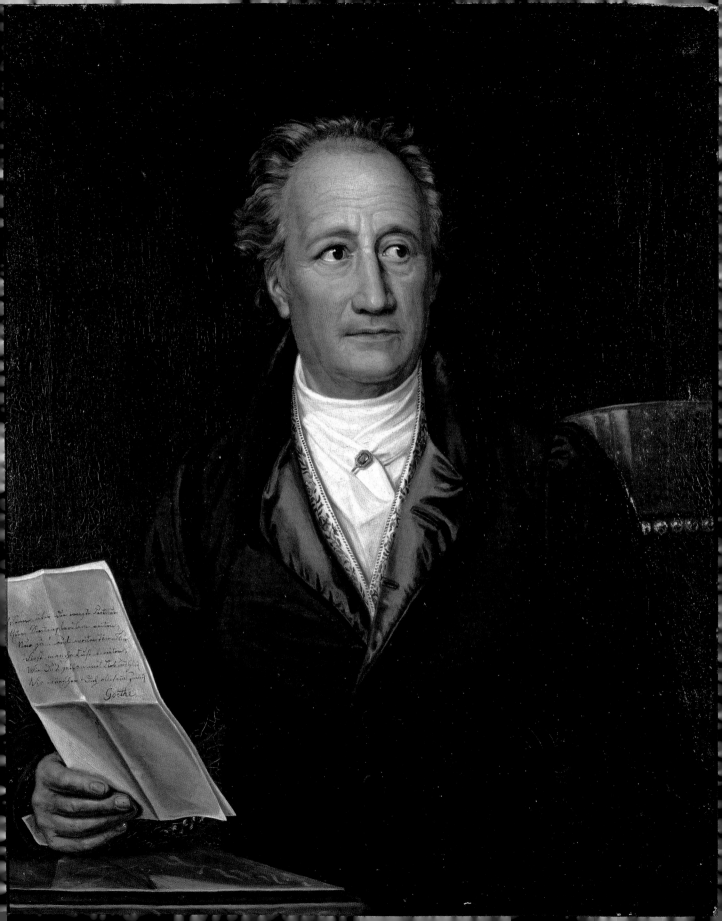

Johann Wolfgang von Goethe

A WILD FLIRTATION

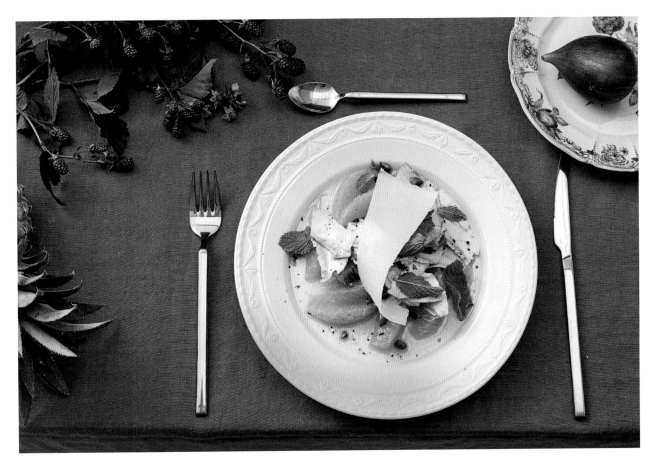

The writer spent the summer of 1815 in Frankfurt,
the city of his birth, where his admirer, Marianne von Willemer,
threw an illustrious party for his birthday. Inspired by Persian
lyrical poetry—Goethe was writing his *West-Eastern Divan*
collection of poems at the time—the festivities took on
a similarly Oriental feel.

- OPPOSITE Johann Wolfgang von Goethe was a passionate gourmet.
- ABOVE: FIRST COURSE: ARTICHOKE & ORANGE SALAD The birthday party guests would have enjoyed kicking off with
a light salad similar to the one we have created with shaved artichokes, served with orange slices, mint leaves, and olive oil.

Frankfurt, August 28, 1815: The writer had barely risen on the morning of his sixty-sixth birthday when he heard music coming through his window. A band was playing on a raft in the Main River that flowed just below. He grimaced: Would he have to endure a serenade by two-bit city musicians? Johann Wolfgang von Goethe could breathe a sigh of relief, however. It turned out his host, Marianne von Willemer, had called in the illustrious Frankfurt Theater Orchestra, and the birthday boy was so thrilled with their performance he sent his butler over with a ducat (a gold coin used for currency at the time) for the conductor. Somewhat offended, the proud bandmaster returned the coin—a small faux pas that fortunately ended up being the only note of discord that day.

For von Willemer had planned Goethe's birthday celebrations meticulously. After all, she had one of the nation's greatest stars staying in her home in the old tanner's mill on the shores of the Main. The author of such bestsellers as *The Sorrows of Young Werther* and *Wilhelm Meister's Apprenticeship* could, indeed, barely take a step without being accosted by admirers. Marianne's husband, Johann Jakob von Willemer, a successful Frankfurt banker and art lover, had been a good friend of Goethe's since childhood.

Goethe had been visiting the Willemers, who lived on the outskirts of the city he had grown up in, for two weeks. He spent his time going for walks, during which he took notes of unusual cloud formations or interesting plants, and cut off sprigs for himself with his pocketknife. He had brought his own wine with him, which he drank every morning out of a silver goblet. In the evening, he would appear in his white flannel smoking jacket, and encourage his hostess to sing.

That particular summer, he was working on his *West-Eastern Divan* collection of poems, inspired by Persian lyrical poetry. As such, both Goethe himself and his entire circle of friends were caught up in an "Oriental fever" of sorts. The summerhouse in which the party was to be held had been suitably decorated by Marianne von Willemer, who had used bunches of reeds to imitate palm trees, and scattered exotic flowers and fruit, such as dates, figs, and oranges. She was determined to give the writer the best birthday of his life.

There was a reason for her ambitions. Although only recently married, the temperamental young lady with dark curls (who had already been pursued by the Romantic poet and writer Clemens von Brentano) was head over heels in love with Goethe, thirty-five years her senior. Goethe reciprocated the feelings of the humorous Marianne, who joked about being "as tall as she was wide." While Christiane, the writer's wife, was at home in Weimar, some fierce flirtation had developed between the pair—right in front of Johann Jakob's eyes.

In planning the party, Marianne likely also wanted to demonstrate she was not at all inferior to Goethe, who was himself a passionate host. His house on the Frauenplan in Weimar was considered the most hospitable in the city. Every day, it was visited not only by members of the regional elite, but also by scholars, politicians, and artists from all over Germany, all of whom were liberally regaled at his dinner table. The rooms of his house were painted in well-harmonizing colors: The large room where he and

• ABOVE LEFT The Urbino Room was where Goethe received his guests; the room was named after the painting depicting the Italian Duke of Urbino.

• ABOVE RIGHT Marianne von Willemer fell in love with Goethe. The celebrated writer also liked the humorous young woman: A flirtation developed into intense written correspondence.

• ABOVE A soirée with Duchess Anna Amalia and Goethe (third from left).
• BELOW Celebrating with a view of the Main River. Today a restaurant, the one-time tanner's mill was, in Goethe's day, home to the banker Johann Jakob von Willemer and his wife, Marianne, who organized the birthday party for their guest of honor.

• Goethe had been married to his long-time love, Christiane Vulpius, since 1806. Her health deteriorated in 1815, when she suffered a stroke. She died in 1816 at the age of fifty-one.

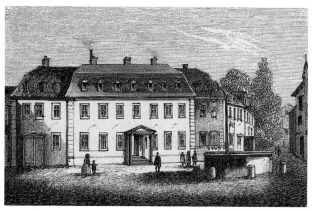

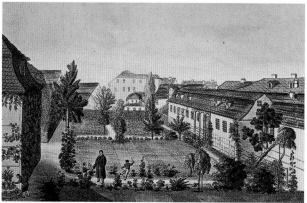

• TOP Goethe's townhouse on the Frauenplan in Weimar.
• ABOVE The writer's garden, where he grew vegetables that he then often sent to friends.

• OPPOSITE: INTERMEDIATE COURSE: QUAIL CONSOMMÉ WITH CARROTS, CELERY, AND GINGER A rich broth flavored with soy sauce and sherry, served with tender, lightly roasted quail breast

his guests dined was a resplendent sunny yellow, while the smaller family dining room was green. He loved thinking up new ways of making his table a place of intellectually stimulating conversation, and songs were often sung between courses. He also encouraged guests to present poems, songs, or reports of scientific experiments.

He once served a pot of rare plants as a "first course" to get people talking, and he had aristocrats mingling with commoners—an utterly novel concept in table etiquette, given the rules of the royal court stipulated seating guests strictly according to their hierarchical rank. Goethe, a frequent visitor to the palace of the reigning duke, a close friend, flouted those rules in his own home without hesitation, seating people based on whether he thought they would have something to talk about. He applied the same principle when assigning seats to women—whose seating position would otherwise be determined by their husbands' social rank. The liberal Weimar society adopted the innovations with enthusiasm.

The vibe at the tanner's mill was to be similarly free and easy. A magnificent basket of select fruit, including dates, figs, pineapples, oranges, and grapes, awaited the celebrant for breakfast in the bright sunshine. The guests arrived later, and almost all were friends of the Frankfurt-born writer: art collector Sulpiz Boisserée, jurist Fritz Schlosser, former schoolmate Johann Jacob Riese, physicist Thomas Seebeck, and influential Frankfurt banker's wife Susanna Elisabeth Bethmann-Hollweg. Willemer's daughters Anna Städel and Meline Scharff, with the latter's husband, were also invited. Gifts were presented: Sulpiz Boisserée had composed verses, apologizing they were the first he had ever written. "Well, the ideas are good, the rest will come," was Goethe's verdict. Anna Städel, a successful painter, gave him a picture she had painted of the view from his room at the tanner's mill. From Marianne, he received knitted slippers and a turban made from Indian muslin and garlanded with laurel. She playfully placed it on his head, uttering the words "Come, dearest, come, wind round my brow this band! Thy fingers only make the turban fair"—a quote from the Divan. The ladies at the table also wore turbans..

Before everyone picked up their knives and forks, however, the master of the house, Willemer, gave a speech for his honored guest, and toasted his health. A Rhine wine from Goethe's year of birth was served. What did they eat? We know only that there were "exotic dishes"—probably an Oriental-inspired menu. The hostess undoubtedly took her friend's tastes into account; Goethe the gourmet loved fresh, seasonal food. "Give me the finest dishes, choice and rare, in their right month, and carefully prepared," he wrote in Part Two of Faust. He liked fruit and vegetables to be perfectly ripe and never overcooked. At home, he would

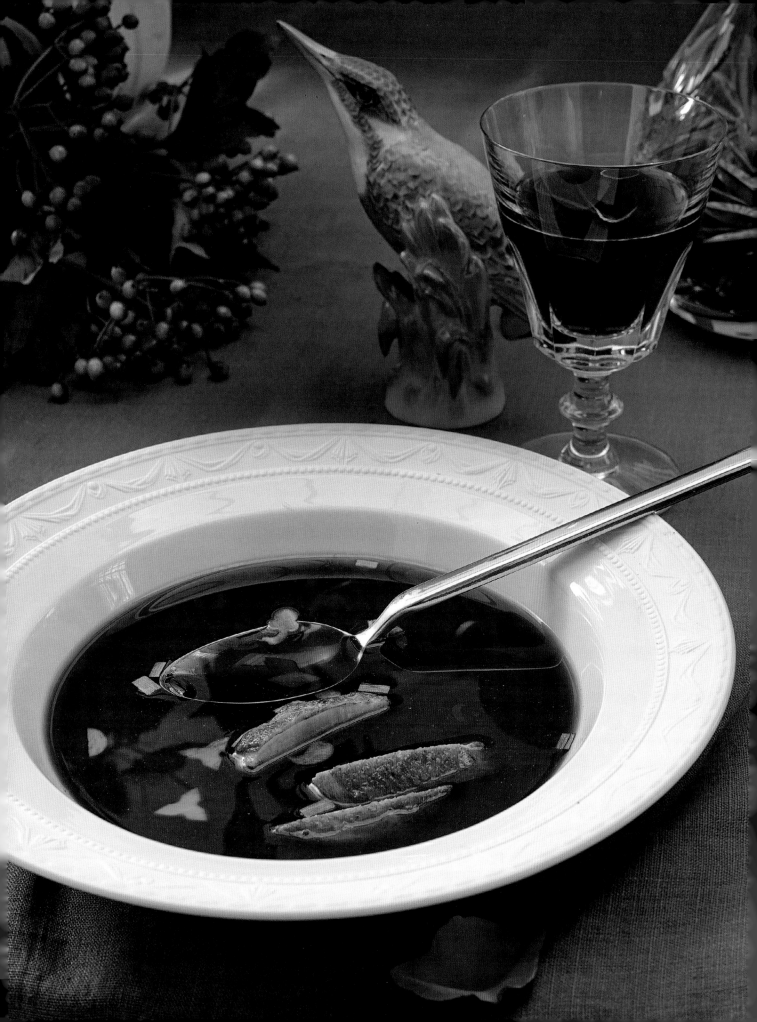

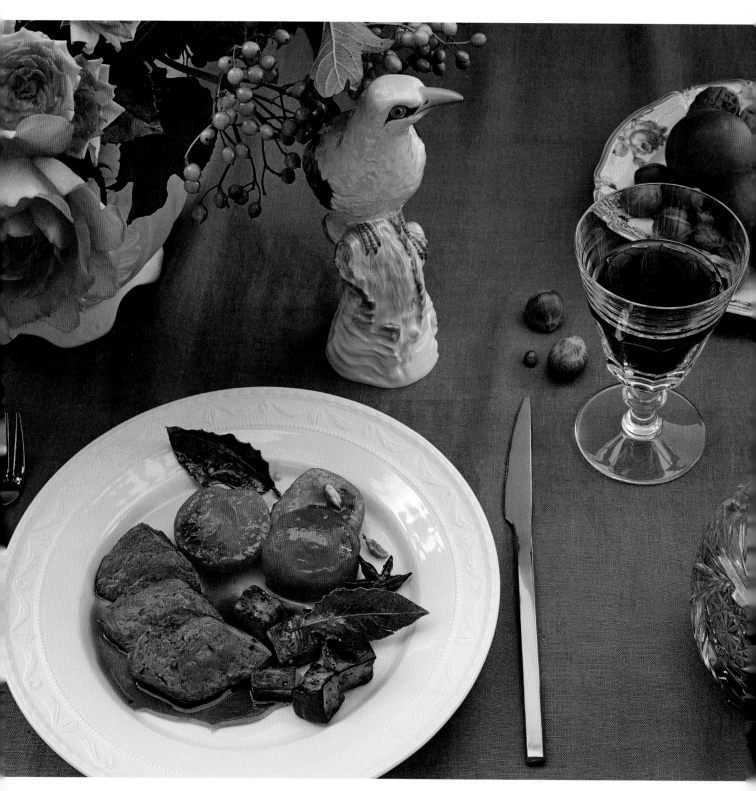

• MAIN COURSE: SADDLE OF VENISON WITH VENISON SAUCE, SERVED WITH EGGPLANT AND TOMATOES Fillets of venison with a sauce made from broth, butter, onions, port wine, and red wine; apricots steamed in honey and orange juice for a sweet touch.

eat salad, salted with anchovies, which he prepared at the table, using lemon juice and olive oil from Provence. He was always aware of how things were going in his vegetable garden, with friends in Weimar sending him greetings in the form of personally cut asparagus, his favorite vegetable. He never forgot his Frankfurt culinary roots, and had his mother send him of his favorite local delicacies, such as chestnuts or *pfeffernüsse* (peppernuts; small, spicy cookies), until her death.

There is no doubt the dishes served at Goethe's birthday party at the tanner's mill would have been of top quality—the vegetables freshly picked, the game recently shot, and the more unusual ingredients purchased from the city's best traders. People dined, chatted, and laughed in the summerhouse until the sun went down. "The mood among the small group was one of cheer and friendliness," Boisserée later noted. After the meal, Marianne, a trained singer, played self-composed melodies to Goethe's ballads on the guitar. One such ballad was "The God and the Bayadere," the story of an Indian temple servant who follows her lover into death by fire. Later came the highlight of the party: the master giving a reading from *West-Eastern Divan*.

The next day, the writer discovered he had enjoyed a little too much of his birth year Rhine wine. Dreadfully hungover, he henceforth only consumed lighter wines, particularly the Bacharach variety, which he rated very highly. About two weeks later, Goethe left the tanner's mill to travel onward.

He kept up a passionate written correspondence with Marianne—an erotically lyrical dialog in which he played the role of Hatem from the Divan, and she Suleika. As a result, several of Marianne's poems found their way into the famous collection. The tone of the letters later became a purely friendly one. From then on, Marianne fed Goethe at both a literary and culinary level, perpetuating the tradition of his deceased mother by sending Frankfurt specialties to his Weimar home. Even just before his death at age eighty-two, he received a delivery of chestnuts and brawn from the tanner's mill.

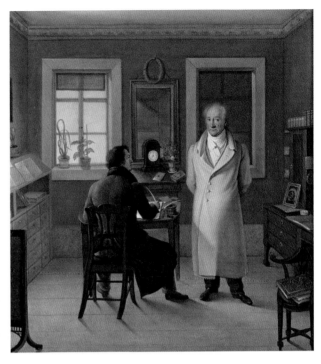

• ABOVE Goethe in his study with his secretary, John.
• BELOW The first edition of Goethe's extensive *West-Eastern Divan* collection of poems from 1819; some of the poems emerged during his correspondence with Marianne von Willemer.

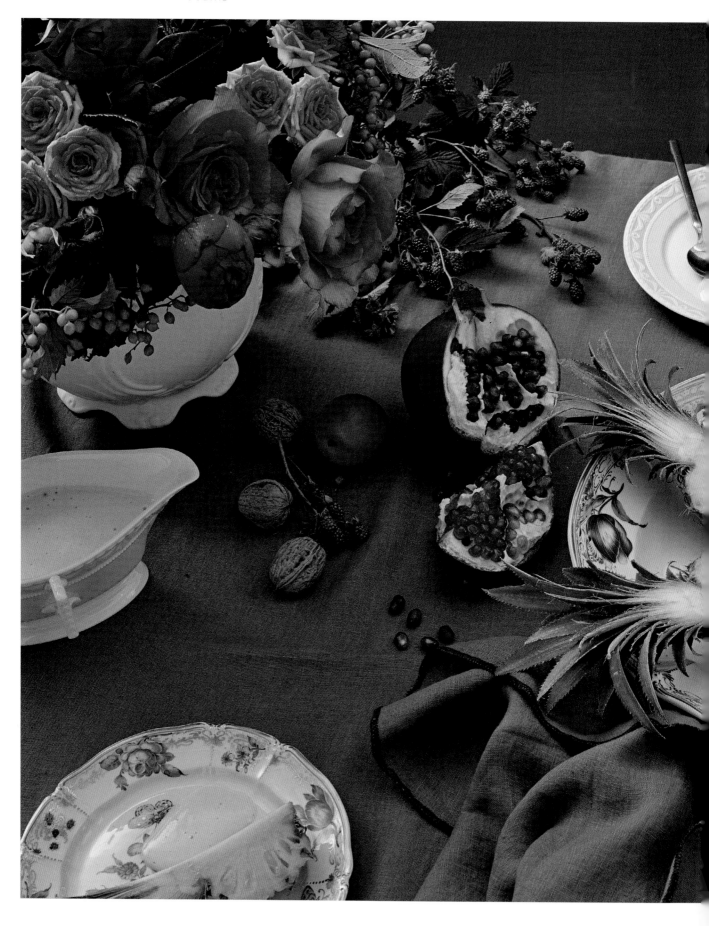

• LEFT: FRUIT IN ZABAGLIONE
Goethe's birthday celebrations
started off right from breakfast,
when he was treated to a lavish
basket of exotic fruit. The feast
also followed an Oriental theme,
with fresh figs, pineapples,
oranges, and dates.

Artichoke and Orange Salad

INGREDIENTS SERVES 4
juice of 2–3 lemons
salt and pepper
3 large oranges
4 large artichokes
3 handfuls mint leaves
4 tbsp. shelled pistachio
* nuts*
½–⅔ cup / 125–150 ml
* good-quality olive oil*
3 oz. / 75 g Parmesan cheese

TIME NEEDED:
40 mins.

METHOD LEVEL OF DIFFICULTY: MEDIUM

Put the juice of 2 lemons and a little salt and pepper into a salad bowl. Peel the oranges with a knife, so the white pith is also removed. Using a sharp knife, cut out the orange segments between the membranes, catching the juice. Add the juice to the lemon juice. Set aside the orange segments.

To trim the artichokes, one by one, remove all the leaves and woody parts with a sharp knife, so the only thing left is the artichoke heart. Scrape out the hairy choke with a teaspoon. Immediately halve each artichoke heart, rinse under cold water, and, using a mandolin or fine vegetable slicer, cut paper-thin slices directly into the bowl with the lemon juice.

Wash and spin-dry the mint leaves, then coarsely chop or leave whole, if preferred. Coarsely chop the pistachios.

Combine the orange segments, mint leaves, pistachios, and olive oil with the artichokes. Possibly add a little more lemon juice.

Cut 4 thin lengthwise slices from the Parmesan, if liked, and set aside. Shave the remaining Parmesan into small, thin slices.

Just before serving, fold the small Parmesan slices into the salad and divide the salad among four plates. Garnish with the large Parmesan slices.

RECOMMENDED WINE Goethe would have enjoyed his much-loved wine from the Würzburger Stein vineyard; with this dish probably a Sylvaner, rather than a Riesling. Both wines are still available today, for example, from the amazing Juliusspital Foundation in Würzburg.

Quail Consommé

INGREDIENTS SERVES 4
2 quail
2 tbsp. sunflower oil
1½ oz. /50 g onion
1½ oz. / 50 g celery root
1½ oz. / 50 g carrot
1½ oz. / 50 g leek
5 black peppercorns
¾ in. / 2 cm piece cinnamon
* stick*
1 star anise
1 thin slice gingerroot
3–4 tbsp. soy sauce
2 egg whites, optional
salt and pepper
4 tbsp. peeled and
* decoratively sliced or*
* finely diced carrots, to*
* garnish*
1 tbsp. finely snipped chives,
* to garnish*

TIME NEEDED:
55 mins. + 1 hour 15 mins.
cooking

METHOD LEVEL OF DIFFICULTY: MEDIUM

Heat the oven to 475°F / 240°C (Gas 9; convection ovens 450°F / 220°C). Separate the quail breasts and legs from the bones. Wrap the breasts in plastic wrap and chill until just before serving.

Using poultry scissors, chop the quail carcasses and legs. Brush a baking tray with 1 tablespoon oil, place the quail carcasses and legs on top and roast about 5 minutes. Peel and halve the onion, wash the celery, carrot, and leek, and cut each into large chunks. Add the vegetables to the bones and roast 15–25 minutes longer until everything has started browning. Transfer everything to a saucepan and cover with 2 quarts / 2 liters cold water.

Crush the peppercorns and add to the pan with the cinnamon, star anise, ginger, and 3 table-spoons of the soy sauce. Bring to a boil, then reduce the heat and simmer about 1 hour until reduced about half. Carefully strain the broth through a cheesecloth-lined strainer. You should get about 1 quart / 1 liter quail broth.

If you are after a crystal-clear broth, whisk together the egg whites and 7 tablespoons /100 ml water in a large bowl. Bring the broth to a boil, then slowly pour it into the bowl with the egg whites, whisking all the time. Return the mixture to the pan and slowly return it to a boil. Do not stir too vigorously, but make sure the egg whites don't stick to the bottom of the pan. Bring to a rolling boil once, or until the egg whites have bound all the cloudiness. Take the pan off the heat and leave to rest 10 minutes. Strain the broth through a strainer with the well-rinsed piece of cheesecloth, then season to taste with soy sauce.

Just before serving, heat the remaining oil in a large skillet and quickly fry the quail breasts, skin sides down. Season with salt and pepper, then cut into thin slices. Also just before serving, reheat the consommé. Add the carrot garnish and bring to a boil. Transfer the consommé to soup bowls. Add the quail breasts and sprinkle with snipped chives.

RECOMMENDED WINE This is where Goethe's passion for his home country's Rhine wine comes into play: A Riesling Spätlese would probably have been his choice to partner the strong aromas of the consommé.

Saddle of Venison with Eggplant and Apricots

INGREDIENTS SERVES 4

1 lb. 12 oz. / 800 g boneless saddle of venison
7 oz. / 200 g venison trimmings (from the butcher or a hunter)
1 tbsp. clarified butter
1 onion
1 tsp. all-purpose flour
7 oz. / 200 ml red port wine
7 oz. / 200 ml dry red wine
1¾ cups / 400 ml venison broth (ideally made from the venison bones), or game broth
1 eggplant, about 14 oz. / 400 g
salt and pepper
6 tbsp. olive oil
8 apricots
2 tbsp. / 30 g butter + 1 tbsp. / 15 g cold butter for the sauce
1–2 tbsp. honey
2 bay leaves
juice of 1 orange

TIME NEEDED:
45 mins. + 1 hour 15 mins. cooking

METHOD LEVEL OF DIFFICULTY: MEDIUM

Remove the sinews and membranes from the venison; reserve any trimmings for making the sauce. Wrap the meat in plastic wrap.

To make the sauce, melt the clarified butter in a saucepan over high heat. Add the offcuts and fry. Peel and thinly slice the onion and add to the pan. As soon as the onion starts to brown, dust the mixture with the flour and briefly fry it. Pour in the port wine and cook until it has almost boiled away. Add the red wine and also let it almost boil away. Add the venison broth and boil to reduce to half, then strain the sauce through a fine strainer. Return it to the rinsed pan and boil again until it reaches the desired consistency.

About 20 minutes before serving, heat the oven to 350°F / 180°C (Gas 4; convection ovens 325°F / 160°C). Wash and trim the eggplant, then cut it into ¾ in. / 2 cm dice. Sprinkle with salt and leave to stand 10 minutes, then rinse and pat dry with paper towels. Heat the olive oil in a wide skillet over medium heat. Add the eggplant and fry, stirring, until lightly browned all over. Season with pepper and keep warm.

Meanwhile, wash and halve the apricots, remove the pits. Melt 1 tablespoon butter with the honey and the bay leaves in a skillet over medium heat. Add the apricots and the orange juice and sauté until the apricots are tender and the liquid has cooked down to a creamy consistency; add a dash of water if it is too dry.

Season the saddle of venison with salt and pepper. Melt 1 tablespoon butter in an ovenproof skillet over medium heat. Add the venison and fry about 3 minutes on both sides. Place the skillet with the venison in the hot oven 3–5 minutes. Take the venison out of the skillet, cover with aluminum foil, and leave to rest 5 minutes.

Meanwhile, heat the venison sauce in a small saucepan. Take it off the heat and use a small whisk to whisk the butter into the sauce—only stir in one direction to get the best emulsion.

To serve, divide the eggplant and apricots among four plates. Slice the venison, place it on the plates, and spoon the venison sauce over.

RECOMMENDED WINE The great poet never spurned an elegant and complex Burgundy—he would certainly have chosen a particularly fruity and spicy one to go with this red meat dish.

Fruit in Zabaglione

INGREDIENTS SERVES 4

2 baby pineapples
8 ripe figs
½ cup / 125 ml sweet white wine
3 egg yolks
3 tbsp. granulated sugar
a dash lemon juice

TIME NEEDED:
30 mins.

METHOD LEVEL OF DIFFICULTY: MEDIUM

Quarter the baby pineapples. Using a sharp knife, cut the flesh away from the skin, then cut it into bite-size slices. Return the slices to the pineapple skin. Wash and halve the figs.

To make the zabaglione, bring the white wine to a boil in a small saucepan, then take the pan off the heat. In a heatproof bowl, whisk together the egg yolks, sugar, and lemon juice, then transfer to a hot water bath. Whisking constantly, slowly pour the white wine into the egg yolks and beat. As soon as the zabaglione starts to thicken, transfer the bowl to a cold water bath and continue beating until the sauce is cool. Set the sauce aside until you are ready to serve.

To serve, place the fruit on a large platter or four plates and serve with the zabaglione spooned over.

RECOMMENDED WINE As a crowning finish and to accompany the fruits, this illustrious group would probably have chosen a fruity champagne, one that's not too dry, of course!

Truman Capote

BLACK
ON WHITE

It was to be the party of the century, and the author and
darling of New York City's high society revised the guest list
as if it were one of his novels. The evening in November 1966
began with private dinner parties across Manhattan, after
which the 500 stars of film, art, and politics headed to Truman
Capote's Black and White Ball at the city's iconic Plaza Hotel.

• OPPOSITE: A TANGY START: ORANGE & GRENADINE APERITIF SPICED WITH CAYENNE PEPPER, SERVED
ON CRUSHED ICE A refreshing palate-stimulant made from fresh orange juice, sweet grenadine, and crushed
ice, served with crisp fans would doubtless have pleased the New Yorkers on Capote's exclusive guest list.
• ABOVE The writer welcoming guests to his Black and White Ball at New York's Plaza Hotel. Capote referred
to his high-society female friends as "swans." He was their go-to person when it came to discussing society
gossip, and knew all their secrets.

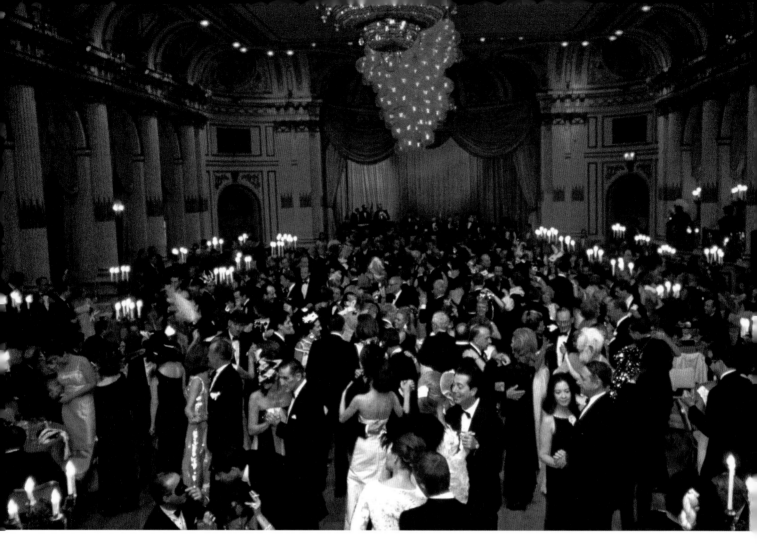

The king of the ball didn't dance. Truman Capote stood on the sidelines and watched the proceedings, a secretive Mona Lisa smile on his face. The large ballroom at New York's Plaza Hotel was buzzing with the band's catchy jazz tunes, the laughter of the some 500 guests, and the clinking of glasses filled with Taittinger champagne. Capote had called, and they had all come: New York's eternal star, Frank Sinatra; Hollywood greats included Mia Farrow and Shirley MacLaine; among his writer colleagues were Tennessee Williams and Norman Mailer; there were artists such as Andy Warhol; wealthy families like the Rockefellers; car manufacturer Henry Ford II; and even Theodore Roosevelt's 82-year-old daughter, Alice Longworth. Showbiz glamour, art, politics, and business all came together that night in November at Capote's Black and White Ball to—as the host himself put it—celebrate the party of the century. The dress code? Black and white, of course.

For years, the rich and famous had been hobnobbing with the star of the literary scene, who had managed to become one of them despite not having any notable wealth of his own. During the prudish 1950s, readers had found a new voice in Capote; a voice with open homosexual undertones—written by a young man who allowed himself to be photographed in scandalously lascivious poses, and who made style a religion. Within three years after publication of *Breakfast at Tiffany's* (1958), his

• TOP November 28, 1966, was a rainy Monday in Manhattan. Hundreds of curious onlookers applauded the arriving guests, while photographers and cameramen thronged the Plaza Hotel lobby. Capote only asked very few ladies to dance, preferring to admire his creation from the edge of the dance floor.
• OPPOSITE: PARTY SNACKS, A LITTLE SUPPLEMENT TO THE DINNER, OR SOMETHING FOR IN-BETWEEN While we don't know what was served at the private dinner parties earlier in the evening, we drew inspiration from the New Yorkers' style to create a light and simple menu (clockwise from top left): Grapefruit Salad with Onions and Radish, Oysters Rockefeller, small bowls of Chilled Avocado Cream Soup, Scandinavian-style Meatballs, and Scrambled Eggs with Anchovy Crumbs.

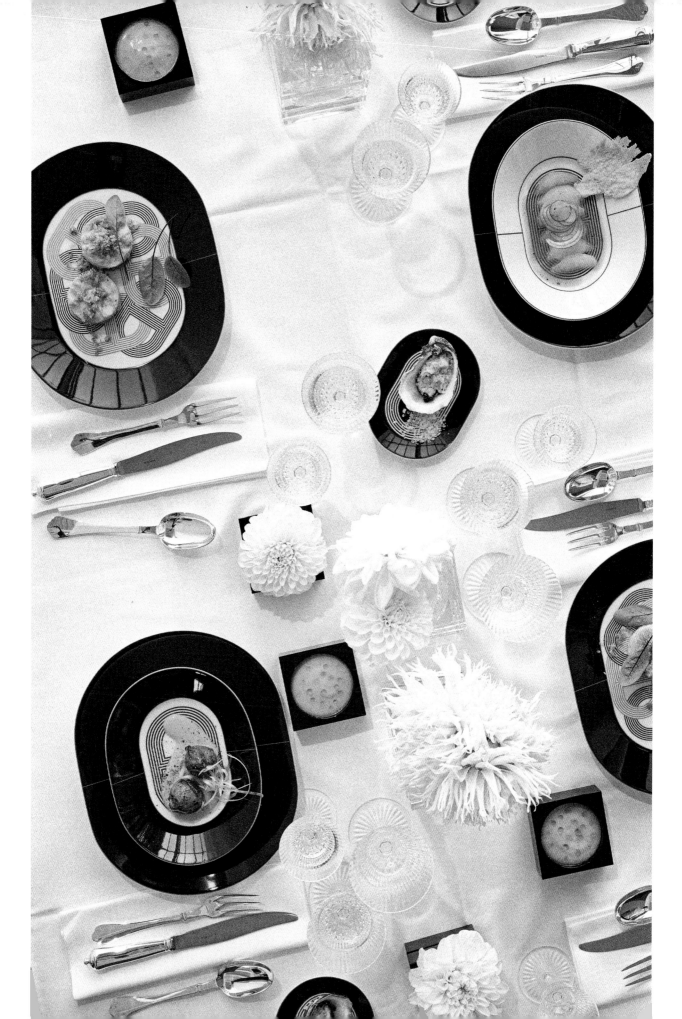

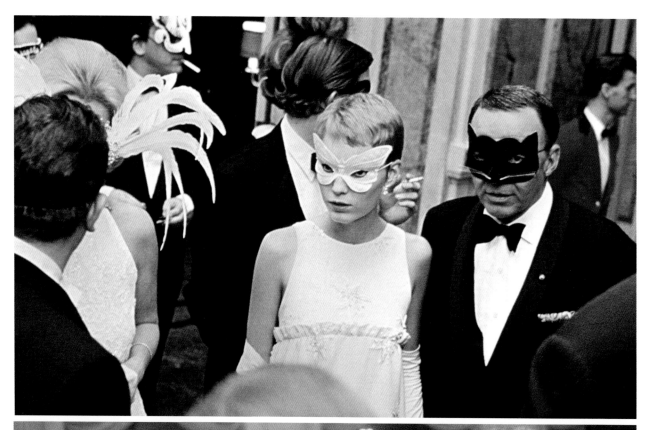

• TOP The then newly married Mia Farrow and Frank Sinatra were among the ball's illustrious guests.
CBS even set up a studio at the Plaza Hotel to report live from the party.
• ABOVE Actress Candice Bergen removed her mink bunny mask while dancing.

global bestseller, it was made into a movie starring Audrey Hepburn. Truman—who spent a lonely childhood with relatives in what he considered to be the tiny godforsaken town of Monroeville, Alabama—had long found himself surrounded by adoring women from the New York jet set, including millionaire heiress Gloria Vanderbilt and the beautiful Marella Agnelli, married to the Fiat empire heir. The little man with the high-pitched voice referred to these elegant, unconventional lady-friends, who often towered over him, as his "swans." It was with them that he indulged in his passion: gossiping. They loved him for his good listening skills and his clever, original ideas. He would soon know all their secrets.

By hosting his ball, Capote sought to finally cement his place among New York's elite. In the summer of 1966, he was never seen without his trusty notebook, whose pages were packed full of names. He honed his guest list incessantly, deleting some people, adding new ones, and moving his imaginary guests around like pawns on a chessboard in a bid to find the most thrilling, glamorous mix. Who made it onto the list? That was top secret! But one thing was abundantly clear to America's elite circles: Not being invited to the party was akin to social ruin. Truman further dialed up the suspense by tantalizing friends and acquaintances with comments such as "You might be invited, you might not be!" The first invitations were sent out in early October, sparking black-and-white fever across Manhattan.

It was pouring with rain when, at 10 p.m. on Monday, November 28, the first limousines pulled up outside the Plaza Hotel. Hundreds of curious onlookers applauded the arriving guests, and the lobby heaved with photographers and flashing cameras. And they weren't disappointed. Fashion designer Oscar de la Renta and his wife were wearing surrealist cats' heads, while actress Candice Bergen debuted a white bunny mask with mink ears. Interior decorator Billy Baldwin hid his face behind a silvery unicorn head, and ketchup millionaire Henry J. Heinz opted for a provocative understatement by making his own mask from a paper plate.

Capote similarly countered the expensive, custom creations worn by most guests with a simple black eye mask, bought for thirty-nine cents the previous day. He and his guest of honor, newspaper publisher Katharine Graham (Kay to close friends), waited in the ballroom to greet the guests. One hundred and fifty balloons hung from the ceiling. The table settings were scarlet red, and candles flickered in large silver candelabras. A footman called out the

names of those arriving, the band's rhythms steering them virtually straight to the dance floor. Capote, however, only danced with a handful of women, preferring to go from table to table, exclaiming "Aren't we having a wonderful night?" Standing on the edge of the dance floor, he watched his creation bear fruit: John Kenneth Galbraith, one of the world's most influential economists as well as a gangly beanpole, discovering soul music, awkwardly, but enthusiastically, swinging his arms and legs around; the ethereally beautiful wife of the Maharaja of Jaipur sashaying through the black-and-white crowd in her striking gold sari; notorious bad boy Norman Mailer arguing with the president's security advisor over the Vietnam War; the dancers making way for Lauren Bacall and her dance partner to do a waltz; and, later, some of the merry guests squealing away as they played tag with Galbraith's hat.

At midnight, the waiters opened the country-style buffet, which consisted of the Plaza Hotel's famous chicken fricassee (a calorie bomb containing hollandaise sauce, sherry, and cream), spaghetti Bolognese, sausages, and scrambled eggs with anchovy crumbs. Too excited by the occasion, Capote hardly ate a morsel.

The following day, flowers and effusive thank-you notes came pouring into the host's hotel room. He'd done it: His ball would fill the gossip columns of America's newspapers for months. And the evening was from then on be hailed as the benchmark for New York's social scene.

As ambitiously as he had worked on becoming the king of the jet set, however, Capote was soon just as assiduously biting the bejeweled hand that had fed him. He had long been planning to write a great society novel, providing a look behind the façades of the rich and famous. Esquire published some initial excerpts in 1975, exposing

• RIGHT The heroes of the party: Truman Capote (left) with writer and notorious New York bad boy, Norman Mailer.

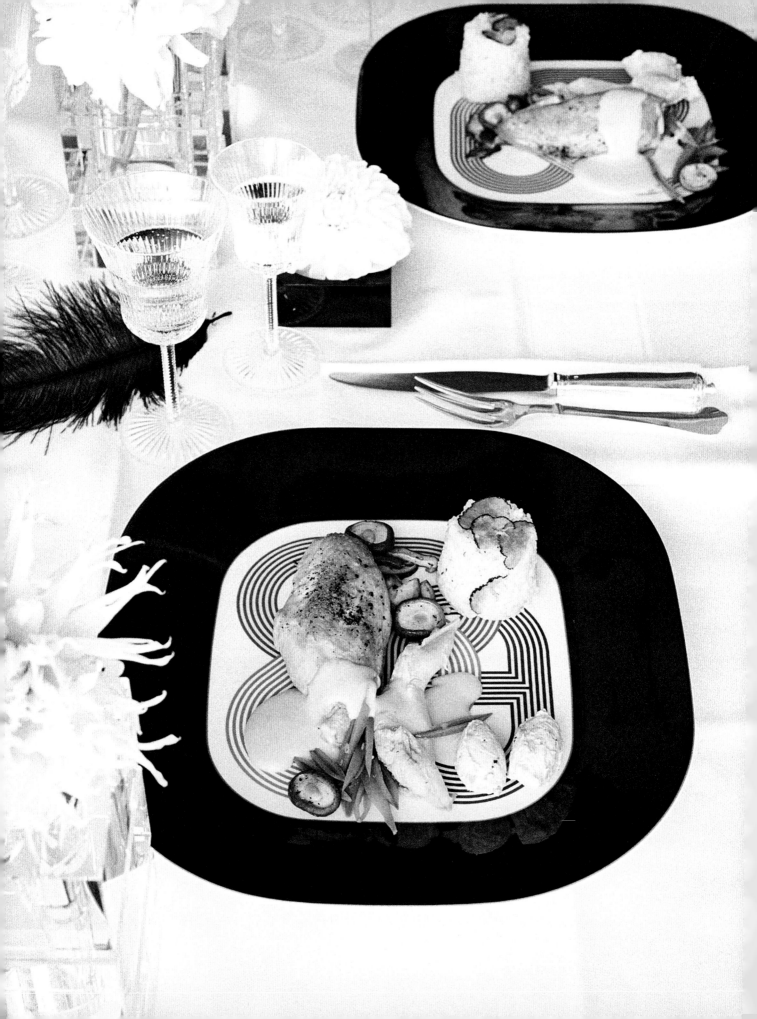

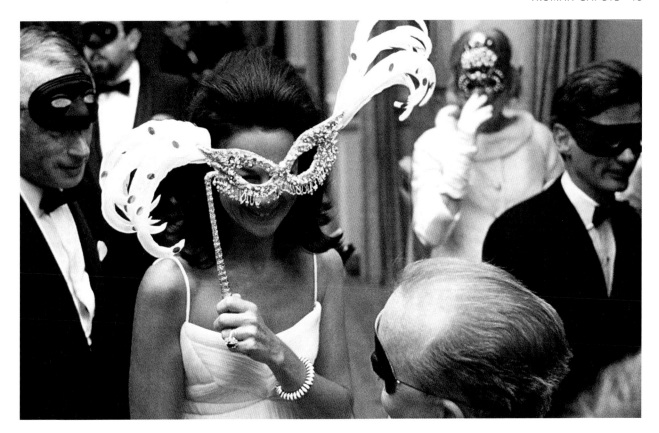

the secrets of his closest acquaintances, effectively uncut, to the world. He considered it art. But for his "swans" and everyone else, it was the height of betrayal. Former friends left restaurants when they saw him enter. A compromised millionaire's widow committed suicide. Capote never finished that book.

Disappointed, he turned to drugs and alcohol, often cutting a wretched figure on talk shows. All of America became witness to his downfall. Had he, in fact, only been the court jester of high society, rather than its king? He was not even sixty when he died of the consequences of his alcohol consumption in the Los Angeles home of a female friend. For many, however, the Black and White Ball remains his greatest artwork. And anyone who was there would, for decades to come, be asked the reverential question of what it was like to attend the party of the century.

• OPPOSITE: CHICKEN FRICASSEE A LA "PLAZA" SERVED WITH RICE DOME AND TRUFFLES Midnight snack: The guests had met for dinner before the party, which is why the famous "Plaza chicken fricassee" snack was not served until midnight.
• ABOVE Capote opted not to have any floral decorations, declaring his guests were the flowers.

Orange and Grenadine Aperitif

INGREDIENTS SERVES 6
2 cups / 500 ml freshly
squeezed orange juice
1 cup / 250 ml grenadine
½–¾ tsp. cayenne pepper
salt
crushed ice cubes

TIME NEEDED:
10 mins.

METHOD LEVEL OF DIFFICULTY: EASY
Stir together the orange juice and the grenadine, and generously season with cayenne pepper and salt. Fill glasses with crushed ice cubes and top with the aperitif. Serve immediately.

TIP This aperitif tastes great served with crispy bread wafers.

APPETIZERS

Each appetizer serves 4. If you want to prepare all four appetizers, each one will serve 6, with a slightly smaller portion per person.

RECOMMENDED WINE Oysters, scrambled egg, and avocado soup are best partnered by champagne, as would have been customary at dinner parties in the 1960s; Capote himself was a fan of Taittinger.

Scrambled Eggs with Anchovy Crumbs

INGREDIENTS SERVES 4
For the anchovy crumbs:
1 oz. / 30 g anchovies in oil
5 tbsp. / 75 g butter, softened
2–3 tbsp. panko (Japanese
bread crumbs)
For the scrambled egg:
4 eggs
4 tbsp. heavy cream, or
whole milk
freshly ground pepper
1 tbsp. vegetable oil
Plus:
8 slices brioche or whole
wheat bread, to serve
lightly dressed red-veined
sorrel, to serve (optional)

TIME NEEDED:
35 mins. + 5 mins. cooking

METHOD LEVEL OF DIFFICULTY: EASY

Rinse the anchovies in water, then drain and finely chop them. Stir into the butter until smooth. Melt the mixture in a small nonstick skillet until foaming. Add the panko and fry over low heat until crisp. Drain well on paper towels.

Beat together the eggs and cream and season with pepper. In the wiped-out nonstick skillet, heat the oil over medium heat. Add the egg and cream mixture, and, using a spatula with a straight edge, slowly push the eggs from one side of the skillet to the other. Only just allow the eggs to set so they are still soft in consistency.

Meanwhile, toast the brioche slices and cut out four 10 in. / 4 cm circles. Let the scrambled egg slide out of the skillet on to a large plate and cut out pieces the same size as the brioche circles. Transfer the egg circles onto the brioche circles. Generously sprinkle with anchovy crumbs and serve with red-veined sorrel, if you like.

NOTE: If you cannot find any red-veined sorrel to serve, make a herb salad instead, using long chive stems, chervil, garden cress, and strips of winter salad leaves tossed with a light dressing.

Coconut Wafers (vegan)

INGREDIENTS SERVES 4
2 cups + 1 tbsp. / 250 g all-
purpose flour
1 tbsp. baking powder
1 tsp. salt
½ tsp. dried thyme
7–8 tbsp. / 100–120 g vegan
margarine
½ cup / 125 ml coconut milk

TIME NEEDED:
30 mins. + 8 mins. baking

METHOD LEVEL OF DIFFICULTY: MEDIUM

Heat the oven to 400°F / 200°C (Gas 6; convection ovens 375°F / 180°C). In a wide bowl, thoroughly combine the flour, baking powder, salt, and thyme. Add the margarine in small flakes or cubes. Using a fork, quickly work everything into a crumble mixture.

Add the coconut milk, a little at a time, then work it in with the fork only until you have a soft dough—do not knead the mixture!

Using a spatula, cut narrow strips from the dough, put them onto parchment paper, then lightly spread them out in one direction with the spatula. Bake 8–10 minutes, then transfer to a wire rack to cool.

Serve half the spoon bread with the Grapefruit Salad; use the other half to serve with the aperitif, or freeze to serve another time.

Grapefruit Salad

INGREDIENTS SERVES 4
*4 grapefruit with light-
colored flesh*
1 red onion
8–10 radishes
For the dressing:
½ tsp. fleur de sel
1 tsp. smooth Dijon mustard
*3 tbsp. freshly squeezed
lemon juice*
3–4 tbsp. olive oil
3 tbsp. squeezed orange juice
crushed peppercorns

TIME NEEDED:
20 mins. + 30 mins. marinating

METHOD LEVEL OF DIFFICULTY: EASY

Using a small serrated knife, peel the grapefruit, removing all the white pith. Cut out the segments between the membranes and transfer them to a nonmetallic bowl. Peel and thinly slice the onion. Wash and trim the radishes, then cut them into thin slices. Cover the grapefruit with onion and radish slices.

Beat together all the dressing ingredients and season generously. Add the dressing to the other ingredients and toss together. Leave to marinate at least 30 minutes, or better 1 hour. Sprinkle with crushed peppercorns to serve. Serve with Coconut Wafers.

TIP: You can also garnish this salad with radish leaves, arugula, or garden cress.

Chilled Avocado Cream Soup

INGREDIENTS SERVES 4
*3¼ cups / 800 ml chicken
broth*
2–3 ripe avocados
⅔ cup / 150 g plain yogurt
2–3 tsp. lemon juice
salt and pepper
*best-quality olive oil for
drizzling, to serve*

TIME NEEDED:
20 mins. + chilling

METHOD LEVEL OF DIFFICULTY: EASY

In a saucepan, boil the chicken broth to reduce to 1¼–1¾ cups / 300–400 ml, then leave to cool. Peel and halve the avocados, then remove the pits. In a food processor, puree the broth, avocados and yogurt until very smooth. Cover and chill.

When you are ready to serve, generously season the avocado cream soup with lemon juice and salt and pepper. Pour it into small cups and drizzle with a little olive oil.

TIP: The avocado cream soup can be prepared up to a day ahead. In that case, however, leave the avocado pits in the soup until just before serving, so it stays nice and green, without turning brown—the pits stop the flesh from oxidizing. Instead of olive oil, you can also top the soup with thin scallion rings.

Oysters Rockefeller

INGREDIENTS SERVES 4
1 stick celery
1 small shallot
1 garlic clove
*3½ oz. / 100 g Chinese
cabbage*
1–2 sprigs tarragon
4 tbsp. / 60 g butter, softened
*3 tbsp. orange-flavored
liqueur*
1–2 tsp. grated lemon zest
a dash lemon juice
2½ tbsp. crème fraîche
salt
cayenne pepper
8–12 large oysters, shucked
coarse salt for the salt bed

TIME NEEDED:
30 mins. + 4 mins. gratinating

METHOD LEVEL OF DIFFICULTY: MEDIUM

Wash, trim, and chop the celery. Peel and chop the shallots. Peel and chop the garlic. Wash the Chinese cabbage, remove any hard ribs, and thinly slice the leaves. Wash and shake dry the tarragon, then tear the leaves.

Melt 2 tbsp. / 30 g of the butter in a large skillet. Add the celery, shallots, garlic, and Chinese cabbage, and sauté 2–3 minutes until the liquid has almost cooked away. Add the tarragon, orange-flavored liqueur, lemon zest, and lemon juice. Blend everything in a food processor, but not too smoothly.

Stir together the vegetable mixture, the remaining butter, and crème fraîche, and generously season to taste with salt and cayenne powder.

Heat the broiler. Make sure the oysters don't have any shell pieces, then place them on a salt bed in a baking tray so they cannot tumble over. Top with the vegetable stuffing. Place under the broiler 4–6 minutes on the top rack of the oven. Serve immediately.

TIP: Instead of Chinese cabbage, Belgian endive, spinach leaves, young chard leaves, or any tender salad leaves are equally well suited for the vegetable stuffing.

Intermediate course: Meatballs with Scandinavian Roots

INGREDIENTS SERVES 6

½ cup / 50 g panko
 (Japanese bread crumbs)
7 tbsp. / 100 ml buttermilk
14 oz. / 400 g ground veal
7 oz. / 200 g ground pork
1 egg
1 tbsp. lemon juice
3 tbsp. finely chopped
 parsley
salt and pepper
3 oz. / 80 g prosciutto
1 scallion
For the dressing:
7 oz. / 200 ml double cream
1 cup / 250 g 1.5% plain
 yogurt
1½–1¾ oz. / 40–50 g beets
 (vacuum-packed)
1–2 tsp. capers with brine
2¼ oz. / 60 g peeled potatoes,
 boiled and drained
3 tsp. wildflower honey
2 tbsp. lemon juice
salt
a little vegetable broth
pink peppercorns, to serve

TIME NEEDED:
40 mins. + 20 mins. cooking

METHOD LEVEL OF DIFFICULTY: MEDIUM

Stir together the panko and the buttermilk and leave to soak. Heat the oven to 425°F / 220°C (Gas 7; convection ovens 400°F / 200°C). In a bowl, combine the ground veal and pork, the egg, lemon juice, parsley, and the prepared panko mixture to make a smooth mixture. Season with salt and pepper.

Line a roasting tray with aluminum foil and place a roasting rack on top. Shape the ground meat mixture into 18–20 meatballs, each 1½–2 in. / 4–5 cm diameter. Cut the prosciutto lengthwise into 18–20 strips and wrap a strip around each meatball. Place them on the roasting rack with the side down where the ham ends overlap. Roast the meatballs 20–25 minutes on the middle rack in the oven.

Meanwhile, wash and trim the scallion, then cut it into short, thin strips. Place them into ice-cold water until they curl.

To make the dressing, puree all the ingredients, except the broth, in a food processor. Now stir in a little of the vegetable broth to thin down the mixture (depending on how floury the potato is). Transfer to a small saucepan. Season generously and heat until just lukewarm.

Serve the hot meatballs on the warm potato and beet dressing with the drained scallion strips and the pink peppercorns scattered over.

TIP: The dressing can also be enjoyed at room temperature or chilled with the hot meatballs.

• SCANDINAVIAN-STYLE MEATBALLS

Main course: Chicken Fricassee à la Plaza Hotel

INGREDIENTS SERVES 6

1 oven-ready, free-range
chicken, about 3 lb. 8 oz.
/ 1.6 kg
3 tbsp. lemon juice
salt and pepper
1 tbsp. / 15 g butter
2–3 sprigs oregano
2–3 sprigs thyme
2 unpeeled garlic cloves
1 cup / 250 ml vegetable
broth, hot
3 tbsp. dry sherry
For the quenelles:
2¼ oz. / 60 g day-old white
bread without crust
3 tbsp. milk
3½ oz. / 100 g cold-smoked
salmon
1 shallot
9 oz. / 250 g well-chilled
chicken breast fillet,
skinned, without sinews
5 tbsp. chilled double cream
1 tsp. grated zest of an
organic lemon
1–2 tbsp. lemon juice
salt and pepper
1 bay leaf
For the vegetables:
9–10 oz. / 250–300 g sugar-
snap peas
9 oz. / 250 g shiitake
mushrooms
2 tbsp. / 30 g butter
1 tsp. vegetable bouillon
For the hollandaise sauce:
3¼ sticks / 375 g butter, cold
5 small egg yolks
salt and white pepper
cayenne pepper
1 tbsp. lemon juice

TIME NEEDED:
60 mins. + 60 mins. cooking

METHOD LEVEL OF DIFFICULTY: MEDIUM

Heat the oven to 375–400°F / 190–200°C (Gas 5–6; convection ovens 350–375°F / 170–180°C). Wash and pat dry the chicken, then cut it into serving portions. Season with lemon juice and salt, and pepper. Melt the butter in an ovenproof Dutch oven. Add the chicken, and quickly fry all over. Add the oregano, thyme, and the crushed garlic cloves in their skins. Cover and cook about 30 minutes in the oven. Add the hot broth and the sherry, then cook uncovered 25–30 minutes until the chicken is tender and the juices run clear when tested with the tip of a knife. Remove and discard the herbs and the garlic.

To make the quenelles, cut the white bread into cubes and soak in the milk. Finely chop the salmon. Finely chop the shallot. Chop the cold chicken breast fillets and puree in a food processor together with the chopped shallot. Add the cream, a little at a time. Stir in the soaked bread and the salmon, then season with the lemon zest and juice, salt, and pepper. Set aside.

Bring a saucepan of salted water to a boil. Using two moistened tablespoons, shape the mixture into quenelles. Let them drop into the water and add the bay leaf. As soon as the quenelles rise to the surface, take the pan off the heat, cover, and set aside.

Meanwhile, cut the sugar-snap peas into thin strips. Cut the stems off the shiitake mushrooms. Add the sugar-snap peas and the shiitake mushrooms to the foamed butter with the bouillon powder and stir until the vegetables are tender, but still firm to the bite. Keep warm.

To make the hollandaise sauce, cut the butter into small pieces. Heat a water bath until simmering, then reduce the heat. In a large metal bowl, stir together the egg yolks and 1½ tablespoons water until smooth. Stir in 1 tablespoon / 15 g of the butter pieces.

Place the bowl over the water bath and beat everything until the egg and butter have bound. Continue until all the butter has been added. Season the thick, creamy hollandaise sauce with cayenne pepper, lemon juice, and salt and pepper.

To serve, arrange the braised chicken with the prepared vegetables and the drained chicken and salmon quenelles. Spoon over plenty of the hollandaise sauce.

TIPS: If you like, pass the braising gravy round separately rather than spooning it over the dish.

The fricassee is faster and easier to prepare if you use 3 double chicken breasts (on the bone and unskinned). This reduces the cooking times: Roast the chicken breasts 12–15 minutes and braise them 10–12 minutes until tender and the juices run clear when tested with the tip of a knife.

If you prefer, use snow peas instead of sugar-snap peas, which have a milder taste.

RECOMMENDED WINE **New Yorkers** would enjoy drinking an elegant Pinot Blanc with smoky notes with this meal.

Upside-down Truffled Rice

INGREDIENTS SERVES 6

1¼ cups / 250 g risotto rice
1 tbsp. olive oil, salt, pepper
2 cups / 500 ml vegetable broth
7 oz. / 200 ml dry white wine
1 tbsp. / 15 g butter, softened
3 tbsp. heavy / double cream
1 tbsp. / 15 g butter, softened
1 small truffle

TIME NEEDED:
30 mins. + 25 mins. cooking

METHOD LEVEL OF DIFFICULTY: MEDIUM

Peel and finely chop the shallots. Rinse the rice in a strainer and drain. Heat the olive oil in a large skillet. Add the rice and the shallots and sauté briefly. Gradually add the broth and the white wine and bring to a boil, stirring occasionally. Reduce the heat and leave to simmer until the liquid is almost completely absorbed. Cover the rice and leave it to swell 5–10 minutes.

Meanwhile, heat the oven to 300°F / 150°C (Gas 2; convection ovens not recommended). Grease 4 metal molds (about 2½ in. / 6 cm diameter) with the butter. Beat the cream until stiff, then fold it into the rice and season with salt and pepper. Shave the truffle into thin slices and place them in the bottom of the molds. Put the rice on top, patting it down lightly. Transfer to the oven 5 minutes to heat through. Take out, unmold, and serve with the fricassee.

Dessert: Angel Food Cakes

INGREDIENTS SERVES 6

1 cup less 1 tbsp. / 110 g all-purpose flour
about 2½ tbsp. cornstarch
1¾ cups + 2 tbsp. / 380 g granulated sugar
10 egg whites, at room temperature
1¼ tsp. cream of tartar
¼ tsp. salt
½ tsp. ground vanilla bean
3–4 tbsp. orange-flavored liqueur, such as Grand Marnier, or fruit juice, for drizzling

For the chocolate cream:
11 oz. / 330 g dark chocolate, such as Valrhona
a pinch salt
1 cup / 250 g crème fraiche at room temperature

For the spiced walnuts and Cape gooseberries:
2 tbsp. granulated sugar
12–15 walnut halves
¼ tsp. dried chili flakes
zest of 1 organic orange
a dash orange juice
12–18 Cape gooseberries

TIME NEEDED:
60 mins. + 40 mins. baking + cooling

METHOD LEVEL OF DIFFICULTY: DIFFICULT

Heat the oven to 325°F / 170°C (Gas 3; convention ovens 300°F / 150°C. Combine the flour, cornstarch, and ½ cup + 2 tablespoons / 130 g of the sugar. Beat the egg whites with the cream of tartar and the salt until forming soft peaks. Drizzle in the remaining sugar and add the vanilla.

Sift the flour mixture in 2 to 3 batches over the egg white mixture and gently fold in. Transfer the batter immediately to 4 small nonstick and ungreased angel food cake pans (about 4½ in. / 12 cm diameter) and fill them three-quarters full. Bake the cakes 30 minutes on the lowest rack, then move to the middle rack and bake 10 minutes longer.

Take the cakes out of the oven and turn upside down onto a wire rack. If the batter is higher or as high as the rim of the pans, first place two wooden spoons parallel on the rack. Invert the pans onto the spoons, so the cakes can slide out as they cool. Once cool, use a piece of thread to divide the cakes horizontally in half. (The crumb is entirely white and has the consistency of cotton wool.) Drizzle the cut side of six halves with the orange-flavored liqueur.

To make the chocolate cream, coarsely chop the chocolate, then melt it with the salt over a hot water bath. Quickly stir in the room-temperature crème fraîche. It's important that the crème fraîche is not cold; if it is, the chocolate will set too quickly and the cream will become flaky! The cream needs to be soft and spreadable, so work quickly. Assemble the cakes, then brush the tops with the chocolate cream mixture.

For the spiced walnuts, melt the sugar and caramelize to light brown. Add the walnut halves and the chili flakes, and toss briefly. Add the orange zest and juice, then boil rapidly until the liquid has cooked away. Briefly stir in the Cape gooseberries. Serve alongside the angel food cakes.

TIPS: These cakes are quite filling, so half a cake per person is sufficient. You will end up with two extra cake halves, which can be frozen unfilled or simply dusted with confectioners' sugar and served with fresh fruit.

If the chocolate cream does become flaky, lightly reheat it in the bowl over a hot water bath and beat again until smooth.

Other delicious accompaniments include cream whipped with cranberry puree; fresh pineapple; poached apple with cinnamon, cloves, and ginger; and a winter fruit salad.

Angel food cake pans can be purchased from specialist bakeware stores or online. These nonstick pans have a removable bridge with a flat base. Small, round tube cake pans or a large tube pan are also suitable.

RECOMMENDED WINE The sweet wines of the Mosel are popular in the United States, so we recommend a 2015 Mosel Auslese to serve with this dessert.

• DESSERT: ANGEL FOOD CAKES WITH CHOCOLATE, WALNUTS, AND ORANGES
The American classic made from feather-light beaten egg whites with sugar and vanilla might made for a sweet finish to one or other dinner party.

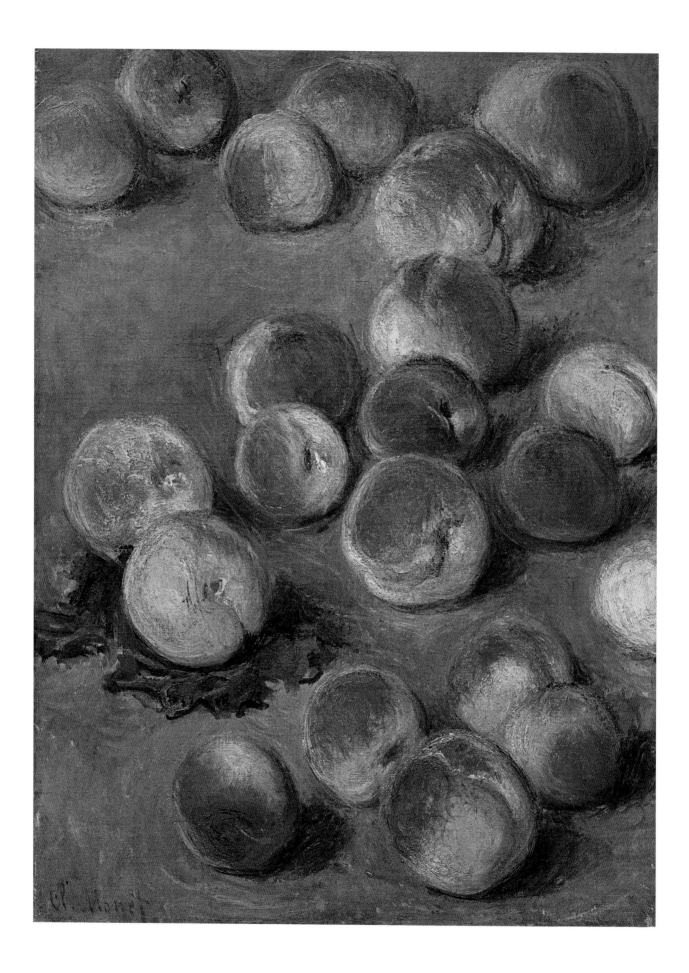

Claude Monet

IN FULL BLOOM

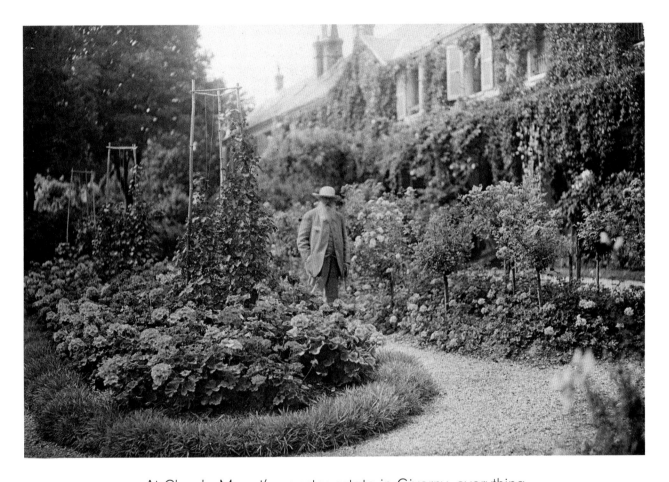

At Claude Monet's country estate in Giverny, everything
revolved around French impressionist painting—and his meal
requests, because there was nothing the cordial host
and father of eight children and stepchildren
loved more than good, sumptuous food.

• OPPOSITE "FOR ME, GIVERNY IS A TRULY MAGNIFICENT PLACE." THE PAINTER CRAVED A LIFE IN NATURE
Monet's still life *Peaches* from 1883, the year he moved to Giverny with his future wife, Alice, and all their children.
• ABOVE Monet was devoted to the garden at his country estate in Giverny, a village in Normandy. He often bought new,
sometimes, rare, plants, and was particularly delighted when nature was allowed to run wild. Lavender, roses, daisies,
and sunflowers all flourished in his lush garden.

The gong rang out through the garden at 11:30 every morning. If everyone were not seated at the laid table by the second strike, the master of the house would start giving a little cough, and pandemonium would break out in the kitchen. He was adamant he would not wait a single minute for his lunch.

Claude Monet lived at his country estate in Giverny, west of Paris, with his second wife, Alice, and the eight children from their respective previous marriages. His day began early. He would be up before dawn and enjoy a sumptuous breakfast of eggs with ham and sausage—much like the ones he had encountered on his travels through England. Some days, however, Monet would eat nothing at all. The only other person who rose as early as him was his stepdaughter Blanche, with whom he was very close, and who also painted. She usually trailed behind him, pushing his canvases and easels in a wheelbarrow. He positioned several easels alongside each other, and switched between them, depending on the way the light changed with the passing clouds. This approach gave rise to images depicting every season and all kinds of weather.

As a young man, Monet went to Paris, joining peers from a new avant-garde, such as Edouard Manet, Paul Cézanne, Edgar Degas, and Pierre-Auguste Renoir, in their mission to revolutionize art. The impetuous youngsters left their studios and headed out into nature to capture the sunlight with bold color compositions, preferring to paint snapshots rather than carefully constructed scenes. The impressionist movement got its name from Monet's *Impression, Sunrise* painting, with one critic from *Le Figaro* scoffing that the images looked like those of a "monkey who might have gotten hold of a box of paints."

Monet lived in the most modest of settings with his first wife, Camille, whom he had married in 1870, and their son Jean. When Camille died in 1879, a year after the birth of their second child, Monet was distraught. He found solace, however, in Alice, the wife of one of his patrons, and she and her six children soon moved in with him. Neither was bothered by the scandal, only marrying years later, after the death of Alice's husband. Monet then discovered the old farmhouse for his large patchwork family.

In 1883, the forty-two-year-old Monet made it his permanent home, and the garden became his open-air studio. With the farmhouse overgrown with climbing roses and vines, the color-coordinated flowerbeds, the rose arches, and the watercress running rampant over the paths, Monet had created a living artwork that left visitors feeling as if they had, indeed, been transported into one of his paintings.

It took a while for any decent money to come in, though you wouldn't have known it from the meals, with Marguerite the cook serving up sumptuous food every

• ABOVE LEFT "I'm good for nothing except painting and gardening," Monet is reported to have said. He spent forty years. living at his country estate in Normandy. • ABOVE MIDDLE Monet and his second wife, Alice, at St. Mark's Square in Venice, 1908. • ABOVE RIGHT Monet with friends on the Japanese bridge over his garden pond.

lunchtime: a hot first course, such as chanterelles with bacon, would be followed by main courses that included crisp broiled duck wings with all kinds of vegetables from the garden, such as cauliflower, or Monet's beloved crosne, a chinese artichoke that was in vogue in France at the time. The man of the house dressed the salad at the table, which involved filling a large spoon with crushed pepper-corns, coarse-grained salt, olive oil, and wine vinegar, and pouring the dressing over the leaves. Only he and Blanche liked this peppery mix, hence there was always a second salad bowl on the table for the rest of the family. Dessert consisted of cake and fruit.

The atmosphere at the table depended entirely on Monet's mood. If a painting hadn't gone well for him that morning, there would be a fearful silence—lest a careless comment provoke one of his notorious fits of rage. Family and friends often watched in silence on as the burly, bushy-bearded, and seemingly so placid Monet cut a painting to shreds or furiously trampled all over it. If his work had gone well, however, he sent everyone into high spirits with his good mood, blaring out *Carmen* opera arias, and acting the most loving, caring father, husband, and host. Guests often joined him for meals, with journalists, actors, composers, writers such as Guy de Maupassant, painters such as Pierre-Auguste Renoir, Paul Cézanne, and Édouard Manet, or statesman and close friend Georges Clemenceau all keenly coming to visit him at Giverny.

The products had to be fresh—which is why, under the suspicious eye of his farming neighbors—, Monet grew all kinds of vegetables in his own garden, including tomatoes, eggplants, artichokes, and small, white Egyptian onions that he pickled in vinegar. He also bred Bresse chickens and Muscovy ducks.

Marguerite knew exactly what the man of the house wanted. Vegetables only needed to be briefly steamed, and he even liked asparagus to be almost raw, while snipes had to be hung up for two weeks to develop their gamy flavor. Marguerite had to recreate a number of recipes that Monet and Alice loved: The Yorkshire pudding had to taste just like it did at The Savoy hotel in London, and the sole had to be prepared the same way as the ones at the Café de Paris. With red floor tiles and blue-and-white wall tiles, her kitchen had all the latest equipment of the time, including copper pots, pans, and roasters, large kitchen scales, an ice-cream maker, and a giant stove. If an art dealer came around, the pressure was on for the cook. The best game or pike was be required, and it was imperative that she cater to personal preferences, whether it be a collector who always ate two ducks, an eccentric Englishman who loved extra-long-braised pigeon, or an American expecting lobster cooked to his preferred New York style. This was the case even when Monet no longer needed to pander quite so intensively to the dealers' whims after a joint exhibition with his friend Rodin in Paris saw both artists suddenly shoot to fame in 1889. "Monet's palette

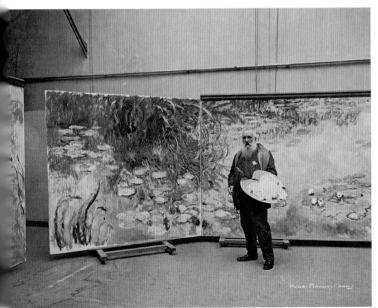 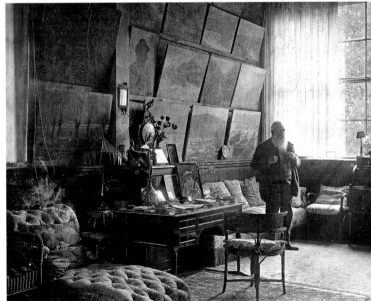

• ABOVE LEFT Monet standing in front of a painting from his water-lily series in his studio, 1920.
His pond, with its colors and varying light, was one of the main themes during this period of his work.
• ABOVE RIGHT A view of his paintings: Monet in the living room of his home in Giverny.

captures all the light's elements, all the air's charms, and every trace of floating mist," gushed a critic. By the end of the century, Monet's works were being auctioned for thousands of francs.

The money now enabled him to afford a host of servants, who helped Monet farther develop his garden. He ordered the creation of a large pond and—inspired by his collection of Japanese art prints that hung in the dining room—had a bridge built over it. A gardener was specifically employed to scoop foliage off the water's surface and clean the water lilies' leaves every day.

The water lilies were Monet's last great passion. He had a new studio built, in which he arranged floor-to-ceiling water-lily paintings in a circle to give viewers the impression of being surrounded by shimmering blue, green, and purple water.

Eventually, Monet began to develop cataracts, and he used what remained of his vision to finish painting the water lily pictures. He died in 1926, and the estate fell into disrepair after World War II. It took another thirty-five years before it was restored and opened to the public, once again allowing visitors to immerse themselves in Monet's life—and take a peek in the kitchen, which looks as if Marguerite had only just left the room to pick vegetables in the garden.

• Instead of planning great historic scenes, Monet preferred to capture the beauty and mood of everyday situations, as evident in his *The Luncheon* from 1873.

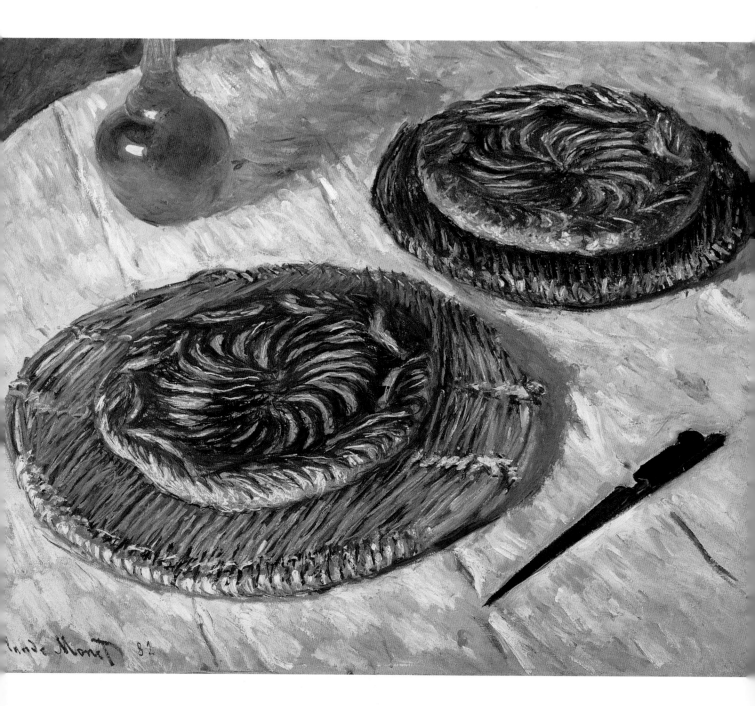

- ABOVE Sweet treats from the oven: *Fruit Tarts* by Claude Monet, 1882
- OPPOSITE LEFT Fresh from the garden: Monet grew vegetables, including zucchini, artichokes, tomatoes, and even Egyptian onions. Stuffed Tomatoes, shown here with a mix of bread, herbs, shallots, and garlic (From *The Monet Cookbook*, Recipes from Giverny, by Florence Gentner, Prestel, 2016).
- OPPOSITE RIGHT An aromatic Tarte Tatin, baked with apples and butter, was one of the easiest desserts for his cook, Marguerite.

Stuffed Tomatoes

INGREDIENTS SERVES 6

6 large tomatoes
1 bouquet garni (thyme,
 parsley, and 1 bay leaf)
salt and pepper
2 thick slices day-old
 country-style bread
7 tbsp. / 100 ml vegetable
 broth
2 oz. / 55 g Canadian bacon
 or cooked ham
2 oz. / 55 g mushrooms
1 bunch flat-leaf parsley
2 large garlic cloves
6 large shallots
1 tbsp. / 15 g butter
2 egg yolks
vegetable oil for greasing

TIME NEEDED:
60 mins. + 30 mins. cooking

METHOD LEVEL OF DIFFICULTY: MEDIUM

Wash and pat dry the tomatoes. Using a sharp knife, off the tops and set aside. Carefully hollow out the tomatoes with a spoon and put the flesh and seeds into a saucepan. Briefly bring to a boil, then strain and return to the pan. Add the herb bouquet and simmer the sauce about 20 minutes. Remove the herbs, then season the tomato sauce with salt and pepper.

Cut the crusts off the bread slices, chop the bread, and place it in a bowl with the broth. Cut the bacon into small dice. Rub the mushrooms clean with a moist cloth, then trim them, remove the stems, and finely chop. Wash and shake dry the parsley, remove the leaves, and finely chop them. Peel and finely chop the garlic and the shallots.

Heat the oven to 400°F / 200°C (Gas 6; convection ovens 375°F / 180°C). Melt the butter in a large skillet. Add the bacon, mushrooms, parsley, garlic, and shallots to the skillet, and fry until golden-brown. Stir in the bread cubes and the tomato sauce. Stir in the egg yolks to bind and season with salt and pepper. Place the tomatoes into a greased gratin pan or baking dish that holds them upright, then fill them with the mixture. Put the tomato tops back on top. Roast the tomatoes about 30 minutes. Serve hot or cold.

Tarte Tatin

INGREDIENTS

MAKES 12 SLICES

2 cups + 1 tbsp. / 250 g all-
 purpose flour
1 cup / 225 g superfine sugar
1 egg yolk
salt
3½ sticks / 400 g cold butter
6 tart, firm apples, such as
 Granny Smith

TIME NEEDED:
40 mins. + 1 hour resting
+ 45 mins. baking

METHOD LEVEL OF DIFFICULTY: MEDIUM

Heap the flour onto the countertop and make a well in the middle. Add 5½ tablespoons of the sugar, the egg yolk, a pinch of salt, and 3 tablespoons lukewarm water. Thoroughly knead everything. Cut 2¼ sticks / 250 g butter into small pieces, and knead them in until you have a smooth dough. Shape the dough into a ball, wrap in plastic wrap, and chill in the refrigerator about 60 minutes.

Heat the oven to 400°F / 200°C (Gas 6; convection ovens 375°F / 180°C). Peel and quarter the apples, then remove the cores and the stems. Cut the flesh into thick wedges.

Roll out the dough on the floured countertop into a circle about ¼ in. / 6 mm thick, the size of a loose-bottom cake pan (10 in. / 25 cm). Arrange the apple wedges on the bottom of the pan. Top with the remaining butter in small pieces and dust with the remaining sugar. Cover with the dough circle and lightly press it down and tuck in the edge. Bake the tart about 45 minutes.

Take the tart out of the oven and leave to rest 5 minutes. Carefully tip the tart upside down onto a cake plate and remove the pan. Serve hot.

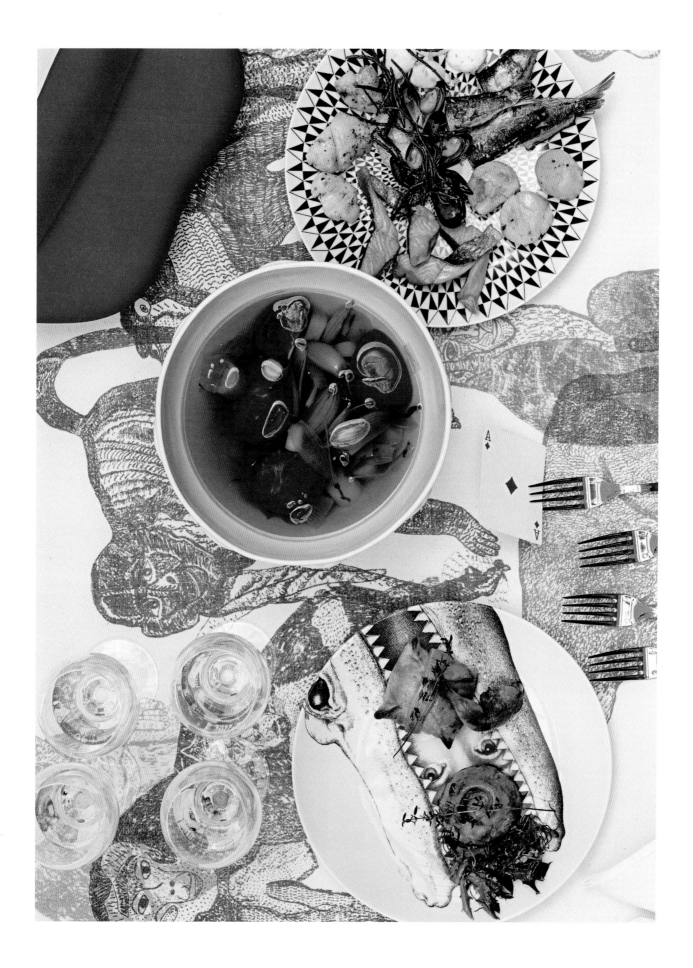

Marie-Hélène de Rothschild

HEAD
TO HEAD

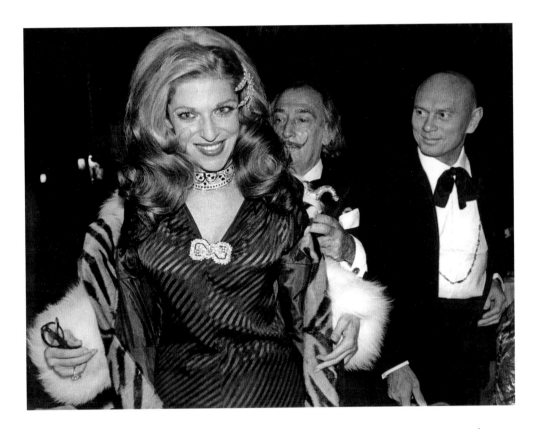

Her style added a new sense of glamour to the international banking family, and she became a dazzling hostess, famed from Paris to New York City. In December 1972, Marie-Hélène de Rothschild hosted the Surrealist Ball, a party inspired by the works of Dalí and Magritte, where guests wore elaborate masks and hats, and dessert consisted of a life-size naked beauty made out of marzipan.

• OPPOSITE: A DREAMY APPETIZER: A CLEAR BOUILLON SERVED WITH QUAIL PIE AND A WINTER SALAD Shallots, bay, leek, fish broth, and a little white wine formed the basis of bouillon, with a selection of fish, shellfish, and seaweed served separately for adding at the table. To the guests' delight, the Exquisite Corpses that the hostess had mentioned on the menu turned out to be fine quail pies served with lettuce leaves.
• ABOVE Marie-Hélène de Rothschild, pictured here with Salvador Dalí (middle) and Yul Brynner, threw costume parties that were veritable works of art.

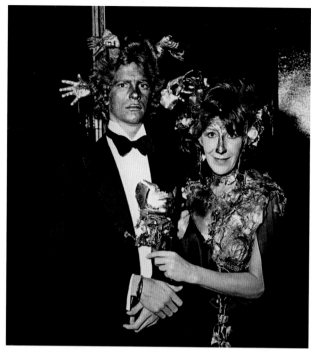

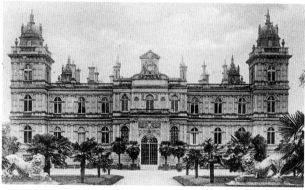

• TOP Party guests included photographer and writer François-Marie Banier, with hands and feet sticking out of his hair, and Charlotte Aillaud, the sister of Juliette Gréco.
• ABOVE Château de Ferrières, at the end of a long entry drive.

• OPPOSITE: CHARMING IRRITATION: MINI BAGUETTES DYED SKY BLUE How long did Madame de Rothschild's kitchen staff have to practice before achieving the perfect shade of blue for the crisp bread? We created our mini baguettes bleues by brushing them with blueberry, elder, or beet juice while still in the oven.

Château de Ferrières, the country estate of the Rothschild family, had already attracted a lot of attention after chatelaine Marie-Hèlène moved in. The wife of Baron Guy de Rothschild had had the giant building encased in white organza to make it look as if it were covered in cobwebs. She once also had a ghostly galleon sail across the lake in the parklands. And then there was the time in 1971 she invited 700 guests—including Elizabeth Taylor and Richard Burton—to mark the one-hundredth birthday of writer Marcel Proust, all wearing costumes in the style of his era, couture by the likes of Yves Saint Laurent among others.

But the ball season of 1972 saw her take her quest to host the most spectacular social event to a new level. Rothschild wanted to cast reality aside for a night; "tuxedos, evening gowns, and surrealist heads" was the dress code for her dinner, which was to have the theme of a fanciful daydream. To achieve this, she drew inspiration from the works of surrealist artists René Magritte and Salvador Dalí. The latter, a darling of society and a close friend of Rothschild, had thrown his own surrealist parties in the 1930s, and was still hosting lavish dinners in Paris.

Enthusiasm, coupled with an iron will, made Rothschild a star of high society in Paris and New York, securing her front-row seats at French couturiers' fashion shows. When she organized charity parties, her name alone would magically attract major donors, while her friendship opened all doors for artists, fashion designers, and musicians. The perfectionism with which Rothschild organized her parties could also become excessive, such as when she ordered about 400 fried eggs to be redone because the yolks weren't the right shade of yellow.

She planned all of her events down to the tiniest of details. One of her rules was that the perfect party should always start with the invitation, which alone was meant to inspire the guests, and so she had the invitations for her *Dîner de Têtes Surréalistes* printed as back-to-front mirror images, with only fragments appearing behind Magritte-style clouds.

On the night of December 12, the walls of Château de Ferrières looked as if they had been set alight, the exterior bathed in a flickering orange glow. One hundred and fifty guests had been invited, and no reporters were allowed.

The Rolls-Royces in which the guests began arriving at 9 p.m. did not have roofs high enough for their oversized head covers, so many of the guests hurried into a dressing room through a side entrance to don their masks and ornamentations before finally entering the castle through the main entrance.

French politician Michel Guy appeared to have a dagger stuck into his bald head, surrounded by a silver halo. "Am I grotesque enough?" he asked. And his worries were

indeed justified, for Audrey Hepburn's head was inside a birdcage, through whose bars she gracefully batted her eyelashes, while various limbs stuck out from the gold-sprayed head of writer François-Marie Banier. Many guests had to do a double-take when they spotted Baroness Denise von Thyssen, who was balancing a true-to-original replica of her own head, complete with blonde mane, above her real one. Journalist Nicole Salinger, meanwhile, carried a green-and-mauve cauliflower on her head, and style icon and perfume heiress Hélène Rochas wore a veiled hat topped with a gigantic gramophone. Dalí, wheelchair-bound and accompanied by his masseuse and his muse, Amanda Lear, was the only guest not in costume, claiming he didn't need a mask because his face was his mask. Yet, he had designed a number of the other attendees' head covers.

Arriving at the party was like stepping into a scene from *Alice in Wonderland*. Maîtres d'hôtel dressed as cats pretended to sleep in all manner of poses on the steps to the entrance hall. Guests would then pass through a labyrinth of black ribbons. Anyone who lost their way would be rescued by one of the "cat attendants" and led into the ballroom, where the hosts would be waiting for them: Baron de Rothschild, with a still-life sculpture on his head, and Marie-Hélène, whose face was hidden behind a gilded deer head that wept diamond tears. She wore a shimmering aquamarine dress with fur trim by Yves Saint Laurent.

The awestruck guests took their seats at the decorated tables. The tablecloths were printed with pink-and-blue clouds, while the plates were wrapped in black mink and adorned with bright red Mae West lips made of plastic. The baguettes had been dyed bluish-green, and each table had its own motto, for which Rothschild adopted Dalí's surrealist theme of combining two clashing concepts: There was the "table of the tenderized turtles," at the center of which two turtles stood supporting one another; the "table of the swaying dolls"; and the "table of the insane shoe." The menu also read like a surrealist poem:

Soupe extra Lucide (Extra-lucid Soup)
Imbroglio de Cadavres Exquis (Exquisite Corpse Imbroglio)
Lady and Sir-Loin
Tubercules en Folie (Tubers of Madness)
L'es-tu ? (Is It You?)
Pêches et Chèvres hurlant de Tristesse
(Peaches and Goat Cheese Howling with Sadness)
Enfin ! (Finally!)

However, comfortingly realistic dishes were then served, including venison, foie gras, and roasted goat cheese, most likely accompanied by a Château Lafite from the family's own estate. The highlight of the evening came at around midnight, when eight maîtres d'hôtel brought in the surreal dessert: a life-size figure of a naked woman, surrounded by roses. The sweet creation was made of

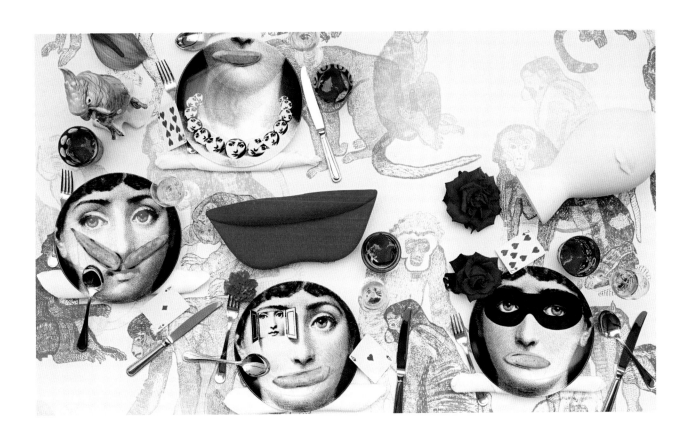

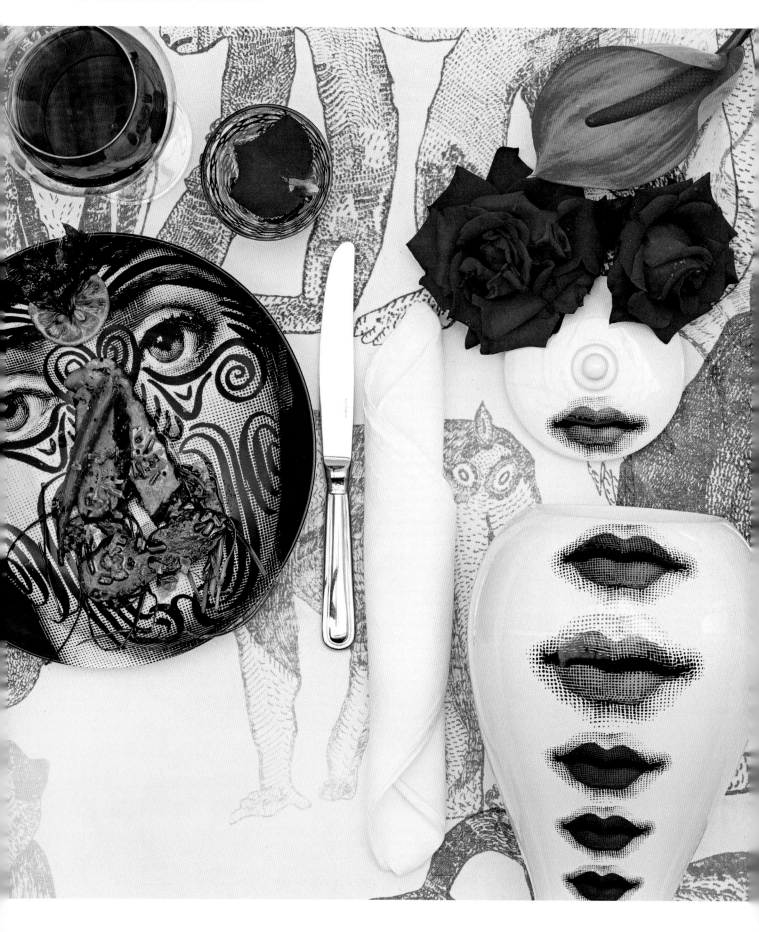

marzipan and caramel, and was chopped into pieces in front of the guests.

Little information as to what went on at the party afterward has made it beyond the castle walls. The guests danced in the "nightclub," and an orchestra is likely to have been playing. But very few would have been fleet-footed across the dance floor, with an anonymous guest revealing to *The New York Times* that the dance partners were like wrestling mammoths as they clasped hands under their teetering headpieces.

Did Madame de Rothschild herself enjoy the party? Not really, it seems, because society's star choreographer—as she was called by the New York press—was racked with horrendous stage fright before each of her parties. Even on this occasion, it would only subside once, as she herself later said, the guest numbers had finally thinned "like a good sauce."

"I want to convince people, to open their eyes," the fascinating hostess once said about herself. And rarely did she do this more successfully than on that night at Château de Ferrières in December 1972, when she made the craziest of dreams come true.

• MAIN COURSE FOR THE LADY AND SIR-LOIN: FOR HIM STEAK WITH VEGETABLES AND FOR HER PORK MEDALLIONS WITH APRICOT AND PUMPKIN MEDLEY
Tubers of Madness was the name given to the side dish for the steak that night, although, fortunately, it was only carrots, parsley root, and parsnips that were served with the sirloin steaks. The ladies enjoyed tender pork with soft-steamed pumpkin and wine-infused apricots, rounded off with sesame and sour cream.

Appetizer: Imbroglio de Cadavres Exquis (Exquisite Corpse Imbroglio Or: quail pies on a winter salad)

INGREDIENTS SERVES 4

2 oven-ready quail
1 oz. / 25 g lardo (fatty Italian bacon), thinly sliced
1 tbsp. /15 g butter for frying
For the marinade:
1 sprig thyme
1 shallot
4 tbsp. cognac
1 tsp. granulated sugar
For the dough:
1¼ cups / 150 g all-purpose flour
1½ tsp. salt
3 tbsp. / 45 g butter
For the filling:
5½ oz. / 150 g duck liver
1½ tsp. / 7 g butter
2 tbsp. crème fraîche
salt and pepper
5–7 oz. / 140–200 g brown mushrooms
2 stems flat-leaf parsley
1 tbsp. vegetable oil
For brushing:
1 egg yolk + 1 tbsp. milk
small thyme sprigs
To serve:
1 oakleaf lettuce,
1 radicchio
1–2 tbsp. olive oil
fleur de sel

TIME NEEDED:
1¼ hours + 3 hours marinating + 40 mins. cooking

METHOD LEVEL OF DIFFICULTY: DIFFICULT

For the marinade, wash and shake dry the thyme, then pull off and finely chop the leaves. Peel and finely chop the shallot. Combine the cognac, sugar, thyme, and shallot in a bowl. Add the quail and lardo and leave to marinate at least 3 hours, or better overnight.

To make the dough, place the flour in a heatproof bowl. Dissolve the salt in ⅔ cup / 150 ml water in a saucepan over high heat. Add the butter and bring to a boil. Pour over the flour and immediately work with the kneading hooks of a handheld mixer to make a smooth dough. Divide the dough into 8 portions. Between two layers of plastic wrap, roll each portion out into a circle with a 4½–6 in. / 12–15 cm diameter. Put the circles with the wrap into the refrigerator until you are ready to use them.

Remove the quail from the marinade and pat them dry. Melt the butter in a large skillet over high heat. Add the quail and fry all over. Remove from the pan, cut off the breasts and separate the legs. To make the filling, remove the skin and sinews from the duck liver. Briefly fry the liver in the quail frying juices with the extra butter. Leave to cool, then finely chop in a food processor together with the lardo and the shallot. Fold in the crème fraîche and season, then divide into 4 portions. Clean and slice the mushrooms. Wash and shake dry the parsley, then pull off and chop the leaves. Fry the mushrooms in the oil until it has cooked away, adding the parsley just before.

Remove the dough circles from the refrigerator and pull off the top layer of plastic wrap. Arrange the mushrooms on top of four circles, leaving a 1¼–1½ in. / 3–4 cm rim uncovered. For each circle, place ½ quail breast and one portion of filling on top of the mushrooms. Pull up the bottom plastic wrap around the sides to shape small tarts or parcels. Remove from the plastic wrap.

Heat the oven to 425°F / 220°C (Gas 7; convection ovens not recommended). Make lids from the remaining 4 dough circles. Place them on the pies and close up. Using a wooden toothpick, make several holes in the tops for the steam to escape. Line a cookie sheet with parchment paper and place the quail pies on top. Whisk together the egg yolk and milk, then brush the pies with the mixture. Make decorative shapes from the remaining dough pieces, place them on the pies, and lightly press them down. Brush again with the egg yolk and milk mixture and garnish with the thyme. Bake the pies 20–25 minutes. After 10 minutes, place the quail legs onto the sheet and roast with the pies.

Meanwhile, trim, wash, and shake dry the salad leaves, then tear the leaves into bite-size pieces. Toss in the olive oil and season with the coarse salt. Divide the salad among four plates and place the pies on top. Lay the crisp quail legs next to the pies and serve.

Mini Baguettes Bleues (Small Blue Baguettes)

INGREDIENTS
MAKES 12 BAGUETTES
1 sprig thyme
2 cups + 1 tbsp. / 250 g all-purpose flour
½ envelope instant dry yeast
½ tsp. salt
½ tsp. sugar
⅔ cup / 150 ml milk
2 tbsp. olive oil
a pinch ground fennel seeds
For color brushing and blue sheen:
4–4 tbsp. very dark fruit or vegetable juice, such as blueberry, elder, or beet
1 small or ½ egg white

TIME NEEDED:
20 mins. + 30 mins. rising + 10 mins. baking

METHOD LEVEL OF DIFFICULTY: EASY

Wash and shake dry the thyme, then pull off and chop the leaves. Combine the flour with the yeast, thyme, salt, and sugar. Heat the milk to lukewarm, then add it to the flour mixture together with the oil and the fennel seeds. Knead until you have a smooth dough, then cover and leave to rise 30 minutes.

Heat the oven to 410°F / 210°C (gas ovens not recommended; convection ovens 385°F / 190°C) and place a small ovenproof bowl of water in the bottom of the oven. (The moisture makes sure the baguettes do not dry out.)

Shape the dough into a ball, then use a wide baking spatula to cut 12 elongated baguettes (just under 4 in. / 10 cm long). Line a cookie sheet with parchment paper and place the baguettes on top. Bake about 10 minutes on the middle rack. After about 2 minutes, open the oven door and brush the baguettes with 2–3 tablepoons of the fruit or vegetable juice; it will soak in very quickly.

Whisk together the egg white and the remaining juice for the sheen, then brush the baguettes with the mixture. Bake 5–6 minutes longer until done—the breads should be golden-brown underneath.

TIP: To create the colored sheen, you can also combine the egg white with blue food coloring instead of fruit juice. This will color the dough a light green.

Soupe Extralucide (Extra-lucid Soup)

INGREDIENTS SERVES 4

For the broth:
2 shallots
2 leeks
2 beef tomatoes
2 fresh bay leaves
2¼ cups / 600 ml fish broth
7 tbsp. / 100 ml dry white wine
½ tbsp. bottled capers, plus
* some of the brine*
salt and pepper
For the soup add-ins:
4–8 live mussels
5 oz. / 140 g char fillet
4 tsp. / 20 g butter
4 monkfish cheeks
4 shelled scallops
4 small anchovies / sardines
salt and pepper
1½ oz. / 40 g edible seaweed,
* such as glasswort,*
* samphire*
4 poached quail eggs

TIME NEEDED:
30 mins. + 25 mins. cooking

METHOD LEVEL OF DIFFICULTY: EASY

For the broth, peel and roughly chop the shallots. Trim and wash the leeks, then cut the white parts into rings (use the green parts in another dish). Wash and halve or quarter the tomatoes.

In a saucepan, quickly dry-fry the shallots, bay leaves, and leeks, then pour in the fish broth and white wine. Add the tomatoes and slowly heat through, then simmer 10 minutes over low heat. Add the capers and the brine, and season with salt and pepper.

Prepare the soup add-ins separately to be added at the table. Thoroughly scrub the closed mussels and discard any open ones that do not snap shut when tapped, then let them simmer in the soup until the shells open; lift them out. Rinse and pat dry the char fillet. Melt the butter in a skillet. Add the fillet and fry on both sides, one after the other. Remove from the pan and cut into strips. Return to the pan with the monkfish cheeks, scallops, and anchovies. Season with salt and pepper. Briefly toss or blanch the seaweed in the frying juices.

To serve, ladle the soup into warm bowls. Arrange all the prepared fish add-ins on a plate together with the mussels and the poached quail eggs. Sprinkle with the seaweed. This is especially good with Mini Baguettes Bleues.

TIP: The soup also tastes great with less varied add-ins. Instead of the seaweed you can also use Mediterranean herbs.

For the ladies: Pork Medallions with Apricots

INGREDIENTS SERVES 4

4–6 ready-to-eat dried
* apricots*
about ½ cup / 125 ml dry
* white wine*
10 oz. / 300 g red kuri or
* other winter squash*
1 lb. 2 oz. / 500 g pork
* tenderloin*
1 tbsp. / 15 g butter
1 tbsp. olive oil
½ tsp. nigella seeds
2 tbsp. crème fraîche
fleur de sel
Mediterranean herbs,
* optional, to garnish*

TIME NEEDED:
30 mins. + 25 mins. cooking

METHOD LEVEL OF DIFFICULTY: EASY

In a saucepan, combine the apricots and wine, then slowly bring to a boil. Turn off the heat, cover, and set aside. Peel the squash, if necessary, and seed it, then cut the flesh into small cubes.

Remove any fatty parts and sinews from the pork tenderloin, then cut into 4 equal medallions. Tie them with kitchen string around the sides to get a nice, round shape.

Melt the butter with the oil in a skillet over medium heat. Add the medallions and fry until golden brown on both sides. Take out of the pan, remove the string, cover the meat with aluminum foil, and set aside. Sauté the squash in the fat remaining in the pan until tender. Add the nigella seeds and the apricots with the wine. Stir in the crème fraîche, season with salt, and sauté briefly.

To serve, place some squash sauce on four plates, then set a pork medallion on top and top with the apricots.

TIP: Garnish the dishes with Mediterranean herbs, if you like.

For the gentlemen: Sir-Loin Steak with Chive Butter

INGREDIENTS SERVES 4

1 tsp. each of monk's pepper
(chaste tree berries),
long pepper, and black
peppercorns
2 garlic cloves
1 lb. 12 oz.–2 lb. 4 oz. / 800 g–
1 kg well-marbled top
sirloin steak, 2–2½ in. /
5–6 cm thick
coarse kosher salt
For the chive butter:
2 small shallots
1 small bunch chives
4–5 tbsp. / 60–75 g butter
salt
1 tsp. grated lemon zest

TIME NEEDED:
30 mins. + 40 mins. cooking

METHOD LEVEL OF DIFFICULTY: MEDIUM

Crush the three types of pepper with a mortar and pestle. Peel and grate the garlic cloves.

Heat the oven to 212°F / 100°C (gas ovens not recommended; convection ovens 187°F / 80°C), leaving the oven door just ajar. Heat a cast-iron skillet over high heat. Rub the steaks with the garlic and season with the peppers, then place in a skillet without any fat. Turn the steaks over when the meat comes away from the pan's surface and the steaks are well browned. (Also fry the steak sides as the meat is at least 2 in. / 5 cm thick, but watch out, it's very hot!)

Roast the sirloin steaks about 25 minutes, calculating 4–5 minutes per ½ in. / 1 cm of thickness. Take the skillet out of the oven, cover with aluminum foil, and leave the steaks to rest for a short while.

To make the chive butter, peel and finely chop the shallots. Wash and shake dry the chives, then finely snip half of them. Melt the butter in another skillet. Add the shallots and sliced chives to heat through, then season with salt; remove and set aside. Fry the remaining chive stems over high heat in the fat remaining in the skillet.

To serve, cut the meat into finger-width strips and plate with the fried chives. Generously ladle chive butter over the strips of steak and sprinkle with the kosher salt and the lemon zest.

Tubercules en Folie (Tubers of Madness)

INGREDIENTS SERVES 4

1 lb. 4 oz. / 600 g at least
3 mixed root vegetables—
parsley roots, carrots of
all colors or with green
tops, orange-fleshed
sweet potato, celery roots,
truffle potatoes, parsnips
salt and pepper
½ bunch lovage
1 lb. 2 oz.–1 lb. 4 oz. /
500–600 g butter
1 organic lemon

TIME NEEDED:
15 mins. + 40 mins. cooking

METHOD LEVEL OF DIFFICULTY: EASY

Heat a convection oven to 325°F / 160°C (gas and convection ovens not recommended).

Wash, scrub, and pat dry the vegetables, then cut them into smaller pieces, if you like. Arrange the vegetables by variety close together in a shallow baking dish. Season with salt and pepper, and add the lovage.

Melt the butter and pour it over the vegetables (the vegetables should be two-thirds covered). Wash, rub dry, and slice the lemon. Place the lemon slices on the vegetables. Roast the vegetables about 40 minutes, turning them occasionally.

To serve, lift the vegetables out of the butter, plate them up, and drizzle with some of the brown butter.

TIP: Chill or freeze the remaining vegetable roasting butter and use for another dish.

Dessert: L'es-tu ? (Is it you? Or: a nonalcoholic cocktail)

INGREDIENTS SERVES 4

1 organic lime
2 acidic apples
2 pink grapefruit
1 small fresh red chili
salt
2 tbsp. honey
1¼ cups / 300 ml milk

TIME NEEDED:
20 mins.

METHOD LEVEL OF DIFFICULTY: EASY

Wash and rub dry the lime, then grate 1–2 teaspoons of the zest and squeeze out the juice. Wash and quarter the apples, then seed and roughly chop them. Peel the grapefruit, being sure to remove the bitter white pith, and roughly chop the flesh. Wash the chili, halve it lengthwise, and seed. Finely puree the chili with the apples and the grapefruit. Flavor with lime juice, a pinch of salt, and honey. Chill.

To make the milk froth cap, heat the milk and finely froth it up. This is easiest with a milk frother.

Transfer the fruit puree to glasses and place a cap of froth on top of each one. Sprinkle with the lime zest and serve immediately.

TIP: Hide a ball of ice cream in the drink before adding the froth cap. Do not remove the segment membranes when peeling the grapefruits—they are packed with flavonoids, phytochemicals that have an antioxidant effect and protect our cells.

Pêches et Chèvres Hurlant de Tristesse (Peaches and Goat Cheese Howling with Sadness)

INGREDIENTS SERVES 4

4 firm, ripe peaches
32 small fresh bay leaves
For the filling:
½–1 tsp. rosemary needles
3 wheels firm goat cream
 cheeses, such as Picandou
crushed pepper
2–3 tbsp. slivered almonds
2 tbsp. / 30 g butter for
 greasing the skillet
2 tsp. honey
3 tbsp. peach-flavored liqueur
For the "sadness":
9–10 oz. / 250–300 g wild
 blueberries
2 sachets Bourbon vanilla
 sugar (store bought)
½ tsp. clear glaze powder

TIME NEEDED:
25 mins. + 20 mins. cooking

METHOD LEVEL OF DIFFICULTY: MEDIUM

Wash and pat dry the peaches, then halve them and remove the pits. Using a melon baller, enlarge the hollows a little. Put 2 bay leaves into each peach half.

Heat the oven to 375°F / 190°C (Gas 5; convection ovens 350°F / 170°C). To make the filling, very finely chop the rosemary needles. Using a fork, combine the goat cream cheese, pepper, and rosemary. Transfer the mixture to the peach hollows. Lightly press the slivered almonds into the filling, which stops the cheese from running out as it melts.

Heat the butter in an ovenproof nonstick skillet. Place the peaches in the skillet with the filling side down and fry until golden-brown, then turn over. Divide the honey among the peaches and drizzle with the peach liqueur. Cover the skillet and bake the peaches about 15 minutes, or until tender.

Take them out of the skillet and transfer them to dessert plates, with the filling side down. Garnish with the remaining bay leaves.

To make the "sadness," toss the blueberries and the vanilla sugar in a skillet and heat through. Stir the glaze powder into very little water, then stir into the skillet and bring to a boil. To serve, pour the blueberries over the peaches.

TIPS: Use canned wild blueberries for the "sadness." Cultivated blueberries are too light. A good substitute are blackberries. Instead of glaze powder, you can also use the natural gelling agent xanthan. If the skillet's handle is not ovenproof, wrap two layers of aluminum foil around it and press on tightly to protect it from the heat.

• GRAND FINALE: PEACHES AND GOAT CHEESE As Madame de Rothschild had it eternalized on the menu: "Peaches and Goat Cheese Howling with Sadness." The halved peaches are sautéed in butter, filled with goat cheese, then flavored with honey and peach liqueur. The sadness in this case is a sauce of blueberries and vanilla sugar; *L'es-tu ?* is a drink of lime juice, grapefruit, apples, and chili, topped with a milk foam crown.

EINLADUNG

WIR FEIERN AM 29 NOV. 1924
. SONNABEND

ILMSCHLÖSSCHEN

OBER-WEIMAR

DAS 5 JÄHRIGE

BEGINN PUNKT 8ᴴ ABENDS

BESTEHEN

BAUHAUSᴇs
DES

AUTOBUS VERKEHR BAUHAUS-KANTINE
ILM SCHLÖSSCHEN
⁷⁄₂₇–₄³⁸

ZUR DECKUNG DER UNKOSTEN DER KAFFEE TAFEL USW...
WERDEN IN DER KANTINE (BAUHAUS) UND ABENDS AN SAAL—
EINGANG KARTEN ALS AUSWEIS AUSGEGEN:
VON 3.50MK AB IST DER GEBE FREUDIGK EIT KEINE
GRENZE GESETZT ● WIR BITTEN UM NACHRICHT — 28.XI

PROGRAMM: 8–9 REFLEKTOR. FARBENSPIELE

9–10³⁷ PREMIERE DER
BAUHAUS BÜHNE GRUPPE B

10³⁸–11⁰³ KAFFEE - TAFEL

11⁰⁷–? TANZ-TOMBOLA U.S.W.

SIE SIND HERZLICH EINGELADEN
I·A· Joost Schmidt

Bauhaus Art School

THE PARTY AS A WORK OF ART

Their parties were creative and wild—as any good party should be. Whether it be "dragon," "white," or "metallic" parties— the illustrated invitations, the decorations, and the elaborate costumes were as fanciful as the occasions themselves. In the 1920s, there was one thing the avant-garde school valued above all else: transcending the boundaries between everyday life and celebration, between life and art.

• OPPOSITE The five-year anniversary of the Weimar Bauhaus was celebrated at the Ilmschlösschen tavern on November 29, 1924; the poster was designed by Joost Schmidt, a typographer, painter, and teacher at the Bauhaus.
• ABOVE Avant-garde designs made of wood, leather, wire, aluminum foil, and celluloid: The Triadic Ballet danced in costumes created by Oskar Schlemmer, who was in charge of the theater department and experimental stages at the Dessau Bauhaus from 1925.

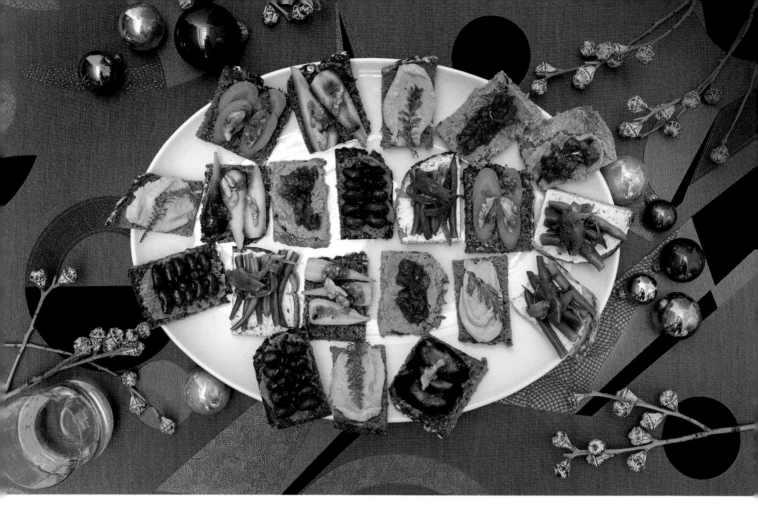

• A FEAST FOR THE EYES: BAUHAUS-STYLE OPEN SANDWICHES Whole wheat bread topped with steamed carrots and Walnut Pesto; toasted spelt bread with green Pea Spread; open-faced sandwiches topped with marinated kidney beans, green beans, and pickled onions.

A proper party is much more than just a party. It brings together all of life's evolutionary lineages like rays on a burning glass, where all rules and certainties dissolve, giving rise to a new life. If anyone knew how to do this, it was the founders of the Bauhaus. After all, the mere existence of their institution was a party in itself. Having escaped the bleakness of World War I, a creative new generation was starting to gather around a handful of groundbreaking artists, intent on designing a new world. A fairer, more peaceful, more fanciful world. Right from the outset, the defining lines between artists were transcended, and hierarchies disbanded. Students and teachers became friends, art and craft fused into one, while architecture and design, painting and theater, found new forms of expression. Above all, however, it was the boundary between life and work that fell away. As early as 1918, Bauhaus Art School

• RIGHT The Bauhaus parties were a dazzling firework display of creativity; even the cold platters of open sandwiches resembled geometric works of art.

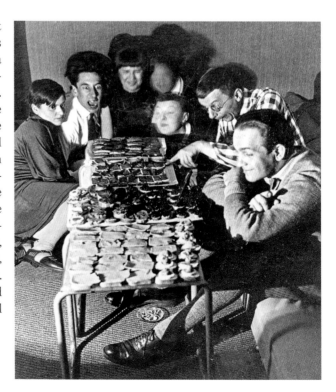

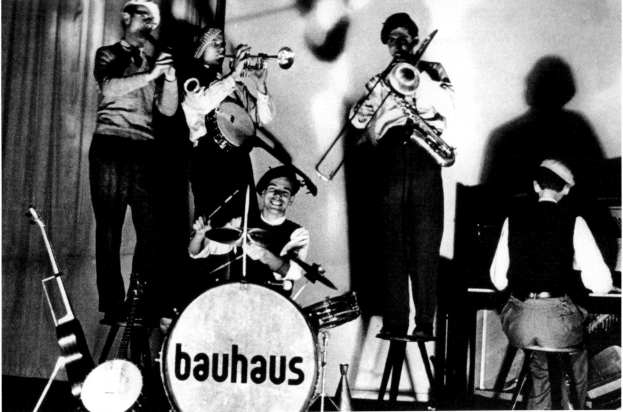

• TOP The Meisterhaus Feininger, designed by Walter Gropius and built 1926–28.
• ABOVE The Bauhaus band became an institution.

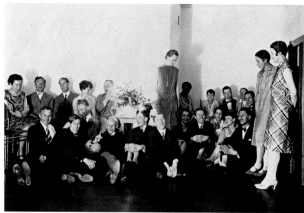

founder Walter Gropius was quoted as saying "Perhaps an artist's calling is instead to live and breathe an artwork, rather than create it."

In other words, fantasy and imagination were not simply consigned to the studio. The idea was for creativity to exist everywhere, all the time. As such, the Bauhaus parties were not a diversion from everyday life; they were a central part of life, which itself was a creative piece of work. It might, indeed, have been these parties—that teased out the best aspects of the Bauhaus—that enabled the Bauhaus to work in the first place. Because there was constant friction between the creative minds. Gropius' wife, Ise, wrote about this in her diary: "My husband had discovered that the best way of tackling these problems was to throw a party. It was like a catharsis, a cleansing, like a storm, after which the air has been cleared. People laughed about others, made jokes. And that was most definitely a pedagogical goal."

Fun rather than pressure, liberation through laughter was the principal ethos. Bauhaus student Xanti Schawinsky wrote the following in 1924: "We dance all night. We work all night if we don't get it done during the day." Even "Old Master" Johannes Itten, who had earned a reputation of being an ascetic and advocate of meager lentil-based meals during the Bauhaus' early days in Weimar, understood the importance of revolutionary vitality. "Play becomes party, party becomes work, work becomes play," was his motto. And there was always a reason to party, be it the arrival of new seasons, Christmas, or, indeed, the completion of an attractive, elaborate rug. One occasion in particular was always celebrated with great abandon: Walter Gropius' birthday on May 18, when people vied to outdo one another with witty gifts, feting the master and carrying him around the room amid cheers and hurrahs.

Whenever creative minds come together, it inevitably becomes a competition of who can be the most imaginative and inventive. "There were no limits as to how original a costume idea could be, and people worked on their creations as intensively as if it were a matter of life or death. When Wassily Kandinsky then appeared sporting a giant beard, Paul Klee with a handlebar moustache, and Gropius performing his magnificent, breakneck nose-dive, it seemed, given the mood of enjoyment, that the work had more than paid off," recounted Xanti Schawinsky.

The Bauhaus band was another institution, bringing

• TOP A 1986 reproduction of Walter Funkat's glass ball. It is based on the 1929 design for the Metal Party.
• MIDDLE Going-away party for Georg and El Muche in Dessau. Guests included Ise and Walter Gropius, Nina and Wassily Kandinsky, and Paul Klee.
• LEFT The invitation to the 1922 Lantern Party was a mini work of art.

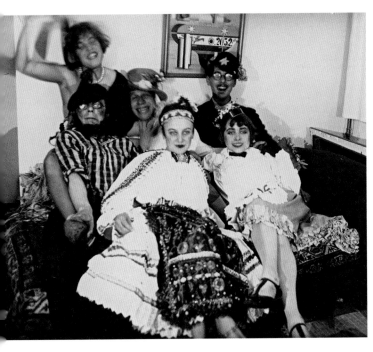

• ABOVE Party time in Dessau, from the left Käthe von Achenbach, Joost Schmidt, Xanti Schawinsky, Otti Berger, Herbert Bayer, and Gunta Stölzl.

musicians to Berlin and elsewhere. Unfortunately, no recordings have been preserved, but, by all accounts, the band led by Andor Weininger must have made for a great atmosphere: Playing double basses, brass, and all kinds of homemade instruments, the young men would get the crowd dancing, busting out traditional heart-warming Eastern European and Jewish melodies with wild, modern jazz rhythms. Anything and everything was used to create sound—every noise could be turned into music; even revolver shots were incorporated.

Forget the categories of "party," "art," "craft," "performance," and "music"—what was happening in the Bauhaus was, as László Moholy-Nagy put it, a "complete oeuvre." One of the legendary Bauhaus parties, the Metal Party in February 1929, ceased to distinguish between guests and artists, party and performance, or life and theater. The Bauhaus itself became a performer at a large, ebullient event that had taken great effort to prepare: The entire building glinted, gleamed, and sparkled, with metallic paper in its

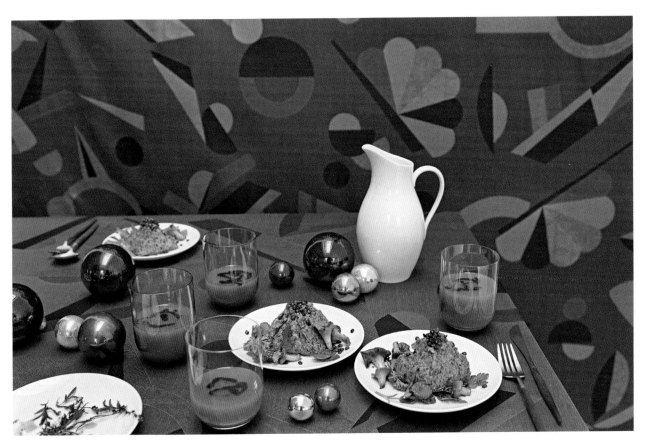

PYRAMIDS OF PUREED LENTILS Long, elaborate menus were not a feature of Bauhaus parties—they were too conventional! Johannes Itten, indeed, preferred simple lentil-based meals. But the food wasn't always that ascetic, sometimes consisting of dishes such as Parsley Salad and Fried Mushrooms. It was served on the classic Urbino tableware designed by Trude Petri for KPM in New Objectivity style.

windows, and ceilings were hung with reflective balls of all shapes and sizes. When the guests danced, their bodies were reflected in distorting mirrors made of bent sheet metal. Metal was the material of the future, and this was an homage to it. Everyone had to wear something metallic. One female Bauhaus member arrived in a tin-foil outfit with a wrench around her wrist, and some of the gentlemen were occasionally asked to retighten the screws on her costume. The staircase jangled and clattered, each step ringing out a different noise. Guests, including the lord mayor of Dessau, could only access the ballroom via a metal slide—their zippy arrival greeted with a fanfare.

The culinary side of the festivities similarly strayed from the tight-laced conventions of the time, with one photo showing several happy Bauhaus members sitting around lavish cold platters of creative canapés. There were also gingerbread cookies, which had been artistically molded into dancing figures and wild, fanciful animals. Multi-course menus and sumptuous buffets were not as much of a focus, for they would have kept the guests from dancing, playing music, and improvising, and impeded them from indulging in all the witty, eccentric buffoonery they so enjoyed. And in any case, all the dishes were needed elsewhere that night in 1929, their rounded shapes glinting silver as they adorned the walls of the Bauhaus.

• NO BOUNDARIES BETWEEN ART AND EVERYDAY LIFE: GINGERSNAP FIGURES Textile artist Gunta Stölzl took charge of the weaving mill at the Dessau Bauhaus in 1927—and she loved shaping gingersnap dough into fanciful figures whenever a big party was to be held. The figures can today still be admired in the Bauhaus Archive, and can, of course, serve as inspiration for others.

Whole Wheat Bread with Carrots and Walnut Pesto

INGREDIENTS SERVES 6

For the walnut pesto:

⅔ cup / 100 g walnut halves,
 plus 6 extra, to garnish
2 garlic cloves
2–3 sprigs parsley or
 cilantro
½ small red chili
⅔ cup / 150 ml canola oil,
 plus 1 tbsp. extra
salt and pepper
1 tbsp. lemon juice
1 tsp. coriander seeds
1 tsp. cumin seeds
For the topping:
9 oz. / 250 g multicolored
 carrots
6 slices whole wheat bread
1 tbsp. canola oil

TIME NEEDED:
35 mins. + 8 mins. cooking

METHOD LEVEL OF DIFFICULTY: EASY

To make the walnut pesto, dry-fry the walnut halves in a skillet without fat. Halve 6 walnut halves lengthwise and set aside for the topping. Peel the garlic and briefly blanch it in boiling water, then drain. Wash and pat dry the parsley, then pull off and chop the leaves. Wash the chili, halve it lengthwise, and remove the seeds. Puree all the prepared ingredients, but not too finely, with the oil, salt and pepper, lemon juice, coriander, and cumin in a blender, or pound them with a mortar and pestle.

Scrub or very thinly peel the carrots, then steam them 8–10 minutes in a steamer, or use a covered wire strainer suspended above boiling water. Leave to cool, then cut up depending on their size and your preferences. Sprinkle with salt and set aside.

Spread the bread with the pesto, reserving a little, and top with the carrots and the walnut pieces.

Stir the extra oil into some of the reserved pesto to make it runnier, then drizzle it over the bread toppings. Serve the remaining pesto separately, or cover and store about 1 week in the refrigerator.

TIPS: Cut the carrots into slices or strips or grate them, as you prefer. Instead of carrots, you can also use radishes, kohlrabi, or beets.

Whole Wheat Bread with Green Beans and Glazed Shallots

INGREDIENTS SERVES 6

7 oz. / 200 g green beans
 (alternatively runner
 beans
salt
6 slices whole wheat bread
For the glazed shallots:
4 large shallots
1 tbsp. canola oil
1½ tsp. granulated sugar
3 tbsp. white or red wine
 vinegar
salt and pepper
1–2 tsp. honey
For the topping:
1–2 tbsp. capers with brine
2 sprigs parsley
a dash Tabasco sauce
4–5 tbsp. / 60–80 g full-fat
 cream cheese or sour
 cream

TIME NEEDED:
35 mins. + 10 mins. cooking

METHOD LEVEL OF DIFFICULTY: EASY

Trim the beans and cook them in well salted, boiling water about 10 minutes. Rinse and put in iced water to stop the cooking, then drain.

To make the glazed shallots, peel and slice the shallots. Heat the oil with the sugar in a skillet. Add the shallots and toss until golden-brown. Add the vinegar and cook until the liquid has cooked away. Season with salt and pepper and honey.

To make the topping, strain and coarsely chop the capers. Rinse the parsley, shake dry, and chop the leaves. Stir the capers, a little of the caper brine, the parsley, and the Tabasco into the cream cheese. Add a little salt, if needed.

Spread the bread slices with the cream cheese, then cut them into portions. Cut the beans to match the size of the bread slices and put on top. To serve, cover with the glazed shallots and season again with pepper.

Whole Wheat Bread with Turmeric Bean Cream

INGREDIENTS SERVES 6
6 slices whole wheat bread
2–3 tbsp. olive oil, plus
 extra, to drizzle
1 large garlic clove
For the turmeric bean cream:
9 oz. / 250 g navy beans,
 cooked and drained
2 garlic cloves
1 tbsp. lemon juice
1–2 tsp. ground turmeric
5 tbsp. whole Greek-style
 yogurt
salt and pepper
To serve:
tender shoots of yarrow
a little olive oil

TIME NEEDED:
30 mins.

METHOD LEVEL OF DIFFICULTY: EASY

Lightly brush the bread slices with the oil and toast in under the broiler or in a skillet until crisp. Peel and halve the large garlic clove and rub it over the bread while still hot.

Puree or squash with a fork all the ingredients for the turmeric-bean cream and season generously with salt and pepper.

To serve, cut the bread slices into smaller portions, spread copiously with the creamy bean mixture, top with mugwort, and drizzle with a few drops of oil.

TIP: Yarrow, also known as *plumajillo*, can be found in gardens and by the side of fields or roads until early in the winter if the weather is mild. Do not pick the herb from very busy roadsides. As an alternative, bitter winter salad leaves can be used, as well as arugula, flat-leaf parsley, or chives.

Whole Wheat Bread with Marinated Beans

INGREDIENTS SERVES 6
9 oz. / 250 g cooked red
 kidney beans
1–2 tbsp. olive oil
1 tsp. medium-hot mustard
2 tbsp. lemon juice
1 tbsp. summer savory
salt and pepper
6 slices whole wheat bread
a little cranberry balsamic
 vinegar
a little cranberry compote

TIME NEEDED:
25 mins. + cooking + 30 mins.
marinating

METHOD LEVEL OF DIFFICULTY: EASY

Reserve some whole beans for the garnish and use any broken beans for pureeing.

Beat together the olive oil, mustard, and lemon juice. Chop the savory. Season generously with savory and salt and pepper. Add the beans and marinate about 30 minutes. Strain, reserving the marinade.

Puree or squash the beans and the reserved marinade with a fork. Spread the bread slices with the pureed beans and cut the bread into smaller pieces. Decoratively arrange the whole beans on top. To serve, drizzle with vinegar and cranberry compote.

Toasted Whole Wheat Bread with a Pea Spread and Tomato Tartare

INGREDIENTS SERVES 6
For the pea spread:
10 oz. / 300 g frozen peas
a pinch baking soda
1½–2 tbsp. balsamic vinegar
2 tbsp. olive oil, salt
For the tomato tartare:
5 oz. / 140 g ripe tomatoes
3 dried tomatoes in oil
1 red onion
1–2 sprigs mint
salt and pepper
1 tsp. harissa paste
6 slices whole wheat bread,
 toasted

TIME NEEDED:
35 mins.

METHOD LEVEL OF DIFFICULTY: EASY

To make the pea spread, put the peas and baking soda Into u saucepan of boiling water and blanch briefly. Drain, rinse In iced water, and drain again. Puree the peas in the food processor together with the vinegar, oil, and salt.

To make the tomato tartare, wash, drain, and halve the tomatoes, then squeeze out the seeds. Drain and finely chop the dried tomatoes. Peel and finely chop the onion. Wash and shake dry the mint, pull off the leaves, and thinly slice. Combine both types of tomato and the chopped onion. Season generously with salt, pepper, harissa, and mint.

Cover the toast slices with the pea spread, then halve the slices. Pile the tomato tartare on top.

TIP: If you like, serve the bread with fine strips of winter salad leaves, seedless grapes, or passion-fruit seeds as well.

Nonalcoholic Drink: Apple and Pear Drink with Rosehip Tea

INGREDIENTS SERVES 6
2–3 large acidic apples
2 large winter pears
1 organic lemon
2 cups / 500 ml rosehip tea
2–2½ tbsp. honey
To serve:
a little blueberry syrup
ice-cold carbonated mineral
water, optional

TIME NEEDED:
20 mins. + 15 mins. cooking

METHOD LEVEL OF DIFFICULTY: EASY

Peel, quarter, and core the apples and pears. Brush the lemon under hot water, then halve it lengthwise. Cook the apples, pears, and lemon with the rosehip tea until all the fruit is tender. Discard the lemon. Puree the apples and pears with the honey until very smooth. Leave to cool.

Transfer the mixture to glasses and add a dash of the syrup. Top with mineral water, if liked.

TIP: The pears give this drink a very fine, creamy consistency. Alternatively, you can use quinces. Instead of the lemon, try adding an orange for flavor. Tropical ingredients, such as gingerroot and chilies, also add a touch of excitement to this drink.

Dessert Cake: Lemon Petits Fours with Marzipan and Silver Glaze

INGREDIENTS MAKES 1 PAN
For the batter:
4 organic lemons
1 cup /100 g ground
blanched almonds
scant 1 cup / 100 g cornstarch
2½ tbsp. all-purpose flour
2 tsp. baking powder
1 stick / 120 g butter, softened
¾ cup / 150 g granulated
sugar
4 eggs, at room temperature
3 tbsp. slivered almonds
2 tbsp. quince jelly
about ½ roll ready-to-use
marzipan (store bought)
1 small organic egg white
1¼–1⅔ cups / 150–200 g
unsifted confectioners'
sugar
To decorate:
pastry silver dust

TIME NEEDED:
60 mins. + 40 mins. baking
+ time for drying

METHOD LEVEL OF DIFFICULTY: MEDIUM

Crumple up some parchment paper that has been cut to the size of a 12–12¾ in. / 30–32 cm diameter cake pan, then smooth it again and use to line the pan. (This is so the moist cake will not stick to the pan after baking.). Heat the oven to 300°F / 150°C (Gas 2; convection ovens not recommended).

Wash and pat dry the lemons. Finely grate the zest of 3 lemons. Peel the 3 lemons so all the white pith is removed. Cut out the lemon segments between the membranes, then and finely chop them, catching the juice. Combine the grated lemon zest with the almonds, cornstarch, flour, and baking powder. Squeeze the juice from the remaining lemon.

Beat the butter and the sugar until it is foamy and the sugar has dissolved. Stir in the eggs, one at a time. Fold in the flour and almond mixture, then stir in the chopped lemon, lemon juice, and slivered almonds. Transfer the batter to the lined cake pan and bake 35–40 minutes on the middle rack. Remove the cake from the oven and leave on a wire rack 10 minutes, before turning out and peeling off the lining paper. Leave to cool completely on the rack.

Stir the quince jelly until smooth and brush the cake with it. Unroll the marzipan and cut it to the cake's diameter. Place on top of the cake and gently press down.

Beat the egg white until not completely stiff. Sprinkle the confectioners' sugar over and beat to make an airy frosting. Spread onto the cake and smooth, leaving the edge of the cake free. Cover with the silver decoration. Leave the frosting to set overnight, if possible.

To serve, cut the cake into square, bite-size pieces or into tiny wedges, rectangles, or triangles.

TIPS: Bake a day before serving, so the cake develops a particularly intense flavor. Well wrapped, the cake will keep at least one week in the refrigerator.

• DANCING WOMEN AND WILD BEASTS FOR THE FEAST Artful pastries by weaver and textile designer Gunta Stölzl.

Lentil Puree with Mugwort and Chanterelles

INGREDIENTS SERVES 6

For the parsley vinaigrette:
4 sprigs curly parsley
5 tbsp. vegetable oil
3 tbsp. white wine vinegar
salt
For the lentils:
2¼–2½ cups / 450–500 g
* lentils (cooked)*
1 onion
2½ tbsp. nut butter
2 sprigs mugwort
* (alternatively marjoram)*
3 juniper berries
7 tbsp. sour cream
salt
For the chanterelles:
10 oz. / 300 g chanterelles
1–2 tbsp. / 15–30 g butter
salt and pepper
For the parsley salad:
3 sprigs each curly and flat-
* leaf parsley*
1–2 tbsp. olive oil
fleur de sel, crushed pepper
small sprigs roasted mugwort,
* to garnish, optional*

TIME NEEDED:
50 mins. + cooking the lentils
+ 15 mins. cooking

METHOD LEVEL OF DIFFICULTY: MEDIUM

To make the parsley vinaigrette, wash and shake dry the parsley, pull off the leaves and quickly blanch them in boiling water, then drain. Puree together with the oil and the vinegar, then season with salt.

Strain the cooked lentils, catching the cooking water. Set half the lentils aside and keep hot. Peel and chop the onion. Melt the nut butter in a skillet, add the onion, and sauté.

Rinse and shake dry the mugwort, then pull off the leaves. Crush the juniper berries. Puree the remaining half of the lentils with the onion and nut butter mixture, the mugwort, juniper berries, and sour cream, adding enough of the lentil cooking water to give the puree a soft consistency. Set aside 3–4 tablespoons of the hot lentils; fold the rest into the puree and season generously. Keep warm.

Clean the chanterelles, then cut them into smaller pieces depending on their size. Melt the butter in a skillet over high heat. Add the chanterelles and fry, then season with salt and pepper. Keep warm.

To make the parsley salad, rinse and shake dry both kinds of parsley, then pull off the leaves. Combine with the oil and fleur de sel, and crushed pepper to taste.

To serve, divide the lentil puree into portions and shape each portion as a pyramid. Serve with the chanterelles and the parsley salad. Sprinkle with the remaining lentils and drizzle with the parsley vinaigrette. Garnish with roasted mugwort, if liked.

TIPS: For this lentil dish, brown, yellow, red, mountain, Puy, and Beluga lentils are all suitable. Make sure you read the package directions, because cooking times vary from one type to another.

Outside the chanterelle season, brown mushrooms, shiitake, or other strongly fl avored cultivated mushrooms can be used.

Decorative cookies: Bauhaus Gingerbread Cookies

INGREDIENTS

MAKES 12–14 COOKIES
1⅓ cups / 250 g honey
5 tbsp. / 75 g margarine
1½ eggs
½ cup / 100 g granulated
* sugar*
½–1 envelope gingerbread
* cookie mix*
scant 1 tbsp. unsweetened
* cocoa powder*
4¼ cups + 2 tbsp. /
* 550 g white spelt flour*
1 tsp. / 5 g potassium
* carbonate*
1 tsp. ammonia baking
* powder*
To decorate:
1 egg white
2–2½ cups / 240–300 g unsif-
* ted confectioners' sugar*
food coloring
sugar pearls
superfine sugar
edible silver/gold decoration

TIME NEEDED:
70 mins. + 15 mins. baking
+ 12 hours chilling

METHOD LEVEL OF DIFFICULTY: DIFFICULT

Heat the honey and the margarine, then leave to cool to lukewarm. Beat the eggs with the sugar until foamy. Combine the gingerbread cookie mix with the cocoa powder and the flour. Stir the potassium carbonate and the ammonia baking powder into 1 tablespoon cold water.

Add all the ingredients to a food processor and knead with the kneading hooks, then knead with your hands to make a smooth dough. Cover and chill overnight.

Cut out templates to make the figures. Heat the oven to 400°F / 200°C (Gas 6; convection ovens not recommended). Place the dough on parchment paper, cover it with plastic wrap, and roll out to about ¼ in. / ½ cm thick. Place the templates on top, ¾ in. / 2 cm apart, and cut out with a small, sharp knife. Give the figures shape and profile by pressing into the dough. They hold their shape while baking and this makes decorating easier. Gently remove excess dough, then do not move the figures on the parchment paper again so they keep their exact shape. Bake about 15 minutes. Transfer to a wire rack and leave to cool.

To make the decoration, lightly whisk the egg white, sprinkle in the confectioners' sugar, and continue whisking until airy. Divide the frosting into portions and color each one to the desired color. If the mixture is too firm after it has been colored, stir in a few drops cold water. Make small pastry bags from parchment paper and use to pipe the contours, then use a brush to apply frosting on larger areas. While still moist, decorate with sugar pearls, superfine sugar, and edible silver or gold decoration as liked. Leave the frosting to dry completely, then store in a cookie jar until ready to serve.

TIPS: Reroll out the excess dough and use to shape and bake more cookies. Potassium carbonate, also known as potash or pearlish, is a traditional German gingerbread baking ingredient. You can substitute ½ teaspoon of baking soda for every teaspoon of potassium carbonate.

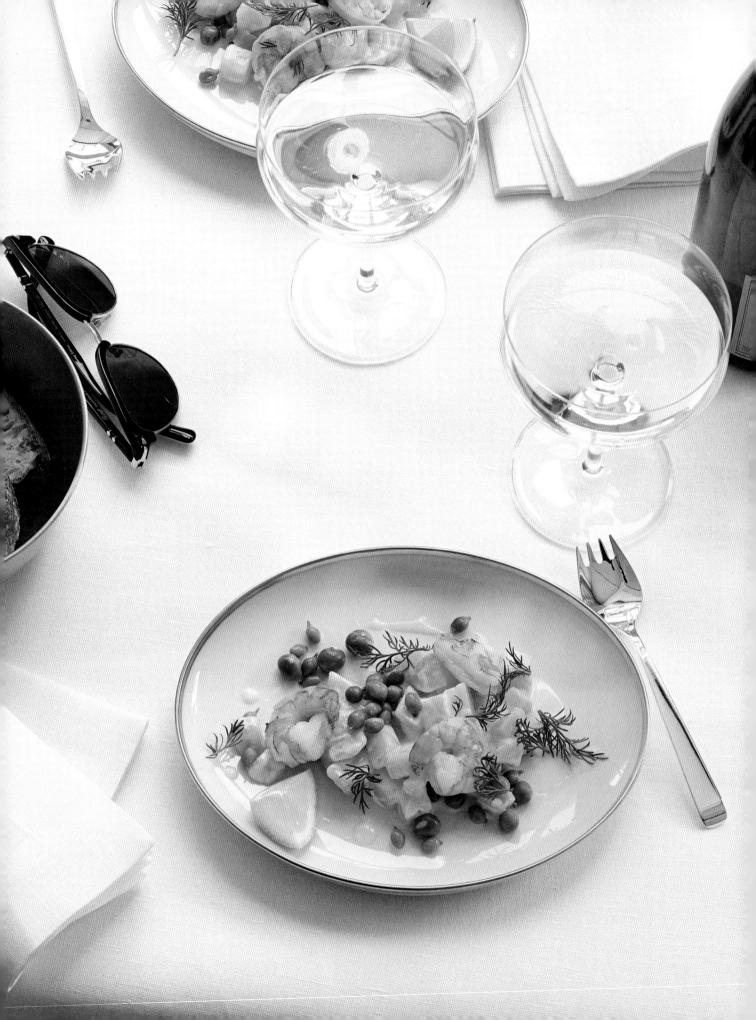

Michael Romanoff

A DAZZLING SWINDLER

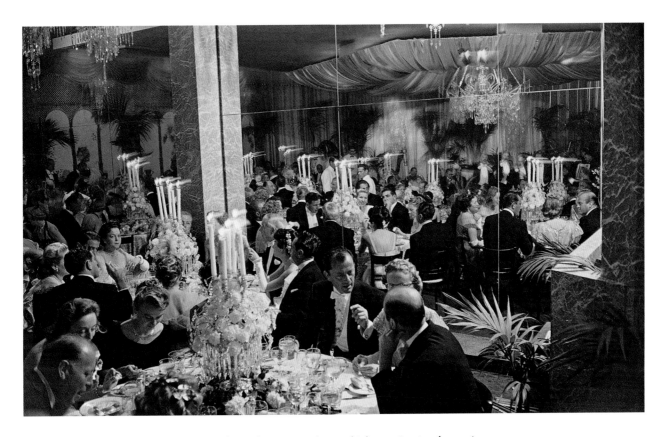

He migrated on his own from Lithuania to America as a
ten-year-old, and spent some time in England, before returning
to the United States as a supposed Russian prince. A conman
whose game was seen through but adored by high society.
The talented Münchhausen-esque character eventually opened
"Romanoff's" restaurant in Beverly Hills, and his flair for
glamour and splendor saw it gain legendary status.

• OPPOSITE: SHRIMP À LA RUSSE A potato salad, the warm potatoes are dressed with white wine and a simple
mayonnaise and topped with sweet prawns, blanched baby peas, and dill for serving.
• ABOVE: FINE DINING IN HOLLYWOOD Romanoff's, in Beverly Hills, was one of the hotspots for stars, starlets, and directors during the
1940s and '50s—everyone loved the restaurateur, who had previously been one of the most notorious conmen in American history.

One fine day in December 1940, Hollywood's biggest stars received the following elaborately worded invitation: "I am commanded by His Imperial Highness Prince Michael Alexandrovich Dimitri Obolensky-Romanoff to request your presence at a soiree he is giving in his own honor. Cover fifty dollars. Bring your own wine, and kindly fee the waiter. Harry Gerguson, Comptroller to the Imperial household."

Stars and starlets, directors, film producers, and the media flocked to accept the rather brazen invitation to open Romanoff's restaurant, in Beverly Hills. They drank the wine they had brought themselves, and dutifully paid the eye-watering price for the first two courses (which had secretly been procured from a nearby snack bar).

To lease the restaurant and fit it out with tables, plates, glasses, and flatware—it still didn't have a kitchen at the time of opening—stars such as Charlie Chaplin and

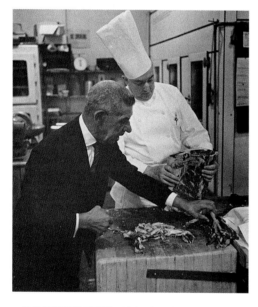

• THE RESTAURATEUR with his head chef.

Cary Grant bought shares in the host's business-to-be for a total of $7,500. They admittedly didn't expect to see a return on their investment, for Prince Michael Romanoff, the new owner of his eponymous restaurant, was not only their friend, but also Hollywood's most entertaining conman—a charming fraudster who had been scrounging off America's illustrious society for almost two decades. And, of course, he wasn't a prince.

Nobody had expected the little man with a pencil-thin moustache—who was never seen in anything other than a three-piece suit with monocle and cane, who spoke English with an exaggerated Oxford accent, and who called working men "pack animals" and "dromedaries"—to ever get his own hands dirty through an honest day's work.

Born in a village in Lithuania, as Hershel Geguzin, he emigrated to New York as a parentless ten-year-old and Americanized himself as Harry Gerguson, later claiming to supposedly be the offspring of either the Vanderbilt or Rockefeller families, graduating from Eton College, Harvard, Oxford, Columbia, or Heidelberg, and, finally, sometimes the cousin or son of the last tsar of Russia. After all his adventures and now in his mid-fifties, Michael "Mike" Romanoff had obviously had enough of fudging his way through life. In his view, every good restaurant needed a French chef. And a very modest one, for he himself would of course be the main attraction. There was enough money left over from Romanoff's opening night to afford a kitchen—and the French chef.

By the time Romanoff had moved to Hollywood a few years prior, he was already well known right across America. A Russian military major, who knew the real Prince Romanoff, had blown his cover at a party, but this had only made him and his Münchhausen-esque feats even more popular. *The New Yorker* magazine featured a five-part portrait on his life, and MGM secured the movie rights to his story.

That story began with a ten-year-old Harry Gerguson, who grew up in various New York orphanages before sailing to England in a cargo ship at the age of nineteen. He pressed trousers in Oxford, where he learned Oxford English and studied the style and habits of the upper class. Hosting a party as a supposed British aristocrat, and spending much more money on it than he actually possessed, landed him in jail for the first time. He would find himself behind bars on several other occasions in years to come. His path through life was one of bounced checks and unpaid bills. Before any more prison sentence could be pronounced, he fled back to the United States, where he effortlessly eased his way into high society as a supposed Russian prince. Princes—particularly a close relative of the tsar—were considered very distinguished guests at exclusive clubs and salons. His game enabled him to experience phases of luxury, when he indulged in the most expensive wines and food. At other times, however, he was homeless, even having to spend several weeks in hospital due to malnutrition.

He came up with the idea of trying his luck in Hollywood on the West Coast in the mid-1930s, and was welcomed with open arms. His growing fame—he remained a darling of the press—once again helped him secure invites to galas and premieres. The people of the film industry understood better than anyone his desire to slip into new identities. They all knew the "prince" was a fraudster, and had fun pretending they didn't. Wasn't an exceptionally gifted conman much more entertaining than a mediocre

• ABOVE: THE PRINCE OF BEVERLY HILLS Michael "Mike" Romanoff playing a game of chess with Humphrey Bogart. Lauren Bacall and actor Bob Coote watch on.
• BELOW RIGHT Among the legendary parties to be held at Romanoff's was one thrown in honor of Sophia Loren in 1957, at which Jayne Mansfield (right) also appeared in memorable fashion.

aristocrat? As Alistair Cooke, a British journalist based in America, once described the scenario: "He did not pretend to be Prince Michael Romanoff of Russia. He pretended to be a great comic pretending to be Prince Michael Romanoff of Russia."

But Romanoff's financial circumstances continued to deteriorate, and he had to travel far and wide to find a restaurant or hotel where he could still pay with his bouncing checks. Perhaps that was why he heeded his friends' advice to simply open his own restaurant instead.

Located on what was then a rather sleepy Rodeo Drive, Romanoff's became the new in place for Hollywood's high society from day one. Images of illustrious personalities, including many portraits of the host himself, hung on the colorfully papered walls. Elegant booth areas were reserved for regular patrons near the bar, and the menu also catered perfectly to guest tastes, with steaks and turkey proving particularly popular. The restaurant became known for its chocolate soufflé and the Strawberries Romanoff dessert, for which the berries are soaked in orange-flavored liqueur and served with soft-serve vanilla

• ABOVE: HOSTING HOLLYWOOD'S A-TEAM A New Year's Eve party at Romanoff's, 1957—from left: Clark Gable, Van Heflin, Gary Cooper, and James Stewart enjoying themselves at the bar.
• OPPOSITE: NEW YORK CUT STEAK WITH BORDELAISE SAUCE A Manhattan (rump) steak with a sauce made from shallots, beef broth, and red wine. It is served with broccoli, hollandaise sauce, and grilled tomatoes.

ice cream and whipped cream. The Pasta à la Romanoff, with its green asparagus and strawberries, also became an instant classic.

At table number one, Humphrey Bogart ordered the same lunch every day: two whisky sodas, an omelet, French toast, milk, and a coffee with brandy. Romanoff himself sat at one of the best tables on a daily basis, accompanied by his two bulldogs, Socrates and Confucius, who had cloth napkins tied around their necks, and effectively dined at the set table itself. Frank Sinatra, Sammy Davis Jr., Dean Martin, and Shirley MacLaine—members of the Rat Pack—invented the name of their legendary clique at the bar; Alfred Hitchcock, Billy Wilder, Clark Gable, and Cole Porter were other frequent guests. Movie companies such as MGM hosted dinners after premieres at the restaurant, including the one for *The Seven Year Itch*, starring Marilyn Monroe, who soon also started making appearances at Romanoff's. Lucille Ball danced the rumba here, and Joan Crawford the Charleston. Sophia Loren was snapped one evening by a photographer, captured for eternity giving Jayne Mansfield and her dangerously plunging neckline the side-eye.

Romanoff would be at the restaurant from 9 a.m. to midnight, sitting here, sitting there, directing his ninety employees, and chasing away photographers and intrusive onlookers. The female gastro-columnist who had written a negative review was banned from entering, as was a heavyweight movie director with miserable table manners. Romanoff found himself constantly at loggerheads with Bogart, who was the only guest to flout the compulsory tie rule. On the other hand, an actor couple who had long faded into oblivion, but had bailed Romanoff out in his early days and were now unable to pay for themselves, were allowed to order—on the house—whatever the kitchen was serving. "I haven't forgotten the old days," Romanoff whispered. He was also known to place real pearls in some of his friends' oysters.

The restaurant's heyday began to wane in the late 1950s. And on New Year's Eve 1962, Prince Michael Romanoff of Russia, the hardworking restaurateur, opened his doors for the last time. His restaurant sold for a handsome sum, allowing the man labeled by *Time* magazine as America's most famous swindler of the twentieth century to retire with honestly earned gains.

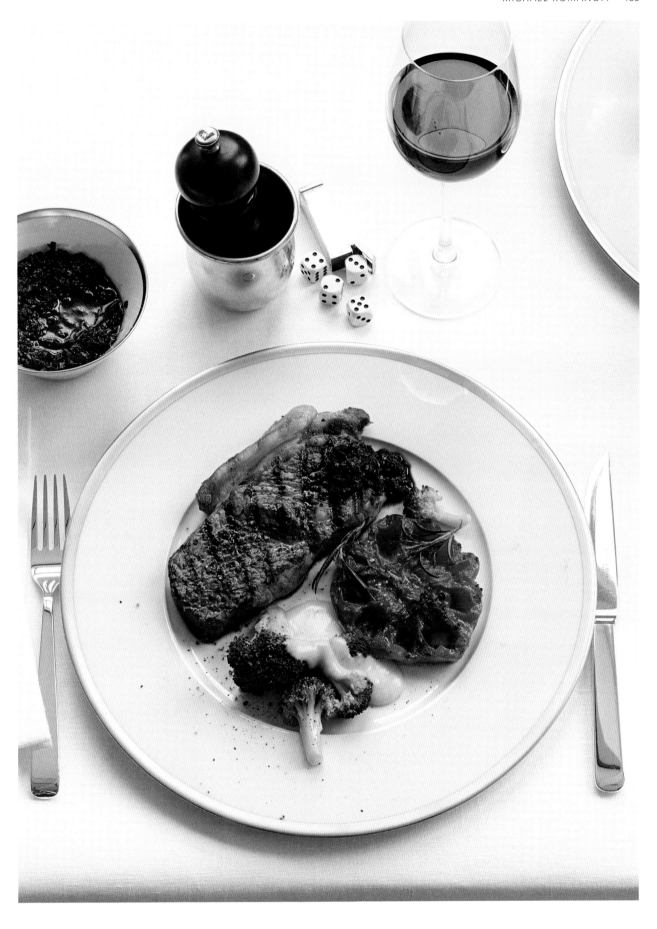

Shrimp à la Russe

INGREDIENTS SERVES 4

1 lb. 2 oz. / 500 g salad
* potatoes*
salt
1 very fresh organic egg, at
* room temperature*
1 tsp. mustard
2–3 tbsp. lemon juice
pepper
⅔ cup / 150 ml sunflower oil
1 cup / 150 g frozen peas
10 oz. / 300 g cooked shrimp
* without shells or heads*
5 tbsp. dry white wine
a handful dill tips, to
* garnish*
lemon wedges, to serve
baguette slices, to serve

TIME NEEDED:
25 mins. + 25 mins. cooking

METHOD LEVEL OF DIFFICULTY: EASY

Wash the potatoes and put them into a saucepan over medium heat. Cover with water, add 1 table-spoon salt, and boil about 25 minutes until tender when you check with a knife.

Meanwhile, put the egg, mustard, 2 tablespoons of the lemon juice, a pinch of salt, and pepper into a long, slim mixing beaker and puree with a stick mixer. Slowly add the sunflower oil and continue until a light mayonnaise forms.

Blanch the peas 1 minute in a saucepan with boiling salted water, then drain, rinse under cold water, and drain again. Rinse the shrimp in cold water and pat them dry.

Drain the boiled potatoes, leave to cool briefly, then slip of the skins and cut the flesh into cubes. Transfer the potatoes to a bowl, pour the white wine over, and leave to cool.

Combine the potatoes with the mayonnaise and leave about 15 minutes to develop the flavor. Fold in the peas, then season the potato salad with salt, pepper, and a little lemon juice.

To serve, divide the potato and pea salad among four plates. Place the shrimp on top and sprinkle with the dill. Serve with lemon wedges and freshly baked baguette slices.

RECOMMENDED WINE: Francis Ford Coppola Sofia Blanc de Blancs 2015, from the movie director's own vineyard. Its colorful blend of pineapple, apricot, crunchy apple, honeydew melon, and lime aromas is a perfect match for this appetizer.

New York Cut Steak with Bordelaise Sauce, Grilled Tomatoes, and Broccoli with Hollandaise Sauce

INGREDIENTS SERVES 4

For the bordelaise sauce:
4 shallots
2 tbsp. / 30 g butter, chilled
1 tbsp. granulated sugar
2 tbsp. light soy sauce
1 quart / 1 liter full-bodied
* red wine, such as Merlot*
7 oz. / 200 ml beef broth
For the broccoli:
5 black peppercorns
1 shallot
1 tbsp. white wine vinegar
7 oz. / 200 ml dry white wine
½ tsp. granulated sugar
2¼ sticks / 250 g butter
4 egg yolks
salt
a dash lemon juice
9 oz. / 250 g broccoli
For the grilled tomatoes:
2 ox-heart tomatoes
½ sprig rosemary
2 sprigs thyme
1 tbsp. olive oil
salt and pepper
For the steaks:
4 Manhattan (rump) steaks,
* about 7 oz. / 200 g each*
salt and pepper

TIME NEEDED:
60 mins. + 50 mins. cooking

METHOD LEVEL OF DIFFICULTY: MEDIUM

To make the bordelaise sauce, peel and finely chop the shallots. Melt 1 tablespoon of the butter in a skillet. Add the shallots and sauté until they are translucent. Add the sugar and let it dissolve and caramelize slightly. Stir in the soy sauce and 1 cup / 250 ml of the red wine. Simmer until the wine has almost completely cooked away, then add the same amount again. Continue like this until all the red wine has been added. Pour in the beef broth, then transfer the sauce to a small saucepan.

To make the hollandaise sauce for the broccoli, crush the peppercorns. Peel and thinly slice the shallot. Put the white wine vinegar, white wine, sugar, and crushed pepper into a small saucepan and bring to a boil. Cook to reduce by half, then strain through a fine strainer into a bowl suitable for a water bath, squeezing out the shallot.

Meanwhile, melt the butter in a small saucepan. Bring to a boil, then simmer over medium heat until the whey separates from the butter fat and collects at the bottom of the pan. Line a fine strainer with paper towels. Strain the butter—it should be golden-yellow and clear.

Add the egg yolks to the white wine reduction, which should be warm but not hot, and briefly whisk with a handheld mixer or with a whisk. Place the bowl onto a not-too-hot water bath and continue whisking until the egg yolks start to bind and set as they are heated.

Now take the bowl off the water bath, and continue to whisk. Work in the warm, liquid clarified butter, at first drop by drop, then in a thin stream, whisking continuously. Season the sauce with a little salt and lemon juice. Keep warm until you are serving, ideally over the water bath; the water bath should not boil again.

Divide the broccoli into florets. Add to a saucepan of boiling salted water and boil 2 minutes, then drain and keep warm. Wash and pat dry the tomatoes, then halve them crosswise. Pull rosemary needles and thyme leaves off the sprigs and finely chop them. Brush the cut surfaces of the toma-toes with the olive oil, then sprinkle them with the chopped herbs and pepper. Place the tomatoes with their cut sides down onto a hot grill or into a chargrill pan until the grill pattern is burned into the tomatoes' cut sides. Turn the tomatoes over, sprinkle with salt, and keep warm.

Season the steaks with salt and coarsely ground pepper, place them onto the hot grill or into a chargrill pan, and cook 3–4 minutes on each side.

Just before serving, bring the bordelaise sauce to a boil and whisk in the cold butter. Make sure you always stir the sauce in the same direction, because this allows the butter to emulsify better.

Transfer the steaks to four plates and spoon the bordelaise sauce over. Place a grilled tomato next to each steak. Add the broccoli to the plates with the hollandaise sauce spooned over.

RECOMMENDED WINE: Francis Ford Coppola Director's Cut Cabernet Sauvignon 2014, a full-bodied and juice red, with dark aromas of blackcurrant, cherry, and coffee beans, plus a hint of vanilla.

Strawberries Romanoff

INGREDIENTS SERVES 4

1 organic orange
2 tbsp. granulated sugar
1 lb. 12 oz. / 800 g
* strawberries*
4 tbsp. orange-flavored
* liqueur*
1 cup / 250 ml heavy cream
1 envelope vanilla sugar

TIME NEEDED:
25 mins. + 5 mins. cooking + 20 mins. macerating

METHOD LEVEL OF DIFFICULTY: EASY

Wash the orange under hot water and pat it dry. Peel off the zest with a zester. Halve the orange and squeeze out the juice.

Bring a small saucepan of water to a boil. Add the orange zest and return the water to a boil, then drain. Return the orange zest to the pan, add the sugar and orange juice, and simmer until the liquid has a syrupy consistency. Leave the orange syrup to cool.

Wash and hull the strawberries, then halve or quarter them, depending on their size. Transfer the strawberries to a bowl, pour the orange-flavored liqueur over, and add the orange zest and syrup. Leave the strawberries to macerate about 20 minutes.

Meanwhile, beat the cream with the vanilla sugar until stiff.

Divide the strawberries and the orange zest and syrup among four dessert bowls or glasses. Place the cream on top and serve immediately.

RECOMMENDED WINE: A phenomenon, just like Romanoff himself, vintner Andrew Quady revived the long-forgotten grape variety Orange Blossom Muscat. Despite some initial skepticism from others in the industry, his bold, sweet wines have become top sellers. Orange Muscat Essensia boasts an aroma of dark chocolate, candied oranges, and orange tree blossom, the perfect partner-in-crime for this dessert!

• PREVIOUS PAGES: STRAWBERRIES ROMANOFF Strawberries served in a syrup made from the zest and juice of an orange, plus cream beaten with orange-flavored liqueur and vanilla sugar.

Thomas Mann

THERE USED TO BE MORE TINSEL

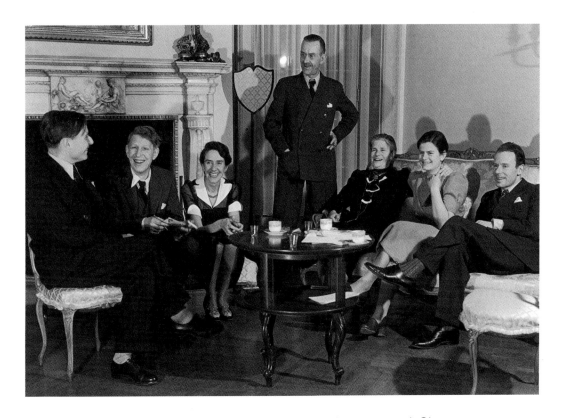

As turbulent as the Manns' life was, their annual Christmas
Eve party was well established—whether they were celebrating
in Germany, Switzerland, or the United States. The tree was
decorated with tinsel, the table set all in white, and the children
entered the living room singing *O Tannenbaum*. The only thing
that changed was the menu, and the Moselle wine gradually
made way for champagne. This is a tale of the magic of rituals.

• OPPOSITE: MARINATED CHAR WITH CHAR CAVIAR Thomas Mann loved to indulge in the glamorously pearl-
like caviar at Christmas, especially black sturgeon. But orange char caviar, as we've used, was also served.
• ABOVE Although the Manns' family ties were strained, the adult children continued to spend Christmas
with their parents. Even in exile, when everyone had long gone their separate ways, the family kept gathering
together, such as here in New Jersey in 1939. Erika, Thomas, Katia, Elisabeth, and Klaus Mann sitting or
standing around the coffee table, joined by two writer friends (far left).

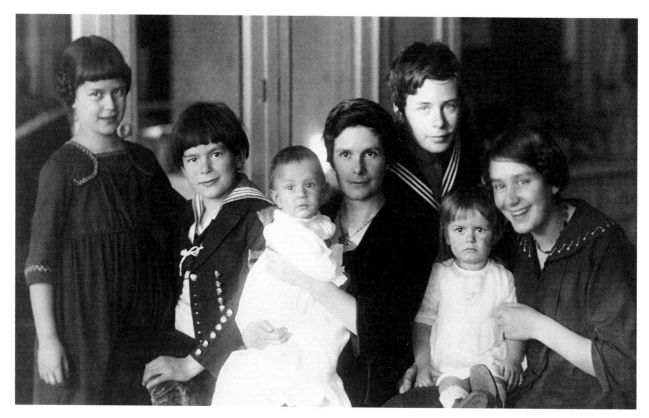

• ABOVE It's getting dark: On Christmas Eve, the children all gathered together (pictured from left: Monika, Golo, Michael, mother Katia, Klaus, Elisabeth, Erika) in their father's study. The lights were turned out, and Christmas carols were sung until Katia Mann rang the bell and everyone trooped into the festively illuminated drawing room.

The mood in Germany was bleak. Even though the weapons on the front had been laid down at the end of 1918, a sense of unrest continued. The last German emperor had been forced to abdicate in November of that year, and nobody knew what was going to happen postwar. On December 24, the distinguished writer Thomas Mann noted he had "read in the newspaper about bloody battles," but he did not let that disrupt his day. He spent the morning writing, before readying himself at noon to collect the Christmas gifts for his wife, Katia, which he had picked out the day before. They included practical items like an alarm clock with an illuminated face. Back at his Munich home, he permitted himself an afternoon siesta, and chatted with his mother-in-law over afternoon tea. According to his diary, Christmas Eve was thus "the same as every other year." While the outside

• TOP RIGHT Another Christmas ritual: Mann's "record concert" at his Munich villa.
• RIGHT "I might almost say I only eat for the sake of being able to smoke, though, of course, that is more or less an exaggeration," Mann said. This photo from 1938 shows he wasn't exaggerating.

world might have been falling down around him, inside, Mann always kept a semblance of peace, and calmly had the Christmas tree decorated with white paper lilies, candles, and lametta—the original angel hair tinsel—, as was his Lubeck family tradition.

When Mann's father died in 1891, his mother, sufficiently well off, moved to Munich. He stayed at his old school in Lübeck for a short time, before also heading to the Bavarian capital, where his mother lived in the artists' neighborhood of Schwabing. Viktor, Mann's youngest brother, recalled a Christmas party held there in 1898: "Christmas Eve exceeded all my expectations and memories . . . Mama didn't preach any introductory sermon with edifying admonitions or advice for the whole family, as her good mother-in-law would do; instead, she read us the Christmas Gospel from the old Lübeck Bible so beautifully and expressively that I actually forgot my impatience and listened, enraptured. And then, I led my siblings, singing *O Tannenbaum* [O Christmas Tree], through the open folding doors and 'into heaven' like little Hanno Buddenbrook."

Mann was, in fact, working on his novel *Buddenbrooks: The Decline of a Family* at the time. It chronicles four generations of a Lübeck patrician and merchant family—clearly inspired by the Manns themselves. A Christmas Eve party, the highlight of traditional German Christmas festivities, is described on three separate occasions, interweaving literature and fact. For example, Viktor also recalled, "Sitting on white tables that lined the long walls on both sides of the room were eight little Christmas trees, and this glimmering Christmas pathway led to the main illuminated Christmas tree, which soared from floor to ceiling in the bay window . . . It was a typical Lübeck Christmas: At every place setting, in addition to the plates of apples, nuts, dates, figs, almonds, raisins, and oranges, there were also large white boxes from the renowned Niederegger marzipan company on Breite Strasse, which the postman, dressed in blue and white, had delivered."

In 1905, Mann married Katia Pringsheim, the daughter of a mathematics professor and an actress. The pair later changed from Schwabing to the exclusive Bogenhausen district on the right bank of the Isar, where they built a villa on Poschingerstrasse, which is today known as Thomas-Mann-Allee. They moved into the villa in 1914, and had several domestic staff, including a cook.

It was in this stately home that Mann sat drinking tea with his mother-in-law in 1918, waiting for the Christmas Eve festivities—which had been rehearsed and replayed for years—to begin. One of the integral parts was the procession around the house, from the darkness into the light, to the twinkling Christmas tree, a symbol of heavenly light, grace, and benediction. It would kick off with the father and four eldest children sitting in the dark in his study, singing Christmas carols. As soon as *O Tannenbaum* was intoned, the children would parade into the festively decorated dining room. The tree smelled sweet and spicy, particularly as the flames of the real candles would have started singeing a few of the branches.

Then came the exchanging of gifts. Everyone had their own table on which to place their presents. Even the youngest daughter, eight-month-old Elisabeth, whom Mann affectionately referred to as *Kindchen* [little child], took part. "After the entry procession, I brought *Kindchen* down; she wore a short little dress, stockings, and shoes for the first time. She was sweet and cheerful today . . . The children were happy with their wondrous new things, especially Moni. Katia liked my gifts." Mann took gifting very seriously—as a sign of generosity, benevolence, and love. "It is remarkable how things are transformed in the light of Christmas candles—for both young and old. Walking sticks, cups, pocketknives, or whatever it might be, all cease to be mere objects and instead become 'gifts' from heaven," he wrote to his friend and colleague, Ernst Bertram.

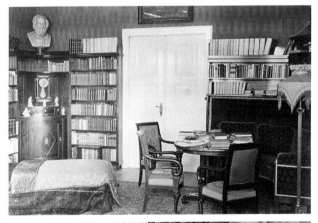

• TOP RIGHT Thomas Mann's study.
• RIGHT The writer with his daughter Erika in 1947.

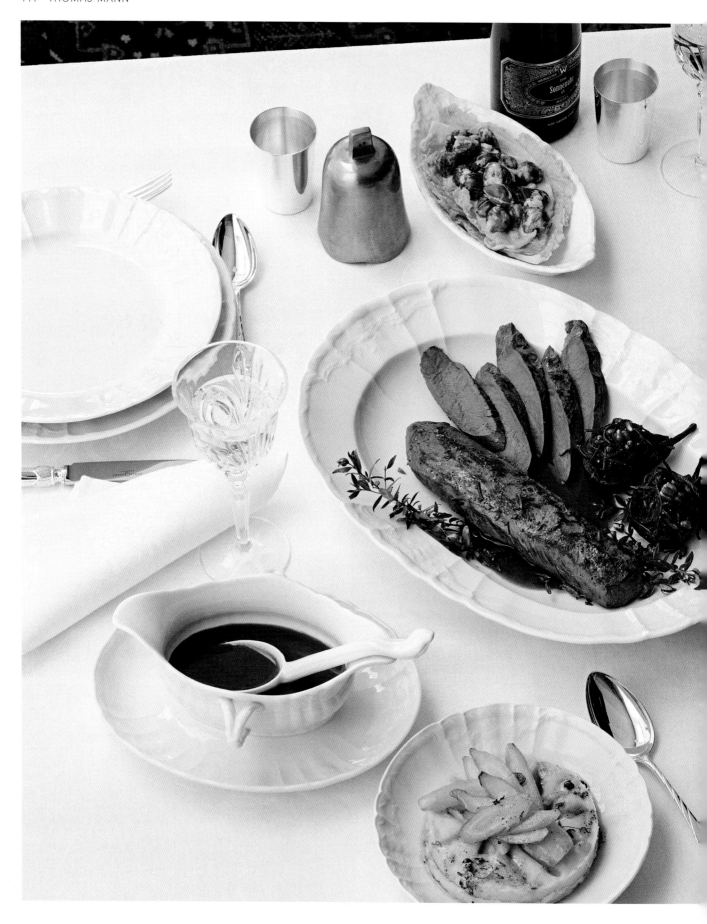

SADDLE OF VENISON WITH
RED CABBAGE SALAD AND
ELDERBERRY PEARS Additional
Christmas Eve winter side
dishes usually included Mashed
Potatoes and Celery Root,
Orange Carrots, and Savoy
Cabbage in Chestnut Sauce.

The meal that night consisted of "turkey, pastries, Moselle wine, and sweet wine, along with Christmas cookies for dessert." This first postwar Christmas dinner continued to strictly follow Lübeck traditions, which revolved around abundance. But there would soon be a few minor adjustments that placed greater emphasis on quality rather than just quantity. Turkey was replaced with goose, and the Christmas cookies with chocolate cake, as early as 1919. Even more significant was the fact that the Moselle wine was now also joined by champagne—no doubt partly due to the fact that it fizzed so spectacularly in the candlelight as soon as it was poured into the flutes. The drink became the soul of the Christmas dining culture, as evidenced by Mann's notes: "Champagne dinner . . . by the light of grandmother's candelabras." Or, in 1945, after World War II: "Champagne Supper."

The dinner routinely commenced at 7 p.m., after which everyone stayed together in the living room until about midnight. Music was a must. Initially it was only Erika, the eldest daughter, who played the piano, though Monika soon followed suit, and the pair were eventually also accompanied by Michael, the youngest, on the violin or viola. They listened to records of classical music, by Bach, Brahms, or Wagner, and generally fooled around and were merry. The father occasionally grew tired, but forced himself to carry on.

In 1933, the Manns fled the Nazis, first escaping to the south of France, then to Switzerland, and later to New Jersey and California, before returning to Switzerland in 1952. The Christmas party remained a pillar of moral support amid all this upheaval. Even during the émigré years, when the family sometimes found themselves scattered, almost all six children, who were by then adults, continued to gather around their parents' table of gifts. Grandchildren attended for the first time in Pacific Palisades, near Los Angeles. And, as usual, the tree was decorated with white lilies, candles, and angel hair. Despite the fact that there wasn't any gold or silver lametta to be found in California in 1945, the writer insisted that, "As there was no lametta, we spent the night before cutting a pile of aluminum foil into thin strips."

The champagne had long been served with caviar, presumably of the blackish-brown sturgeon variety. Goose was superseded by the more easily digested roast chicken, while dessert was a zabaglione. Finally, in 1953—now back in Switzerland, on the shores of Lake Zurich—, roast saddle of venison emerged victorious, as the most appropriate to the Central European winters. The following morning, breakfast would not be complete without a stollen fruit loaf, often accompanied by a fried egg. The doctor, however, advised the old gentleman not to drink coffee and smoke a cigar at the same time, although he himself did wonder, "Is it really worth denying oneself this small bit of pleasure?" It certainly provided good sustenance for reflecting on the essence of the human condition.

• OPPOSITE Thomas Mann with his daughter Elisabeth in St. Moritz, 1929.

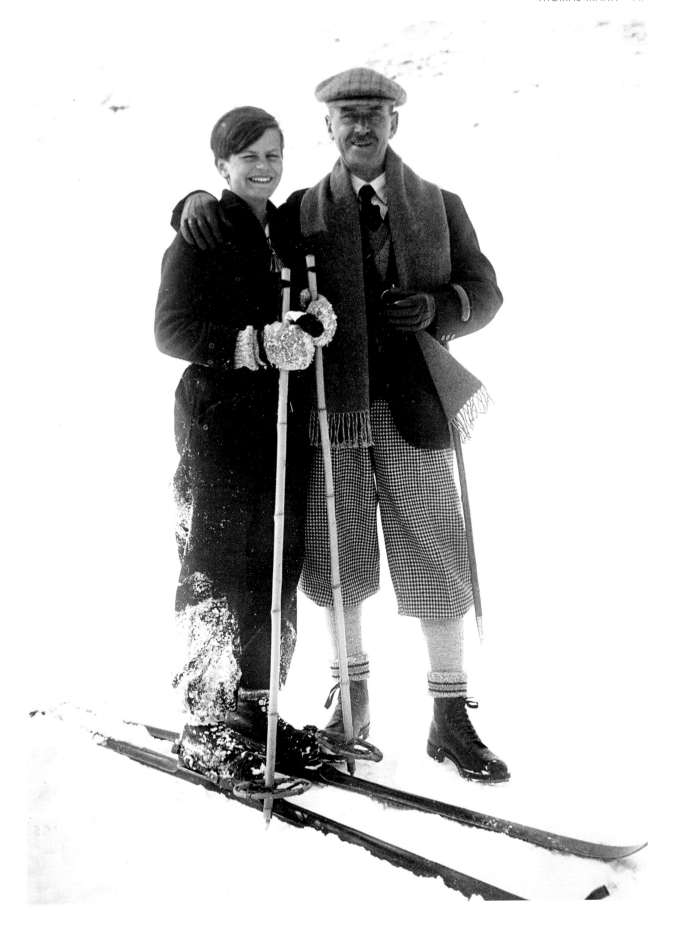

Marinated Char with Char Caviar

INGREDIENTS SERVES 6

1 sprig tarragon
12–14 oz. / 350–400 g arctic
 char fillet, skinned, boned
1–2 pinches Espelette
 pepper
coarse kosher salt
1–2 tbsp. grated orange zest
orange-flavored olive oil of
 your choice
1¾ oz. / 50 g char caviar
For the vinaigrette:
1 small organic orange
2 tbsp. lemon juice
1–2 tsp. quince jelly
1 tsp. medium-hot mustard
kosher salt and pepper
3–4 tbsp. canola oil
For the salad:
1 medium fennel bulb
a good handful frisée salad
 leaves

TIME NEEDED:
25 mins. + 30 mins. marinating

METHOD LEVEL OF DIFFICULTY: EASY

Wash and shake dry the tarragon, then pull off the leaves. Rinse the char fillet under cold water and pat dry. Rub the fillet with Espelette pepper, kosher salt, the orange zest, and tarragon. Cover and leave to marinate about 30 minutes.

Meanwhile, make the vinaigrette. Wash the orange under hot water and pat dry. Using a zester, peel off about 1 teaspoon zest in thin strips, cover with plastic wrap, and set aside. Halve the orange and squeeze out the juice. Combine 2 tablespoons orange juice, the lemon juice, quince jelly, mustard, and salt and pepper. Beat in the oil, then check the seasoning. To make the salad, trim, wash, and dry the fennel. Using a mandolin or fine vegetable cutter, thinly slice the fennel down to its hard core. Toss the fennel strips in the vinaigrette.

Heat the oven to 160–175°F / 70–80°C (gas and convection ovens not recommended). Line a cookie sheet with parchment paper. Divide the char fillet into portions and place on the cookie sheet. Brush with the orange oil and roast 7–8 minutes in the oven.

Trim, wash, and spin-dry the frisée, then tear the leaves into small pieces. Arrange the frisée and the drained fennel strips on plates. Place the lukewarm char on top, then drizzle with the vinaigrette. Grind over a little pepper and sprinkle with the orange zest.

Serve the char caviar in mother-of-pearl spoons on the side or place it on top of the fish. Serve with very thin, crisply toasted brioche or Melba toast.

TIP Instead of frisée, use other winter leaf salads, such as corn salad or winter purslane.

Saddle of Venison

INGREDIENTS SERVES 6

3¾–4 lb. / 1.7–1.8 kg saddle
 of venison on the bone
½–1 tsp. freshly pounded
 cubeb or long peppercorns
1 tbsp. / 15 g butter
1 tbsp. vegetable oil for
 frying
a few sprigs myrtle
day-old dark bread crumbs
 with a pinch gingerbread
 cookie mix
kosher salt and freshly
 ground pepper
For the venison broth:
2 onions
2 carrots
2 tbsp. / 30 g butter
3 tbsp. vegetable oil
2–3 oz. / 55–85 g lean bacon
 slices, roughly chopped
4–5 juniper berries
1–2 bay leaves
1¼ cups / 300 ml game or
 vegetable broth
1 cup / 250 ml dry red wine
For the herb sauce:
1–2 sage leaves
1 sprig thyme
1 small sprig rosemary
2 juniper berries

TIME NEEDED:
35 mins. + 70 mins. cooking

METHOD LEVEL OF DIFFICULTY: MEDIUM TO DIFFICULT

If you haven't bought your meat prepared from a butcher or game merchant, cut the meat off the bones, and carefully remove the silvery skin and tendons. In either case, save the bones. Cover and chill the meat. To make the broth, coarsely chop the bones, or ask the butcher to do this.

Peel the onions and cut them into wedges. Trim the carrots and brush them thoroughly under running water, then roughly dice them. Melt the butter with the oil in a heavy saucepan over high heat. Add the bones, bacon, onions, and carrots and fry, turning everything, until browned. Lightly crush the juniper berries, then add them together with the bay leaves and a little salt.

Pour the game broth and the red wine over the vegetables. Reduce the heat to low, cover, and simmer at least 60 minutes.

Strain the broth through a fine strainer into a saucepan. Simmer, uncovered, to reduce a little.

Heat the oven to 300°F / 150°C (gas and convection ovens not recommended). Rinse the boned saddle of venison under cold water, pat dry, and rub with the crushed pepper.

Melt the butter with the oil in an ovenproof skillet. Add the meat and fry all over, then place the skillet in the oven and roast the venison 8–10 minutes. Important: The meat should still give and be slightly elastic when pressed with a finger; it must not be firm!

Meanwhile, make the herb sauce. Pick over, rinse, and pat dry the herbs. Pull the leaves or needles off the stems, and finely chop together. Crush the juniper berries. Quickly cook the herbs and berries in 4 tablespoons of the prepared venison broth.

Line a shallow gratin dish with strong aluminum foil. Rinse and shake dry the myrtle, then place it in the dish. Remove the skillet from the oven. Open the oven door to quickly reduce the temperature to about 160°F / 70°C.

Lift the meat out of the skillet and place it on top of the myrtle. Spoon the herb sauce over the meat and return the meat to the oven 8–10 minutes so the juices soak in and develop the flavor.

Take the venison out of the oven. Add the frying juices to the remaining broth and heat through. Stir the crumbs and spices into the sauce, then strain the sauce through a fine strainer. Heat again and season generously.

To serve, heat a meat platter. Slice the venison against the grain, then arrange it with the myrtle on the warm platter. Place the Elderberry Pears (see below) on the platter, if you like, and drizzle a little of the sauce over. Serve the remaining sauce and other side dishes separately.

TIP: If you like, stir a little sour cream into the sauce.

Mashed Potatoes and Celery Root

INGREDIENTS SERVES 6
1 lb. 2 oz. / 500 g Idaho
 potatoes
10 oz. / 300 g celery root
2–3 tbsp. sour cream
kosher salt and pepper
a little vegetable oil for
 greasing the rings
For the spiced butter:
3–4 juniper berries
winter thyme leaves
2 tbsp. / 30 g sour cream
 butter

TIME NEEDED:
about 20 mins. + 25 mins.
cooking

METHOD LEVEL OF DIFFICULTY: EASY

Thoroughly wash the potatoes. Place them in a saucepan of salted water and boil 25 minutes, or until tender.

Peel, rinse, and drain the celery root. Place in another saucepan with just enough salted water to cover and boil until tender. Drain well, then leave to steam in the pan. Mash with a potato masher while still hot.

Drain the potatoes and slip off the skins, then mash with the potato masher while still hot. Combine the potato and the celery root purees, add the sour cream and season with salt and pepper. If you like, thoroughly mash again using an electric hand-held mixer. Keep the mixture warm.

To make the spiced butter, crush the juniper berries. Rinse and pat dry the thyme. Melt the butter and lightly brown with the juniper berries and thyme.

To serve, thinly brush cake rings with oil and place them on warm plates or a serving platter. Spoon the mashed potatoes and celery root into the rings and smooth the tops, then carefully lift off the rings. Drizzle the spiced butter over. Serve separately or with Orange Carrots (see p. 150) on top.

Red Cabbage Salad with Pomegranate Seeds and Elderberry Pears

INGREDIENTS SERVES 6
3 aromatic pears, such as
 d'Anjou
1 organic lemon
2 cups / 500 ml unfiltered,
 unsweetened first-press
 elderberry juice
1 cup / 250 ml red wine
⅓ cup / 70g raw cane sugar
For the red cabbage salad:
2 small red onions
10 oz. / 300 g trimmed red
 cabbage
salt and crushed
 peppercorns
2 tbsp. lemon juice
2 cloves, freshly pounded
2 tbsp. groundnut oil
2–3 tbsp. pomegranate
 syrup (grenadine)
1 fully ripe pomegranate

TIME NEEDED:
about 15 mins. + at least
1 hour marinating

METHOD LEVEL OF DIFFICULTY: EASY

To make the elderberry pears, peel and halve the pears, then remove the cores. Wash the lemon under hot water and pat it dry, then cut off the zest as a thin spiral. In a saucepan over high heat, bring the elderberry juice, lemon zest, red wine, and sugar to a boil. Reduce the heat, add the pear halves and simmer 8–10 minutes, then turn off the heat and leave to cool in the liquid until lukewarm.

Meanwhile, to make the red cabbage salad, peel the onions. Use a mandolin or vegetable slicer to chop the red cabbage and onions into fine strips.

In a nonmetallic bowl, combine the cabbage, 1 teaspoon salt, pepper to taste, lemon juice, and cloves. Lightly knead until the cabbage softens. Add the onions, groundnut oil, and pomegranate syrup, stir to combine, and leave to marinate.

Halve the pomegranate and carefully squeeze out the juice from one half. Spoon out the seeds of the second half. Stir the pomegranate seeds and juice into the red cabbage salad and season with salt and pepper.

To serve, drain a little of the liquid of the pears and the red cabbage salad. Serve the pear halves and salad with the Saddle of Venison.

Orange Carrots

INGREDIENTS SERVES 6

1 lb. 2 oz. / 500 g carrots, in
a variety of colors, such as
orange, yellow or white
2 tbsp. canola oil
kosher salt
1–2 tsp. ground cumin
7 tbsp. / 105 ml freshly
squeezed orange juice
2–3 pinches brown sugar

TIME NEEDED:
about 20 mins.

METHOD LEVEL OF DIFFICULTY: EASY

Trim the carrots and thinly peel them or brush them thoroughly under running water. Using a vegetable peeler, cut the carrots into thin lengthwise slices. Heat the oil in a skillet over high heat. Add the carrot slices and fry, seasoning them with salt and cumin. Reduce the heat to medium and continue frying the carrots, turning them occasionally.

Gradually add the orange juice, sprinkling with a little sugar after each addition. Continue cooking the carrots, tossing them occasionally, until the liquid almost evaporates—they should still have a little bite and look shiny. Serve with the Mashed Potatoes and Celery Root (see p. 149) or separately.

TIP: Aromatic rutabaga can be cooked in the same way, in which case toss it in finely chopped parsley instead of the cumin.

Braised Savoy Cabbage in Chestnut Sauce

INGREDIENTS SERVES 6

1 small savoy cabbage
salt
1 tsp. baking soda
For the chestnut sauce:
1–2 shallots
1 ⅓ tbsp. / 20 g butter
1 ⅓ cups / 200 g cooked
and peeled chestnuts,
vacuum-packed
3 tbsp. mushroom broth
(store bought)
5 tbsp. / 75 ml heavy cream
grated nutmeg
kosher salt and pepper

TIME NEEDED:
about 20 mins.

METHOD LEVEL OF DIFFICULTY: EASY

To make the braising broth to use in the sauce, peel and finely chop the shallots. Melt the butter in a saucepan over medium-high heat until it browns, but doesn't burn. Add the shallots and sauté until translucent. Reduce the heat to low, then add the chestnuts and mushroom broth. Cover and simmer 5–7 minutes. Pour in the cream and quickly simmer. Season with nutmeg, and salt and pepper.

Meanwhile, trim the savoy cabbage, removing any thick ribs and the stems, then roughly chop the leaves. Cook 4 cups / 300 g of the cabbage 4–5 minutes in a saucepan of boiling salted water with the baking soda, then drain. Cut the leaves a little smaller, if necessary, then stir them into the chestnut sauce and check the seasoning. Heat briefly and serve.

NOTE: Baking soda changes the water's pH value and makes the vegetables cook faster. Another benefit is that the vegetables keep their fresh color even after cooking.

Zabaglione with Cocoa Bean Crunch

INGREDIENTS SERVES 6

6 extra-fresh egg yolks
6 tbsp. superfine sugar
¾ cup / 175 ml Marsala
(Sicilian fortified wine)
For the cocoa bean crunch:
2 oz. / 55 g cocoa beans
3 tbsp. / 45 g butter, chilled
⅓ cup / 40 g all-purpose
flour
2¾ tbsp. / 40 g packed light
brown sugar
seeds of 1 vanilla bean, or
½ tsp. ground vanilla
1 tbsp. unsweetened cocoa
powder

TIME NEEDED:
about 20 mins. (+ cooling)
+ about 12 mins. baking

METHOD LEVEL OF DIFFICULTY: MEDIUM

Heat the oven to 300°F / 150°C (Gas 2; convection ovens 275°F / 130°C). To make the cocoa bean crunch, roughly crush the cocoa beans. Cut the butter into small pieces. Put the flour, sugar, and vanilla seeds into a mixing bowl. Add the butter and rub everything with your fingers to make a fine crumble mixture. Gently work in the cocoa beans and cocoa powder. Line a cookie sheet with parchment paper and spread the crumble on top.

Bake 12–15 minutes until crisp. Transfer the crumble onto a wire rack together with the parchment paper and leave to cool.

To make the zabaglione, put the egg yolks and the sugar into a deep metal bowl for a water bath. Bring a little water to a boil in the saucepan. Beat the egg yolk and sugar mixture until white and foamy. Gradually whisk in the Marsala. Now place the bowl onto the pan so it is not in contact with the boiling water, but sits in the hot steam. Continue beating the egg mixture with a whisk. The zabaglione is done as soon as it has bound and is thick and creamy.

Divide the hot zabaglione among six dessert glasses and serve either hot or chilled. Before serving, sprinkle a little cocoa bean crunch over the top and serve the remaining crunch separately.

TIPS: You can make delicious variations of this creamy dessert with wine or champagne. For children, use fine organic fruit juices. During the winter holiday seasons, use pieces of crumbled gingersnaps or Gingerbread Cookies to sprinkle over the zabaglione instead of the crunch.

• BAUMKUCHEN AND ZABAGLIONE WITH COCOA BEAN CRUNCH The wine custard-cream dessert was served on Christmas Eve 1942 in Pacific Palisades. A little later, they shared a *Baumkuchen* cake with writer Alfred Neumann.

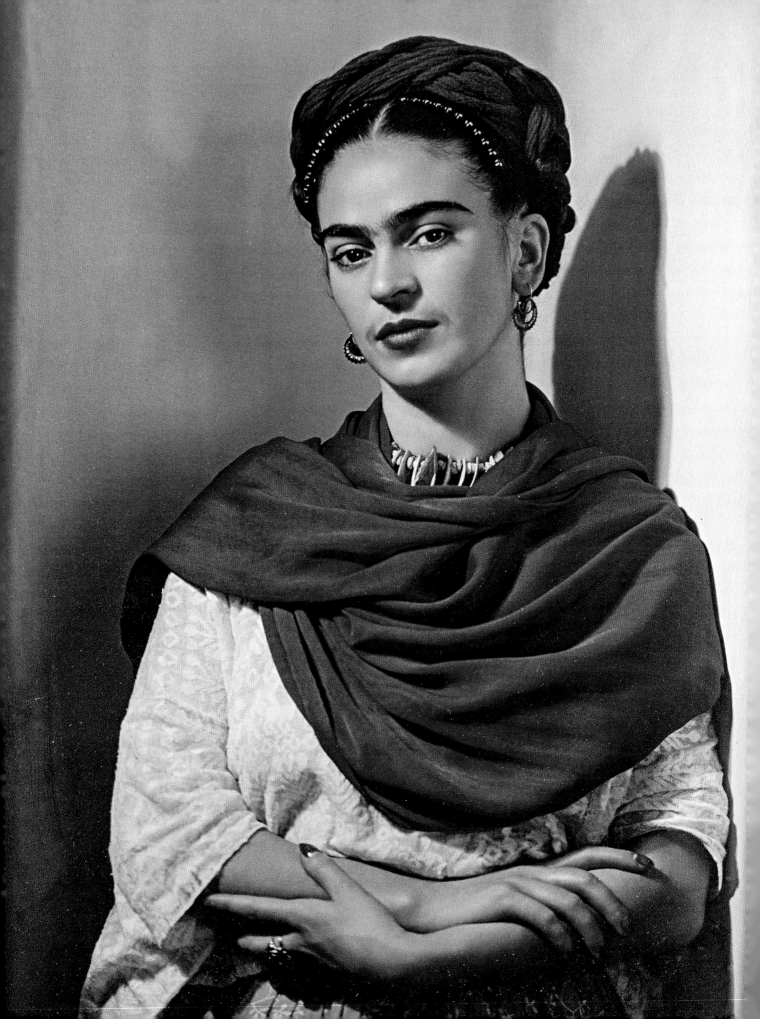

Frida Kahlo

PASSION AND PAIN

Frido Kahlo's wedding to fellow artist Diego Rivera in the
summer of 1929 was a grand affair, with musicians playing
until the early hours, and dishes gleaming in the same colors
as one of the painter's artworks. Her life was plagued by
pain—both physically, as a result of an accident, and in matters
of the heart. But the artist certainly knew how to celebrate the
moment—together with guests, whom she indulged lavishly.

• OPPOSITE Frida Kahlo, 1939, photographed by Nickolas Muray. The Hungarian-born American
was known for his impressive portraits of the painter, and was one of her lovers.
• ABOVE *Cactus Fruits*, 1938

For one night, the little interior courtyard of an ordinary-looking apartment block on the outskirts of Mexico City had been transformed into the festival grounds of a Mexican pueblo. Mariachi, the traditional village musicians, played among paper lanterns, streamers, and colorful papier-mâché doves.

Laid out on the green, yellow, and pink tablecloths were ancient Mexican platters, plates, and bowls painted with birds, dogs, and cats; the flatware was of the blue enamel variety sold at rural markets. The buffet was a similar explosion of color: steaming bowls of white and red rice, traditional Mexican cabbage in a green sauce, cheese-filled peppers, and the dark-brown *mole*—a heavy sauce made of chili, chocolate, and three dozen other spices, which was served with the chicken.

The crowning glory of the buffet was a snow-white wedding cake, topped with tall, slender figures of the bridal couple made of sugar. The figures couldn't have been less similar to the real couple celebrating their wedding that night of August 26, 1929: the petite, still largely unknown Frida Kahlo, whose body had been ravaged by polio and a serious accident, and celebrated Mexican painter Diego Rivera, who was nearly twice her age and three times her size. The dove was marrying the elephant, Frida's family jibed.

Relatives and friends had been invited, as had many of Mexico's artistic elite, along with members of the communist party to which both Kahlo and Diego belonged. The bride wore a plain, layered dress similar to those traditionally worn by Mexico's farmworkers, and sang loudly with the mariachi. Well-aged tequila was flowing. The mood was briefly dampened, however, when Diego's first wife, Lupe, was suddenly overcome with a bout of jealousy of Kahlo and hiked up the latter's skirt to scornfully reveal the bride's polio-ravaged leg. But Kahlo simply pushed Lupe away—and kept partying until dawn regardless. Kahlo and Diego threw many more parties of a similar scale as their wedding, because for Kahlo, no occasion was too insignificant to relax and celebrate with guests. She habitually drowned out her excruciating pain with unbridled joie de vivre.

• TOP LEFT It was a long time before Kahlo's work was recognized. When asked what he thought of his wife's art, Rivera replied that he had no idea, because he wouldn't look. But he was very likely aware of her talent.
• TOP RIGHT The lush interior courtyard of Kahlo's and Rivera's villa in the outskirts of Mexico City.

Kahlo always said there had been two major accidents in her life. The first occurred at the age of eighteen, when the tram in which she was riding home from school crashed into a bus. An iron rod pierced her pelvis, injured her spine, shattered her foot, and broke her right leg in eleven places. She then spent two years in a body cast. It was at that time—when she had actually intended to study medicine—she began painting.

The accident heralded a life of martyrdom for Kahlo, in which she was forced into steel braces, hung from hoists, and repeatedly "tortured" with new operations. She was often bedridden for months on end.

The second major accident in her life was meeting Rivera, with whom she fell in love at a party when she saw him pull out his pistol and shoot a gramophone. This love became a constant source of emotional distress. Although he equally adored her—and publicly vaunted her art as being far superior to his—, he betrayed Kahlo with numerous women. Even though she also had affairs with other men and women, she still craved symbiotic closeness with him. "Your word travels the entirety of space and reaches my cells, which are my stars, then goes to yours, which are my light," she wrote in a poem.

While Diego painted giant murals mostly in public buildings, Kahlo worked on her own in the seclusion of her studio. Her main subject was her herself. She had a mirror above her bed to ensure she could still work while lying down after operations, and she had a custom-made hanging easel. She hurled all her pain at her audience, and painted herself with a broken body, her spine like a crumbling Greek column, held together only by a brace, or on a blood-drenched bed sheet following one of her miscarriages—the accident had left her unable to have children. Other pictures reveal her joie de vivre, featuring plump fruit that are often reminiscent of genitalia.

Success started to come Kahlo's way as the years went on. Surrealists including André Breton had high praise for her when she traveled to Paris in the late 1930s. Pablo Picasso wrote the following to Diego: "Neither Derain, nor I myself nor you can paint a face like Frida Kahlo's faces." In the United States, Vogue featured her as a new style icon. Kahlo began wearing a magnificent, brightly colored

• GLITTERING PARTIES, SUMPTUOUSLY LAID TABLES, AND UNCONDITIONAL LOVE Intensity in the moment and in the colors. Kahlo's *Fruits of the Earth*, 1938, oil on canvas

Tehuana dress shortly after her wedding—Tehuana being an ancient Mexican matriarchal culture. She also wore pre-Columbian jewelry, and stuck flowers into her elaborate hairdos. She sometimes also sported diamond dentures, which sparkled when she smiled.

This success didn't appear to mean much to her. The daughter of a German father and a mother with indigenous roots, she scoffed at the "gringo women" with "faces like unbaked rolls." With her facial hair and monobrow, which she often exaggerated in her self-portraits, she turned against Western ideals of beauty.

Kahlo divorced Rivera in 1939—after he had betrayed her with her own sister—only to remarry him the following year. They moved out of their cool architecturally designed villa to Kahlo's parents' house in an artisan village on the outskirts of Mexico City, where they painted the exterior indigo and transformed the garden into a tropical labyrinth of fountains and tall trees that were home to exotic birds. Monkeys romped around the garden of the Casa Azul, while tamed doves ate out of their hands, and Granzio the fawn gamboled along the paths. Hanging among all this were cardboard Day of the Dead skeletons, which Kahlo and Rivera dressed in clothes, finishing off the look with sombreros.

When Rivera entered the house around midday, he called out "I'm here!" and marched into the sunlit dining room. Kahlo put menus together with great passion, arranging rice-filled bowls, crispy, stuffed tortillas, and hearty meat stews into veritable works of art with fruit and flowers from the garden.

Anyone who visited Mexico would stop by for a meal at the dazzling couple's home. The Casa Azul hosted the Rockefellers, as well as the likes of Frank Lloyd Wright, Orson Welles, Gary Cooper, and Russian revolutionary Leon Trotsky, with whom Frida had an affair. Guests were served chilies in walnut sauce, a very spicy shrimp cake,

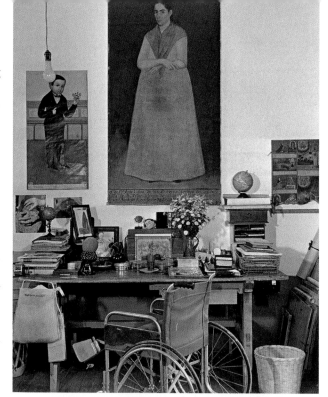

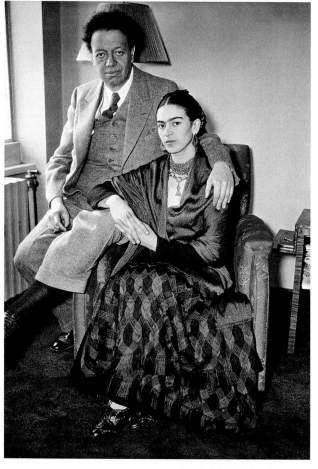

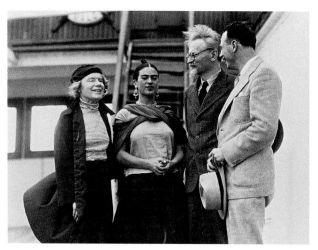

• LEFT Kahlo with Leon Trotsky and his wife, Natalia Sedova, and an unknown photographer on the right.
• TOP The artist's desk; Frida Kahlo was wheelchair-bound in her final years.
• ABOVE Kahlo and Rivera.

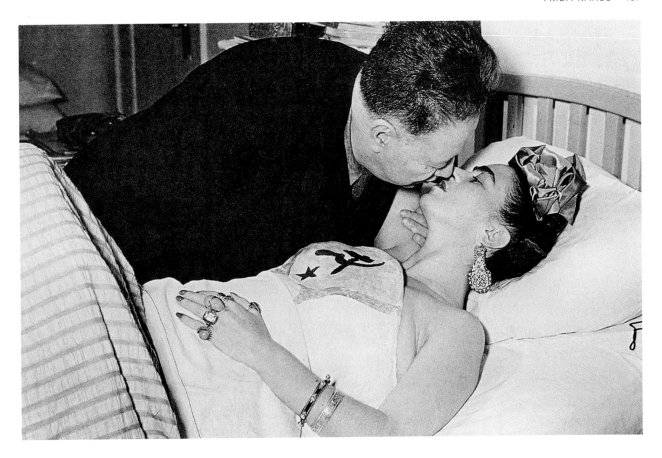

• ABOVE Rivera is visiting Kahlo at Mexico City's Hospital Ingles, where she continued to paint on an easel even while lying down.
• BELOW *Viva la Vida*, 1954

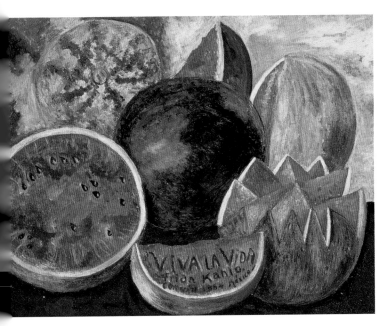

or stuffed corn tortillas. Carafes of fresh water stood on the table, and the sweet treats for dessert were presented in baskets as if at a market, while the mariachi played throughout the night. The hostess drank tequila and brandy, entertaining the guests with dirty jokes, which she told in her characteristic, raucous voice.

The early 1950s saw Kahlo plagued by fierce bouts of fever; only with high doses of morphine was she able to cope with the pain. Her lower right leg had to be amputated. "Feet, what do I need you for when I have wings to fly?" she asked, defiantly.

When Mexico presented Kahlo's paintings at a solo exhibition for the first time in 1953, she attended in a wheelchair, and greeted visitors to her home from a four-poster bed. She died soon after at the age of forty-seven, allegedly of a pulmonary embolism, but possibly from suicide. "I joyfully await the exit," she had written in her diary shortly before. Then, eight days before her death, she completed her still-life watermelon painting with her favorite phrase: "Viva la vida"—long live life.

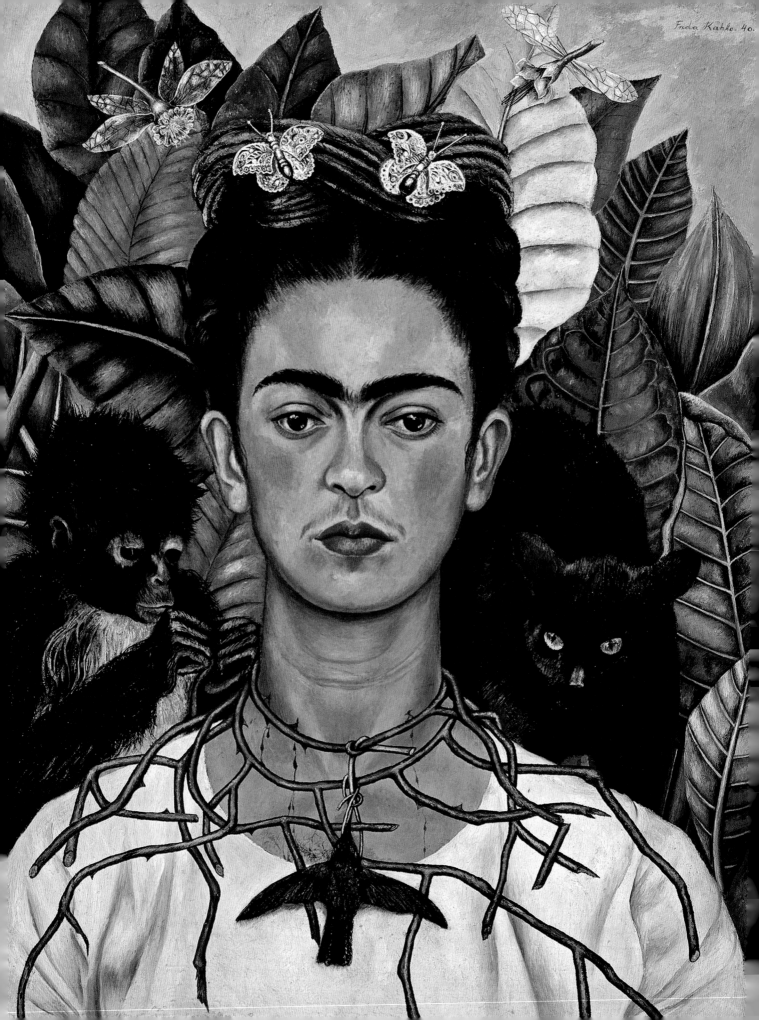

Chiles en Nogada (Stuffed Chiles with Walnut Sauce)

INGREDIENTS SERVES 6

10 oz. / 300 g beef
10 oz. / 300 g pork
1 carrot
1 onion
1 potato
1 zucchini
1½ cups / 225 g candied or
* dried fruit*
⅓ cup / 50 g blanched
* almonds*
3 Roma tomatoes
3 tbsp. oil
⅓ cup / 50 g raisins
⅓ cup / 50 g shelled peas
½ tsp. ground cinnamon
1 tbsp. brown sugar
salt
6 large poblano chile
* peppers (pointed peppers),*
* about 6 in. / 15 cm each*
For the nogada:
7 oz. / 200 ml sour cream
½ cup / 50 g walnut halves
½ tsp. ground cinnamon
1 tbsp. brown sugar
To garnish:
1 pomegranate
1 small bunch parsley

TIME NEEDED:
30 mins + at least 2 hours marinating + 1 ¼ hours cooking

METHOD LEVEL OF DIFFICULTY: MEDIUM

To make the stuffing, place both pieces of meat in a deep skillet and just cover with water. Bring to a boil and simmer about 20 minutes, then turn the meat over and simmer a few minutes longer, until cooked through. Take the meat out of the skillet and leave to cool. Reserve the cooking water.

Cut the meat into chunks, then finely chop. Peel the carrot, onion, and potato, then cut all them, the zucchini, and the candied fruit into ¼ in. / 0.5 cm cubes. Finely chop the almonds. Wash and halve the tomatoes, then remove the stem ends. Using a handheld mixer, puree with ½ cup / 125 ml of the cooking water until smooth, but not too thin.

Heat the oil in a heavy-bottomed saucepan over medium heat. Add the onion and sauté 2 minutes. Add the potato and sauté 5 minutes. Add the chopped meat and fry, stirring. Stir in the pureed tomatoes, then add the carrot, zucchini, and raisins, and simmer 5 minutes. Add the peas, candied fruit, and almonds, and stir well. Season with cinnamon, sugar, and salt, and cook 15 minutes until all the vegetables are tender and the liquid has cooked away. Leave to rest 2 hours.

Heat the broiler. Lay the chile peppers on a cookie sheet and broil all over until the skin starts to turn black and blister. Transfer the peppers into a freezer bag and leave to cool. Using a sharp knife, slip off the skins. Make a lengthwise cut on the side of each pepper, stopping about 1¼ in. / 3 cm before the top. Remove the seeds from the insides.

To make the nogada sauce, puree the sour cream, walnuts, cinnamon, and sugar in a food processor until smooth. Halve the pomegranate and spoon out the seeds. Wash and shake dry the parsley, reserving some of the leaves; very finely chop the rest. Fill each pepper with the meat and vegetable mixture. If necessary, close the peppers with wooden toothpicks.

To serve, place 1 pepper on each plate and cover completely with the nogada sauce. Sprinkle with the pomegranate seeds and chopped parsley, and garnish with the reserved parsley leaves.

TIP: Nogada sauce is traditionally made with Mexican cream, which can be found at Mexican food stores. Good alternatives are sour cream (as used here), crème fraîche, or Greek-style yogurt. If the sauce is too solid, stir in a little more cream to thin it down.

• OPPOSITE A surrealist self-portrait from 1940. "Neither Derain, nor I myself nor you could paint a face like Frida Kahlo's faces," Picasso wrote to Rivera.
• RIGHT Chiles en nogada, a traditional Mexican dish consisting of stuffed peppers with walnut sauce and pomegranate seeds.

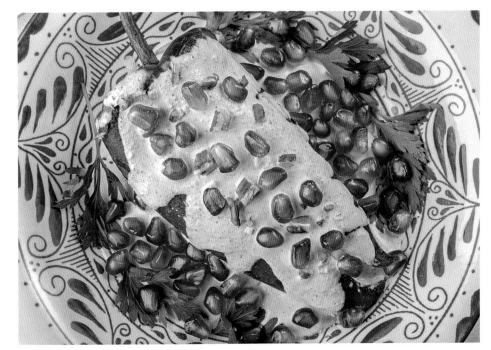

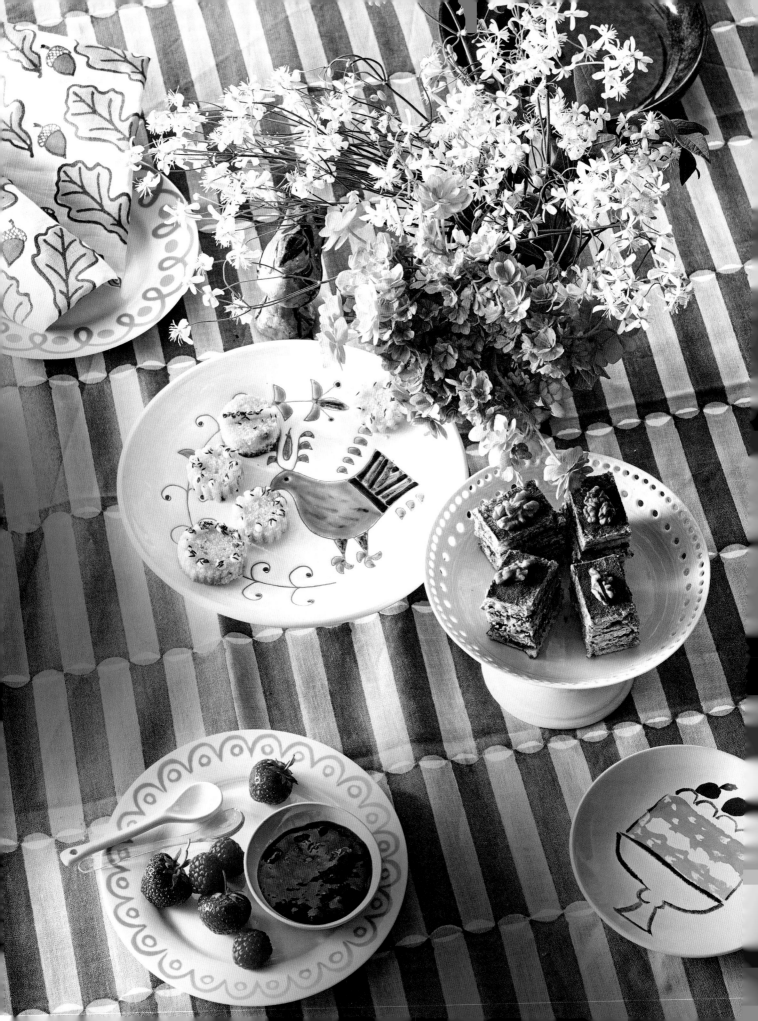

COLORFUL GOINGS-ON

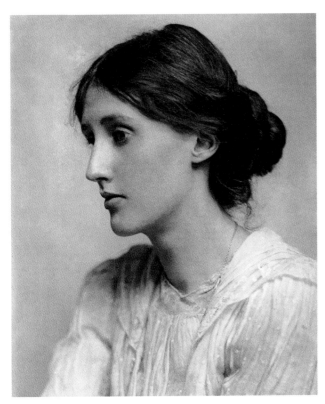

First, they met every Friday at the London home of painter Vanessa Bell, and later, at the Charleston farm house, where she lived with her lover Duncan Grant, but which was also the scene of his homosexual affairs, and home to her husband, Clive Bell. Other artists, writers and intellectuals forming the Bloomsbury Group, including Vanessa's sister, Virginia Woolf, often joined them for tea or dinner.

• VANESSA BELL AND VIRGINIA WOOLF, while not the best of cooks, knew how to make preserves: They often made jams from fruit picked in the garden. The housekeeper, meanwhile, baked Caraway Bites and Walnut and Coffee Slices for Sunday tea time.
• TOP LEFT This 1902 portrait shows a twenty-year-old Virginia Woolf.
• TOP RIGHT A 1913 fabric design by Woolf's sister, Vanessa Bell, for the Omega Workshops' first collection.

The year is 1927, and we're imagining the following scene: Painter Vanessa Bell is reclining on a golden-beige chaise lounge. She casts to one side a manuscript by her sister, Virginia Woolf—who celebrated her breakthrough two years prior with *Mrs. Dalloway*—and regards her lover, Duncan Grant, who is about to put the final brushstrokes on his *Portrait of a Woman*. She then stands up and searches for stationery in the writing desk. Perhaps she wants to write to her sister to tell her how moved she was by her novel *To the Lighthouse*. After all, Woolf had incorporated some of their shared childhood memories in it, namely the early death of their mother, and a family summer vacation in St. Ives, on England's Cornish coast. As such, it is all the more bewildering to see the words Vanessa ends up putting to the paper: "How does one actually make a *boeuf en daube*?"

Woolf had spent pages of her novel raving about this dish—a beef stew served at the end of the first chapter, when all the characters have gathered together, before fate, war, and death tear them apart a few pages later. The writer managed to depict the meal preparations so vividly that, while reading them, Bell has likely forgotten that her sister is just as inept as her at cooking. Woolf has never even made scrambled eggs. One of her first attempts at cooking ended in someone finding her wedding ring in the pudding. Consequently, as stated in her essay *A Room of One's Own*, "one cannot think well, love well, sleep well, if one has not dined well," the two women hired housekeepers—something they had been used to even as children. This was one of the few conventions they retained with their Bloomsbury friends.

The Bloomsbury Group of writers, intellectuals, philosophers, and artists was founded in 1905 in the London district of the same name, to which the sisters had moved following the death of their father. They wanted to get out of the expensive, elegant Kensington neighborhood, and Bloomsbury was, at the time, considered an area of "cheap lodging houses and dubious lodgers," as Bell's son, Quentin Bell, recalled in his memoirs. While in the neighboring streets the suffragettes were vocally campaigning for women's right to vote, 46 Gordon Square became the go-to meeting place for young intellectuals and bohemians. Bell invited her artist friends over every Friday, and they all engaged in lively discussions over cookies and hot chocolate. The young people were in search of new forms of painting, writing, and, indeed, new forms of living. "There was nothing that couldn't be said, nothing that couldn't be done," Woolf later reminisced about the group's early days, perhaps thinking of her sister, who, at these intellectual gatherings, often started dancing so enthusiastically and full of passion she would end up topless.

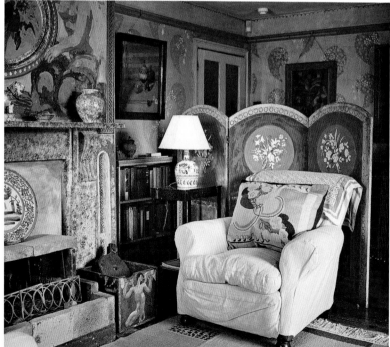

• ABOVE Roger Fry, one of Vanessa's former lovers, appointed her and his successor, Duncan Grant, as the directors of his Omega Workshops—akin to a modern-day design company—in 1913. The Workshops produced ceramics, fabric designs, and entire interiors.
• OPPOSITE *Potage Alpha* (Salmon Soup) was served at the opening of the Omega Workshops.

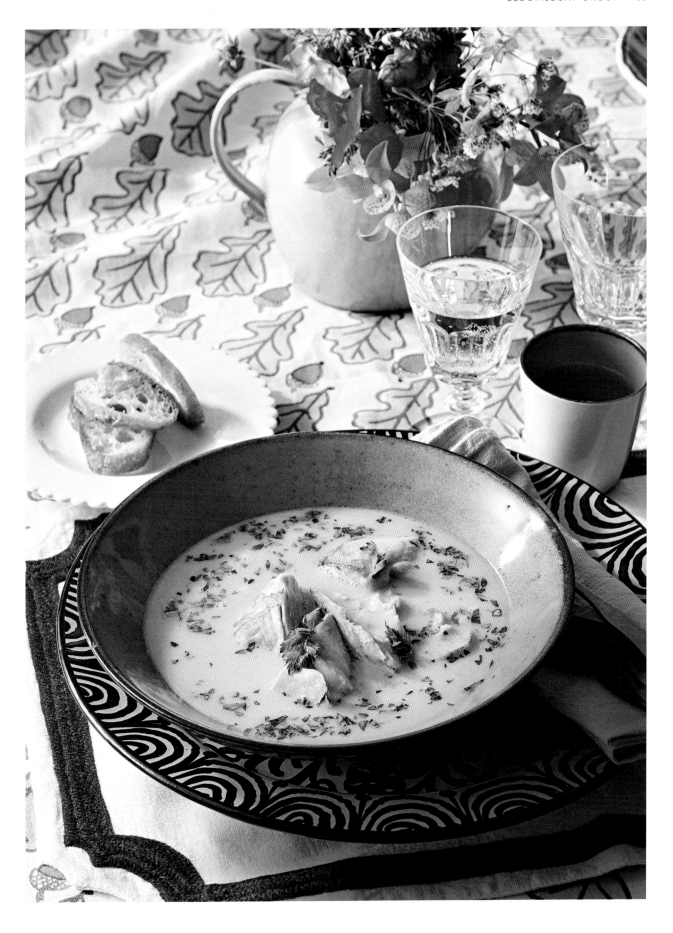

The Bloomsbury Group included the painters Roger Fry and Duncan Grant, ballet dancer Lydia Lopokova, and her husband, the economist John Maynard Keynes. Their freedom-loving lifestyle even made news in the United States, where writer Dorothy Parker described the members' lifestyle thus: "They lived in squares, painted in circles, and loved in triangles." Woolf, for example, maintained an extramarital relationship with writer Vita Sackville-West. Her sister Vanessa initially did the same with Roger Fry—which didn't stop him from working with her husband, Clive, to curate an exhibition on Picasso, Gauguin, Cézanne, and Matisse—, and later with Grant, even though the latter actually preferred men. The unconventional relationship lasted for life, which would no doubt have been a bitter blow for dumped lover Fry. But it was precisely this trio of Fry, Grant, and Bell that made artistic history with the legendary Omega Workshops in 1913. The three painters created a colorful version of the Wiener Werkstätte [Vienna Workshop], an avant-garde studio for applied art, where clothes, ceramics, large screen, fabrics, lights, and entire interior concepts were designed for bold members of high society. The opening party at Gordon Square must have been grand, with Bell writing and painting the menu herself. The first course was a *Potage Alpha*—a salmon soup with a programmatic name—, and the last course— an equally programmatically entitled dessert—was a creation consisting of vanilla ice cream and dried fruit, called *Glaces à l'Omega.*

Food at Bell's private view was, literally, the alpha and omega, and it also played an important role in Woolf's writings, sometimes even serving as a window to her characters' souls. In *Mrs. Dalloway*, for example, the half-cooked salmon is a metaphor for the half-baked life of the protagonist, Clarissa, while the *boeuf en daube* in *To the Lighthouse*, the depiction of which had so captivated Bell on her first reading of the novel, symbolizes the hostess' power: "An exquisite scent of olives and oil and juice rose from the great brown dish," wrote Woolf, with Mrs. Ramsay triumphantly dunking her spoon in the glistening brown sauce made from wine and bay leaves.

Although the sisters operated in different fields, they inspired each other, and were in constant competition— which often proved to be particularly painful for Woolf.

• OPPOSITE The invitation to the Omega Workshops private view promises a complete range of many different designs, from home accessories to clothing textiles.
• RIGHT A house of many colors: Nothing was safe from Bell and Duncan Grant at Charleston, their house in the Sussex countryside. They painted anything they could put a brush to, be it walls, doors, lampshades, shelves, or fireplaces.

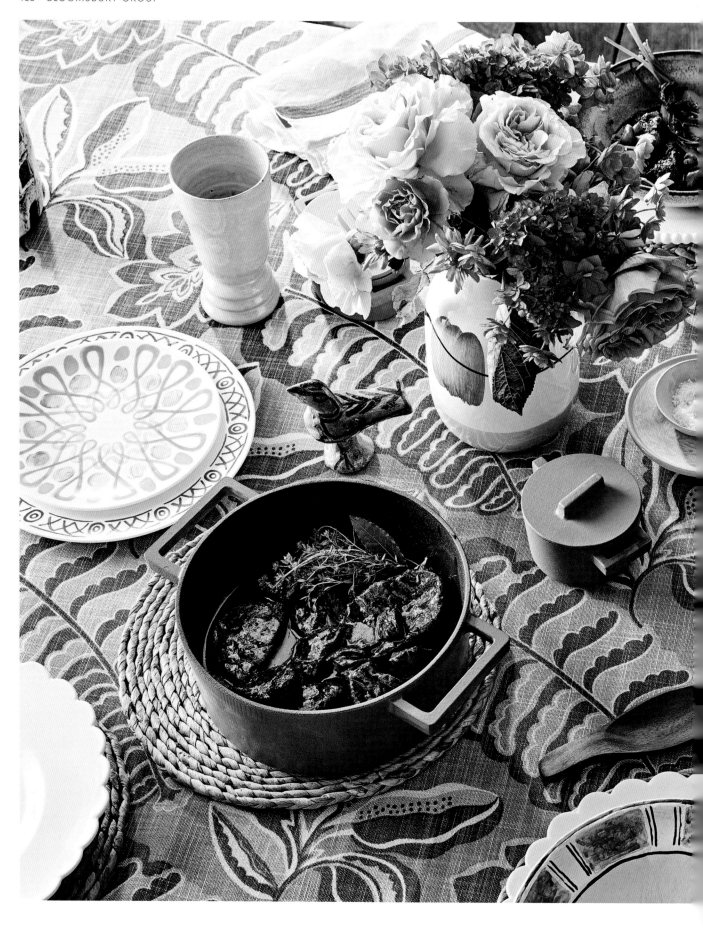

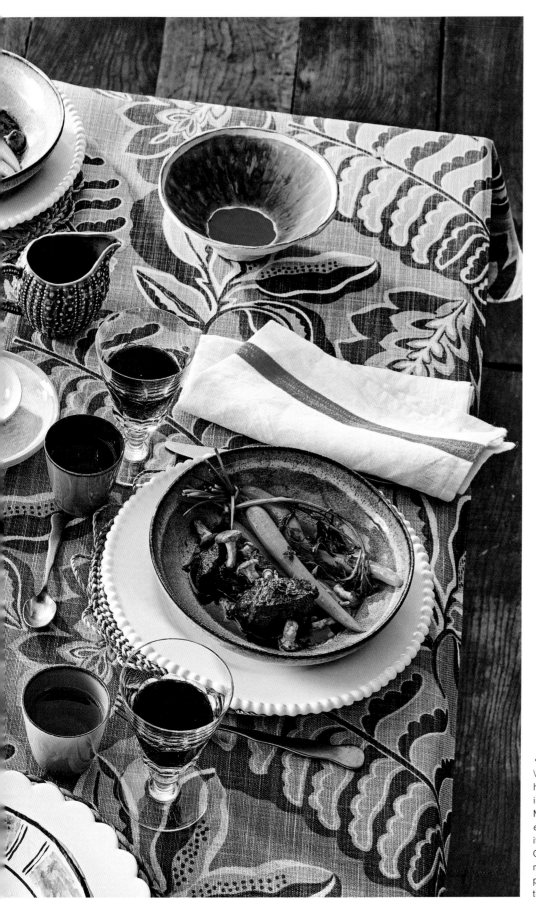

• WHILE READING VIRGINIA WOOLF'S *To the Lighthouse*, her sister Vanessa was deeply impressed by the character Mildred's favorite dish—*Boeuf en Daube*—particularly because it took three days to prepare. Our version only needs to be marinated one night and is prepared and cooked in less than half a day.

"Not only are you a great painter, but you're also a wonderful storyteller," she is believed to have said upon seeing one of Bell's paintings, which depicted three women deep in conversation. She then apparently added, "I wish I could describe three women so well in words."

Yet, for all the admiration, the sisters were always on the level, and it was to Woolf that Bell owed her life's dream: Discovering Charleston—located fifty-six miles south of London, and surrounded by meadows and forests—to which the painter moved with her children and Grant in 1916. "It has a charming garden with a pond, and fruit trees, and vegetables, all now rather run wild, but you could make it lovely," Woolf wrote to her sister, referring to more than just the jams she would later make with Bell and painter Dora Carrington, using the many berries, plums, and figs.

The garden became Bell's muse, and the house—on whose walls, fireplaces, and lampshades she had painted —a manifesto of the Omega Workshops. Some of the paintings had clearly been influenced by Matisse, while others exhibited the aesthetics of the Ballets Russes that was so popular at the time.

Fair-weather Sundays saw all the "Bloomsburys" lounge in rattan chairs among the blossoming hyacinths and eat Walnut and Coffee Slices. In the evening, they met for parties, where they dined on Tipsy Chicken (chicken cooked in gin), and friends and lovers came and went. Did Bell ever end up serving the iconic *boeuf en daube*? Most certainly; after all, her philosophy was all about combining life and art.

- TOP LEFT Cows grazed behind the house: *Farmyard Buildings at Charleston* by Duncan Grant.
- LEFT The intellectuals debated in the garden.

Potage Alpha (Alpha Soup, or: Salmon Soup)

INGREDIENTS SERVES 6

1 lb. 4 oz. / 600 g salmon
 bones (order in advance
 from your fish merchant)
1½ oz. / 50 g shallots
5½ oz. / 150 g fennel
4 oz. / 120 g carrots
3 oz. / 85 g celery root
3 oz. / 85 g leek (whites only)
5 tbsp. oil
1 tbsp. lobster paste
2 tsp. tomato paste
5 tbsp. dry white vermouth
7 tbsp. / 100 ml dry white wine
salt and pepper
1 tsp. fennel seeds
1 bay leaf
5½ oz. / 150 g tomatoes
6 sprigs parsley
⅔ cup / 150 ml heavy cream
2-3 tsp. cornstarch
cayenne pepper
2-3 tbsp. lemon juice
1 lb. 4 oz. / 600 g salmon
 fillet, skinned and boned
1 tbsp. / 15 g. butter
12 toasted baguette slices
coarse kosher salt, to serve

TIME NEEDED:
55 mins. + 30 mins. resting
+ 35 mins. cooking

METHOD LEVEL OF DIFFICULTY: MEDIUM

Chop the fish bones, wash them thoroughly under cold water, and leave to drip dry. Trim or peel, then chop the shallots, fennel, carrots, celery root, and leek.

In a saucepan, heat 3 tablespoons oil, but not too hot. Add the vegetables and the fish bones and sauté over medium heat without browning. Stir in and briefly sauté the lobster paste and the tomato paste. Add the vermouth, white wine, and 1½ quarts / 1.5 liters cold water. Season with salt, pepper, fennel seeds, and the bay leaf. Wash the tomatoes and cut off the stem ends, then chop the flesh and add to the pan. Slowly bring everything to a boil, then take the pan off the heat, and leave to rest 30 minutes, covered.

Wash and shake dry the parsley, then pull off and finely chop the leaves. Strain the fish broth through a fine strainer into another pan. Add the cream and cook the broth until it reaches about 4¾ cups / 1.2 liters. Stir the cornstarch into a little water, then use to lightly bind the soup. Season with salt, cayenne pepper, and lemon juice.

Season the salmon with salt and pepper. Heat 2 tablespoons oil in a nonstick skillet. Add the salmon and fry 1–2 minutes on both sides over not too high a heat. Add the butter and gently fry the fillets 4–5 minutes longer, frequently spooning the butter over the top.

Reheat the soup. Break the salmon into pieces. Place one baguette slice into each of six soup bowls and divide the salmon among the bowls. Fill the bowls with the soup and sprinkle with the parsley.

Season with coarse salt and cayenne pepper, and serve with the remaining toast.

Bœuf en Daube

INGREDIENTS SERVES 6

3 lb. 5 oz. / 1.5 kg boneless
 beef, such as chuck
1 organic orange
2 garlic cloves
1 bottle (75cl) dry red wine
10 sprigs thyme
2 bay leaves
1 tbsp. black peppercorns
14 oz. / 400 g onions
10 oz. / 300 g carrots with
 greens
10 oz. / 300 g celery root
½ cup + 1 tbsp. / 135 ml
 vegetable oil
salt, pepper, 1 tsp. sugar
1 tbsp. tomato paste
1¼ cups / 300 ml beef broth
2-3 tsp. cornstarch
4 tbsp. black olives
10 oz. / 300 g chanterelles
1 lb. 4 oz. / 600 g carrots
1 tbsp. / 15 g butter
grated nutmeg

TIME NEEDED:
1¼ hours + overnight marinat-
ing + 4 hours cooking

METHOD LEVEL OF DIFFICULTY: MEDIUM

Carefully cut the skins and tendons off the beef, then cut the meat into 2 in. / 5 cm pieces. Wash and pat dry the orange. Peel off 4 thin strips of zest. Halve the orange and squeeze out the juice. Peel and crush the garlic cloves. Put the meat into a bowl together with the red wine, orange zest and juice, garlic, thyme, bay leaves, and pepper. Cover and leave to marinate overnight.

Peel and dice the onions. Peel the carrots and the celery root and roughly chop the celery root. Take the meat out of the marinade and pat dry really well. Reserve the liquid.

Heat the oven to 325°F / 170°C (Gas 3; convection ovens 300°F / 150°C). In an ovenproof Dutch oven, heat 4 tablespoons oil. Add the meat in batches, sear all around over high heat, and season with salt and pepper.

Take the meat out of the pot. Heat 3 tablespoons oil in the pot. Add the onions, carrots, and celery root, and fry 10 minutes until browned. Stir in the tomato paste, sprinkle with the sugar, and stir briefly. Pour in 1¼ cups / 300 ml of the marinade and boil to reduce. Return the meat to the pot and pour in the remaining marinade, the beef broth, and ⅔ cup / 150 ml water. Also add the orange zest, thyme, and bay leaf from the marinade. Place the Dutch oven on the lowest rack in the oven and cook the beef 3½–4 hours—do not completely cover with the lid so some of the liquid can evaporate.

Take the pot out of the oven and remove the meat. Strain the sauce into a saucepan, then push the vegetables through the strainer, but not too hard. Return the meat and the sauce to the pot and bring to a boil. Stir the cornstarch into a little water, then use to bind the sauce. Add the olives.

Clean the chanterelles and trim and peel the carrots, reserving 2 tablespoons of the carrot greens. Melt the butter in a wide skillet. Add the carrots and sauté briefly. Add enough water to nearly but

not completely cover the carrots. Season the carrots with salt, pepper, and nutmeg. Bring to a boil, then cook over medium heat 5–6 minutes, or until tender, but still firm to the bite.

Heat 2 tablespoons oil in another skillet over high heat. Add the chanterelles and sauté 3–4 minutes, then season with salt and pepper. Divide the meat, carrots, chanterelles, and the sauce among the plates. Chop the carrot greens, sprinkle over the carrots, and serve.

Caraway Bites

INGREDIENTS
MAKES ABOUT 25 BITES
2 tsp. caraway seeds
1¾ sticks / 200 g butter,
 softened
¾ cup + 1 tbsp. / 200 g
 superfine sugar
salt
2 tsp. finely grated zest of
 1 organic lemon
4 eggs
2⅓ cups + 1 tbsp. / 300 g all-
 purpose flour
2 tsp. cream of tartar
½ cup / 125ml milk
¾ cup + 1½ tbsp. / 100 g
 confectioners' sugar
1½ tbsp. lemon juice

TIME NEEDED:
45 mins. + 45 mins. baking

METHOD LEVEL OF DIFFICULTY: EASY

Dry-fry the caraway seeds in a skillet without fat until they start to release their aroma. Leave to cool, then coarsely grind with a mortar and pestle.

Heat the oven to 350°F / 180°C (Gas 4; convection ovens 325°F / 160°C). Grease a 12 in. / 30 cm rectangular loaf pan (about 4 cups / 1 liter volume). In a bowl, beat the butter, sugar, a pinch of salt, and lemon zest at least 5 minutes with a handheld mixer, or until white and creamy. Add the eggs, one after the other, and beat each one 30 seconds. Combine the flour, cream of tartar, and half the caraway seeds, then quickly stir in, alternating with the milk.

Spoon the batter into a greased loaf pan (9 x 5 in. / 23 x 13 cm) and smooth the top with a palette knife. Bake 45–55 minutes on the second rack from the bottom in the oven until light brown. Take out of the oven and leave 10 minutes to cool in the pan, then tip onto a wire rack and leave to cool completely.

Sift the confectioners' sugar into a bowl and stir in the lemon juice to make a fairly thick frosting. Transfer to a small pastry bag and cut off a very thin tip.

Cut the cake into ¾ in. / 2 cm thick slices. Using a small, fluted round cookie cutter, cut out small circles from the slices. Decorate with the frosting and sprinkle with the remaining caraway seeds.

Walnut and Coffee Slices

INGREDIENTS
MAKES 16–20 SLICES
¾ cup / 150 g granulated
 sugar
salt
4 eggs
1 cup / 120 g all-purpose flour
½ tsp. baking powder
1 cup / 150 g walnut halves
2¼ sticks / 250 g butter,
 softened
1⅔ cups / 200 g unsifted
 confectioners' sugar
salt
2 fresh egg yolks
¾ cup / 175 ml strong, cold
 espresso
1 tsp. grated orange zest
4 tsp. instant espresso
 powder
16–20 walnut halves, to
 decorate

TIME NEEDED:
1¼ hours + 12 mins. baking
+ 4 hours chilling

METHOD LEVEL OF DIFFICULTY: MEDIUM

Heat the oven to 375°F / 190°C (Gas 5; convection ovens 350°F / 170°C). Line a 16 x 12 in. / 40 x 30 cm shallow baking pan or jelly roll pan with parchment paper. Set aside 1½ tablespoons sugar. Put the remainder into a bowl with a pinch of salt and the eggs and beat at least 5 minutes with a handheld mixer, until white and creamy. Combine the flour and the baking powder and sift onto the egg mixture in batches, carefully folding in after each batch.

Place the batter in the pan and use a metal spatula to spread it evenly into the corners. Bake 12 minutes on the middle rack of the oven, or until golden-yellow. Sprinkle a kitchen towel with the remaining sugar, then immediately tip the cake on top. Carefully pull off the parchment paper, turn the cake over, and loosely replace the paper. Leave on a wire rack to cool completely.

Chop the walnuts. Beat the butter, confectioners' sugar, and a pinch of salt 10 minutes with a handheld mixer until white and creamy. Add the egg yolks, 3 tablespoons espresso, the orange zest, and 2 teaspoons instant espresso powder, and carefully stir in. Finally, fold in the walnuts.

Cut the cake layer into 4 even-size pieces, each 8 x 5½ in. / 20 x 14 cm. Line the bottom of a high-rim baking pan with parchment paper and place one cake piece on top. Soak the cake with a little espresso, then spread evenly with one-quarter of the buttercream. Place another cake piece on top, lightly press down, and soak with a little espresso, then spread with a little buttercream. Carry on layering the remaining cake layers and the buttercream in the same way. Smooth the top layer with a metal spatula. Cover with plastic wrap and chill at least 4 hours.

Remove the cake from the pan. Slice the cake, always dipping the knife into hot water, then drying it. Dust the slices with the remaining espresso powder and place a walnut half on each slice.

Strawberry Jam

INGREDIENTS

MAKES 3-4 JARS

1 lb. 4 oz. / 600 g ripe strawberries
2 tbsp. lemon juice
1¼ cups / 250 g jelly sugar (2:1)

TIME NEEDED:
30 mins. + 3 mins. cooking

METHOD LEVEL OF DIFFICULTY: EASY

Wash the strawberries in cold water and let them drip dry, then hull and chop them.

Put 3 cups / 500 g strawberries into a saucepan over high heat together with the lemon juice and the jelly sugar. Thoroughly mash with a potato masher.

Bring the strawberries to a boil, stirring. Once the mixture starts to boil, continue boiling exactly 3 minutes (or according to the sugar package directions).

To do a gel test, spoon 1 tablespoon jam onto a cold saucer. If the jam sets within 1–2 minutes, it is ready to be transferred to the jars. If not, boil 1 minute longer. Carefully skim the foam off the top of the strawberry jam.

Using a funnel, transfer the jam into sterilized, screw-top jars and fill to the rim.

Close the jars and place upside-down 5 minutes on a wire rack. Turn them right side up again and leave to cool completely.

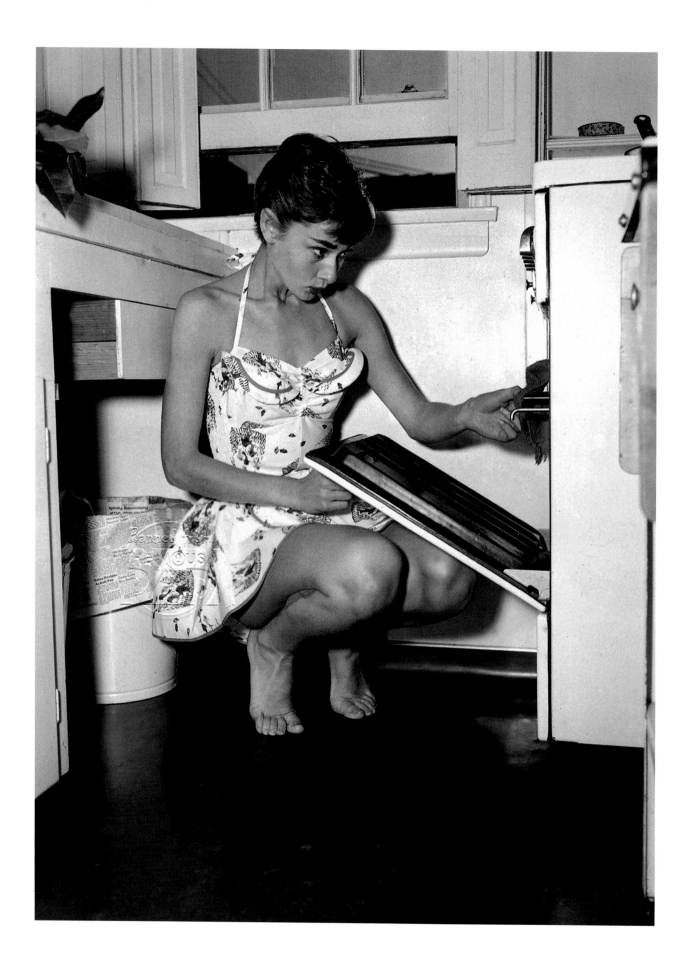

Audrey Hepburn

THE ROLE OF HER LIFE

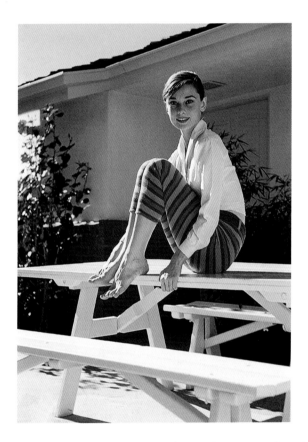

The actress and style icon was also a keen cook, who loved treating friends and family to pasta and apple crumble. After fifteen successful years in the movie industry, Audrey Hepburn withdrew from public life somewhat—and only those familiar with her childhood history could know just how much she valued grocery shopping at a market, or how much she appreciated beautifully set dinner tables.

• OPPOSITE Dinner's ready! Audrey Hepburn in her little apartment on Wilshire Boulevard in Los Angeles, which she rented in 1953 while filming *Sabrina*.
• ABOVE Hepburn seated on top of a picnic table, wearing cheerful striped trousers, 1950.

It was a summer's day in the early '70s. The scent of lavender was in the air, the garden parasols were up, and the children were romping around the garden while the adults drank chilled punch. It was a garden party at Audrey Hepburn's Swiss country house. Steaming bowls sat on small round tables, and the hostess, sporting a yellow mini dress, oversized shades, and a stylish updo, served the guests her favorite dish: *spaghetti al pomodoro*. Simple and freshly prepared, this Italian classic included tomatoes, fresh from the garden, with olive oil, onions, a pinch of sugar, and some freshly grated Parmesan.

Hepburn had quietly and unobtrusively retreated from the movie business. While she did still attend festivals, premieres, and awards ceremonies, and make appearances at the studio and fashion shows of her close friend, designer Hubert de Givenchy, she had been rejecting movie roles for some time. Even the most interesting of scripts failed to sway her. Her private life—with her second husband, Andrea Dotti, an Italian psychiatrist; her son, Luca, born in 1970; his half-brother, Sean; and her closest friends, who included Terence Young, director of three James Bond films, actor David Niven, and Pink Panther star Capucine—was too precious. The bulk of this quiet time was spent at La Paisible, her country house in Tolochenaz, near Lake Geneva.

She had worked continuously until the age of forty. Her first lead role in 1953 movie *Roman Holiday* saw her play a princess who fell in love with a newspaper reporter. It earned her an Oscar. Following additional films—and Oscar nominations—her career peaked in 1961 when she played Holly Golightly in the film adaption of Truman Capote's novella *Breakfast at Tiffany's*. With her pearl necklace, tiara, cigarette holder, Givenchy dress, and seductive look, the world had a new style icon. But it all meant very little to Audrey, as became apparent just a few years later. In 1967, she shot *Wait Until Dark*, which would provisionally be her last movie. Her marriage to actor and producer Mel Ferrer ended soon after. Sometime later, she met Dotti, and the pair wasted no time in getting hitched. "Do you know what it's like when a brick falls on your head?" she commented about the sudden manner in which she fell in love with Dotti.

"Family life was something she had waited a long time for," said son Luca. Hepburn and Dotti commuted between Rome and Lake Geneva, with Hepburn preferring to party at home than to go out—after all, there were too many paparazzi on the streets of Rome. It didn't take long for

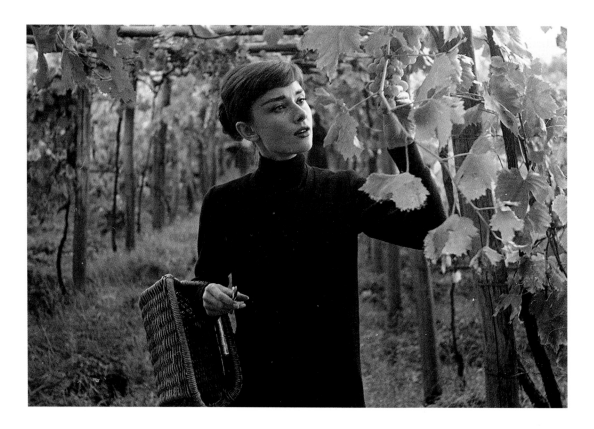

• ABOVE Hepburn picking grapes in her Italian vineyard, 1955.
• OPPOSITE In 1955, near Rome, posing with a little donkey during a break while shooting *War and Peace*.

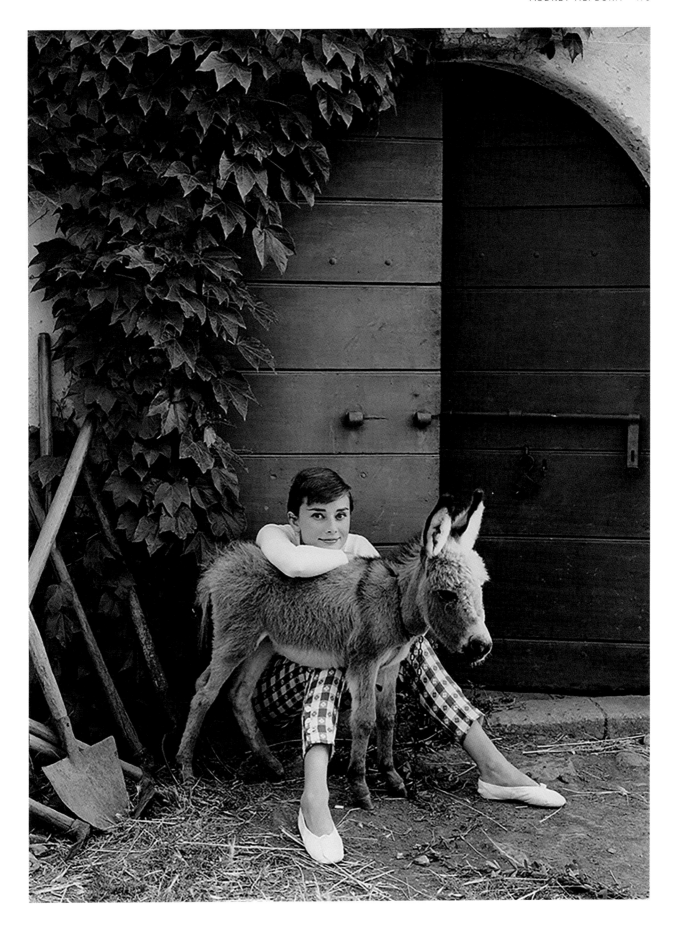

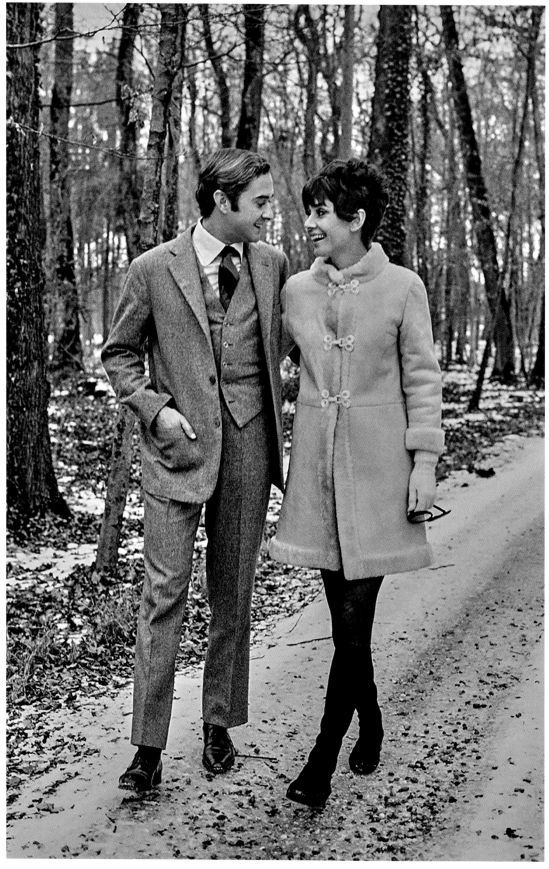

• THE NEWLYWEDS Hepburn and Dr. Andrea Mario Dotti walking down a road through the forest near her home in Rome, in 1969.

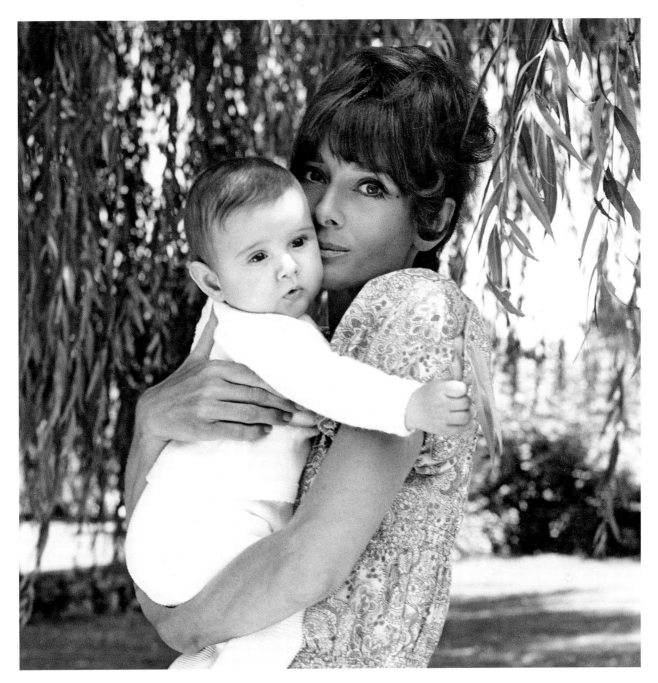

• IN THE EARLY 1970S *Hepburn holding her second son, Luca, born in 1970, under a large willow in the garden of La Paisible.*

whispers to start circulating in the movie industry, however: Who would have thought? Holly Golightly's become a housewife! While Audrey couldn't escape this, she didn't let it unsettle her. "It's sad if people think that's a dull existence, but you can't just buy an apartment and furnish it and walk away. It's the flowers you choose, the music you play, the smile you have waiting," she said, turning her back on the pressures of the glamorous world. She didn't have to prove anything to anyone. Only those familiar with her childhood would understand how much she valued her country house, her family, and a bowl of steaming tomato sauce on fresh pasta.

The daughter of a British father and Dutch mother, Hepburn first grew up in England, then in Arnhem, in the Netherlands. She was ten years old when World War II broke out in 1939, and her parents separated. During the Dutch famine of 1944/45, she, like many others, ate tulip bulbs and grass out of desperation. She never forgot

the trucks of the UNRRA, the predecessor organization of today's UNICEF, arriving in the Netherlands in 1945, loaded with flour, butter, and other foods. It was these memories that later drove her to tirelessly travel to the poorest regions of Africa as a UNICEF ambassador. She continued to do this until shortly before her death in 1993.

The country house in Switzerland was where she felt safest. In the summer, the cows from the surrounding meadows grazed in her garden, in the shade of the trees. A family of ducks bathed in the pool every morning, and Audrey would take great care when swimming so as not to scare them away. Plums; Abate Fetel pears, to be braised in wine before being served; apples, which were made into juice and jelly and baked into simple desserts; and, her favorite, cherries, all grew in her fruit garden. Her breakfast routine involved eating toast with cherry jam. Her diet was determined by the seasons. With one exception: Gardener Giovanni picked the tomatoes in the summer, and a large quantity of them would then be frozen so Audrey could cook her *Spaghetti al pomodoro* all year around. "My mother was a self-sufficient person; she tended a giant vegetable garden on our property, stewed fruit, shopped at the market, and was interested in organic farming long before anyone was talking about it," Luca recounts.

She collated many of her favorite recipes in a folder. They included *Boeuf à la cuillère* (a roast dish braised in Marsala and tomato paste), which Givenchy requested on every visit. Another of Audrey's specialties was her own pesto creation made from basil and parsley with a dash of milk. She prepared this for fashion designer Valentino Garavani, also one of her friends. A creamy, flourless chocolate cake and warm apple crumble were mandatory desserts. There were enough apples all year around, and the house constantly smelled of compote. Even decades later, her son associated each recipe with memories of Hepburn, her friends, and her parties. "For my mother, luxury meant everyone being happy."

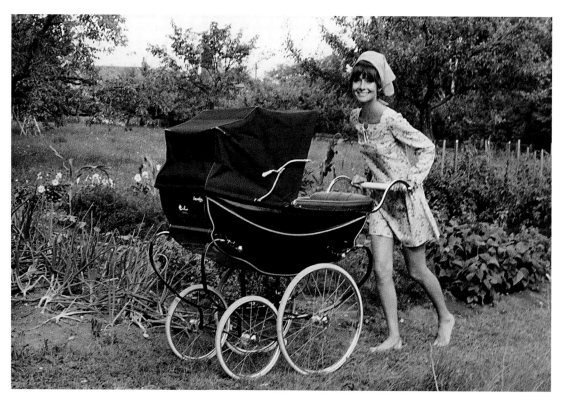

• ITALY 1971 **Hepburn pushing her son, Luca, through her garden.**

Spaghetti al pomodoro (Spaghetti with Fresh Tomato Sauce)

INGREDIENTS SERVES 4

3 lb. 5 oz. / 1.5 kg ripe vine tomatoes, stemmed, seeded and roughly chopped
1 onion, peeled and whole
1 celery stick, trimmed and whole
1 carrot, cleaned and whole
6 basil leaves, chopped, plus a few leaves for garnishing
virgin olive oil
a pinch sugar, optional
salt and freshly ground black pepper
500 g spaghetti
coarse salt for cooking the spaghetti

METHOD LEVEL OF DIFFICULTY: EASY

In a large skillet with lid, cook the tomatoes with the onion, celery, and carrot, covered, over high heat 10 minutes, or until the vegetables are tender.

Uncover and simmer 10–15 minutes longer, stirring with a wooden spoon.

Reduce the heat and add the chopped basil and a splash of oil.

The tomato sauce is finished when it is *pipiotta*, as they say in Naples: when it is no longer watery, but forms bubbles with small craters. Take the skillet off the heat, remove the whole vegetables and leave the sauce to cool.

Using a food mill, puree the tomato sauce and vegetable pieces to the desired consistency. This also removes the tomato's bitter skins and seeds.

Return the tomato sauce to the skillet and warm through. Add a little olive oil and, if the sauce is a little bitter, counter the flavor with a pinch of sugar. Season with salt and pepper. Cover the sauce and keep warm until serving.

To cook the spaghetti, fill a large saucepan with plenty of water and bring to a boil. As soon as the water boils, add a handful of coarse salt and the spaghetti, without breaking the strands.

As soon as the pasta is al dente (perhaps after a minute less than the cooking time given on the package), take the pan off the heat. Drain in a colander, then add the pasta and a little finely grated Parmagiano reggiano to the sauce. Toss well, garnish with a few basil leaves, and serve.

Apple Crumble

INGREDIENTS SERVES 4

For the filling:
1 tbsp. / 15 g butter, plus extra for the baking dish
5 apples (Golden Delicious or Reinette), peeled, cored, and cut into ½ in. / 1 cm dice
juice of ½ lemon
¾ cup / 150 g packed brown sugar
1 tsp. ground cinnamon
For the crumble:
1½ cups / 180 g all-purpose flour
heaped ½ cup / 150 g cane sugar
1 stick / 120 g butter, chilled and diced
vanilla ice cream or whipped cream, to serve

TIME NEEDED:
50 mins.

METHOD LEVEL OF DIFFICULTY: EASY

Heat the oven to 400°F / 200°C (Gas 6; convection ovens 375°F / 180°C). Grease a baking dish suitable for serving from (9½ in. / 24 cm diameter) with butter.

To make the filling, melt the butter in a large skillet. Add the apples, lemon juice, sugar, and cinnamon, and sauté 2 minutes, then set aside.

To make the crumble, put the flour, cane sugar, and butter into a large bowl and quickly rub together with your fingers to make a crumbly mix.

Transfer the apples into the prepared dish and cover evenly with the topping. Bake 30 minutes on the middle rack in the oven, or until the top is golden-brown. Take out of the oven and let cool a little.

Serve the apple crumble while still lukewarm, with vanilla ice cream or whipped cream.

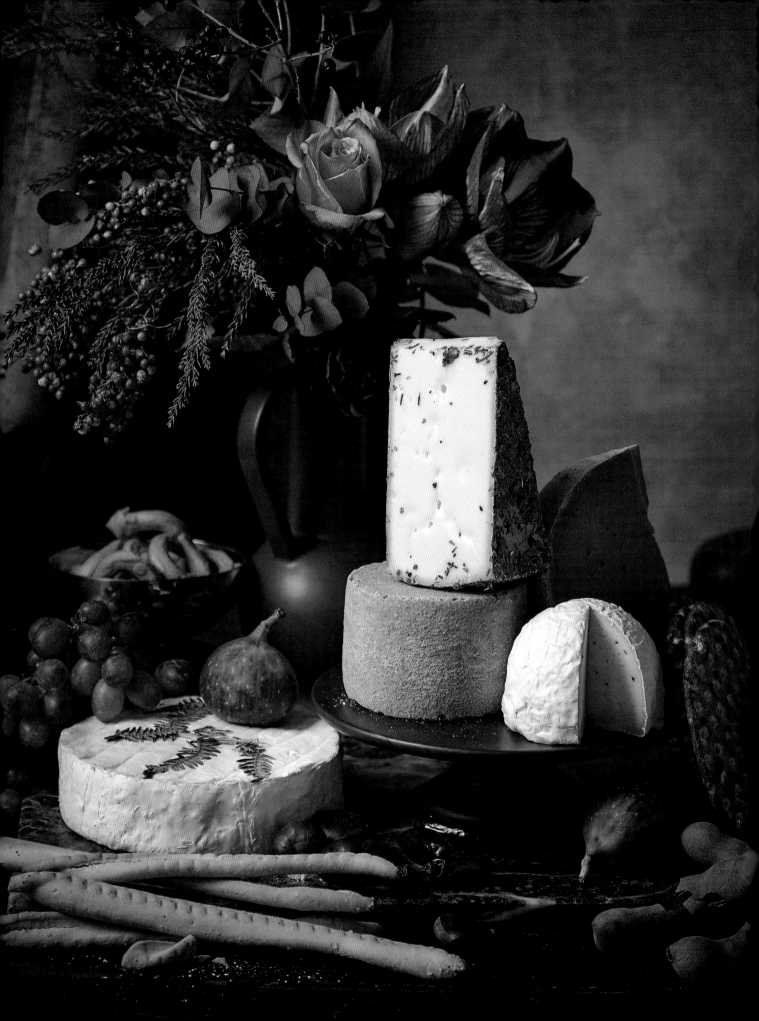

Tomi Ungerer

SCAREDY-CAT
FOR MAINS

When reading Tomi Ungerer's children's books,
a vague feeling of unease is often created. So, for example,
in *Zeralda's Ogre* for the monstrous giant in this book loves
nothing more than to eat tender, juicy children—until little
Zeralda starts serving him up one feast after another.
The ogre soon realizes veal chops in truffled
aspic aren't that bad, either.

• OPPOSITE Even if cheese is certainly not one of Zeralda's favorite dishes (children have
to grow up first), the cheese platter should, of course, not be missing from a feast. A good
selectionmight include, for example, a fougeru made from cow's milk with fern, a sheep's cheese
from the Pyrenees, a piece of hay flower cheese, a Gaperon fermier and a mimolette.
• ABOVE Copper pans and giant pots on an imaginative version of the Aga range—in this
kitchen filled with magical details, Zeralda creates delicacies that would save her life. The
animals—not quite ready to cook and hanging on a hook—were less fortunate.

Fear is no joke. A feeling that puts a lump in your throat and makes it difficult to swallow. That sends beads of sweat dripping down your forehead, and leaves your hands clammy. Produced by adrenalin that races through your veins like a bullet train. This hormone that sends off red alerts, causing your heart to beat faster. It is the same hormone that also pushes us to peak performance, sending us into fits of ecstasy. Yet, there are two sides to fear. We throw our hands in front of our face when watching a gruesome scene in a movie, only to then peep through our fingers to see if the axe-wielding burglar really did do what we think he will do. Curiosity, that cocky little creature, frequently challenges our fear to a duel. The shivers it sends down our spine are like a fiery chili spicing up an otherwise sugary, harmonious everyday life. And, in the right quantities, it certainly is tasty.

Few have mastered the art of playing with fear, and the fascination it engenders, as perfectly as French writer and illustrator Tomi Ungerer, who died in 2019. With every turn of the page, a subtle sense of uneasiness creeps in, a trepidation that takes a hold between the lines. "One must see fear as an adventure," said Ungerer, who used the feeling as the basis for his books, drawings, and caricatures. Coupling it with provocation, he maxed out the limits of both literature and law. In the United States, where he had migrated in 1956 with just $60 in his pocket, his works were regularly censored, the FBI monitored him, and his social criticism was viewed with suspicion. The émigré's stories were too explicit, sexist, and provocative for puritanical America. Even in enlightened Europe, Ungerer's texts and illustrations often left people shaking their heads, and teachers issuing warnings about his children's books. At one panel discussion, the president of the Swiss kindergarten association made it abundantly clear that she would never allow any of his children's books in kindergartens, because the stories would scare the little ones. Fine, thought Ungerer, "no courage without fear."

In his children's book *Zeralda's Ogre*, Ungerer combines two of his great passions: fear and culinary art. With a sharpened pencil and equally sharp tongue, which also happened to have gourmet tastes, he tells the story of an ogre who is partial to eating little children. The ogre particularly enjoys munching on boys and girls for breakfast,

• TOMI UNGERER was born in Strasbourg in 1931. He published his first drawings in *Simplicissimus*, and he celebrated world success in New York. His award-winning books were published by Diogenes Verlag in Zurich, where the photo above was taken. Ungerer died in Cork, Ireland, in 2019.

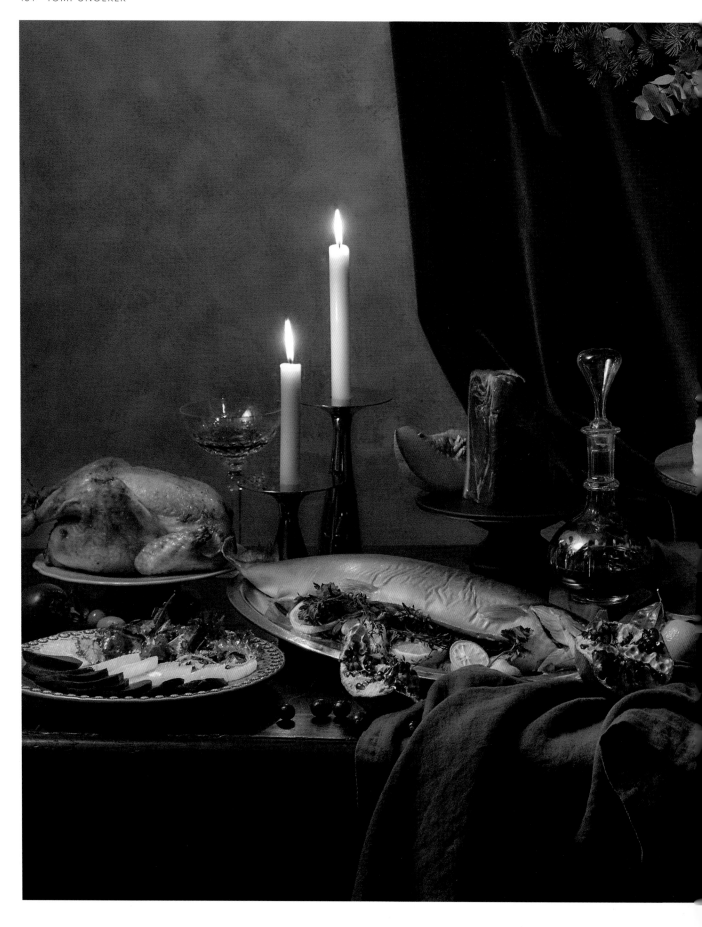

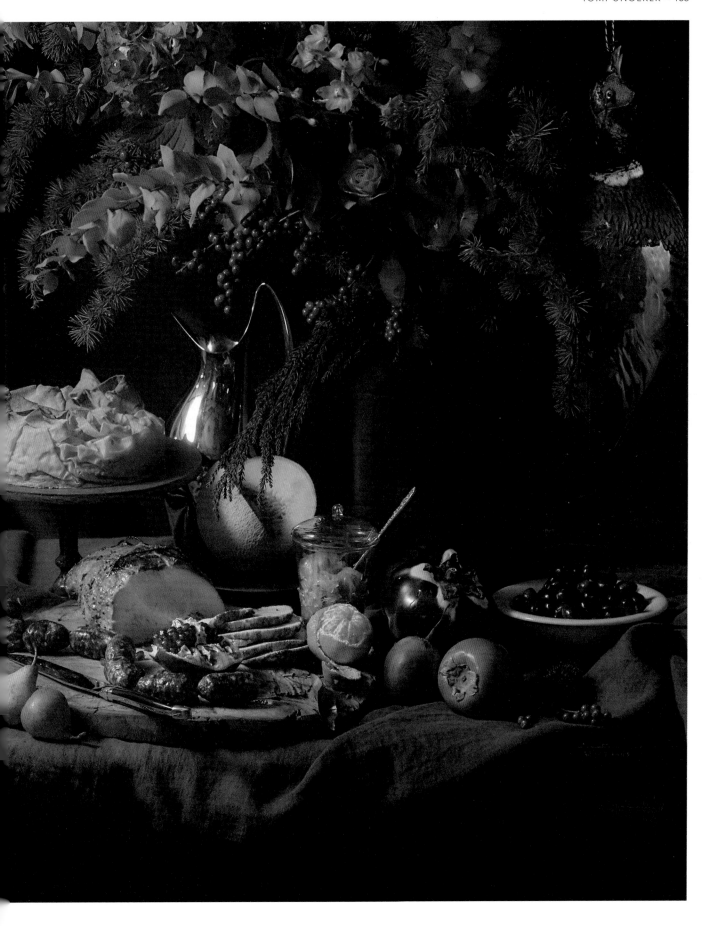

which makes sense, for breakfast is the most important meal of the day. "For cannibals, the flesh of young children is nice when fried in butter with lots of spice," we are told. Ungerer makes the ogre's cannibalistic cravings clear from the very first page, showing no regard for the potential nightmares or intensive thumb-sucking they might cause: Gripping a blood-smeared knife, the ogre eyeballs a crate with bars that are are being rattled by two small hands. Definitely not for the faint-hearted, but "one must scare children a little bit." Even though, according to Ungerer, the children in his books never are scared.

Little Zeralda doesn't for a moment think she might need to be scared of the cranky hulk who accosts her on the street. Ravenous and impatient, the ogre falls off the cliff, from which he had planned to pounce on Zeralda. "Pride comes before a fall," we may have thought with an admonishingly raised finger, had Ungerer not been horrified at any form of conventional didactics. The little girl lovingly cares for the injured ogre and nurses him back to health—with cream of watercress soup, smoked trout with capers, escargots with garlic butter, roast chicken, and even a suckling pig. Because, like Ungerer, Zeralda is a gourmet who loves to cook. "You eat, and you realize that you are alive," Ungerer wrote in his diary in 1974.

The amateur chef even wrote a play called *Die Wurstpartei* [The Sausage Party], and worked for several years as a food critic—for *Playboy*. After all, he was well versed in matters of bare flesh—as can be gleaned from his erotic drawings for adults.

The ogre likes Zeralda's dishes, and forgets about his favorite food, namely little children. In the ogre's castle kitchen, Zeralda conjures up the most outlandish of menus, filling cookbook after cookbook with her recipes. *Zeralda's Ogre* was published in 1970, a time when Flower Power songs were being strummed on guitars, and posters advocating free love were being stuck to dorm and bedroom walls. Intermittent fasting and keto diets were unheard of—and for war baby Ungerer, who always scraped his plate clean and took doggie bags home from restaurants, they remained so, even in his books. Zeralda, thus, has abundant resources to draw on, serving up the following "midnight snack" for her now-refined ogre: sauerkraut and sausage, foie gras in puff pastry, veal chops

in truffled aspic, pompano à la Sarah Bernhardt, chocolate sauce Rasputin, and roast turkey à la Cinderella, finished off with Ogre's Delight, which consisted of candied fruit, ladyfingers, and ice-cream cake. Worrying about cholesterol levels is overrated.

"Sauerkraut is just phenomenal," Ungerer said in an interview with the *Frankfurter Allgemeine Zeitung* newspaper, adding that he had even used it to help his publisher back to health. But potatoes were his favorite, and he even draws them as a side dish to Zeralda's sauerkraut and sausage creation. Even though Ungerer was born in Alsace, he deplored French haute cuisine, considering it too snobby and exclusive. He was very down-to-earth, and loved everything that came out of it, especially his mother's sorrel soup. He discovered cooking through his brother-in-law, a natural talent, and called himself a "tinkering cook." Ungerer, a free spirit, both in the kitchen and at his drawing table, avowed "My cooking philosophy revolves around tricks, not recipes . . . A baker needs his recipes, but for me it's all about improvisation." A rebel who went his own way his whole life, even as a wrinkly old man with snow-white hair.

And, Ungerer applied this same cooking philosophy to his writing: "Every children's book is different; I can't stick to one recipe there either," he once explained. Zeralda also could not stick to one recipe with her dishes. As the years went on, she stirred and baked her way into the ogre's heart, while he with his now "healthy" appetite captured hers. And one almost catches a flash of a cliché in Ungerer's otherwise utterly unconventional stories: Much like in the Grimm brothers' fairytales, there is a happy ending, with a grown-up Zeralda and the ogre eventually marrying and having lots of children. Ungerer even opted for the traditional closing sentence "And they lived happily ever after," albeit with the added parenthesis of "one might imagine," which readers could be forgiven for overlooking. A phrase that once again sends alarm bells ringing and adrenalin levels soaring. Just as the little boy does, looking at the baby in Zeralda's arms, his arms folded behind his back—and gripping a knife and fork. All of a sudden, you find yourself with that lump in your throat again, struggling to swallow. This is the way it should be.

Orange, Beet, and Kale Salad

INGREDIENTS SERVES 4
(BY ITSELF, AS AN APPETIZER) OR
8 (AS PART OF A BUFFET)
½ cup / 70 g pumpkin seeds
4 oranges
1 tbsp. honey
7 tbsp. best-quality olive oil
2 tbsp. white wine vinegar
salt
9 oz. / 250 g kale leaves
1 lb. 2 oz. / 500 g cooked
 beets, vacuum-packed

TIME NEEDED
20 mins.

METHOD LEVEL OF DIFFICULTY: EASY

In a skillet without any fat, dry-fry the pumpkin seeds, then remove them. Wash and pat dry 1 orange, then finely grate the zest and squeeze out the juice. In a large bowl, combine the orange zest with the honey, olive oil, vinegar, and salt to taste. Rinse and pat dry the kale, then tear the leaves into small pieces. Add the kale to the bowl and knead with your fingers about 1 minute in the dressing. Fold in the pumpkin seeds.

Drain and slice the beets. Peel the remaining oranges, removing all the bitter white pith. Slice the oranges and remove the seeds.

Arrange the beets, oranges, and kale on a platter.

• TIP: This also tastes delicious with buffalo mozzarella.

Phyllo Pastry Pie with King Oyster Mushrooms and Alpine Cheese

INGREDIENTS SERVES 4
(BY ITSELF, AS AN APPETIZER)
OR 8 (AS PART OF A BUFFET)
1 lb. 2 oz. / 500 g frozen
 spinach
7 oz. / 200 g king oyster
 mushrooms
salt and pepper
2 shallots
3 tbsp. olive oil
1 heaped tbsp. all-purpose
 flour
5 oz. / 140 g medium-aged
 alpine cheese
5 tbsp. / 75 g butter
4½ oz / 125 g phyllo pastry
 dough, thawed if frozen
4 organic eggs, at room
 temperature
1 cup / 250 g crème fraîche
grated nutmeg

TIME NEEDED:
1 hour + 20–30 mins. cooking

METHOD LEVEL OF DIFFICULTY: MEDIUM

Heat the oven to 400°F / 200°C (Gas 6; convection ovens 375°F / 180°C).

Thaw the spinach and squeeze it out well. Clean and slice the king oyster mushrooms, then season them with salt. Peel and finely chop the shallots. Heat 2 tablespoons oil in a skillet. Add the mushrooms and fry until golden-brown, then take them out. Pour the remaining oil into the skillet, add the shallots, and fry until translucent. Stir in the spinach and season with salt and pepper. Sprinkle the flour over and stir about 1 minute, then remove from the pan. Finely grate the cheese.

Melt the butter in a small pan. Generously brush the phyllo dough sheets on one side with the about 4½ tablespoons of the butter. Use the remaining butter to grease a springform pan with a high rim (8–8½ in. / 20–22 cm diameter). Place the dough sheets, buttered sides up, on top of each other in the pan, letting the edges overlap.

Put the spinach, mushrooms, and cheese into the prepared pan. Beat together the eggs and crème fraîche, season with salt, pepper, and nutmeg, then pour over the vegetables. Loosely twist together the overhanging dough edges to cover the filling.

Bake the pie on the bottom rack of the oven about 35 minutes, or until golden-yellow. If the pastry darkens too quickly, cover it with parchment paper.

• TIPS: It is helpful to wrap the outside of the springform pan in aluminum foil so none of the egg mixture can run out. Prepare the pie the day before your dinner. Serve cold or hot.

Arctic Char with Deep-fried Capers and Amalfi Lemons

INGREDIENTS SERVES 8
(BY ITSELF, AS AN APPETIZER) OR
10 (AS PART OF A BUFFET)
1 ready-to-cook arctic char
 with head, 4 lb. 8 oz. / 2 kg,
 gutted and gills removed
kosher salt
1 bunch each flat-leaf
 parsley and thyme
3 Amalfi or organic lemons
vegetable oil for greasing
4 tbsp. / 60 g clarified butter
½ cup / 80 g bottled capers
1 tsp. Espelette pepper

TIME NEEDED:
20 mins. + 1 hour cooking

METHOD LEVEL OF DIFFICULTY: EASY

Rinse the fish under cold water and pat it dry, then rub it inside and out with salt. Push the herbs into the belly opening. Wash 2 lemons in hot water, then slice them and also push them into the belly opening. Wash the remaining lemon in hot water, then finely grate off the zest.

Heat the oven to 225°F / 110°C (Gas ¼; convection ovens 200°F / 90°C). Place the fish on a greased cookie sheet. Slide a roasting pan onto the lowest rack and fill it with hot water. Place the cookie sheet with the fish one rack above. Cook the fish about 1 hour in the steam.

Turn off the oven and leave in the closed oven 10 minutes longer. Take out and leave to cool, if you like—the fish tastes delicious hot or cold.

Just before serving, drain and thoroughly pat dry the capers. Melt the clarified butter in a skillet. Add the capers and fry 4–5 minutes until crisp.

Stir together the capers, lemon zest, and Espelette pepper, and serve with the fish.

Chicken with Saffron Butter and Chestnuts

INGREDIENTS SERVES 4
(BY ITSELF, AS AN APPETIZER) OR
8 (AS PART OF A BUFFET)

*3 tbsp./ 45g clarified butter,
 softened*
a good pinch ground saffron
salt and pepper
*1 organic corn-fed chicken,
 about 4 lb. 8 oz. / 2 kg*
5 oz. / 140 g red onions
2 garlic cloves
6 sprigs sage
4 tbsp. olive oil
1 tsp. chili flakes
*9 oz. / 250 g cooked, shelled
 chestnuts, vacuum-packed*

TIME NEEDED:
15 mins. + 40 mins. marinating
+ 1 hour 40 mins. cooking

METHOD LEVEL OF DIFFICULTY: MEDIUM

Stir together the clarified butter, saffron, and ½ teaspoon salt. Wash the chicken, pat dry with paper towels, and rub the inside with salt and pepper. Remove the fat gland from the top of the pope's nose. Rub the outside with the saffron butter, cover, and leave to marinate about 40 minutes.

Meanwhile, peel and finely chop the onions and the garlic. Wash and finely chop the sage. Heat 2 tablespoons oil in a nonstick skillet. Add the onions, garlic, and chili flakes, and fry gently 10–15 minutes. Add the chestnuts and fry 1 minute. Season with salt and pepper, transfer to a bowl, and leave to cool a little.

Meanwhile, heat the oven to 350°F / 180°C (Gas 4; convection ovens 325°F / 160°C). Fill the chicken with the chestnut mixture and close the belly with wooden toothpicks. Tie the legs together with kitchen string. Rub the skin with the remaining oil.

Place the chicken on a rack in a roasting pan and push it onto the middle rack in the oven. Put another roasting pan filled with water below. Roast the chicken about 20 minutes, then reduce the heat to 325°F / 160°C (Gas 3; convection ovens 300°F / 150°C). Continue roasting the chicken 1 hour 20 minutes. Remove the chicken from the oven, cover, and leave to rest about 10 minutes before serving.

Roast Ham with Dijon Mustard and Orange

INGREDIENTS SERVES 8
(BY ITSELF, AS AN APPETIZER) OR
14 (AS PART OF A BUFFET)

1 organic orange
4 sprigs flat-leaf parsley
2 tbsp. runny honey
2 tbsp. Dijon mustard
1 tbsp. wholegrain mustard
1 tsp. chili flakes
1 tsp. ground cinnamon
*3 lb. 5 oz. / 1.5 kg, fresh pork
 rear leg roast, rinded*

TIME NEEDED:
20 mins. + 2 hours 30 mins.
cooking

METHOD LEVEL OF DIFFICULTY: EASY

Heat the oven to 325°F / 170°C (Gas 3; convection ovens 300°F / 150°C).

Wash and pat dry the orange, then finely grate the zest. Wash and pat dry the parsley, then pull off and finely chop the leaves. In a bowl, stir together the honey, both types of mustard, the orange zest, chili flakes, cinnamon, and parsley.

Pat dry the meat and rub all over with the honey and mustard spice rub. Put the ham into a Dutch oven, cover, and roast in the oven about 2½ hours. Take out the roast and brush well with the roasting juices. Serve hot or cold.

Raspberry Ice Cream Cake

INGREDIENTS
MAKES 16 PIECES

*1 lb. 9 oz. / 700 g frozen
 raspberries*
1 lb. 2 oz. / 500 g mascarpone
*2 cups / 240g unsifted
 confectioners' sugar*
2 cups / 500 g whipping cream
*2 tbsp. hibiscus powder or
 raspberry powder, optional*
For the crust:
*2 tbsp. / 30 g chopped
 blanched almonds*
7 tbsp. / 100 g butter
*3½ oz. / 100 g ladyfinger
 cookies*

TIME NEEDED:
1 hour + 12 hours freezing

METHOD LEVEL OF DIFFICULTY: EASY

To make the ice cream, thaw, then puree and drain the raspberries. Beat the mascarpone with a handheld mixer until creamy. Sift the confectioners' sugar over, add the raspberry puree, and the whipping cream, then beat until half-stiff. Stir in the hibiscus or raspberry powder, if using.

Transfer the mixture to an ice-cream maker and freeze 20–30 minutes (see Tip). Transfer the raspberry ice cream into a silicone Kugelhuph or Bundt pan (8½ in. / 22 cm diameter), smooth the top, and place in the freezer.

To make the crust, heat a skillet without any fat. Add the almonds and dry-fry until golden-brown, then tip out of the pan. Melt the butter in the same pan. Crumble the ladyfinger cookies, then finely grind them in a food processor. Thoroughly combine the almonds, cookies, and butter. Sprinkle the mixture over the top of the ice cream and pat down, then return the ice cream cake to the freezer overnight. The next day, turn the cake out on a platter. To do so, briefly dip the pan into hot water so the cake comes away from the side of the pan. Leave the cake to thaw 30 minutes before serving.

TIP: If you do not have an ice cream maker, put the cream into the freezer about 1 hour, then puree everything with a handheld mixer every 20 minutes so large ice crystals do not form. After that, continue by transferring it to the pan as described above.

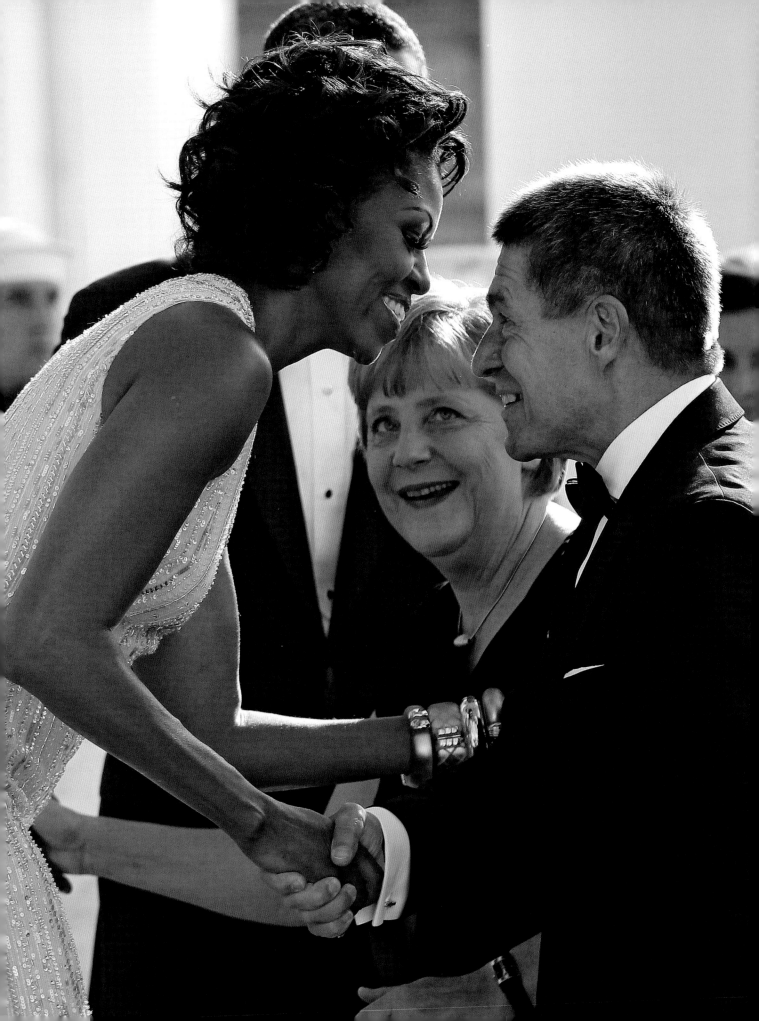

Michelle Obama

CULINARY DIPLOMACY

She went down in history as America's first black hostess.
In 2011, she and her husband, Barack Obama, then the
President of the United States, invited Chancellor Angela
Merkel of Germany to a state dinner at the
White House Rose Garden. It would be an evening
marked by a spirit of international friendship.

• OPPOSITE The eyes have it: A highly respectful and friendly greeting between Angela Merkel's
husband Joachim Sauer and First Lady Michelle Obama. Merkel was pleased to see the Obamas
again—and also to be receiving the Presidential Medal Freedom later that evening.
• ABOVE Although this little place card denotes the head of the table, the diplomatic soirees are
actually organized by the First Lady. She is the one officially responsible for invitations, programs,
ambiance, flower arrangements, and the menu.

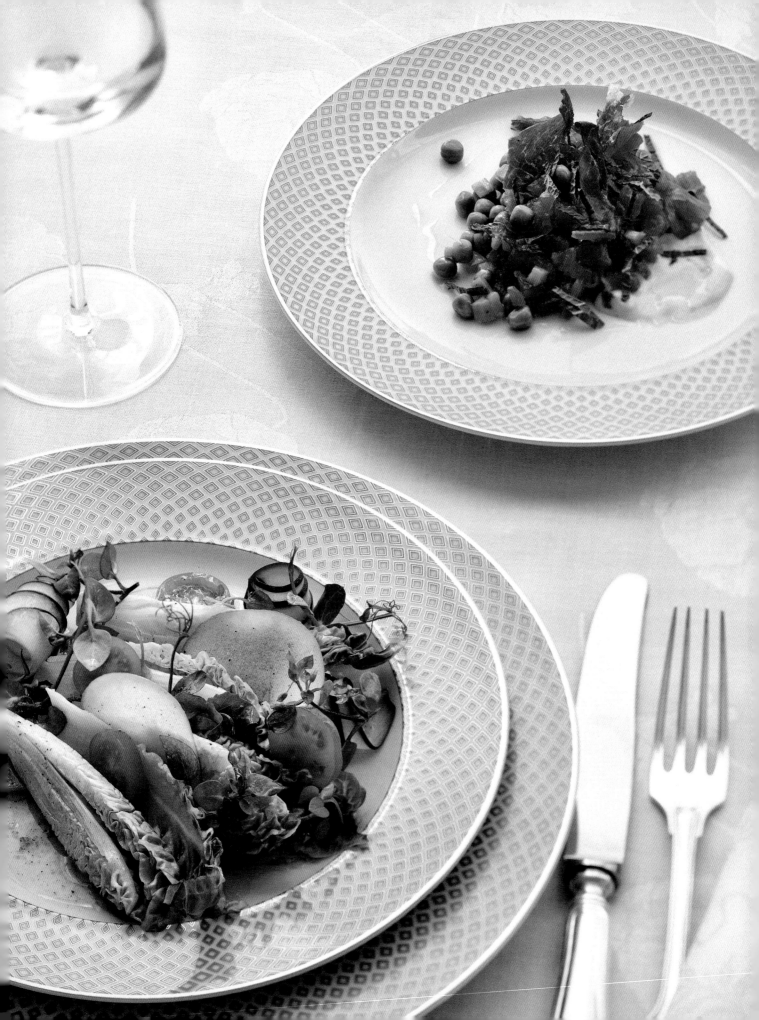

It is a well-known fact that the way to someone's heart is through their stomach: The place where enzymes break down food, and where butterflies occasionally also flutter. And when it comes to Michelle Obama, she would certainly set off a whole swarm of butterflies. During her time as First Lady between 2009 and 2017, she arranged fourteen state dinners at the world's most famous address, the White House, hosting politicians and personalities from the world's finance and entertainment industries at 1,600 Pennsylvania Avenue NW in Washington D.C. There were, for example, British Prime Minister David Cameron, who had not yet got the Brexit ball rolling; Facebook CEO Mark Zuckerberg, who was collecting Likes; and superstar Beyoncé, who even performed a serenade that evening. And Mrs. Obama? A towering presence in more than just her 5 foot 9 inch stature and a qualified lawyer, she chatted away and stole the show, serving up osetra caviar and beef braciole, as champagne fizzed in crystal glasses. While the guets list varied, the two main ingredients remained the same at every one of her receptions and dinners: genuine warmth and elegant style.

Although her husband, Barack, was in the spotlight as president, the state dinners were all Mrs. Obama's own work. As First Lady—and as such, first hostess—one of the Harvard graduate's tasks was to host diplomatic soirees, where talks and negotiations were obligatory, but a cordial ambience was entirely optional. According to the White House Historical Association, "the First Lady and her staff are responsible for the elaborate planning and attention behind the glitter and ceremony of the state dinner." Protocol dictates that this includes creating the guest lists and seating plans, designing the invitations, organizing the entertainment program, choosing the menus, and taking charge of flower arrangements.

At her fourth state dinner—the one honoring the German chancellor—Obama opted for yellow lilies (symbolizing hope) and orchids (admiration) mixed with laurustinus (pride), placed on white linen—for the success or failure of a banquet does not just hinge on how the topics are covered during the conversations, but also on the way tables, chairs, and floors are covered.

On the evening of June 7, 2011, a total of 206 invited guests walked down a gray-and-white striped carpet that

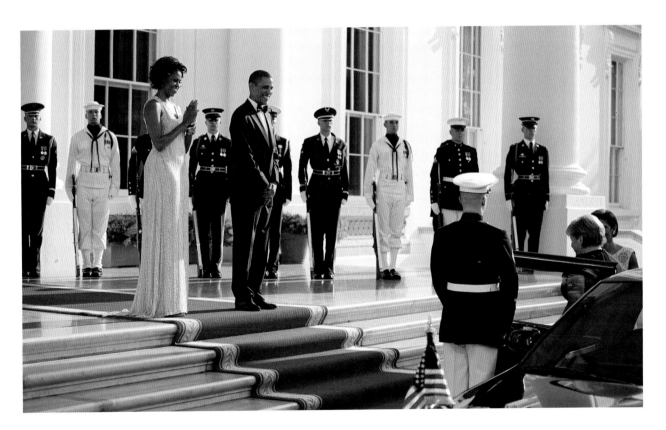

• OPPOSITE: TUNA TARTARE AND GARDEN SALAD The fish served at the dinner was sourced from Hawaii, the birthplace of Barack Obama, and the vegetables came from the White House Kitchen Garden, created by the First Lady.
• ABOVE A reception that was as cordial as it was grand: The Obamas waited on the red carpet, Michelle wearing a gown designed by Naeem Khan.

had been rolled out on the Rose Garden lawn. The First Lady looked out on the queen of flowers from her dressing room every morning. That night, Mrs. Obama, who has featured on three covers of *Vogue*, was herself the eye-catcher in a stunning cream dress designed by Naeem Khan, even though the guest of honor was actually the German head of state. President Obama was going to be presenting "his friend" with the Presidential Medal of Freedom, the country's highest civil award, for her commitment to freedom and prosperity in Germany and Europe. As such, the unofficial motto of the dinner was also "friendship." Following a performance by the National Symphony Orchestra, led by German pianist and conductor Christoph Eschenbach, of music by Beethoven, Mendelssohn, and Handel, American singer James Taylor treated the guests to the especially requested song *You've Got a Friend*. Images of the Rose Garden were projected onto the colonnades, while on the tables, the flames of white candles flickered in the balmy evening breeze.

The state banquet opened with a nineteen-gun salute on the South Lawn, just a few yards from the place Mrs. Obama had created in April 2009: the legendary White House Kitchen Garden, whose beds are filled with broccoli, sweet potato, tomato, fig, and rhubarb plants. It was from here that Michelle frequently pinched her favorite snack of green apples, dipped in the honey from her own bees, the White House's tiniest workers. "It tastes like sunshine," the First Lady said. The menu chosen for the state dinner for Merkel was also inspired by the Kitchen Garden's first harvests of the year. The appetizer consisted of a Garden Salad with Honey Vinaigrette, followed by Tuna Tartare, featuring fish from Hawaii, the president's birthplace, that was served with carrots, peas, and ham. The main course was beef tenderloin and ravioli stuffed with Maryland blue crabmeat, while dessert was a homage to the recipient of the Presidential Medal of Freedom: apple strudel and whipped cream.

A year after the that particular state dinner, the First Lady published *American Grown*, a book about the White House Kitchen Garden. "Her baby" was more than a food source; it was her pet project. Obama would often invite school groups or disadvantaged children to help out in the garden and learn about healthy eating, something she made her mission during her tenure in the White House. She said she wanted to plant the seed to get the nation thinking differently about food. "I knew what mattered to

• ABOVE The apple strudel appears to have impressed everyone. Merkel had the same dessert served at the farewell dinner for Barack Obama in Berlin five years later.

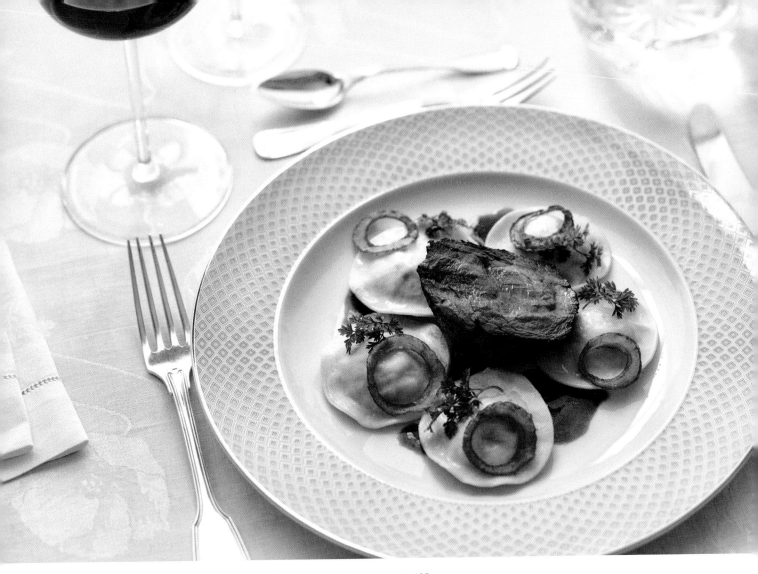

• ABOVE: PETIT FILET AND CRAB RAVIOLI WITH A PORT AND RED WINE SAUCE
Maryland blue crabs, which Merkel is said to have enjoyed, are a specialty—and difficult
to source in Germany, which, perhaps, gave the dish its special appeal.

me. I didn't want to be some sort of well-dressed ornament who showed up at parties and ribbon cuttings. I wanted to do things that were purposeful and lasting." Shortly before the end of the president's term in office, the First Lady reinforced the Kitchen Garden structure with additional concrete pillars and stone slabs to secure it as firmly as possible for the future. After all, life in the White House is but a temporary stint. Many incumbents have had their predecessors' creations demolished or dismantled in a bid to erase all memories. Ronald Reagan, for example, removed the solar panels Jimmy Carter had installed on the roof, and Bill Clinton got rid of the horseshoe pitch created by George Bush, Sr.

Yet, no matter how long the Kitchen Garden remains at the White House, or how long its produce continues to end up on gold-rimmed plates at state dinners, the services rendered by Obama as the first African-American First Lady will endure, her lawyer's views and thought-provoking ideas having taken root in many minds as firmly as the produce did in the soil of her garden. "Michelle Obama may have changed history in the most powerful way—by example," lauded feminist Gloria Steinem in one of four thank-you letters published by prominent authors in *The New York Times Style Magazine* after Obama returned to her nonofficial life.

The First Lady had once again demonstrated her magnanimity when preparing the guest list for the state banquet for Merkel by inviting Mitch McConnell, a Republican senator, majority leader—and staunch political opponent. It was reported he and his wife loved the dinner. McConnell later ended up declining the invitation to Donald Trump's first state dinner, claiming he was unable to attend. It seems the way to someone's heart really is through the stomach.

Garden Salad with a Honey Vinaigrette

INGREDIENTS SERVES 4

4 mini romaine lettuce hearts
1 handful microgreens
1 handful garden herbs of
 your choice or watercress
1 green apple
4 small orange tomatoes
For the honey vinaigrette:
2 tbsp. acacia honey
4 tbsp. apple cider vinegar
4 tbsp. olive oil
4 tbsp. grapeseed oil
salt and pepper

TIME NEEDED:
20 mins.

METHOD LEVEL OF DIFFICULTY: EASY

Cut the stem off the lettuce hearts so the leaves still hold together and remove the two outer leaves. Now quarter the lettuces lengthwise, then wash and carefully spin them dry.

Wash and spin-dry the microgreens and the herbs or watercress. Wash and pat dry the apple and the tomatoes. Quarter and seed the apple. Slice the tomatoes.

To make the dressing, stir together the honey, vinegar, and salt and pepper. Stir in the two oils and check the seasoning.

Just before serving, cut the apple quarters into paper-thin slices.

Divide all the ingredients among four plates and drizzle with the dressing.

Tuna Tartare with Ham and Peas

INGREDIENTS SERVES 4

1 small carrot
1 cup / 150 g frozen peas
2 tbsp. olive oil
4 thin slices prosciutto or
 Serrano ham
10 mint leaves
14 oz. / 400 g sushi-quality
 tuna fillet, cold
juice of 1 lime
salt and pepper
3 tbsp. olive oil
1 tsp. medium-hot mustard
4 tbsp. mayonnaise

TIME NEEDED:
25 mins.

METHOD LEVEL OF DIFFICULTY: EASY

Peel and finely dice the carrot, then blanch it about 2 minutes in boiling salted water until the cubes are tender, but still have some bite. After 1 minute, add the peas and return the water to a boil, then tip both into a strainer. Rinse under cold water and leave to drip dry.

Heat the olive oil in a wide skillet, add the prosciutto slices, and fry until crisp. Remove them from the pan and drain on paper towels.

Wash and spin-dry the mint leaves, then finely shred them.

Cut the tuna into small cubes. Stir together the lime juice, salt, pepper, and olive oil. Add the tuna to the marinade and fold in the carrot and peas.

Stir the mustard into the mayonnaise. Put 1 tablespoon onto each of four plates. Arrange the tuna tartare on top. Break the crisp ham into small pieces and insert these among the tuna pieces. Sprinkle with the mint and serve immediately.

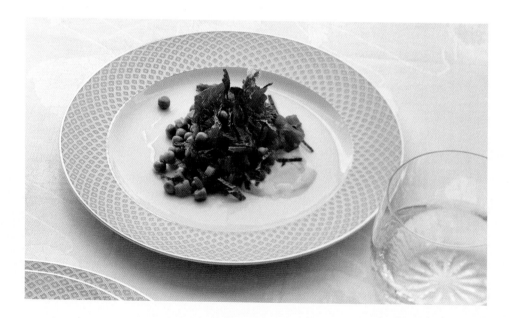

RIGHT **Tuna Tartare**

Petit Filet with Crab Ravioli

INGREDIENTS SERVES 4

For the ravioli:

1½ cups + 2 tbsp. / 200 g all-purpose flour, plus extra for dusting

3 eggs

4 slices bread, toasted

7 oz. / 200 g cooked crab-meat or shelled shrimp

salt and pepper

2 tbsp. / 30 g butter

For the onion rings:

1 onion

1 tbsp. all-purpose flour

vegetable oil for deep-frying

For the red wine sauce and beef:

2 shallots

2 tsp. / 10 g clarified butter

7 tbsp. / 100 ml red port wine

¾ cup + 2 tbsp. / 200 ml full-bodied red wine

1¾ cups / 400 ml beef broth

¼ tsp. cornstarch

600 g fillet of beef (best from the middle)

chervil leaves, to garnish

TIME NEEDED:
90 mins.

METHOD LEVEL OF DIFFICULTY: MEDIUM

To make the ravioli, sift the flour into a bowl. Add 2 eggs and knead until you have an elastic dough. Wrap in plastic wrap and chill at least 30 minutes.

Meanwhile, make the filling. Remove the crusts from the toast and put it in a food processor to make fine crumbs. Finely chop the crabmeat and combine with the remaining egg and the bread crumbs. Generously season the mixture with salt and pepper.

To make the red wine sauce, peel and finely chop the shallots. Heat 1 teaspoon clarified butter in a saucepan. Add the shallots and sauté until light brown. Pour in the port and the red wines and boil to reduce by about half. Add the beef broth and continue boiling to reduce to ⅔ cup / 150 ml. Strain through a fine strainer. Stir the cornstarch into a little water, then use to lightly bind the sauce.

Divide the pasta dough into two portions. Dust each portion with a little flour, then, one after the other and using a pasta maker, roll out until very thin (setting 6 on some models), dusting the dough repeatedly with flour.

Brush one portion of the dough very lightly with water, then place about 20 small portions of the crab mixture on top, leaving a little distance between each. Place the second dough sheet on top and press down in the spaces between the filling portions. Using a cookie cutter (about 2 in. / 5 cm diameter), cut out round ravioli, firmly pressing down the edges. Dust a cookie sheet with flour and place the ravioli on top.

To make the onion rngs, peel the onion, then thinly slice it using a mandolin. Season the flour with salt and pepper, then lightly toss the rings in it, knocking off any surplus. In a saucepan with a thermometer attached, heat the enough vegetable oil for deep-frying to about 350°F / 180°C. Add the onion rings in batches and deep-fry until golden-brown and crisp. Use a slotted spoon to remove them from the oil and leave to drain on paper towels, then keep hot.

Heat the oven to 325°F / 170°C (Gas 3; convection ovens 300°F / 150°C). Season the beef with salt and pepper, and melt the remaining clarified butter in an ovenproof skillet. Add the beef and sear all over. Transfer the skillet to the oven and roast the beef 10–15 minutes on the second rack from the bottom (cooking times will vary a little depending on the quality and the thickness of the tenderloin).

Meanwhile, bring a large saucepan of salted water to a boil. Add the ravioli and cook 3 minutes, then drain. Melt 2 tablespoons / 30 g butter in a saucepan and toss the ravioli in it.

Take the meat out of the oven, cover, and leave to rest 5 minutes. Cut into four equal portions.

Place 3 tablespoons red wine sauce into the middle of four plates and arrange the beef and the ravioli on top. Garnish with onion rings and chervil leaves.

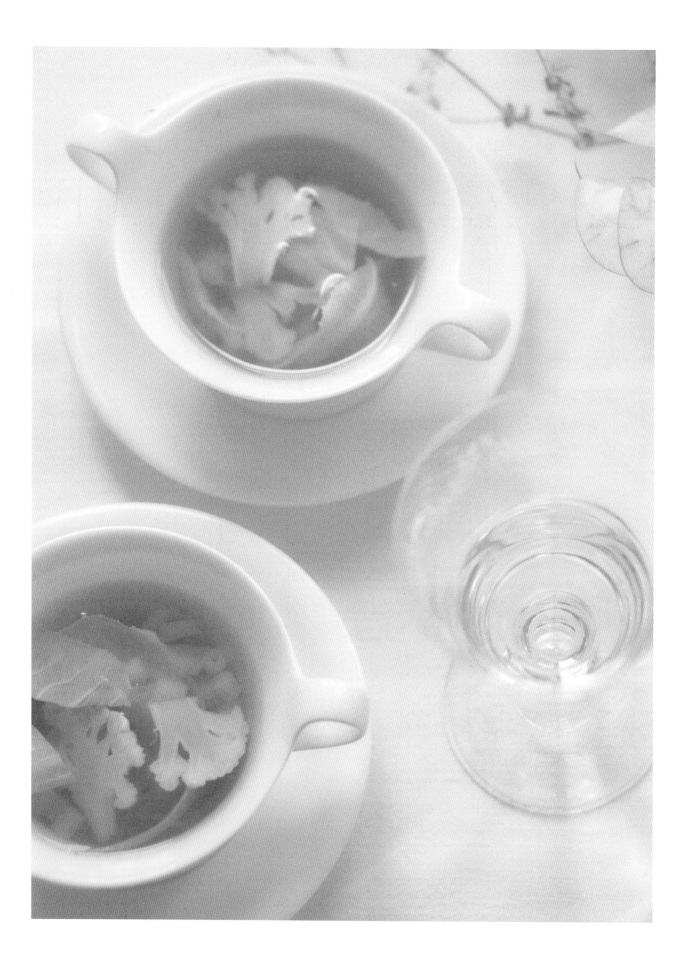

Napoleon Bonaparte

BIG FISH AND SACRIFICIAL LAMB

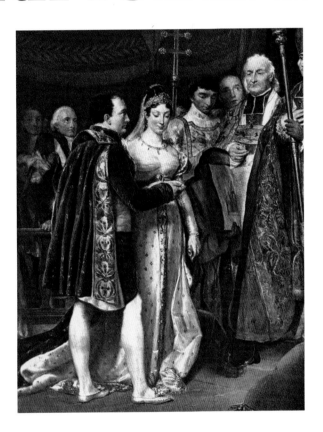

The wedding of Napoleon and Marie Louise was a story that could have been entitled "Sleeping with the enemy," for Austria had lost four wars against France in the two decades before. It was for this reason that the Habsburgs decided to sacrifice "little Louise." The young woman was to become Napoleon's second wife, and bear him the long-awaited heir to the throne. What she didn't know, however, was that the pope had never annulled the emperor's first marriage.

• OPPOSITE Clear Vegetable Broth with tubetti (a short type of pasta) and herbs. While macaroni was the pasta of choice at the historic feast, the tubetti can be seen as an allusion to the emperor's fabled short stature. The soup also contains slices of carrot and cauliflower florets and leaves.
• ABOVE The Louvre's Salon Carré was converted into a chapel for the imperial wedding in Paris.

The imperial couple were in a carriage, not far from Paris, the rain beating down outside, when they met for the first time, the young woman complimenting her somewhat older husband by exclaiming, "Sire, your portrait has not flattered you!" He had sent her the portrait as an engagement gift, framed with sixteen large diamonds. She was eighteen, he forty-one. Did she have any idea of the effort to which he had gone to impress her? He had lost weight, practiced (and abandoned) the waltz, and ordered fashionable embroidered tailcoats. That day, however, he was wearing his usual gray military coat. This first encounter took place on March 27, 1810. Marie Louise Habsburg and Napoleon Bonaparte had been married two weeks—a practice not unusual in royal circles at the time.

An uncle of the bride had said the vows on behalf of Napoleon at Vienna's Augustinerkirche (Church of the Augustinians). Marie Louise now had twelve sanctified wedding rings in her luggage—one was bound to fit her husband's finger. The pair had actually been meant to meet a few hours later at a grand ceremony in Soissons, but Napoleon, bursting with impatience to finally see his wife, rode out to meet her and surprised her in the carriage while the horses were being changed over. They spent that very night together. Although protocol dictated that the marriage could only be made official in Paris, after the wedding reception, Napoleon brushed off the objections of the grand master of ceremonies. ("I sent him packing," he later said.)

In other words, he was tremendously pleasantly surprised by his wife—for it is true he had had his concerns: He asked everyone who returned from Vienna about her, every messenger he had sent out to her on her "bridal journey" (he had letters or gifts delivered to her every day,

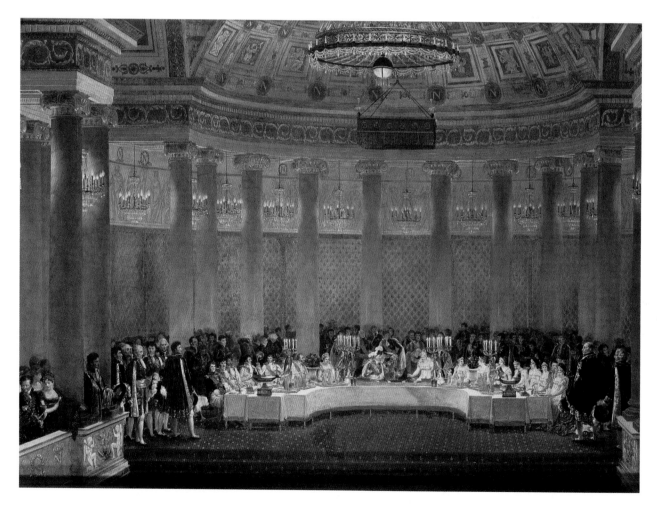

• ABOVE The wedding feast was held in the Salle des Spectacles. To Napoleon's right sat his mother, and to his left his new bride, Marie Louise. The Habsburg princess felt a little nauseous, having had to endure a procession of 1,500 subjects before the feast could begin.
• OPPOSITE: PIKE À LA CHAMBORD Served with truffle jus, mushrooms, crawfish, and toasted bread. Chambord Castle is considered to be the largest in the Loire Valley, and the ingredients in this dish, which even inspired the likes of Alexandre Dumas, are fittingly regal. Dumas, however, refined it farther with a rare non-sparkling (!) champagne.

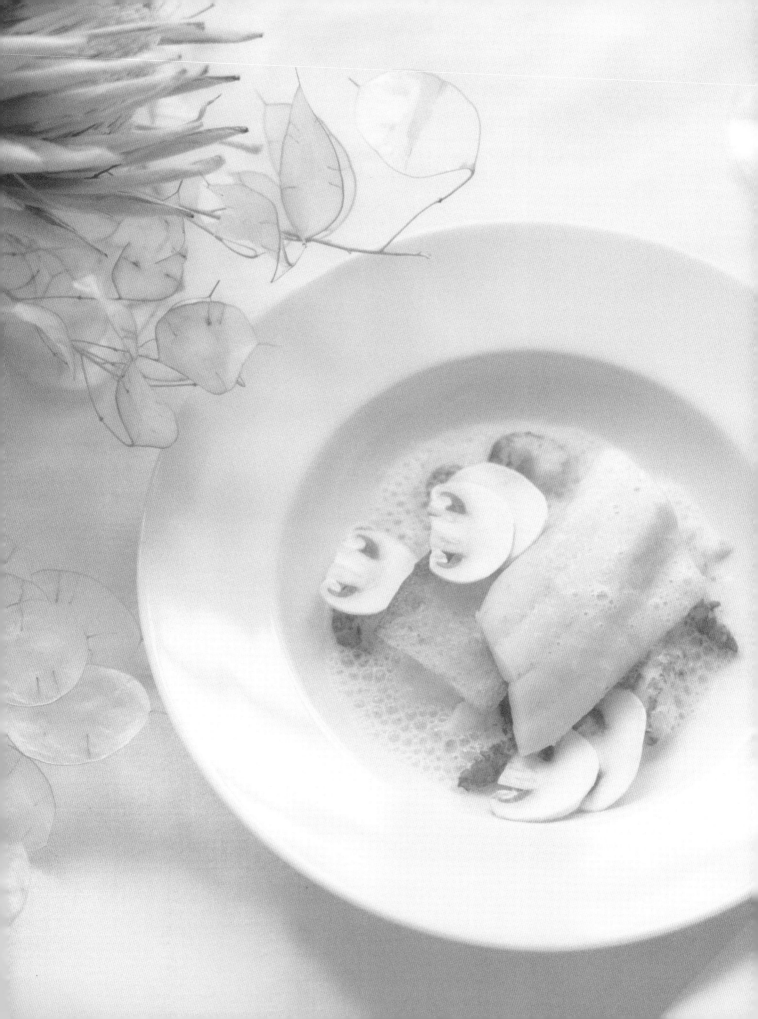

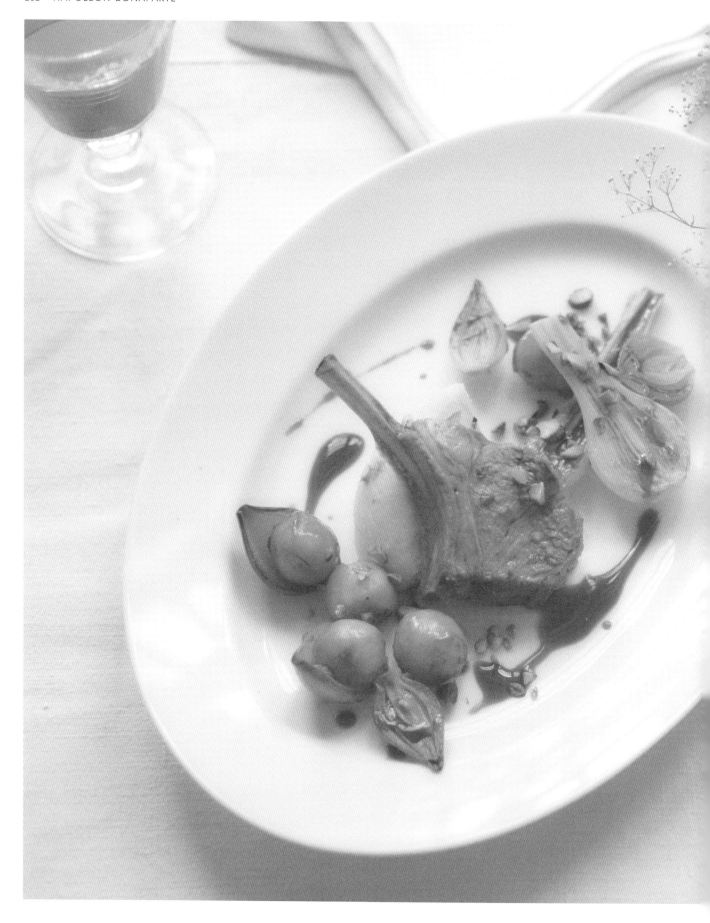

• LAMB À LA SOUBISE Served with a variety of onions and baked celery root in a morel-based champagne sauce. *À la soubise* is a cream sauce with onions added to a béchamel sauce. Napoleon's cooks would serve the onions in pureed form. And while the banquet is not believed to have triggered any tears of emotion, there probably was not a dry eye in the kitchen.

including pheasants he had shot himself, flowers, and a fur coat). His questions yielded a fairly consistent response: Marie Louise, with her somewhat unconventional features and excessively full Habsburg bottom lip, was "more ugly than pretty," as Austrian foreign minister Prince Metternich once put it. But because nobody wanted to say this so frankly to the emperor, the informants would carefully sidestep the issue and gush about her youthfulness and attractive feet.

But beauty was of secondary importance here; Napoleon had already cut his ties with one beauty in the form of ravishing Creole Josephine. While he still loved her, he had told her, "in politics, it is not the heart that counts; only the head." And his head had said he needed an heir, otherwise all his efforts to wage wars and conquer territories could end up being in vain. Josephine was unable to provide him with one, so Napoleon had to find a new wife from Europe's royal families to establish his dynasty.

The House of Habsburg appeared to be the safest bet, for its women were reputed to be very fertile. And a French count who had seen Marie Louise at a ball in Vienna, and who knew about Napoleon's situation, had assured the emperor that "it would be impossible to find a healthier person even in the lower classes." Napoleon himself is said to have rather ungallantly declared he would marry "a stomach." Another reason he liked the idea of forging ties with Europe's oldest family of rulers was that he wanted to shed the label of "nouveau riche" and finally become a fully-fledged member of the "royalty" club.

But there was something else that made the matter especially interesting (or outrageous, depending on your perspective): Napoleon was the Habsburgs' archenemy. Austria had lost four wars against France in the previous two decades; Emperor Franz had had to surrender the finest provinces and millions of subjects, and pay enormous amounts of money in reparations—and now the "loathsome fellow," in Emperor Franz's words, wanted his favorite daughter, little Louise, too. What should he do? "She must be sacrificed," was the opinion of the Austrian ambassador in France. "Can one afford to hesitate when one has to choose between the monarchy's ruin and a princess' unhappiness?"

The daughter in question had a panic attack when she caught wind of the rumor that the most powerful man in Europe wanted her to be his wife. While Habsburg princesses were prepared to be used as pawns to serve the state's interests, and the dynasty was proud of its clever marriage policy, why did it have to be Napoleon, of all people? The bogeyman from whom she twice had needed to swiftly flee Vienna?

"Papa is far too good a man to put pressure on me in such an important matter," she wrote to a girlfriend. But she was wrong, as she would soon learn from Metternich.

Some in Vienna found the sacrifice too painful. After the wedding at the Augustinerkirche, one court counselor noted in his diary that the evening had been one of the saddest of his life. But the war-weary people were jubilant: If enemies were marrying, there was surely finally hope for lasting peace. There were celebrations in the streets, and government stocks rose in value.

For Marie Louise, the prospect of soon living with Napoleon gradually became less horrifying on the long "bridal journey," during which the emperor paid her "endless attention." Indeed, soon after the pair arrived in Paris, she wrote about her husband to her father, saying "I find him more attractive the better I get to know him."

But *mon Dieu*, what a family! The first taste of the great "unpleasantness" she would have to put up with, particularly from her sisters-in-law, during her marriage (something she would complain about years later) came on the morning of her wedding when the Bonaparte ladies refused to carry the bridal train. There were scenes, tears, and fits of fainting. Napoleon eventually laid down the law to put an end to the drama, although this dampened his mood. What really riled the groom, however, was when he and Marie Louise entered the room at the Louvre that had been converted into a chapel—he in a white satin doublet and short coat, and she in a silver tulle dress dripping in diamonds—only to find that not even half the college of cardinals had turned up! For some, it was a case of their conscience not allowing them to attend the wedding; in their eyes, Napoleon was still Josephine's husband, because the marriage had not been annulled by the pope. The emperor was seething, and the cardinals would pay a hefty price for sticking true to their principles: Stripped of their red robes, they would spend the rest of their days on meager pensions in godforsaken backwaters. Marie Louise, a staunch Catholic, would not say a word about the incident in any of her letters.

The wedding feast was served "in keeping with old etiquette, but at a new pace," as one historian later reported. But first Marie Louise had to endure a parade of 1,500 subjects, who were all introduced to her. Her diamond-encrusted crown was so heavy, it made her feel nauseous.

One year later, she bore Napoleon his long-awaited son. While the marriage was generally not seen as a disaster, it was not a blessing either. Three years after the wedding, France and Austria again found themselves at war. And, following Napoleon's defeat, Emperor Franz had his daughter and grandson brought back to Vienna. Napoleon would never see his wife or son again; he was exiled to Elba, then St. Helena, and remained single thereafter. Upon his death, Marie Louise wrote that she had "never had deep feelings" for him. She was offered Napoleon's heart, which had been preserved in "spirits of wine" as per his will. She declined.

Vegetable Broth

INGREDIENTS SERVES 4

1 medium onion, about
* 3 oz. / 75 g*
2 carrots
1 leek
1 piece celery root, about
* 3½ oz. / 100 g*
1 celery stick
½ head fennel
2 vine tomatoes
2 garlic cloves
5 sprigs parsley
1 sprig thyme
1 bay leaf
5 black peppercorns
salt
a splash lemon juice
To serve:
10 oz. / 300 g cauliflower,
* with green leaves*
1 carrot
½ cup / 80 g soup pasta,
* such as tubetti*

TIME NEEDED:
25 mins. + 40 mins. cooking

METHOD LEVEL OF DIFFICULTY: EASY

Peel and thinly slice the onion. Trim and wash, then thinly slice the remaining vegetables. Skin and chop the garlic cloves. Put all'the vegetables, garlic, herbs, peppercorns, and ½ teaspoon salt into a saucepan with enough water to cover, about 2½ quarts / 2.5 liters. Bring to a boil, then reduce the heat and simmer 40 minutes. Strain through a fine strainer.

Meanwhile, trim the cauliflower, reserving the light green leaves. Using a mandolin or a sharp knife, cut the florets into paper-thin slices. Peel the carrot and cut into 2 in. / 5 cm long paper-thin strips.

Cook the pasta in lightly salted water according to the package directions, or until al dente. Drain and divide among four soup bowls.

Just before serving, bring the vegetable broth to a boil and season with a dash of lemon juice and salt and pepper to taste. Add the cauliflower florets and the carrot strips and boil 30 seconds. Cut the cauliflower leaves into bite-size pieces, add, and boil 30 seconds longer.

Transfer the hot broth and the vegetables to the soup bowls and serve immediately.

Pike à la Chambord

INGREDIENTS SERVES 4

2 large, very beautiful
* mushrooms*
14 oz. / 400 g pike fillets,
* skinned*
1¾ cups / 400 ml chicken
* or vegetable broth,*
* homemade, if possible*
salt and pepper
2 tbsp. olive oil
4 thin baguette slices
2 tbsp. / 30 g butter, softened,
* for the baking pan and*
* the fish*
3 tbsp. truffle jus (store
* bought)*
3 tbsp. / 45 g cold butter,
* diced*
a splash lemon juice
24 crayfish tails, shelled and
* cooked*

TIME NEEDED:
50 mins.

METHOD LEVEL OF DIFFICULTY: MEDIUM

Heat the oven to 200°F / 100°C (gas and convection ovens not recommended). Clean the mushrooms, washing them and patting them dry, if necessary, then set aside. Rinse the pike fillets under cold water, pat dry, and cut into 8 equal pieces.

Bring the chicken broth to a boil, then take the pan off the heat. Season the pike fillets with salt and pepper and place them next to each other in the broth. Cover the pan and leave the fillets to poach 5 minutes, or until tender.

Meanwhile, heat the olive oil in a skillet. Add the baguette slices and fry until golden-brown, then set aside.

Carefully lift the poached fish out of the liquid and place into a baking dish greased with butter. Brush the fish with the remaining softened butter, then cover the dish with aluminum foil, and keep warm in the oven.

Strain the poaching liquid through a fine strainer into a smaller saucepan and boil to reduce to ⅔ cup / 150 ml, about 5 minutes. Pour in the truffle jus and return to a boil, then add the diced butter. Using a handheld mixer, beat until the butter has blended into the sauce. Season the sauce with a splash of lemon juice and possibly a little salt.

Put the crayfish tails into the sauce and heat through, making sure the sauce does not return to a boil.

To serve, place one pike fillet piece and six crayfish tails on each of four warmed bowls or plates. Cover each fillet with a slice of fried baguette and place a second pike fillet on top. Briefly mix the sauce to a foam with the mixer or a stick blender, then divide among the fish and the crayfish. Using a mandolin, slice the mushrooms very thinly over each portion and serve immediately.

Lamb à la Soubise

INGREDIENTS SERVES 4

1 celery root, about
 2 lb. 4 oz. / 1 kg
2 large Spanish onions
4 small red onions
salt and pepper
scant ½ oz. / 10 g dried
 morels
2 tbsp. soy sauce
1¼ cups / 300 ml red port
 wine
1¾ cups /400 ml lamb or
 chicken broth
a little cornstarch for
 binding, about ¼ tsp.
4 tbsp. / 60 g butter
4 scallions
1 tbsp. shelled pistachios
2 tbsp. olive oil
2 rack of lamb (with 6–8
 cutlets each)

TIME NEEDED:
3 hours + 30 mins.

METHOD LEVEL OF DIFFICULTY: MEDIUM

Heat the oven to 325°F / 170°C (Gas 3; convection ovens 300°F / 150°C) and line a cookie sheet with parchment paper. Wash the celery root, cut the stalk off straight across, and place the root onto the cookie sheet. Peel, then halve the Spanish and the red onions lengthwise, season the cut sides with salt, and place with the cut side down on the cookie sheet.

Put the cookie sheet into the oven on the second rack from the bottom. After about 40 minutes, take out the red onions first, as soon as they are tender but still have some bite. Leave the Spanish onions and the celery root in the oven until their flesh is really soft (check with a knife); this will take about 90 minutes for the Spanish onions and about 3 hours for the celery root.

Meanwhile, soak the morels in a little cold water about 30 minutes, then take them out and finely chop. Put the morels into a saucepan together with the soy sauce and the port wine and bring to a boil. Pour in the lamb broth and boil to reduce the sauce to about 1 cup plus 2 tablespoons / 250 ml. Strain through a fine strainer, thoroughly pressing down on the morels in the strainer, then set them aside. Return the sauce to a boil. Stir the cornstarch into a little water and use to lightly bind the sauce, but do not let it boil.

Return the chopped morels to the sauce, if liked, or keep for future uses.

Take the baked Spanish onions out of the oven, peel and coarsely chop them, then mix the onions and 2 tablespoons / 30 g butter with a handheld mixer until you have a puree with small chunks. Season the onion puree with salt and pepper and keep warm.

Trim and wash the scallions, setting the green parts aside for future use. Halve the white parts lengthwise. Chop the pistachios.

As soon as the celery root has finished cooking, heat the olive oil for the rack of lamb in a large skillet, or use two skillets. Do not turn off the oven. Season the lamb with salt and pepper and sear in the pan(s) on its meat side. Position the lamb racks so the bones point upward and roast 15–20 minutes on the middle rack in the oven.

Meanwhile, peel the celery root and cut into balls, using a melon baller, or cut into cubes, if you prefer. Keep the celery root pieces warm in the oven.

Melt the remaining butter in a large skillet. Add the scallion halves and fry on both sides. Add the red onion halves and heat through in the pan.

Take the roasted lamb racks out of the oven, wrap in aluminum foil, and leave to rest 5 minutes. Cut the racks into individual chops.

Using two tablespoons, shape quenelles from the onion puree and put one on each of the four warm plates. Place the lamb chops next to the onion puree. Turn the celery root balls in the morel sauce and arrange with fried scallions and the red onion halves around the lamb. Drizzle a little of the sauce over, sprinkle with pistachios, and serve immediately.

TIP: If you don't want to add the chopped morels to the sauce, save them, covered in oil, to add extra mushroom aroma to a mushroom or vegetable stir-fry.

• OPPOSITE: PETITS FOURS WITH ROSEWATER The "decorated biscuits," the wedding feast dessert, sweetened the marriage for Marie-Louise. And Napoleon himself did so, too. Marie Louise wrote to her father about her husband: "I think he wins a lot when you get to know him better."

Petits Fours with Rosewater

INGREDIENTS

MAKES ABOUT 30 PETIT FOURS

For the cake:

5 egg whites

1 cup + 1½ tbsp. / 220 g
granulated sugar

8 egg yolks

scant ⅔ cup / 80 g
cornstarch

¾ cup / 80 g ground
almonds

For the buttercream frosting:

1 cup + 2 tbsp. granulated
sugar

4 egg yolks

1 stick / 125 g butter, softened

4 tbsp. rosewater

candied edible flower
petals, such as roses,
violets, pansies, and
daisies, to decorate

TIME NEEDED:

90 mins. + chilling

METHOD LEVEL OF DIFFICULTY: MEDIUM

Heat the oven to 350°F / 180°C (Gas 4; convection ovens 325°F / 160°C).

To make the cake, beat the egg whites and ¼ cup / 50 g sugar with a handheld mixer until stiff. Beat the egg yolks with the remaining sugar until the sugar has dissolved and the mixture is white and foamy. Combine the cornstarch and the ground almonds, then add to the egg yolks together with a one-third of the beaten egg whites. Using a rubber spatula, carefully fold in the egg whites. Now fold in the remaining egg white mixture. Line a cookie sheet with parchment paper and evenly spread the batter on top.

Bake 10 minutes on the second rack from the bottom. Turn out the cake onto a wire rack and let cool 5 minutes, then carefully pull off the parchment paper.

To make the buttercream frosting, put the sugar into a saucepan with a little water and bring to a boil. Continue boiling until the temperature on a candy thermometer reaches 225°F / 107°C.

Meanwhile, in a heatproof mixing bowl, beat the egg yolks with an electric handheld mixer until light. Slowly and add the sugar syrup to the egg yolk mixture, in a thin stream and beating all the time. Carry on beating the egg yolk and syrup until the mixture is cool. Now gradually add the softened butter in flakes and completely beat in. Add the rosewater and also completely beat in.

Halve the cooled cake horizontally. Spread one layer evenly with half the buttercream frosting. Place the second sponge half on top and cover with plastic wrap. Now weigh everything down with a cookie sheet of the right size and a heavy object (such as one or two books) and chill the cake at least 45 minutes.

Remove the cookie sheet and the plastic wrap. Spread the remaining buttercream frosting on top, then cut the cake into squares or rectangles, as you like. Just before serving, decorate the petits fours with candied flowers.

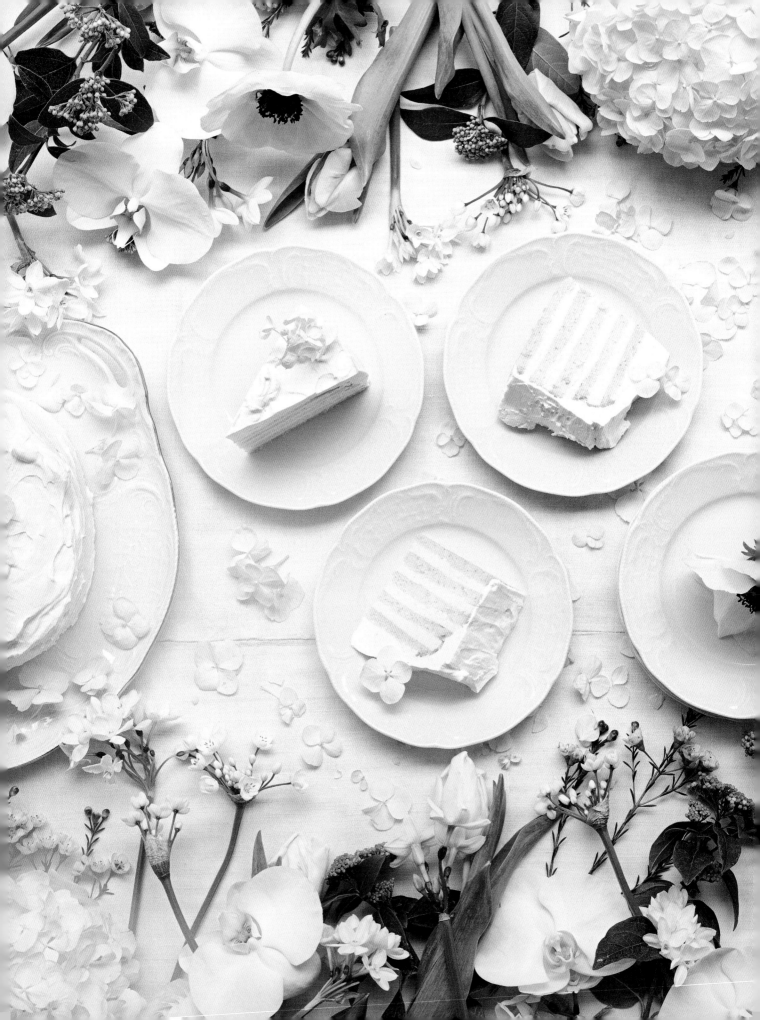

Grace Kelly

A BLOCKBUSTER MOVIE

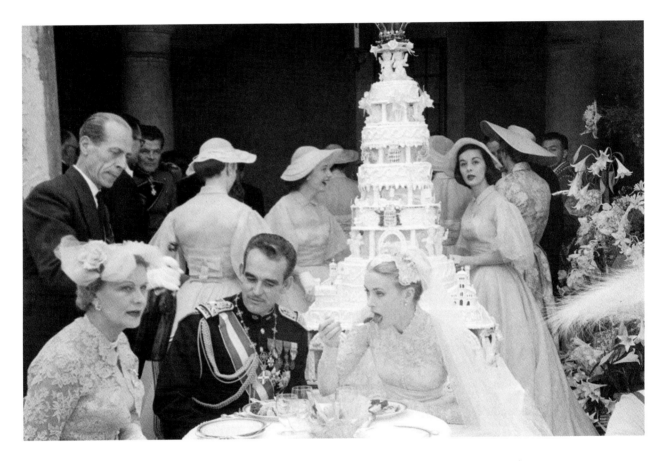

There had never been a more spectacular media event than the wedding of the Hollywood actress and the prince of Monaco. From the bride's arrival, to the dress, to the cake, every detail was carefully choreographed. To this day, wedding planners, tailors, and pastry chefs still receive requests from clients wanting to "have a wedding like Grace's."

• OPPOSITE: A CLASSIC WEDDING CAKE As snow-white as the bridal gown, layers of sponge and cream were temptingly covered with cream whipped and sweetened with confectioners' sugar. The original was decorated with scenes of Monaco's history.
• ABOVE: JUST MARRIED The bridal couple alongside Grace Kelly's mother, Margaret Kelly. In the background is the wedding cake, a gift from the pastry chef of the Hôtel de Paris.

European nobility and a Hollywood princess—the magic and the glamour would be off the scale.

Yet, Kelly was not one for a glamorous lifestyle. She avoided dinner parties, preferring to go to bed early. Simple American fare (she loved hamburgers) was her favorite. And she usually fobbed off her many admirers. Meanwhile, the thirty-two-year-old Rainier, whose full name was Rainier Louis Henri Maxence Bertrand Grimaldi, had, according to the tabloid press, been looking for a wife for some time. It was apparently Greek shipping magnate Aristotle Onassis, having recently become a shareholder of Monaco's casinos, who gave the prince the idea of looking for a Hollywood actress, as the former glamour of Monte Carlo's gambling houses was starting to become overshadowed by Las Vegas. A film star could potentially attract the jet set back to the Riviera.

Grace and the prince were introduced to each other during her attendance at the Cannes Film Festival in May 1955. Rainier was instantly captivated, and, over the following weeks, he sent his future wife romantic letters, in which he called her "Darling" and declared his love for her.

Upon news of the engagement, Kelly's co-stars—she had acted with Clark Gable, James Stewart, and Cary Grant—shook their heads: Just when, after years of hard work, she finally had Hollywood at her feet and could have any role she wanted, she was turning her back on the Dream Factory!

Christmas 1955 saw construction entrepreneur John Kelly and his wife, Margaret, receive a rather special guest at their home in Philadelphia. A real European head of state would be spending the festive season with the wealthy American family: Prince Rainier III of Monaco, who wished to ask for their daughter Grace's hand in marriage. Prince Rainier had been courting her for several months—and she, in any case, found Europe's most eligible bachelor to be "charming." Yet, Kelly's parents were not overly impressed. Her mother initially confused the tiny principality of Monaco first with Macao, at the time a Portuguese territory in China, and then with Morocco, in North Africa. And, indeed, prior to Rainier's visit, her father scoffed that he was just "any old bankrupt prince," who hardly measured up to the fine young woman that was his Grace.

And that was certainly a gross understatement: Twenty-six-year-old Kelly, Hollywood's golden girl at the time, was the preferred actress of the feted Alfred Hitchcock. And after her meteoric rise to fame, she had that year also won the Oscar for best actress in a leading role for *The Country Girl*.

Kelly, nevertheless, accepted Rainier's proposal a few days after Christmas. And when the couple announced their engagement at a press conference on January 5, America's tabloid reporters knew the countdown to the wedding of the century had begun. A union of old

Kelly seemed to want to live a fairytale, rather than play fairytale movie roles. On April 4, 1956, ocean liner *SS Constitution* left New York Harbor for the eight-day crossing to Monaco. Onboard were the bride (with eighty suitcases), her family, friends, and many guests that included Gloria Swanson, Ava Gardner, and Aga Khan III—and some 100 reporters.

In advance of the bridal party's arrival, the court staff had cleaned the palace from top to bottom, the doors and walls had been repainted, and the chandeliers polished. Never before had the Grimaldis' castle been so in the public spotlight.

The *Constitution* was greeted with cannon shots and fanfares when it dropped anchor near the small harbor. Thousands of people stood cheering on the dock as Rainier sailed out to the ocean liner on his yacht, flanked by a number of motorboats, to welcome his bride. Onassis had red and white carnations rain down from a seaplane.

The couple had only a few days together after the arrival of the *Constitution*, because the actress became a

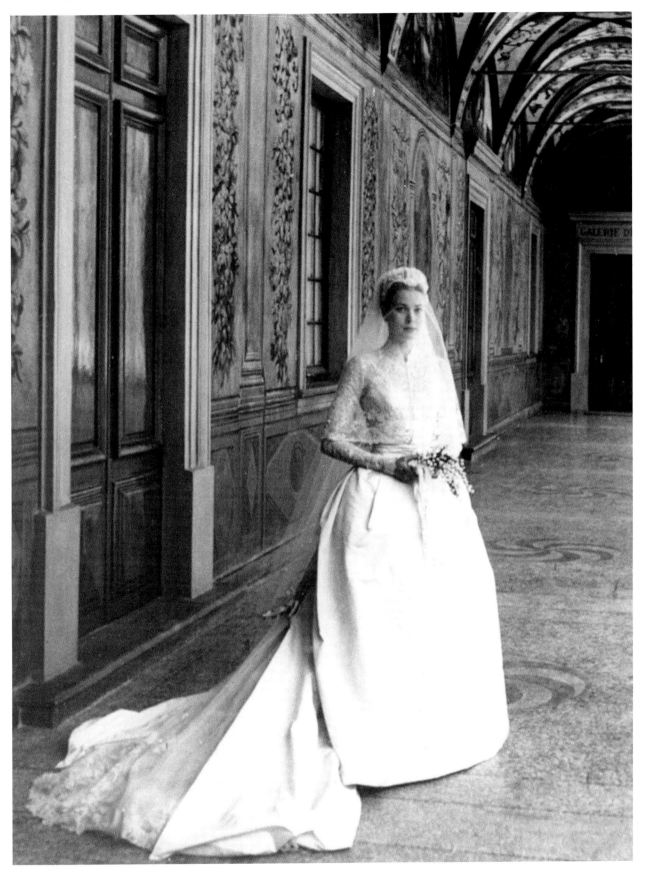

• THE WEDDING DRESS was designed by Helen Rose, costume designer at MGM.

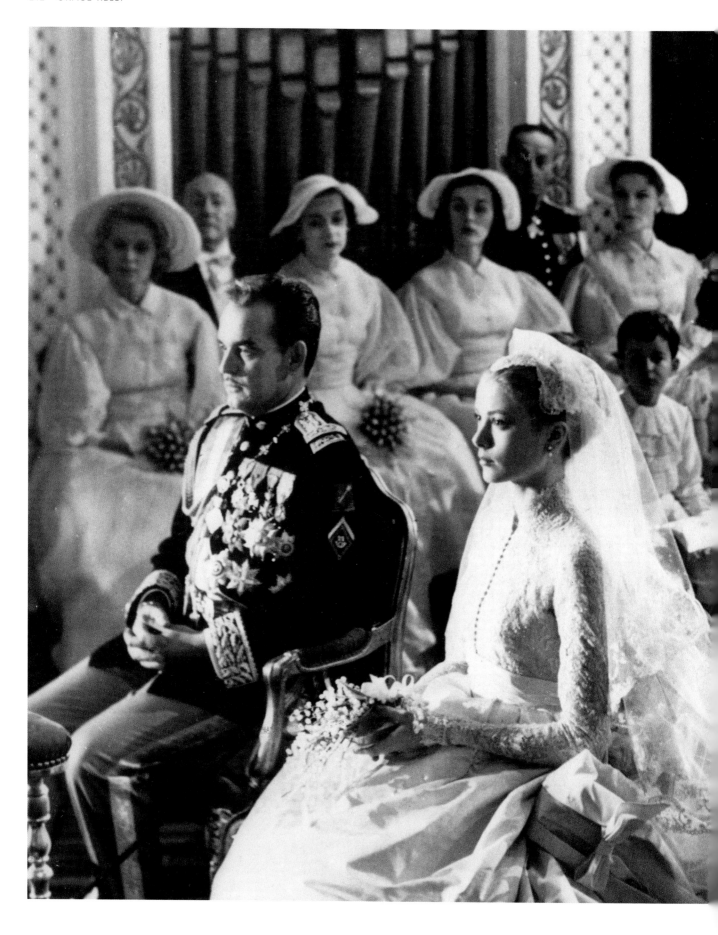

princess on April 18. While the civil wedding in the palace's baroque throne room lasted just fifteen minutes, it took the official nearly half an hour to read out all 140 titles that the princess would now bear. Her new name was Gracia Patricia of Monaco.

But the highlight of the festivities—the church wedding in the snow-white Cathédrale Notre-Dame-Immaculée de Monaco on April 19—was yet to come. As Grace was still under contract with production company Metro-Goldwyn-Mayer for two more movies, the studio had, as compensation, received the rights to make a documentary of the entire wedding celebrations, and had sent a team from Hollywood to decorate the church aesthetically, get the lighting right, and place microphones and cameras in such a way that both television and cinema viewers were able to follow the ceremony from all different angles, including from the priest's perspective. Never before had a wedding ceremony been so professionally filmed in close-up. MGM's chief hairdresser took care of Kelly's hair and makeup, while costume designer Helen Rose had spent weeks working with a dozen seamstresses to create the bridal gown. Kelly was now starring in her own story.

All 600 guests gathered in the cathedral at around 9:30 a.m., before the bride, accompanied by her father, finally entered the church to organ music. There had been much speculation about her dress in the newspapers, and it didn't disappoint: a creation of several hundred yards of silk, taffeta, and 125-year-old Brussels lace, embroidered with thousands of pearls. The bell-shaped silk skirt below the tight-fitting waist, supported by three petticoats, billowed out around her like a giant, soft cushion.

Kelly's entry was followed a few minutes later by the opening of the doors for the groom. Prince Rainier also looked like he had stepped straight out of a fairytale. He himself had designed his military uniform, barely visible under his sash and medals, based on that of the Napoleonic marshals, and he wore a saber in his belt.

The pair exchanged vows in French, in front of thirty million viewers worldwide. Rainier was so nervous he was unable to place the ring on Grace's finger; she had to slip it on herself. But she also appeared to be very emotional, as evidenced by the tears running down her cheeks, visible for all to see through the camera-friendly veil that hardly covered her face.

Awaiting the bridal couple and their guests after the ceremony was the lunch feast at the palace, consisting of a buffet of caviar, salmon, cucumber salad, shrimp, chilled

• THE CHURCH CEREMONY at the Cathédrale Notre-Dame-Immaculée de Monaco was part of the media spectacle that showcased the principality of Monaco as a fairytale land, making it a desirable destination for the international jet set.

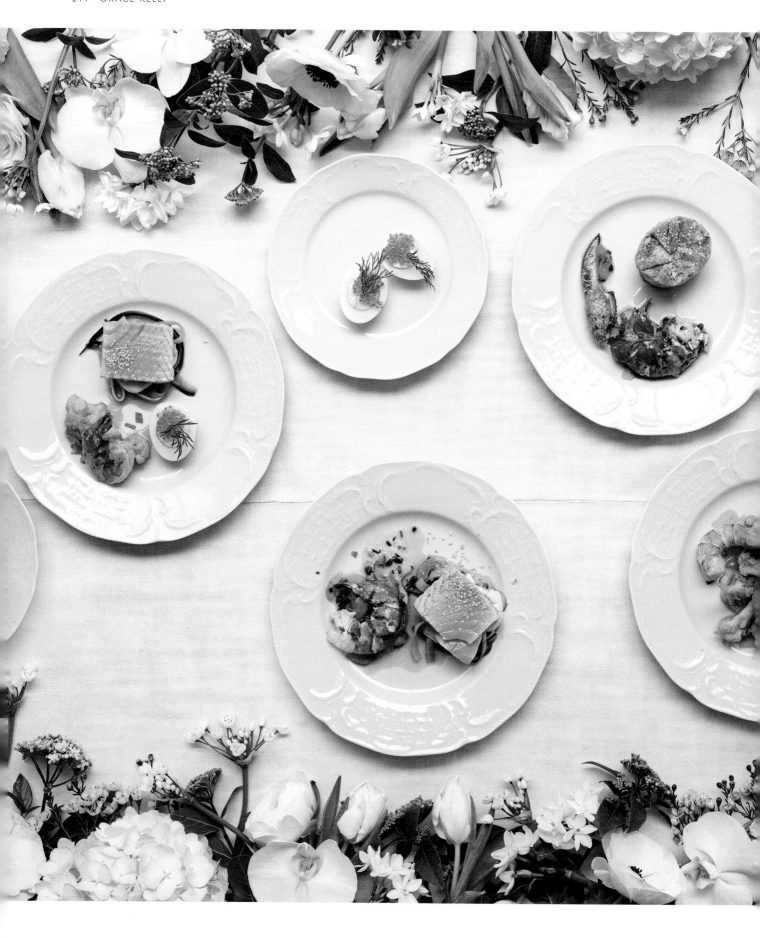

lobster, eggs in aspic, chicken, and champagne. There were very few seats, and the guests found themselves juggling their plates, glasses, gloves, hats, and bags.

Finally, Rainier used his sword to cut the cake—a masterpiece baked by the pastry chef at the Hôtel de Paris. Six tiers high and weighing more than 440 pounds, it was modeled on Monaco's castle, decorated with sugary recreations of scenes from Monegasque history. On top stood two cherubs, who held up the crown of Monaco. Grace and Rainier began their honeymoon on the prince's yacht that same night.

In the movies, this is where a fairytale would end, "and they lived happily ever after." And the marriage did actually appear to be a reasonably happy one: They had three children, and Kelly—now Gracia Patricia—did, indeed, attract stars and big money to the Riviera as hoped. On September 13, 1982, however, the story came to an abrupt end when the princess, driving in her Rover with her youngest daughter, failed to negotiate a hairpin bend and sent the car flying off a cliff. Grace succumbed to her injuries the following day, but her daughter survived. The world mourned with Rainier, who never got over his wife's death, and never remarried.

The couple's magnificent wedding ceremony, however, continues to act as a blueprint and inspiration for fairytale weddings to this day.

• A LIGHT LUNCH BUFFET
After the wedding ceremony, the champagne started flowing, and the guests sat out in the spring sunshine, enjoying Salmon with Cucumber Salad, Chicken Pastilla, Lobster in Celery Vinaigrette, Shrimp and Cauliflower in Saffron Sauce, and Eggs in Aspic.

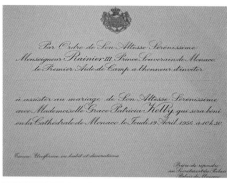

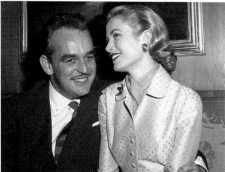

• LEFT: FROM HOLLYWOOD TO MONACO The official wedding invitation.
• BELOW LEFT The Monegasque prince and American actress met for the first time at the annual film festival in Cannes.
• RIGHT: A BRIDE SILENT IN PRAYER Kelly played the role expected of her to perfection in front of the wedding's international audience.

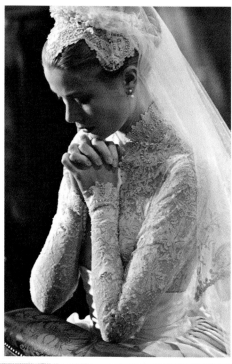

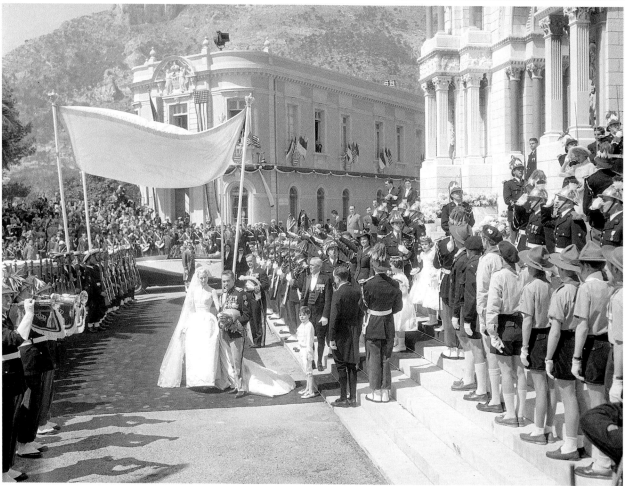

• A LASTING LEGEND The bridal couple outside the cathedral; the bride's gown gleaming white in the sun, Prince Rainier in his ornate uniform, a jubilant royal household, and Monaco's rocky landscape in the background.

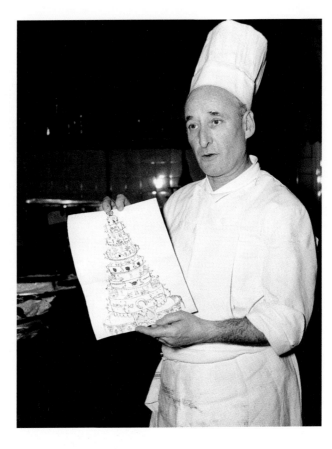

• The Hôtel de Paris pastry chef.

Grace Kelly's Wedding Cake

INGREDIENTS

MAKES 10 SLICES

3 large eggs
6½ tbsp. granulated sugar
1 envelope vanilla sugar
1¼ cups / 150 g all-purpose
 flour
1 tsp. baking powder
3 tbsp. / 45 g butter, melted
 and cooled
4 tbsp. lemon juice
For the cream filling:
1 envelope creamy
 blancmange powder
 (store bought)
¼ cup / 50 g granulated sugar
½ cup / 125 ml lemon juice
⅔ cup / 80 g unsifted
 confectioners' sugar
2 sticks / 225 g butter,
 softened
To decorate:
2 tbsp. confectioners' sugar
1¾ cups + 2 tbsp. / 375 g heavy
cream or mascarpone

TIME NEEDED:
50 mins. + 35 mins. baking
+ overnight chilling

METHOD LEVEL OF DIFFICULTY: MEDIUM

To make the cake, line the bottom of a deep springform cake pan (7 in. / 18 cm diameter) with parchment paper. Heat the oven to 350°F / 180°C (Gas 4; convection ovens 325°F / 160°C).

In a bowl, beat the eggs, sugar, and vanilla sugar with a handheld mixer about 3 minutes until foamy. Combine the flour with the baking powder, then sift it over the egg mixture and beat in on the lowest speed. Quickly beat in the butter. Transfer the batter to the springform pan and bake on the second rack from the bottom about 35 minutes.

Make a blancmange from the blancmange powder, sugar, lemon juice, and ½ cup plus 2 table-spoons / 275 ml water, following the package directions. Pour the mixture into a mixing bowl and place a sheet of plastic wrap on the surface so a skin doesn't form. Leave to cool, then sift over the confectioners' sugar, add the butter, and beat them into the cooled blancmange with the mixer.

Take the cake out of the oven and leave to stand 5 minutes. Remove the rim of the springform. Tip the cake onto a wire rack lined with parchment paper and leave to cool completely.

Lift off the parchment paper from the top of the cake. Slice the cake horizontally into five layers. Place the bottom layer onto a cake plate and soak with 2 tablespoons lemon juice. Spread one-quarter of the cream filling on top and smooth. Place a second layer on top, soak with the remaining lemon juice, and spread with one-quarter of the cream filling. Place two more layers on top, spreading each one with one-quarter of the cream filling. Finish with the top cake layer and lightly press it on.

To decorate the cake, sift the confectioners' sugar over the cream and beat until thickened and smooth, then spread over the top and the sides of the cake. Chill the cake overnight.

To serve, cut the cake into wedges with a knife dipped into hot water.

Chicken Pastilla

INGREDIENTS SERVES 4

pared zest of ½ organic
* orange*
2 tbsp. granulated sugar
1 shallot
1 garlic clove
1 tbsp. olive oil
½ tsp. ground cumin
½ dried red chili
9 oz. / 250 g chicken breast
* fillet, skinned*
salt and pepper
3 tbsp. sunflower oil, plus
* extra for greasing the*
* timbales*
⅓ cup / 50 g blanched
* almonds*
3 tbsp. light soy sauce
4 sheets strudel or phyllo
* pastry dough, each about*
* 12 x 12½ in. / 30 x 31 cm,*
* thawed if frozen*
almond oil
a little ground cinnamon, to
* garnish*
a little confectioners' sugar,
* to garnish*

TIME NEEDED:
40 mins. + 20 mins. cooking
+ 15 mins. baking

METHOD LEVEL OF DIFFICULTY: MEDIUM

Blanch the orange zest in a saucepan of boiling water 2 minutes. Drain, rinse under cold water, and return to the pan. Add the sugar and ⅔ cup / 150 ml water and bring to a boil. Reduce the heat and simmer until the sugar and the water have cooked down to a syrup. Lift the orange zest out of the syrup and finely chop it.

Heat the oven to 350°F / 180°C (Gas 4; convection ovens not recommended). Peel and finely chop the shallot and the garlic. Heat the olive oil in a flameproof Dutch oven over medium heat, then add the shallot and the garlic and sauté briefly. With a mortar and pestle, crush the cumin and the chili. Add the spices and the chicken to the pot, and season with salt and pepper. Pour in 7 oz. / 200 ml water, add the orange zest, cover, and cook about 15 minutes in the oven.

Meanwhile, heat the sunflower oil in a skillet. Add the almonds and fry until lightly browned. Strain, catching the oil, and set aside. Leave the almonds to cool, then coarsely chop them in a blender or with a mortar and pestle.

Lift the chicken out of the liquid and leave to cool a little. Do not turn off the oven. Put the pot over medium-high heat and simmer until most of the liquid has evaporated. Finely chop the meat, then return it to the reduced sauce and stir in the soy sauce and the chopped almonds. Season the mixture with salt and pepper.

Brush two phyllo pastry dough sheets with the reserved almond frying oil, cover with another sheet and smooth, then halve crossways. Grease four timbale molds (2 in. / 5 cm diameter) with sunflower oil. Line each mold with a dough piece, then add the chicken mixture. Fold the overhanging dough over the top of the filling and brush again with oil.

Bake the chicken pastillas about 15 minutes on the middle rack in the oven. Remove from the oven and tip out of their molds. Sprinkle the tops with a little cinnamon and confectioners' sugar.

TIP: The pastillas taste delicious with a yogurt dip or a crunchy leaf salad dressed with lemon juice and olive oil.

Salmon with Cucumber Salad and Sesame Mayonnaise

INGREDIENTS SERVES 4

2 tbsp. sesame seeds
7 oz. / 200 g salmon fillet,
* skinned*
salt and pepper
2 tbsp. sunflower oil
For the sesame mayonnaise:
1 egg + 1 egg yolk
juice of ½ lime
2 tbsp. soy sauce
¾ cup / 175 ml sunflower oil
2 tbsp. sesame oil
possibly a little salt
For the cucumber salad:
1 cucumber
1 tsp. gingerroot, peeled and
* freshly grated*
juice of ½ lime
1 tbsp. maple syrup
2 tbsp. soy sauce
chili, optional

TIME NEEDED:
30 mins. + 6 mins. cooking

METHOD LEVEL OF DIFFICULTY: MEDIUM

To make the mayonnaise, beat the egg, egg yolk, lime juice, and soy sauce with a handheld mixer. Drop by drop, add the two oils, beating all the time. Season the mayonnaise with salt and more lime juice or soy sauce to taste.

In a dry skillet, dry-fry the sesame seeds until golden-brown, then remove and leave to cool.

Make the cucumber salad. Wash the cucumber, cut off the stem end, and thinly slice the cucumber on a mandolin or use a thin knife. Cut the slices into thin strips, then transfer to a bowl. Stir together the gingerroot, lime juice, maple syrup, soy sauce, and chili, if using, then combine with the cucumber strips.

Cut the salmon fillet into 4 roughly even-size pieces and season with salt and pepper. Heat the sunflower oil in a skillet. Add the salmon and fry 2–3 minutes on both sides. Take the skillet off the heat and leave the salmon in the pan 2 minutes longer. Salmon is perfectly cooked when it is cooked through, but retains its beautiful orange color in the center. The flesh can then be flaked by gently pressing with a finger, and it is shiny inside, but does not fall apart.

Arrange the cucumber salad on plates like small nests. Spoon 1 teaspoon sesame mayonnaise into the middle and place a piece of salmon on top. Sprinkle the salmon with the sesame seeds.

Shrimp and Cauliflower in Saffron Sauce

INGREDIENTS SERVES 4

1 small cauliflower
½ tsp. coriander seeds
2 shallots
1 garlic clove
6 tbsp. olive oil
1 tbsp. tomato paste
a pinch saffron threads
1¼ cup / 300 ml dry white
* wine*
1 tbsp. granulated sugar
16 shrimp, heads removed,
* shelled, and deveined*
salt and pepper
3 sprigs tarragon

TIME NEEDED:
30 mins. + 20 mins. cooking
+ 6 hours marinating

METHOD LEVEL OF DIFFICULTY: MEDIUM

Cut the cauliflower into florets, then wash in plenty of cold water. Lightly crush the coriander seeds with a mortar and pestle. Peel and finely chop the shallots and the garlic.

Heat 1 tablespoon oil in a large skillet. Add the shallots and garlic and sauté until translucent. Stir in the tomato paste and saffron and sauté lightly, then add the white wine.

Add the cauliflower florets, coriander, and sugar, and bring to a boil. Reduce the heat to low and simmer 8 minutes, or until the cauliflower is tender, but still firm to the bite. Use a slotted spoon to transfer the florets to a bowl.

With a whisk, beat 4 tablespoons olive oil into the liquid, then pour it over the cauliflower. Cover and marinate at least 6 hours or overnight in the refrigerator.

Just before serving, wash and pat dry the shrimp, then season them with salt and pepper. Heat 1 tablespoon oil in a skillet over high heat. Add the shrimp and cook about 1 minute on each side. Pull the tarragon leaves off the stems, add the leaves to the skillet, and toss. Divide the cauliflower and the cooking liquid among four plates and place the shrimp on top.

Lobster in Celery Vinaigrette

INGREDIENTS SERVES 4

3 tbsp. white wine vinegar
3 tbsp. kosher salt
2 live lobsters, 1 lb. 2 oz.–
* 1 lb. 5 oz. / 500–600 g each*
For the vinaigrette:
4 celery sticks
2 tbsp. Taggiasca (Cailletier)
* olives*
a handful fresh cilantro,
* leaves and stems*
juice of 1 lemon, about
* 3 tbsp.*
salt and pepper
3 tbsp. good-quality olive oil

TIME NEEDED:
40 mins. + 5 mins. cooking
+ 30 mins. marinating

METHOD LEVEL OF DIFFICULTY: DIFFICULT

Fill a very large saucepan with water until just below the rim and bring to a rolling boil. Add the vinegar and the kosher salt. Add the lobsters, one at a time, and cook 5 minutes. Lift out with tongs and leave to cool.

To dissect the lobsters, separate the claws from the bodies by pulling them down and twisting, then pulling them off. Separate the heads from the tails. On a cutting board, press the lobster tails flat, then, using a heavy, sharp knife, halve them in the middle. Remove the intestine.

Release the flesh in the claws by gently bending the small sections of the claws down, then pushing them back and carefully pulling out the meat together with the feathery cartilage. If you bend the sections too far back, the feathery cartilage will get stuck in the meat and will have to be removed later with a knife. Tap the shell with a big knife sharply, but not too heavily, so you can open the shell and get out the meat in one piece. Now crack the leg shells and remove the meat.

To make the vinaigrette, wash and peel the celery, then cut into paper-thin slices. Pit and very finely chop the olives. Wash and spin-dry the cilantro, then finely chop.

Stir together the lemon juice and the salt and pepper, then gradually whisk in the olive oil. Stir in the prepared ingredients. Add the lobster and marinate at least 30 minutes in the vinaigrette.

Eggs in Aspic

INGREDIENTS SERVES 4

3 gelatin leaves
7 oz. / 200 ml clear poultry
* or vegetable broth*
a dash white wine vinegar
salt
8 eggs
3 tbsp. trout caviar
dill tips, to garnish

TIME NEEDED:
40 mins. + 10 mins. cooking
+ gelling

METHOD LEVEL OF DIFFICULTY: EASY

Soak the gelatin 3 minutes in a bowl of cold water. In a saucepan, heat the chicken broth, but do not boil. Squeeze out the gelatin and dissolve in the hot broth. Season with vinegar and salt. Chill the broth until it just starts to congeal.

Meanwhile, cook the eggs 10 minutes in boiling water, rinse under cold water, then shell them. Halve the eggs lengthwise. Drape the gelled broth over the halved eggs and chill.

Just before serving, spoon the trout caviar over the eggs and garnish with dill tips.

Queen Elizabeth II (p. 8)
Author: Barbara Baumgartner
Photographer: Antonina Gern
Stylist: Thomas Niederste-Werbeck
Recipe writer: Susanne Walter
Product credits: pp. 10/11: napkins, Eri Textiles; napkin rings, Siècle Paris; flatware, Puiforcat; plates, Meissen sprinkler (radish-shaped), ABM Paris; glass (left), Rotter; glass (right), Artêl, all Kuball & Kempe; pp. 14/15: table decoration: napkins, Eri Textiles; flatware (sterling silver), Odiot; plates and bowls, Meissen; pheasant (gilded bronze), Odiot; glass (left), Artêl; glass (right), Rotter. All Kuball & Kempe. pp. 14/15: table decoration: sugar spoon (sterling silver), Odiot; plates, Meissen; leaf bowls, Buccellati Italia; glass, Rotter. All Kuball & Kempe.

John F. Kennedy (p. 22)
Author: Barbara Baumgartner
Photographer: Reinhard Hunger
Stylist: Maria Grossmann
Recipe writer: Susanne Walter
Product credits: p. 25: oval platter and plates, KPM, "Rocaille" series; matte golden serving spoon and flatware, Palais XIII; everything else, private. pp. 28/29: plates, KPM, "Rocaille" series; matte golden flatware, Palais XIII. p. 31: plates and sugar dish, KPM, "Rocaille" series; matt golden flatware, Palais XIII

Karen Blixen (p. 32)
Author: Inge Ahrens
Photographer: Janne Peters
Stylist: Thomas Niederste-Werbeck
Recipe writer: Frauke Koops
Product credits: tableware, "Musselmalet" and "Flora Danica," www.royalcopenhagen.com; flatware, "Ostfriesen" collection, www.robbeberking.com; glasses, Vintage, www.das7tezimmer.de

Jackson Pollock (p. 42)
Author: Marcus Woeller
Photographer: Robyn Lea
Recipe writer: Robyn Lea

Coco Chanel (p. 52)
Author: Sina Teigelkötter
Photographer: Antonina Gern
Stylist: Thomas Niederste-Werbeck
Recipe writer: Susanne Walter
Product credits: tableware, "Paliang," finest porcelain, designed by Dr. Katrin Stangenberg. (Designer Karl Lagerfeld immediately fell in love with this design and used it to equip all his houses.), www.paliang.com; stainless-steel flatware collection, "Dune," www.asa-selection.de; glasses, "Palatin" series, www.theresienthal.de

Apollo 11 (p. 64)
Author: Christina Schneider
Photographer: Kathrin Koschitzki
Stylist: Thomas Niederste-Werbeck
Recipe writer: Susanne Walter
Product credits: "Cosmic Diner" moon plates, Diesel living Seletti, www.seletti.it/diesel; tableware glass plates and stone slabs, "Gobi" and "Kronos" series, Lambert, www.lambert-home.de; silver flatware, "Gio" series, Robbe & Berking, www.robbeberking.com; glasses, "Veritas," Riedel, www.shopriedel.com

Johann Wolfgang von Goethe (p. 74)
Author: Christina Schneider
Photographer: Stephan Abry
Stylist: Thomas Niederste-Werbeck
Recipe writer: Frauke Koops
Product credits: tableware appetizer, soup, main course, "Kurland Blanc Nouveau," KPM service; porcelain birds, also KPM, www.kpm-berlin.com; dessert service, "Cumberland," Nymphenburg, www.nymphenburg.com; flatware and linen tablecloth, Broste Copenhagen, www.brostecopenhagen.com; glasses and carafe, private; restaurant and hotel, Gerbermühle, www.gerbermuehle.de

Truman Capote (p. 86)
Author: Christina Schneider
Photographer: Janne Peters
Stylist: Wolfram Neugebauer
Recipe writer: Frauke Koops
Product credits: tableware, Hermès, "Rallye" series, www.hermes.com; glasses, Saint Louis, "Apollo" series, www.saint-louis.com; flatware, Puiforcat Paris, "Cardinal" series, www.puiforcat.com; vintage vases, Die Remise, www.remise-hamburg de

Claude Monet (p. 100)
Author: Christina Schneider
Photographer: Francis Hammond
Stylist: Garlone Bardel
Recipe writer: Florence Gentner

Marie-Hélène de Rothschild (p. 108)
Author: Christina Schneider
Photographer: Jonas von der Hude
Stylist: Thomas Niederste-Werbeck
Recipe writer: Frauke Koops
Product credits: tableware all plates, "Tema & Variazioni" series, Fornasetti; drinking cups, Rotter; tray and lidded vase, Fornasetti. All Scala Wohnen Hamburg, scala-wohnen.de. Flatware: Sambonet, "Contour" series, rosenthal.de; glasses, Rosenthal, "Drop" series, rosenthal.de; vase, "Mr. and Mrs. Muse," Jonathan Adler; soup bowl, "Muse" Jonathan Adler, both vonwilmowsky.com

Bauhaus Art School (p. 118)
Author: Klaus Ungerer
Photographer: Antonina Gern
Stylist: Wolfram Neugebauer
Recipe writer: Frauke Koops
Product credits: tableware, "Urbino" series, KPM, kpm-berlin.com; water glasses, "Rotondo" and "Rotondo Optic" series; wine glasses, "Venice" series. All Dibbern, dibbern-onlineshop.de; flatware, "Goa" series, Cutipol via Dibbern, dibbern-onlineshop.de; materials in the background and on the table, "Manifesto Futurista" series, Dedar, dedar.com

Michael Romanoff (p. 130)
Author: Christina Schneider
Photographer: Jonas von der Hude
Stylist: Stephan Meyer
Recipe writer: Susanne Walter
Product credits: p. 130: tableware, "My China! Treasure Gold," Sieger, Fürstenberg, fuerstenberg-porzellan.com; glasses, "Air," Schott Zwiesel, zwiesel-living.com; silver flatware, "Alta," Robbe & Berking, robbeberking.com; sunglasses, Persol, persol.com. p. 135: tableware, Sieger, Fürstenberg, fuerstenberg-porzellan.com; glasses, Schott Zwiesel, zwiesel-living.com; flatware, "Alta" series, Robbe & Berking, robbeberking.com; peppermill, Peugeot, peugeot-saveurs.com; pewter cup, Vintage Hermès. pp. 136/137: tableware, Sieger, Fürstenberg, fuerstenberg-porzellan.com; glasses: whiskey glasses, "Hommage Carat" for the strawberries, Zwiesel 1872; water glasses, Schott Zwiesel, zwiesel-living.com; flatware. Robbe & Berking, robbeberking.com; clutch: Bottega Veneta, bottegaveneta.com

Thomas Mann (p. 140)
Author: Erwin Seitz
Photographer: Jonas von der Hude
Stylist: Stephan Meyer
Recipe writer: Frauke Koops
Product credits: tableware, "Rocaille," kpm-berlin.com; flatware, "Vendôme," sonja-quandt.com; glasses, "Palais," nachtmann.com; silver beaker, "Classic," sonja-quandt.com; table linen, bielefelder-leinen.de; accessories, Christmas decorations, kaethe-wohlfahrt.com; bronze bell, glockenladen.de

Frida Kahlo (p. 152)
Author: Christina Schneider
Rezeptautor: Achim Ellmer

Bloomsbury Group (p. 160)
Author: Annabelle Hirsch
Photographer: Jorma Gottwald
Stylist: Nina Lang
Recipe writer: Achim Ellmer
Product credits: p. 160: "Terre de Rêves," serax.com; blue-yellow rimmed plates, bloomsburyceramics.com; ceramic birds, czyganowski.de; cake stand with bird motif, "Le Pavoncelle," Cerasarda, artemest.com; "Footed Basket" with lace pattern, fuerstenberg-porzellan.com; dessert plates with blue rim, "Sussex," bloomsburyceramics.com; blue bowl, serax.com; porcelain spoon, private; glass spoon, "Rosé," maison-f.de; plates, "Pretty Pantry" with tart motif by Kate Spade, amara.com; materials, "Luna" and "Oak," mollymahon.com. p. 163: place settings, "Majorque" and plates, "Présentation en Céramique" series, casalopez.com; soup plates, "Aqua," water beakers and carafe, "Terres de Rêves." All serax.com; bread plates, "Bourg-Joly pleine," malicorne.com; crystal glasses, "Caton," saint-louis.com; flatware, "1965 Vintage," Sambonet, rosenthal.de; napkins, "Scalloped Linen," matildagoad.com; printed material, "Oak," mollymahon.com. pp. 166/167: place settings, "Scallop Edge Raffia," matildagoad.com and "Girder," serax.com; serving plates, "Chevet Pleine" and "Perlée Plate," both white, malicorne.com,

as well as "Cross Hatch" with red-blue rim, bloomsburyceramics.com; plates, "Peter Pilotto" with pastel-colored decoration, matchesfashion.com and "Terre Mêlée" in yellow, casalopez.com; serving bowls "Madeira" and vase "Nuno," motelamiio.com; beakers in pink and ceramic bird: czyganowski.de; flatware "1965 Vintage" and cast-iron saucepans, "Terra.Cotto" in turquoise and gray and "Curry," Sambonet, rosenthal.de; beakers for water, wooden spoon, and bowls "Terres de Rêves" and "Isa," serax.com; glasses "Caton," saint-louis.com; jug in blue, maison-f.de; napkins, "Majorque," casalopez.com; material, "Fitzroy" by Sanderson, stylelibrary.com

Audrey Hepburn (p. 172)
Author: Kristine Kirves

Tomi Ungerer (p. 180)
Author: Tina Bremer
Photographer: Thomas Neckermann
Stylist: Kristina Zombiri
Recipe writer: Marion Swoboda

Michelle Obama (p. 190)
Author: Tina Bremer
Photographer: Jonas von der Hude
Recipe writer: Susanne Walter
Product credits: tableware, "Francis Carreau beige"

Napoleon Bonaparte (p. 198)
Author: Barbara Baumgartner
Photographer: Jonas von der Hude
Stylist: Thomas Niederste-Werbeck
Recipe writer: Susanne Walter

Grace Kelly (p. 208)
Author: Christina Schneider
Photographer: Jonas von der Hude
Stylist: Thomas Niederste-Werbeck
Recipe writer: Susanne Walter
Product credits: tableware, "Sanssouci Elfenbein" series, Rosenthal, rosenthal.de

PICTURE CREDITS

© for the reproduced works by Jackson Pollock by Pollock-Krasner Foundation/ VG Bild-Kunst, Bonn 2020; for the reproduced works by Gunta Stölzl-Stadler by VG Bild-Kunst, Bonn 2020; for the reproduced works by Frida Kahlo by Banco de México Diego Rivera Frida Kahlo Museums Trust/VG Bild-Kunst, Bonn 2020; for the reproduced works by Duncan Grant by Estate of Duncan Grant. All rights reserved/VG Bild-Kunst, Bonn 2020
© for the reproduced works by Walter Funkat and Hinnerk Scheper by Bauhaus-Archiv Berlin

6 Slim Aarons / Getty Images; 8 Ann-Marie Aring; 4, 9 Fox Photos / Getty Images; 12 Picture Press / Camera Press; 18 © ullstein bild – TopFoto; 4, 23 © ullstein bild – Lehnartz; 24 © ullstein bild – Sticha; 26 t. © ullstein bild – dpa; 26 b. l. © ullstein bild – BPA; 26 b. r. © ullstein bild – AP; 27 © ullstein bild – Heinz O. Jurisch; 4, 33 INTERFOTO / Granger, NYC; 34 INTERFOTO / Granger, NYC; 38 t. INTERFOTO / Mary Evans / Illustrated London News Ltd.; 38 m. INTERFOTO / Granger, NYC; 38 b. Karen Blixen Museum; 42 © Assouline, photography by Robyn Lea; 4, 43 Martha Holmes / Getty Images; 44 © Assouline, photography by Robyn Lea; 45 picture alliance / United Archives / DEA | -; 46 t. l. Martha Holmes / Getty Images; 46 t. r. © Assouline, photography by Robyn Lea; 46 b. l. © Assouline, photography by Robyn Lea; 46 b. r. © Assouline, photography by Robyn Lea; 47 r. © Assouline, photography by Robyn Lea; 48 l. o. Martha Holmes / Getty Images; 48 b. l. © Assouline, photography by Robyn Lea; 49 t. Martha Holmes / Getty Images; 49 b. l. picture-alliance / dpa | UPI Hans Namuth; 49 b. r. Tony Vaccaro / Getty Images; 50 © Assouline, photography by Robyn Lea; 4, 52 INTERFOTO / Granger, NYC; 53 © ullstein bild – imageBROKER / Peter Seyfferth; 56 t. l. Phillips / Getty Images; 56 t. r. Apic / Getty Images; 58 Sasha / Getty Images; 59 t. INTERFOTO / Granger, NYC; 4, 64 © ullstein bild – NASA; 65 by courtesy of vintagemenuart. com; 67 t. Wally McNamee / Getty Images; 67 b. Fred Bauman / Getty Images; 69 b. l. picture-alliance / dpa | UPI; 69 b. r. Bettmann / Getty Images; 4, 74 bpk / Staatsbibliothek zu Berlin / Ruth Schacht; 76 b. l.; 76 b. l. Babovic / laif; 76 b. r. bpk / Dietmar Katz; 77 t. bpk; 77 b. bpk; 78 t. bpk; 78 m. bpk / Dietmar Katz; 78 b. bpk; 81 t. bpk / Klassik Stiftung Weimar / Alexander Burzik; 81 b. bpk / Klassik Stiftung Weimar / Mokansky, Olaf; 4, 87, 88, 90 b., 91 b. © Elliott Erwitt / Magnum Photos / Agentur Focus; 90 t., 93 t. photo The Lawrence Fried Archive © Lawrence Fried; 100 akg-images; 4, 101 bpk | RMN - Grand Palais; 102 l., 102 m.,

103 b. l., 103 b. r., 106 Bridgeman Images; 102 r. akg-images; 104-105 akg-images / Laurent Lecat; 107 © Francis Hammond; 4, 109 Photo © AGIP / Bridgeman Images; 110 t. © ullstein bild - Roger-Viollet / Jack Nisberg; 100 b. Collection Dupondt / akg-images; 5, 118, 119, 120, 122, 123, 128 Bauhaus- Archiv Berlin; 121 t. akg-images / Schütze / Rodemann; 121 b. akg-images; 131 Slim Aarons / Getty Images; 132 Allan Grant / Getty Images; 5, 133 t. Slim Aarons / Getty Images; 133 b. PictureLux / The Hollywood Archive / Alamy; 134 Slim Aarons / Getty Images; 5, 141 Carl Mydans / Getty Images; 142 t. Imagno / Getty Images; 142 m. © ullstein bild - ullstein bild; 142 b. ETH-Bibliothek Zürich, Thomas Mann Archives / photographer: unknown / TMA_0459; 143 t. © ullstein bild - Friedrich Mueller / Friedrich Mueller; 143 b. picture-alliance / dpa; 146 ETH-Bibliothek Zürich, Thomas Mann Archives / photographer: unknown / TMA_5359; 147 picture-alliance / United Archives / TopFoto | 91050 / United_Archives / TopFoto; 5, 152 Lucas Vallecillos / AGE / F1online; 153 akg-images; 154 l. Bettmann / Getty Images; 154 r. bpk / IMEC, Fonds MCC / Gisèle Freund; 155 Interfoto; 156 l. akg-images / archive photos; 156 r. t. bpk / IMEC, Fonds MCC / Gisèle Freund; 156 r. b. Bettmann / Getty Images; 157 t. akg-images; 157 b. Interfoto; 158 Interfoto; 5, 161 l. © Fine Art Images – ARTOTHEK; 161 r. © Estate of Vanessa Bell. All rights reserved, DACS 2020 / Bridgeman Images; 162 l. Tony Tree / Charleston Trust; 162 r. mauritius images / Rob Cole Photography / Alamy; 164 Photo © Peter Nahum at The Leicester Galleries, London / Bridgeman Images; 165 Charleston Trust; 168 t. Photo © Christie's Images / Bridgeman Images; 168 b. Charleston Trust; 5, 172 PictureLux / The Hollywood Archive / Alamy; 173 Sunset Boulevard / Getty Images; 174 Dwayne DeJoy / Getty Images; 175 Norman Parkinson / Iconic Images / Getty Images; 176 Henry Clarke / Getty Images; 177 akg-images / picture-alliance / KPA / United Archives; 178 Henry Clarke / Getty Images; 5, 181, 183 Tomi Ungerer Zeraldas Riese Copyright © 1970, 2019 Diogenes Verlag AG Zurich. All rights reserved; 182 Vera Hartmann / 13 Photo; 5, 190 picture alliance / AP | Pablo Martinez Monsivais; 191 picture alliance / ASSOCIATED PRESS | Pablo Martinez Monsivais; 193 Shawn Thew / EPA / Shutterstock; 194 ASAUL LOEB / Getty Images; 5, 199 mauritius images / Ivy Close Images / Alamy; 200 akg-images / VISIOARS; 209 Bettmann / Getty Images; 210 Agentur Focus / Magnum Photos / Dennis Stock; 5, 211 Action Press / Sipa; 212-213 Imago / United Archives international; 216 t. l. Allpix Press / Alain Benainous; 216 t. r. Bettmann / Getty Images; 216 m. l. New York Daily News Archive / Getty Images; 216 b. l. © ullstein bild – mirrorpix; 217 United Archives / TopFoto / SZ Photo

THANKS

This wonderful book would not have been possible without the excellent work
of everyone who has been working for SALON magazine with great passion and creativity for years. I would like
to thank all the authors, photographers, stylists, and chefs involved.

Also, thanks to the entire SALON editorial team:
Art Director Beate Meding, who designed this book, Iris Pasch for the picture research, and
Verena Richter and Kristine Kirves for their outstanding editorial work.

In particular, I would like to thank the long-time creative director of SALON,
Thomas Niederste-Werbeck, who produced most of the photographs shown here.

ANNE PETERSEN
Hamburg, June 2020

This book was created in cooperation with SALON,
the German magazine for hospitality, design, and culture.

SALON
DAS MAGAZIN FÜR GASTLICHKEIT, DESIGN UND KULTUR

IMPRINT

Front Cover: Grace Kelly and Prince Rainier with her mother,
Margaret Kelly, on the day of the wedding; in the background the Wedding Cake, see p. 209 (top);
Bombe Glacée Princesse Elizabeth with Strawberries and Meringue, see pp. 16/17 (left)
Frontispiece: Coco Chanel's Salade Niçoise with Tuna Steaks, see pp. 54–55
p. 6: Romanoff's in Beverly Hills, see p. 131

© Prestel Verlag, Munich · London · New York, 2021,
a member of Verlagsgruppe Random House GmbH
Neumarkter Strasse 28 · 81673 Munich, Germany

The publisher expressly points out that external links contained in the text could
only be viewed by the publisher until the time the book was published.
The publisher has no influence on later changes.
The publisher is therefore not liable.

For copyright and picture credits see pp. 222/223

EDITORIAL DIRECTION: Claudia Stäuble and Stella Christiansen
PROJECT MANAGEMENT ENGLISH EDITION: Sylvia Goulding, Les Arques
TRANSLATED FROM THE GERMAN: Sylvia Goulding and Emily Plank
COPYEDITING: Beverly LeBlanc — PROOFREADING: Diana Vowles
LAYOUT: Beate Meding — TYPESETTING: Mike Goulding
PRODUCTION: Friederike Schirge
SEPARATIONS: Reproline mediateam
PRINTING AND BINDING: DZS, Grafik, d.o.o., Ljubljana
PAPER: Profimatt

Verlagsgruppe Random House FSC® N001967

Printed in Slovenia
ISBN 978-3-7913-8722-2

www.prestel.com